'A superhouse is one that delivers a 360-degree completeness of form; its exterior and interior have a seamless execution and, above all else, it is awe-inspiring. This quality can be elicited from the perfection of its natural setting, a remarkable use of materials, an exceptional level of craft, ground-breaking innovation or a use of space that lifts the spirit.'

In *Superhouse*, Karen McCartney, working with internationally renowned photographer Richard Powers, presents an exceptional and intensely personal selection of architecturally designed houses from around the world.

Karen McCartney has a wealth of experience in the areas of design, art and architecture. From an honours degree in the History of Art & English from University College London, and her first job on British magazine *Art Monthly*, Karen has written for, amongst others, British *Elle Decoration* and *The World of Interiors*. In Australia she edited *Marie Claire Lifestyle* and was founding editor of interiors magazine *Inside Out*, a position she held for 10 years. She has published two successful architecture books on iconic Australian houses, and has curated an exhibition on the subject for Sydney Living Museums.

For David

SUPERHOUSE

KAREN McCARTNEY

PHOTOGRAPHY BY RICHARD POWERS

LANTERN

an imprint of
PENGUIN BOOKS

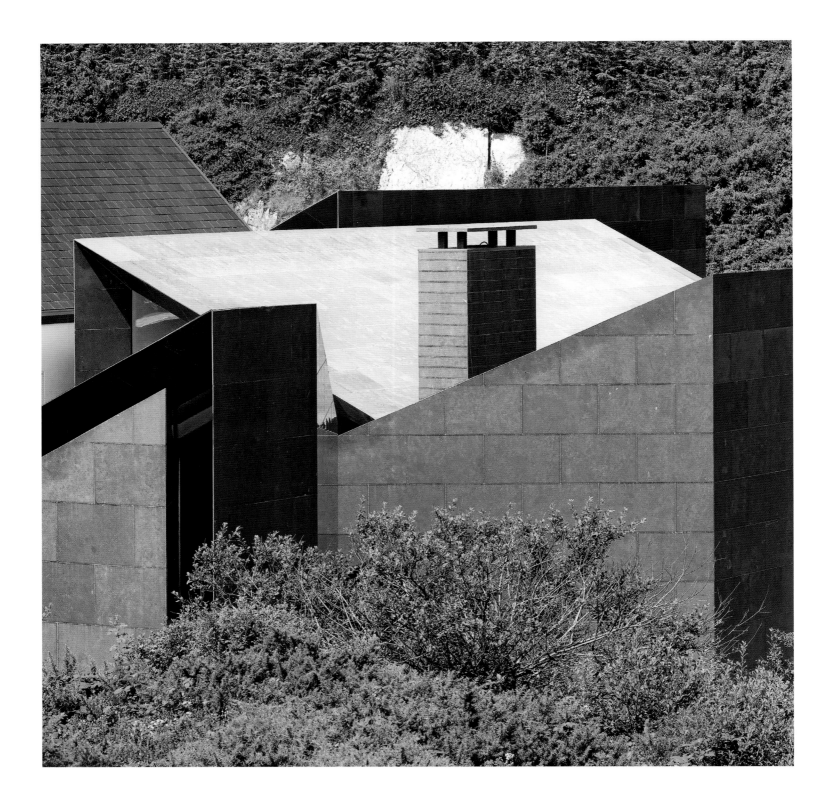

Níall McLaughlin Architects designed the House
at Goleen (2009), on a spectacular piece of Irish
coastline, as a series of linear pavilions connecting
to the original house, which had been re-roofed in
slate, rendered and painted white. The new forms are
clad in Irish blue limestone, which will weather over
time and become more like the surrounding rocks.
Photography courtesy of Níall McLaughlin Architects.

FOREWORD

◇

The idea for *Superhouse* came about, as good ideas often do, over lunch. I was discussing the work of photographer Richard Powers with my publisher and I said that a lot of his work focused on 'the superhouse'. And there, in an instant, the title and, by proxy, the book was born.

But of course, being a Libran, and prone to indecision, it wasn't long before the positives of the title began to drift into negative territory and I worried that it sounded superficial, flash and just too damn moneyed. So I wrote a definition of what 'super' meant to me in this context to see if it stacked up. This was my outline.

'A superhouse is one that delivers a 360-degree completeness of form; its exterior and interior have a seamless execution and, above all else, it is awe-inspiring. This quality can be elicited from the perfection of its natural setting, a remarkable use of materials, an exceptional level of craft, ground-breaking innovation or a use of space that lifts the spirit. All the houses chosen will be beautiful and possess a quality that sets them distinctly apart from the everyday. A strong connection with nature would provide the choice of projects with a necessary thread of coherence.' I also found a quote from architect Peter Zumthor that emphasised something of the quality I wanted the book to convey. 'People are increasingly calling for things that are imbued with mindfulness and love.' So, while each house had to deliver 'beyond normal', it also had to possess qualities that superseded those that money alone could buy.

With this definition I could enjoy the sheer scope of 'super'. A Miesian pavilion, the Goulding Summerhouse (1971–73) in Co Wicklow, Ireland, by modernist architects Scott Tallon Walker was super because not only did it cantilever dramatically over a river but, in a land dominated by low-lying white thick-walled cottages, it was a cultural anomaly. Likewise, Jan Benthem's Almere house (1982–84) in the Netherlands. He designed it overnight as an experiment and competition entry, and proceeded to live there with his family for more than 25 years. It is a spare, innovative space that, although designed to be demountable, has stayed put, becoming increasingly enveloped by greenery over the years. A contemporary approach to traditional Moroccan building techniques, and a desire to reinvent an architectural language for residential Moroccan houses inspired young Frenchmen, Studio KO, to design

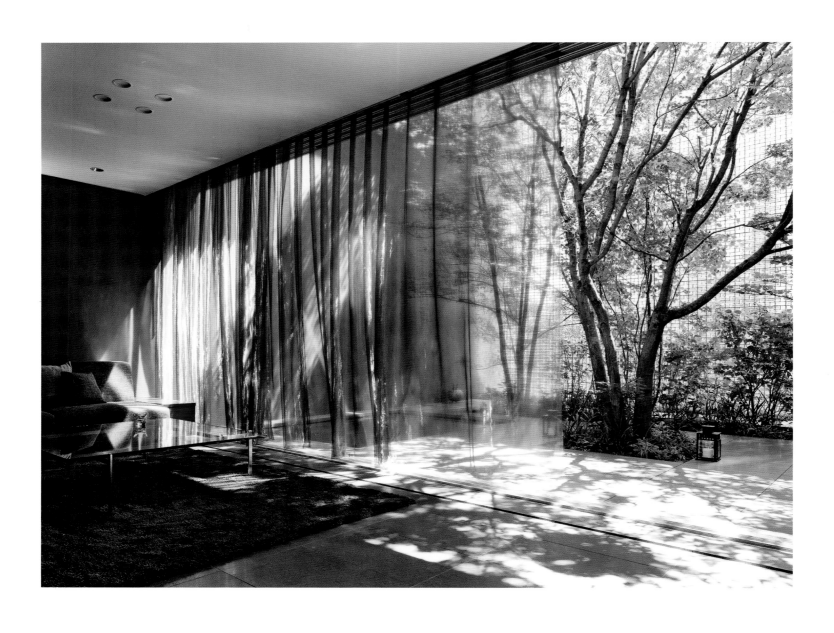

FOREWORD

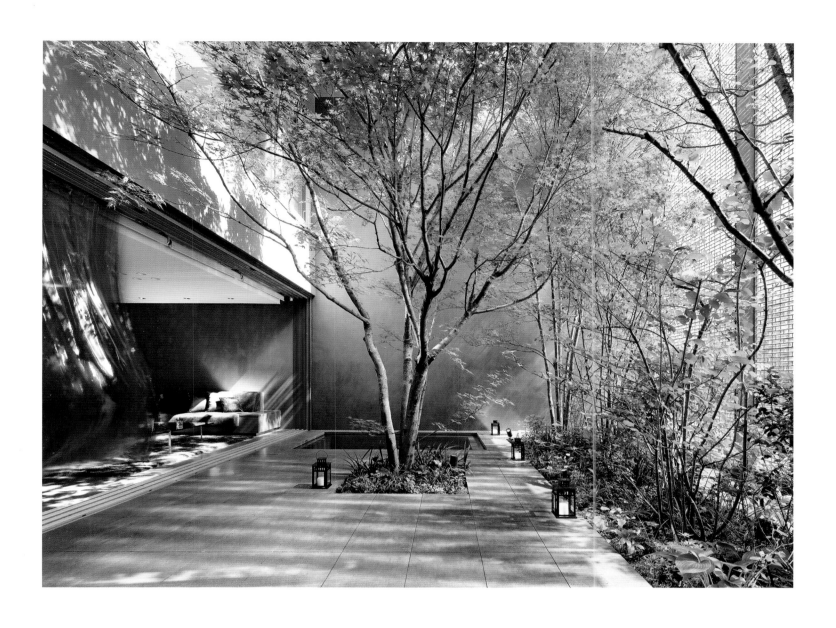

Optical Glass House (2012) by Hiroshi Nakamura &
NAP is a lesson in serenity in the fast-paced city of
Hiroshima. A two-storey-high wall, in specially made
glass block, separates the house from the street,
diffusing the noise but allowing filtered light to fill the
courtyard of maple, ash and holly trees. A light metal
curtain responds to breezes and provides a fluttering
divider between inside and out. Photography by Koji
Fujii/Nacasa & Partners Inc.

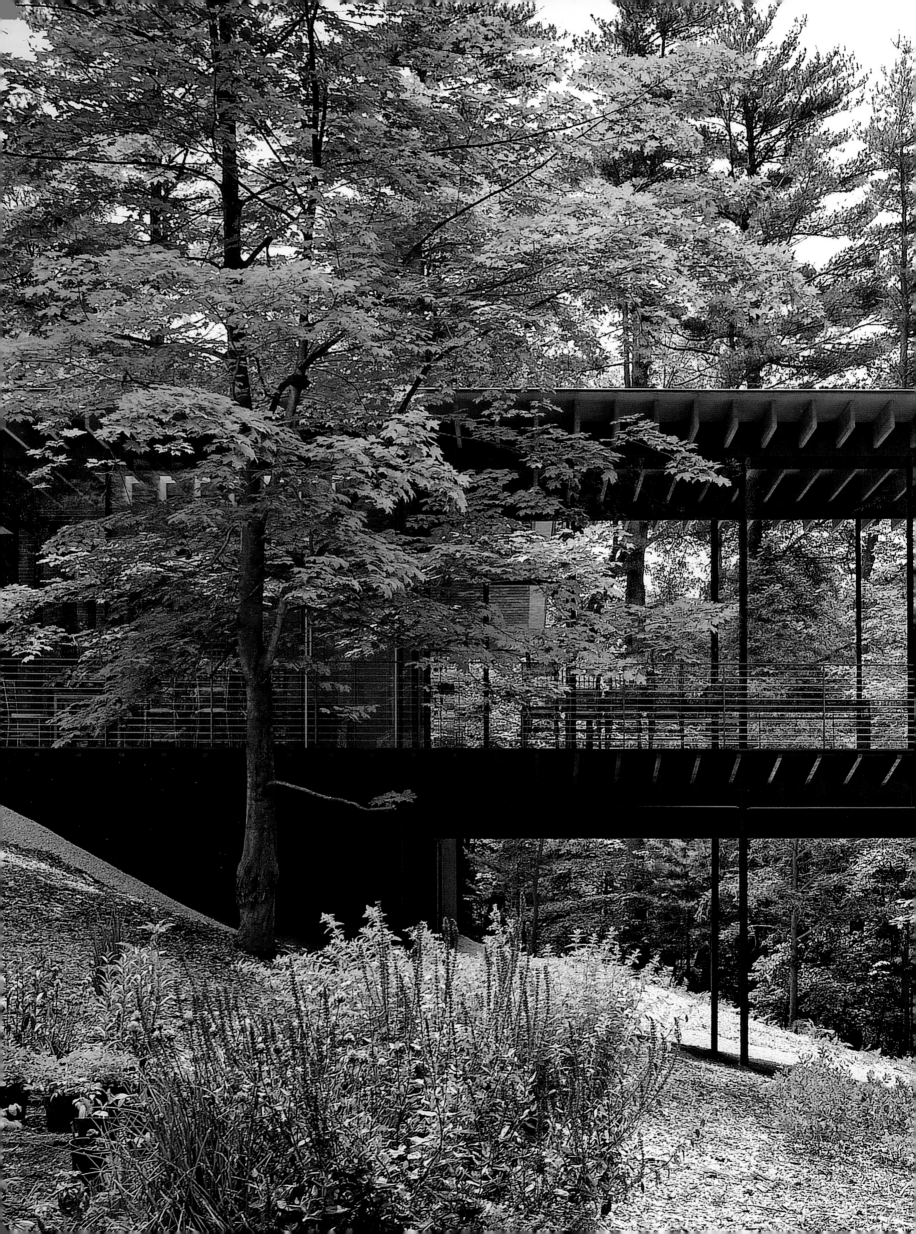

Kengo Kuma's Glass/Wood House (2010) is, in his words, 'hitched' to an existing 1956 house in New Canaan, Connecticut, designed by architect Joe Black Leigh. Kuma created an L-shaped solution by cantilevering a barely-there slice of timber and glass over a five-metre sloping section of the site below the dining room, extending the living space but allowing the building to merge with its natural setting. Photography courtesy of Kengo Kuma and Associates.

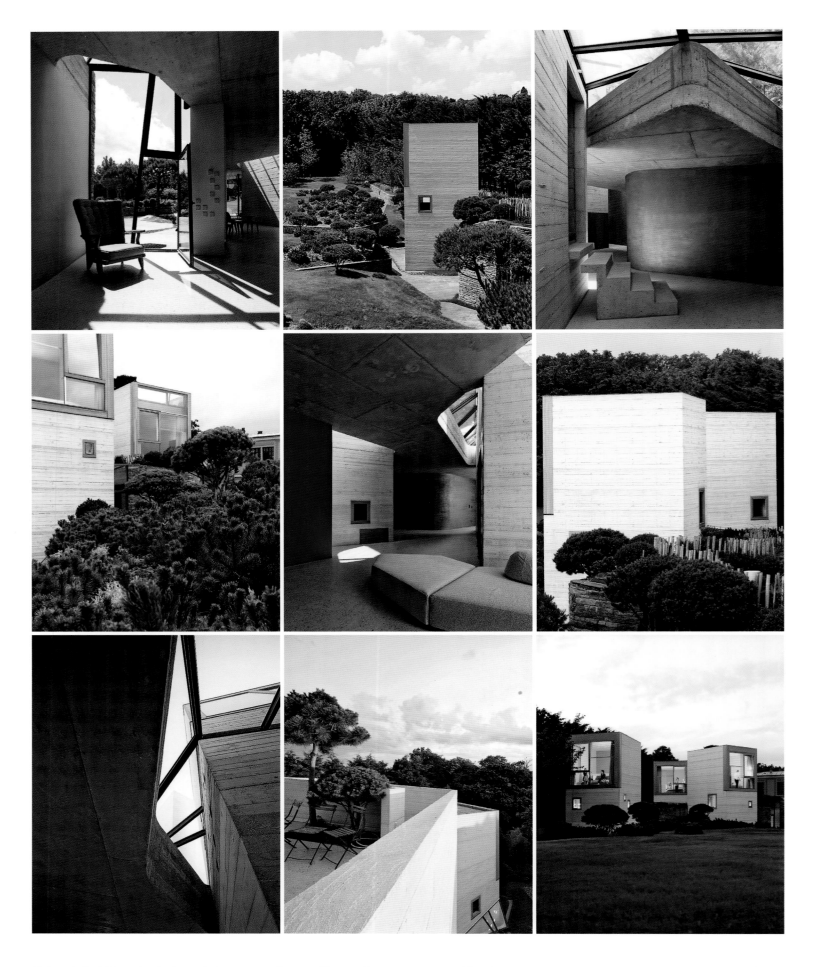

Maison L (2011) is an intriguing solution to providing independent, private spaces for every member of the client's family. Set in the grounds of an eighteenth-century castle half an hour's drive west of Paris, architect Christian Pottgiesser and artist Pascale Thomas Pottgiesser created five three-storey towers carefully integrated with their natural setting. They are connected by a concrete canopy and are bound by a stone wall which wraps around the base. Photography by George Dupin.

Villa D. And so it goes on, each with its own distinctive form of what it means to be 'super'.

While the scope of the book is global, Australia is where I live, where the book is published, and home to many extraordinary examples of architectural expression. The projects from this part of the world range from a small, crafted modern-day woodland cottage by Paul Morgan to a stunningly expressive house by the beach by Wood Marsh, which curves and soars, challenging the genre and creating a whole new language. John Wardle Architects' extraordinary skill with form and material exploits the sheer possibilities of what a building can be and Virginia Kerridge's quiet craft gives new meaning to rural Australian architecture.

As I formed the concept of the book, researched and planned, it seemed to me that Frank Lloyd Wright's Fallingwater was, without doubt, one of the original 'superhouses'. When examining the initial criteria, it remained at the very heart of the concept, showing structural daring and experimentation, illustrating a deep, elemental connection to nature and challenging notions of how we should live. It is also, in all probability, the most famous house on the planet. I felt it was a house that required first-hand experience, despite the countless books on the subject, and I made the pilgrimage to Pennsylvania. After spending the night in another FLW house, the Duncan House, I took the in-depth tour of Fallingwater. It didn't disappoint. What makes the house visionary is Wright's ability to take all nature has to offer and make it part of the experience of the house. Not only is the waterfall pulled into the body of the house through sound, it is physically integrated via the steps from the living space to the water below. Visually, the look of the water is echoed in the treatment of the irregular flagstone flooring internally – waxed, using Johnson's Floor Wax. Wright knew the value of a complete solution, designing interior lighting, bespoke furniture both freestanding and built-in; he also understood the importance of direct access to outdoor space. There was much to absorb and I felt grateful to have been exposed to his philosophy in such a direct and meaningful way so that it could focus and inform my approach.

What makes this book visually strong is that the images are all by the same photographer, Richard Powers, providing the book with a unified and consistent style. Often books of this sort are compiled from various photographic sources, and there is good reason for this. The visual expression of an architect-designed house is often as follows. The building work is finished and, before the clients take up residence with belongings brought from their previous house, the architects swoop in with a few artfully placed pieces of designer furniture and have it professionally photographed. Images showing the magnificent architectural lines of the house, unimpeded by the clients' furnishings, are circulated to the architectural press. The more lifestyle-focused interiors magazines mostly cannot use them because, while wonderful, they have no life. Often architects have a once-only photography deal with their clients, who do not want repeated sets of photography of their private space in the public domain. This is completely understandable.

As well as problems with clients' belongings, sometimes the interior has been specified by an interior designer not to the taste of the architects. Or, in some cases, the property has been sold and completely altered. You begin to see the challenge. I had to source houses in a country to which Richard was travelling, contact the architect, hope that the interior was still good, hope that the client would agree to a shoot (apart from anything else, great effort is required in terms of cleaning and tidying the house) and, when all was organised, hope that the weather would hold up. Moody skies are fine, bucketing rain is not.

The journey of a book of this nature is an interesting one. I worried that it would be too diverse, that the older houses would not connect to the new ones, and that it would appear random and unfocused. Two things happened to help resolve this – the connecting power of nature and a shift in the type of houses. That shift came with Vincent Van Duysen's offer for us to

photograph the VDCA Residence, a new summerhouse pavilion and refurbishment of a 1950s Belgian house in the French style. He is an architect I admire and this blend of the old and new combined with his deft hand with interior spaces made it irresistible. Suddenly alongside Piero Lissoni's Monza Loft, with its cathedral-like space inside a late nineteenth century theatre, this idea of re-use opened up. I discovered La Fábrica, Ricardo Bofill's remarkable reinvention of a cement factory in Barcelona and approached the Landmark Trust in the UK to include Astley Castle, a ruin transformed into an award-winning residence by Witherford Watson Mann. The shift allowed the remit of the book to broaden in the best possible way. I now love that sense of surprise in turning from the examples shown in the foreword, which I'd hoped to shoot but couldn't get access to, to a re-imagined English castle, onto a Brutalist masterpiece in São Paulo by Mendes da Rocha and then a sculptural tower house in Upstate New York reflecting its natural context on its glassy skin.

The design process has been a very rewarding one for me. Where possible I went with Richard on the shoots and acted as 'stylist' and, when the images came in, I would sit with the designer, Evi Oetomo, and we would work through the layouts together. This meant we could make sense of the flow of each house as well as creating powerful visual combinations and a sense of drama and contrast as the pages of one house gives way to those of another. As the layouts came together, it became clear that the natural context of the houses gave them great coherence, whether a landscape of arid Moroccan desert or dense Spanish forest.

This book has been an opportunity to be able to source some of the world's most interesting living spaces, and to meet their creators and sometimes their owners. It's been a chance to get inside the heads of the architects and, in turn, convey their ideas and philosophies alongside a great example of their work. The architects have all been generous with their time, and I hope they feel that my words, and Richard's photographs, have done them justice. ▬▬

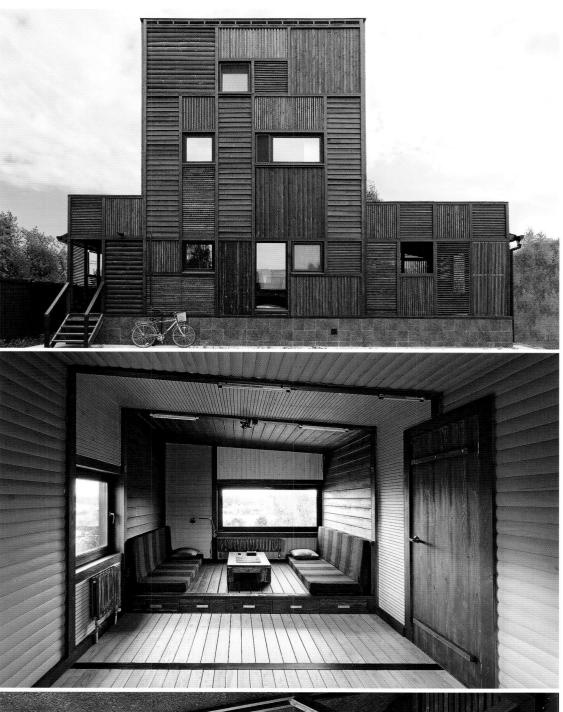

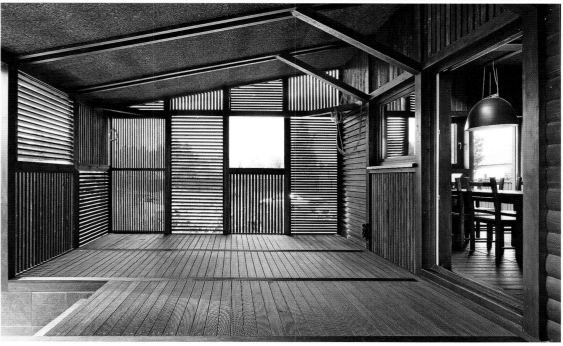

The Wood Patchwork House
(2007–2009) by Russian architect
Peter Kostelov is a *dacha* or
summerhouse on the River Volga
in a small village in the Tverskaya
region between Saint Petersburg
and Moscow. Its facade of wooden
slats, in different colours, recalls
the makeshift days of Soviet-era
building when materials that
came to hand were used in
building. The crafted timber
interior and enclosed summer
verandah use a mixture
of traditional and modern
approaches to timber detailing.
Photography by Alexey Knyazev.

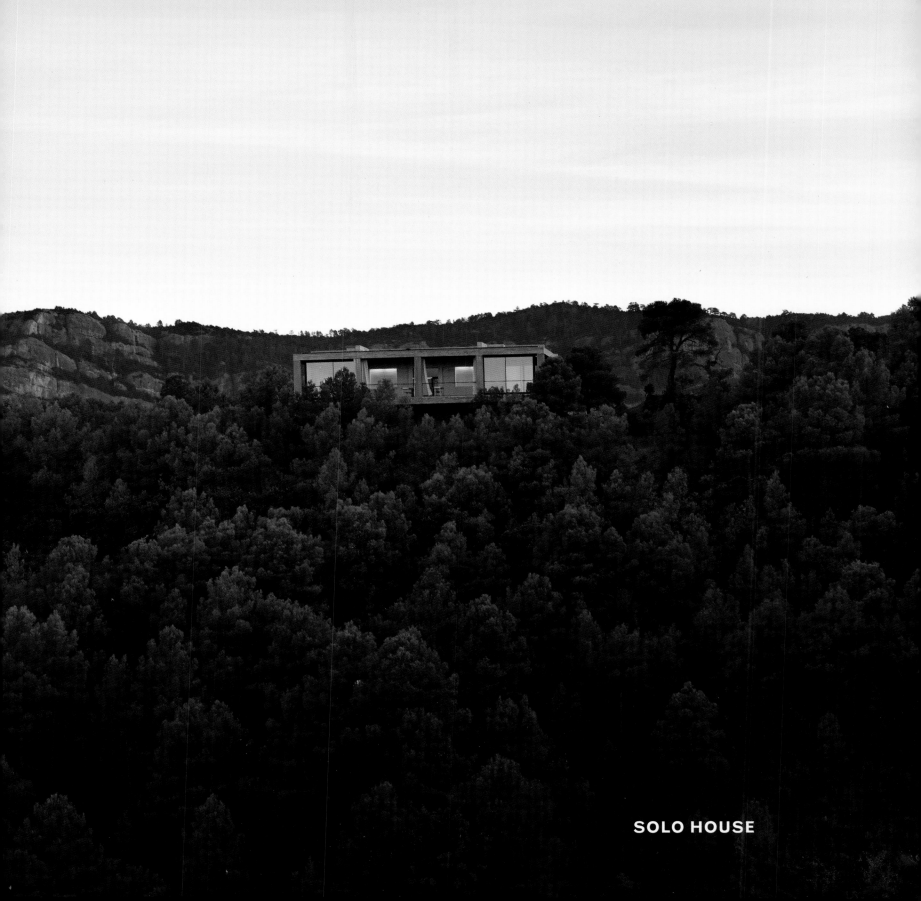

SOLO HOUSE

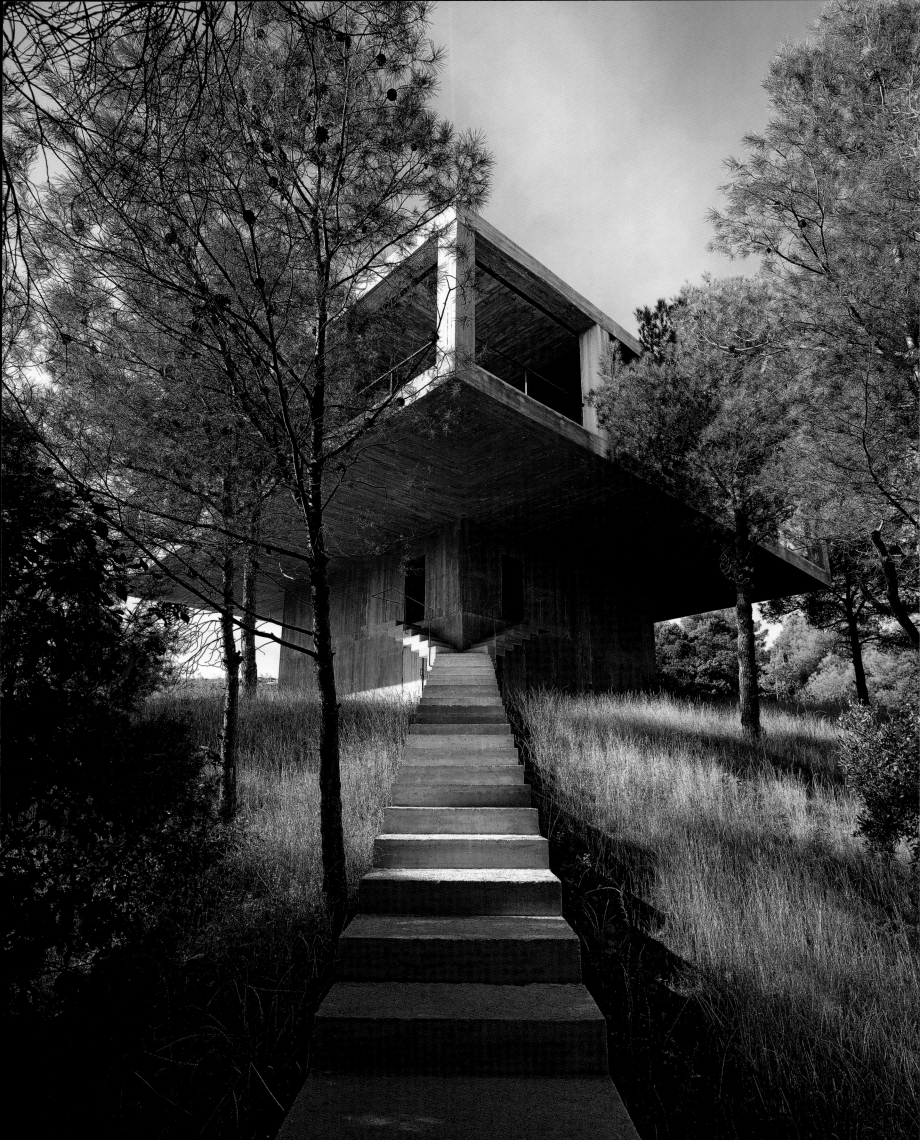

SOLO HOUSE
(2009–2012)

◇

PEZO
VON ELLRICHSHAUSEN

⋈

CRETAS, SPAIN

'There will never be great architects or great architecture without great patrons,' said Edwin Lutyens and, indeed, the Solo House is a case in point. In this instance, the role of patron is taken by Frenchman Christian Bourdais of the Solo Houses project. Not only has he acquired a remarkable 50-hectare site of great geographical beauty near Cretas, in the northeast Spanish province of Teruel, but he is commissioning a cross-section of the world's best young architects to realise his vision. It is ostensibly a development, but not as we know it. Chilean architects Pezo von Ellrichshausen (Mauricio Pezo and Sofia von Ellrichshausen) are the first practice to complete a project, but as I toured the house, a planning meeting was underway for the second building by celebrated Japanese architect Sou Fujimoto.

'What we want to do,' says Bourdais, 'is reinvent the way of living in a secondary (holiday) house.' The commissioning process is a gift for any architect. 'The only thing I give them is the land and the budget, and ask them to imagine who will live here. And then I give them the freedom to create something noteworthy and special. They have carte blanche.' He admits choosing the architects to work with is his 'little pleasure' and acknowledges he was drawn to Pezo von Ellrichshausen (PVE) for two reasons. Not only was the Poli House (2002–2005) in Coliumo, Chile, the best construction he had ever seen, but its physicality was matched by the quality of the intellect applied to its design.

There is a sense that it is not just houses that Bourdais is commissioning, but that he is determined to capture new approaches to residential architecture. 'I don't want just objects, the thinking is important – how they imagine the spaces matters,' he says.

PVE immediately knew something unique had come their way. 'This is one of those rare occasions when you meet with singular circumstances,' says Pezo. 'In this case not only were the physical conditions for the project incredible, but so too was the optimistic and generous disposition of the client.'

At the very heart of the design is the notion that this is a temporary residence with the experiences of arriving and staying as central to its concept. 'This is a house to be occupied in an informal manner,' says von Ellrichshausen. 'It is for holidays, for those days that break your routine, that allow you to dress differently, to eat differently, to enjoy small details, to be detached from what you consider to be a responsibility.'

And, in true holiday mode, the location is one that is far from the everyday. The practice is no stranger to dramatic landscapes; the Poli House, a sculptural concrete cube, sits on the edge of an isolated cliff, and their Rivo House (2002–03), clad in pine boards treated with burnt oil,

A view from partway up the 197 steps towards the ambiguous entry.

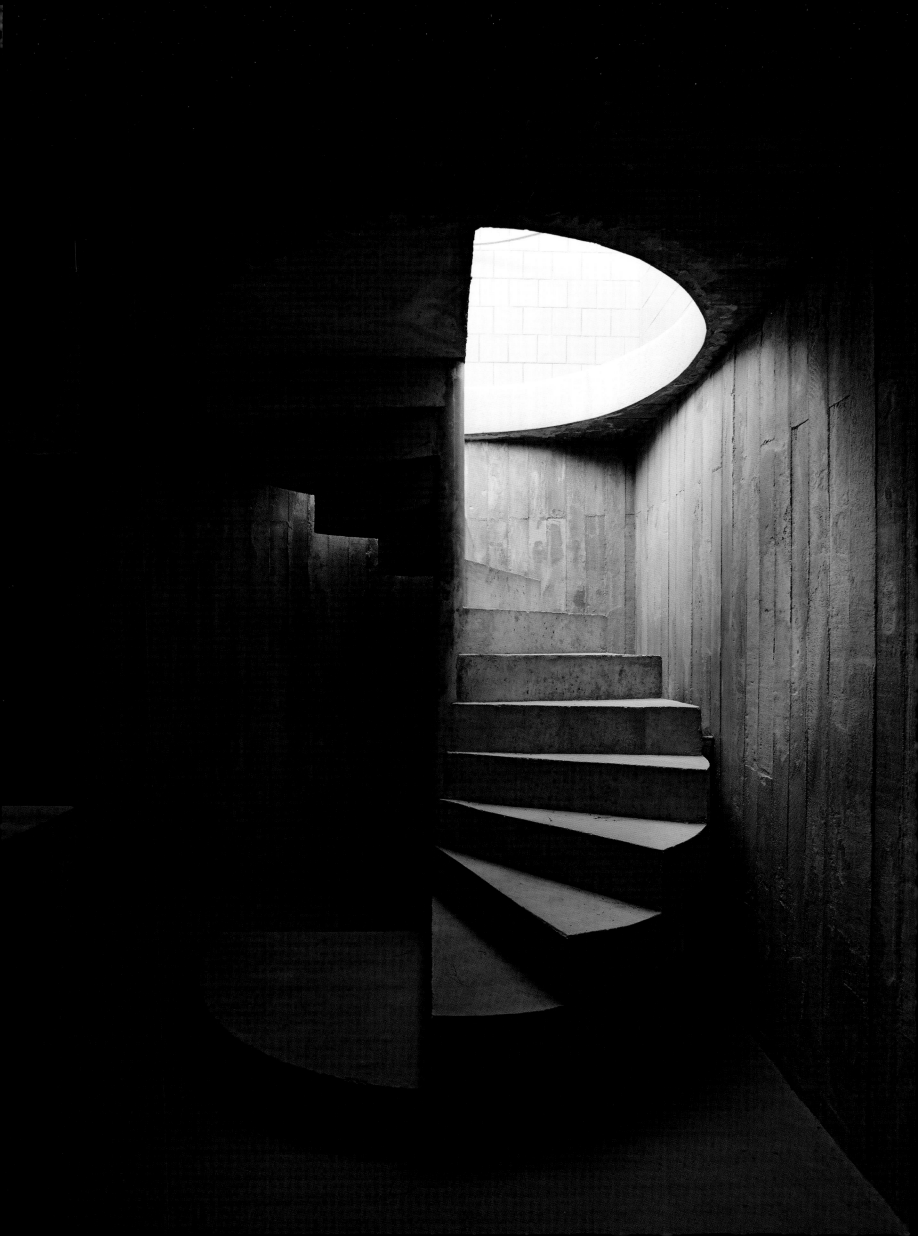

The sculptural
staircase takes
the visitor from
the moody interior
up into the light.

The pool,
at the heart of the
building, is even
an element of the
entry experience.

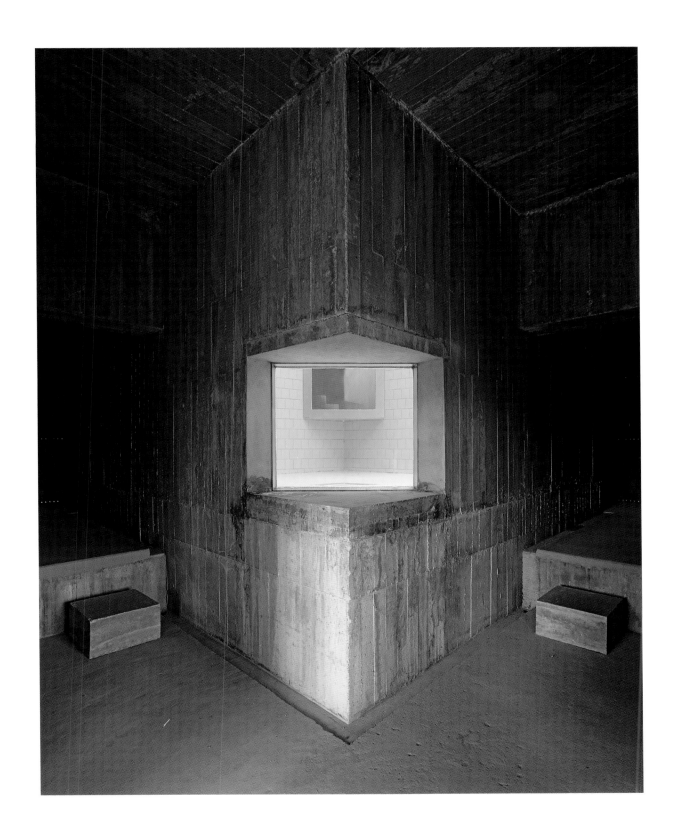

The pool, situated at the core of the house, is accessible from all four of the verandah rooms.

is all but submerged in the foliage of a southern Chilean forest. Hence their first and fundamental act was to determine the positioning of the Solo House on the land. Aware that 'the experience of discovering the magnificent panorama was already there', they toured the land, walking up the hill until they found the optimum setting for the house.

The approach to the house is via a discreet turn from a small local road and onto a track that cuts through scrub. After a couple of kilometres, a low metal bar that pivots to admit entry is the only sign you are on the right approach. The house, sited on a vantage point, is always visible, its monumentality giving it a quiet, assertive power.

The parking platform is at the bottom of 197 steps, the ascent of which is very much part of the process of arrival (there is another entry higher up for when you have luggage to unload). 'Given the fact that a vacation house is always linked with a trip, the proposed arrival is meant to intensify the mental anxiety by a repetitive bodily movement,' says Pezo. 'That movement could be understood as a kind of ritualisation of a rather banal experience. The transition is from the parking at the foot of the hill to an exceptional world, elevated on top of the hill.'

You arrive at the top with your heart thumping, awareness heightened and with a sense of anticipation of the experience to come. And it does not disappoint. The entrance is at a diagonal to the base of the podium, a cool, enclosed meditative space defying all convention in terms of entry. You have the choice to turn left or right.

'The moment you are faced with two options that lead to the same point you tend to be aware of something else,' says Pezo. 'Perhaps the dilemma of the arbitrary, with functions that are not functional. It is like asking two different questions for the same answer.'

This obliqueness may seem contrary in print but, in reality, it is remarkably effective. At the same time, there are glimpses of what is to come. The base of the pool is exposed in this space, pulling the water, which is at the very heart of the building, down into the experience of entry. There are hints of sky balancing the controlled cave-like sense of enclosure the tight planning of this space delivers. 'It might be complex or confusing for a first-time visitor but for the normal inhabitant this should operate at a more relaxed pace,' says Pezo.

The spiral staircase is like a sculpture that transports you from the pleasing gloom of the entrance to the bright daylight, which is all part of the dramatic articulation of events. You arrive, temporarily confused, blinking in the light, by the edge of the pool and the liquid centre of the building.

'The only thing I give them is the land and the budget, and ask them to imagine who will live here. And then I give them the freedom to create something noteworthy and special. They have carte blanche.'

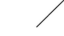

CHRISTIAN BOURDAIS

As well as the practical considerations of pool maintenance when the house is unoccupied, the position of the pool in the centre 'is primarily meant to reinforce the sense of autonomy and balance', says von Ellrichshausen. 'The pool is at the same distance from any room, from any function. So it inversely affects each room in the same way, depending on the influence of natural light.'

What is remarkable about the house is its relentless 360-degree aspect. There are four sensitively proportioned perimeter verandah rooms; two bedrooms, a kitchen/dining, and a living area, each with a scenic view and painterly shifts in light as the sun moves around the building.

'Even though the elevated universe of the house has a centralised structure without any predominant direction, the actual distribution of functions was defined in a cardinal fashion according to the sun movement,' says von Ellrichshausen. 'So, for instance, the social areas are protected from the more horizontal sun of the afternoon.'

Each terrace is the same but different, and the subtle nuances take time to absorb as you move through the space – a bit like understanding the

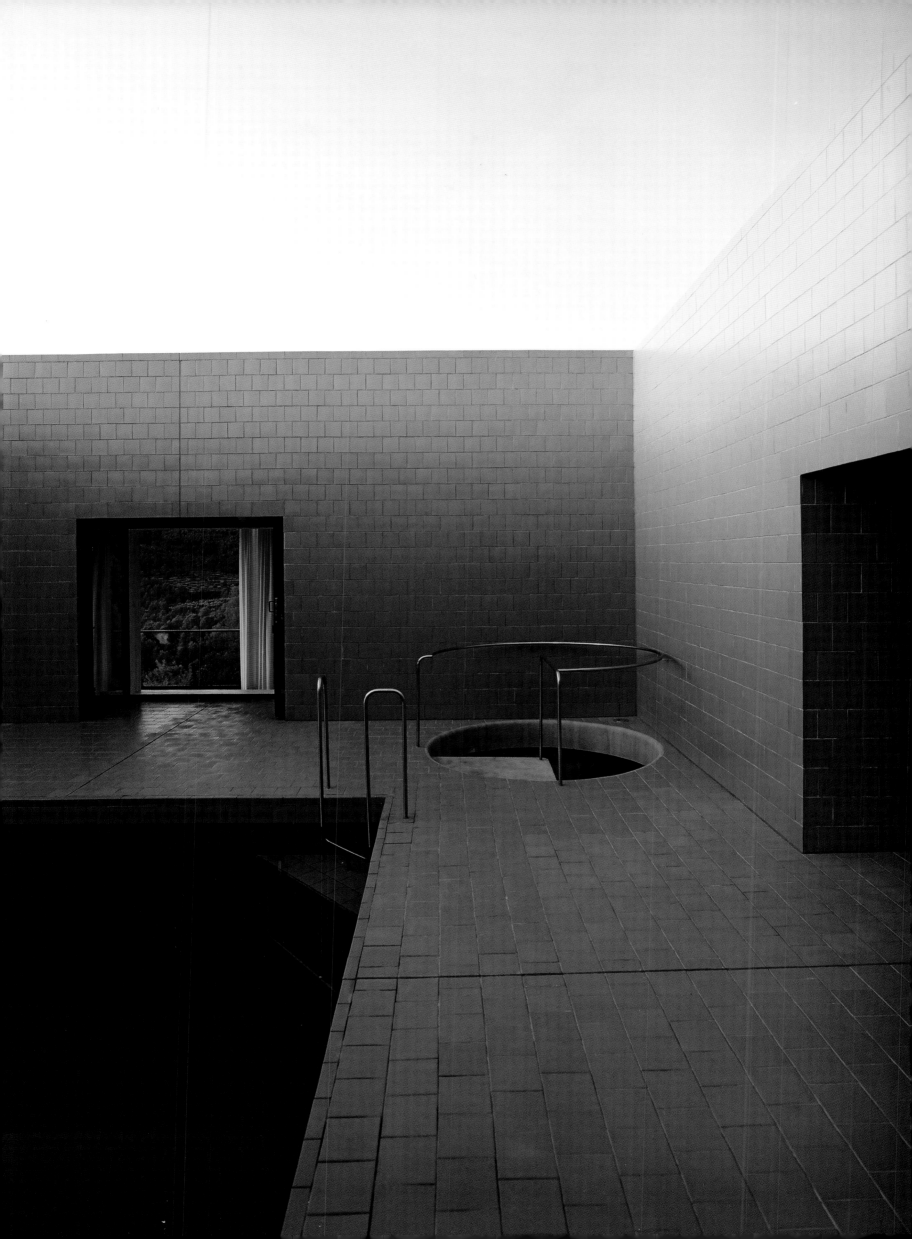

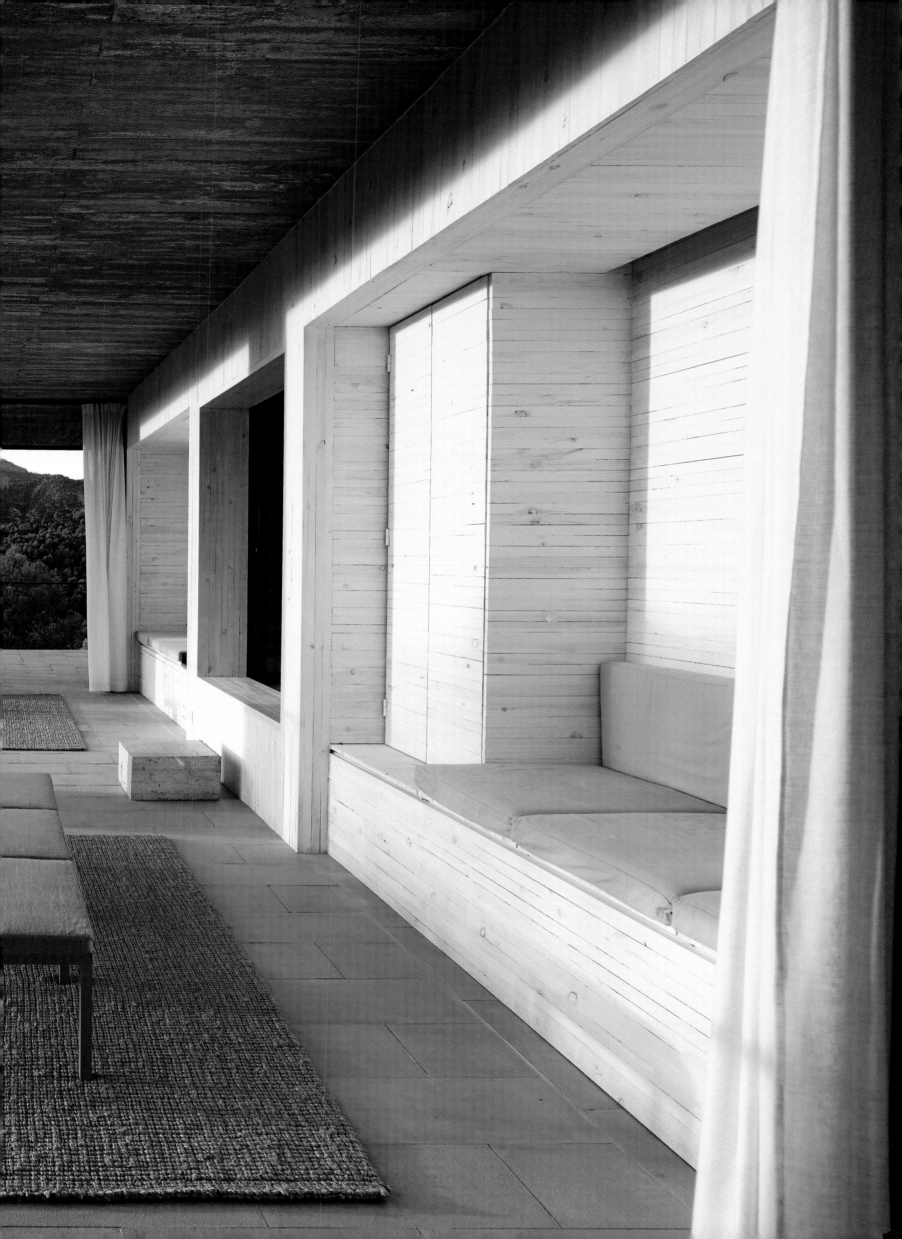

differences between twins. While PVE are mindful of comfort, they have developed what they call an 'inhabited wall': a double wall that allows for necessities – closets, bathrooms, kitchen benches and appliances, etc – to be placed in between, leaving the main areas relatively empty. The idea is to intensify the focus on the finer details such as the movement of a curtain, the tones or materials in the space, or the sounds that surround it. 'We do not believe in buildings that demand too much attention,' says von Ellrichshausen.

In order for the occupants of the house to be placed in a serene mind-set, the architects have given intense consideration to every aspect of inhabiting the space. Their attention to detail is remarkable: faucets, tables, lamps and chairs have all been designed by PVE and manufactured for this utterly bespoke house.

Window openings have great significance in the work of PVE. The Poli House is defined by its irregularly placed openings in the thick-walled sculptural structure. In the Solo House the thinking was not just determined by the pleasing climate but by a logical transition from the punctuated openings linking the enclosed central patio at the building's core to the expansive openings linking directly to nature in the perimeter rooms. This, according to Pezo, creates 'a continuous open plane that oscillates between opacity and transparency'.

And yet transparency is achieved within the context of a contained monolithic structure through the sheer scale of the openings and this notion of living on the edge. Structurally, the building is made human and crafted through the treatment of the concrete construction. 'The exposed handmade formwork is a simple technology that we find fascinating as you can think about it as a negative of the final surface,' says von Ellrichshausen. 'The moment the liquid turns into solid concrete, every little detail is transferred to the wall or slab. We like the fact that something so volatile, so fragile and human can be imprinted into something else so hard and apparently so enduring.'

Although the immediate context is that of forest, the broader landscape takes in medieval Spanish villages, and PVE enjoy the notion that the passing of time will show on the surfaces of the building, adding to its character. 'So the rough construction was born old and will somehow continue ageing naturally,' says von Ellrichshausen.

The work was undertaken by a local construction company under the supervision of a PVE collaborator, a young Portuguese architect who had previously worked with the practice and dealt with all the daily questions around construction, fabrication and detailing. Bourdais feels the local artisans, at first tentative, are now proud of their ground-breaking work and, presumably, with more projects in the pipeline, they will be able to experience working with some of the world's most interesting architects.

Certainly PVE are the perfect inaugural firm to partner with the Solo Houses project, particularly with their heightened awareness of the mutual effects of nature on architecture and vice versa. According to Pezo, architecture 'gives nature a new dimension, a size, a reference. In the case of the Solo House, the measure is given by the mere positioning of a compact artifact on top of the hill. This is not so far from the foundational act of those impressive ancient surveillance towers scattered along the Spanish territory.' And so new and radical thinking links both to nature, and to history, to the idea of seclusion and refuge, and to the absence of visual clutter through the paring back and elimination of the unnecessary. Local rumour has it that an eccentric rock star has bought the house and PVE are enjoying the speculation. ▬▬▬▬

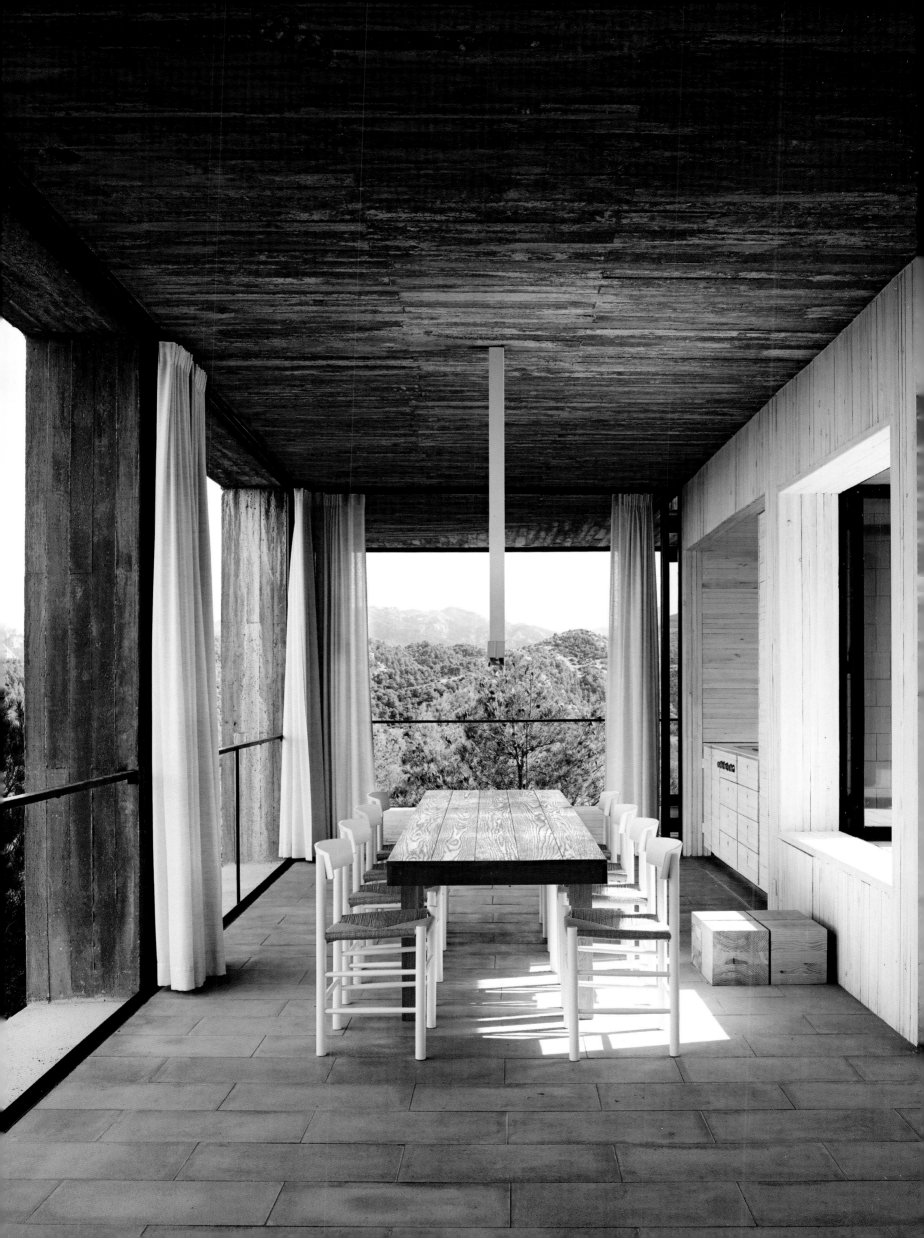

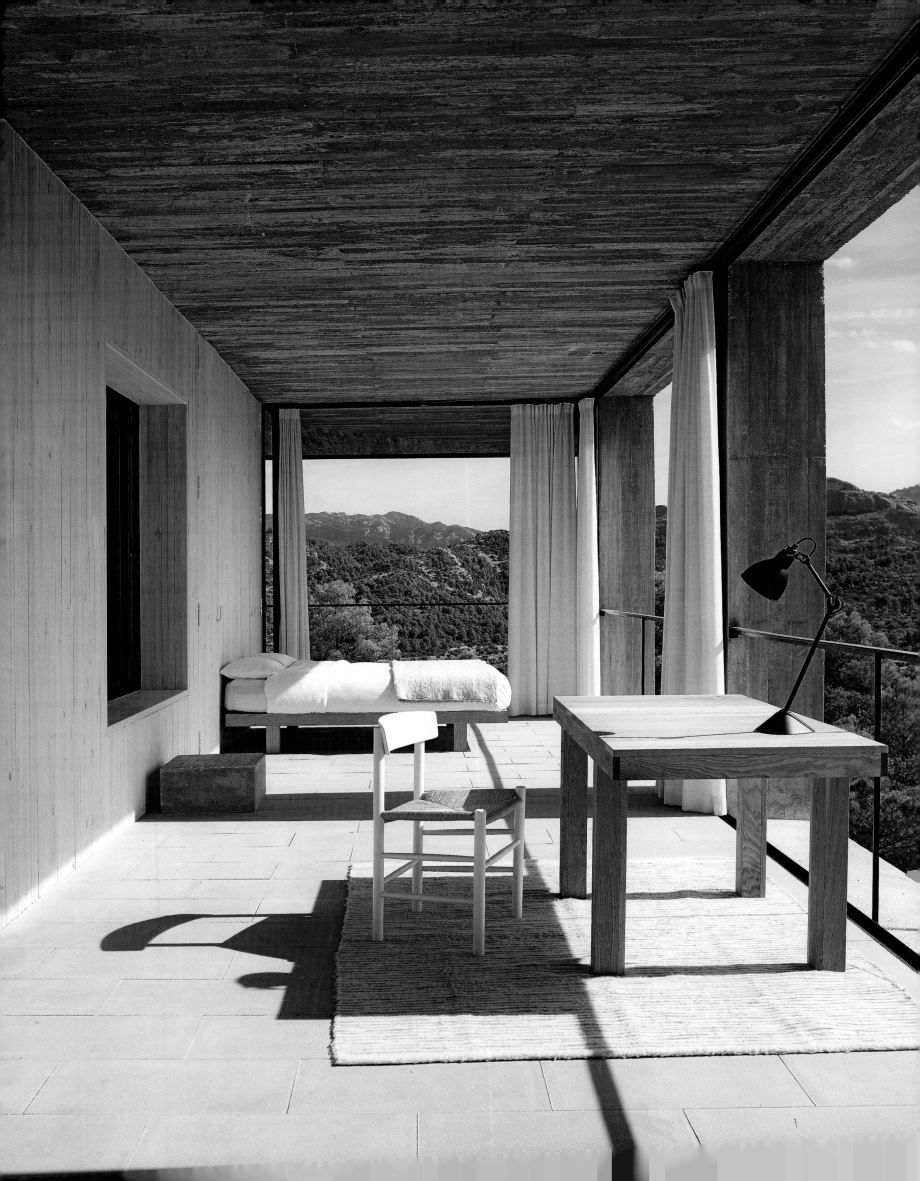

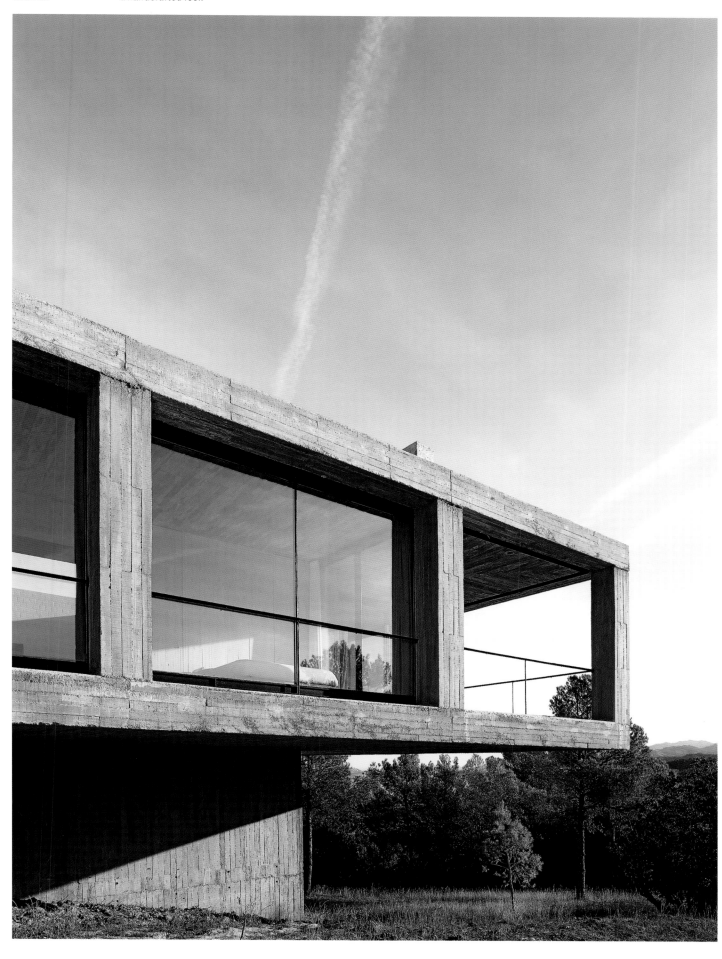

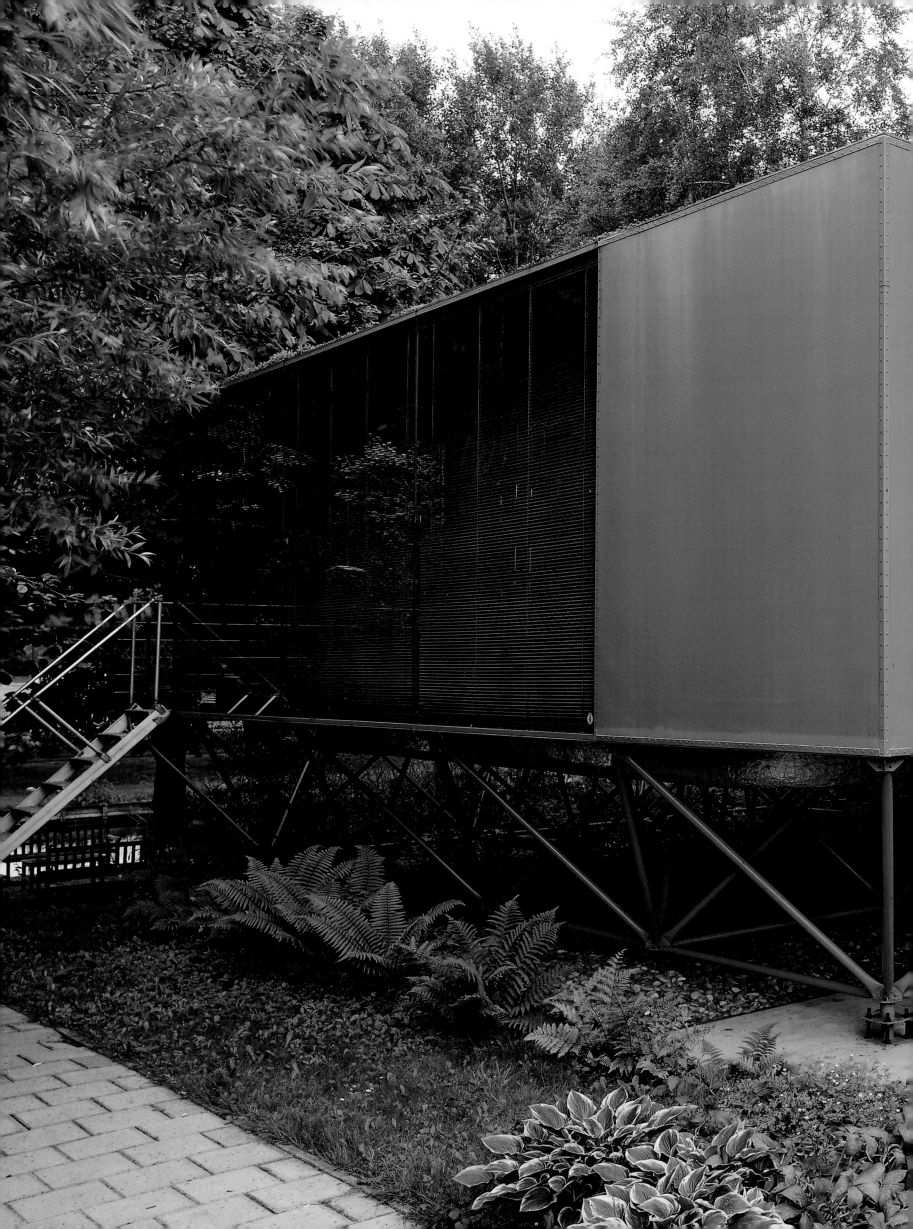

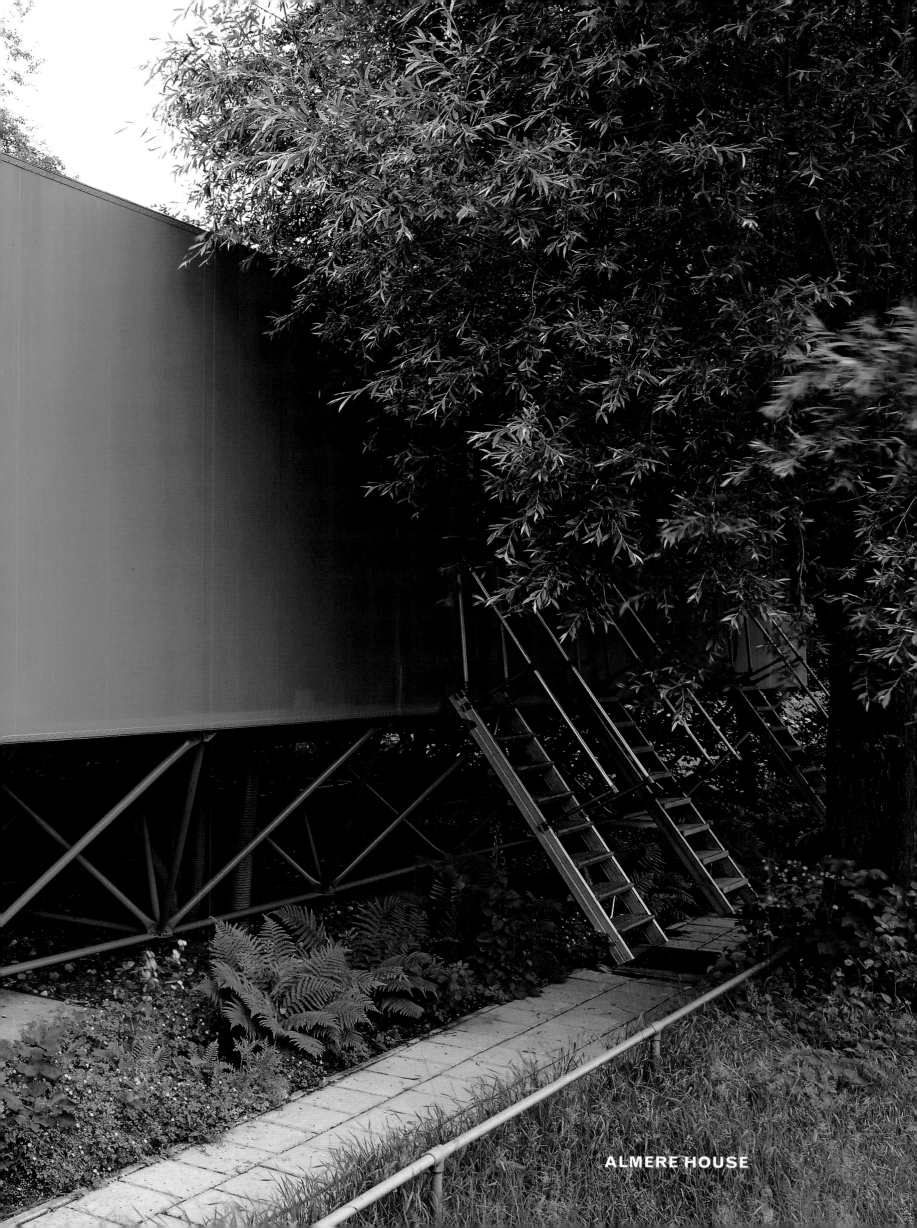

ALMERE HOUSE

Central to the
design is the graphic
arrangement of
adjustable steel
struts.

Entering the house
is via a set of steps,
not dissimilar to the
airstair of a small
aeroplane.

ALMERE HOUSE ——— BENTHEM CROUWEL ARCHITEKTEN

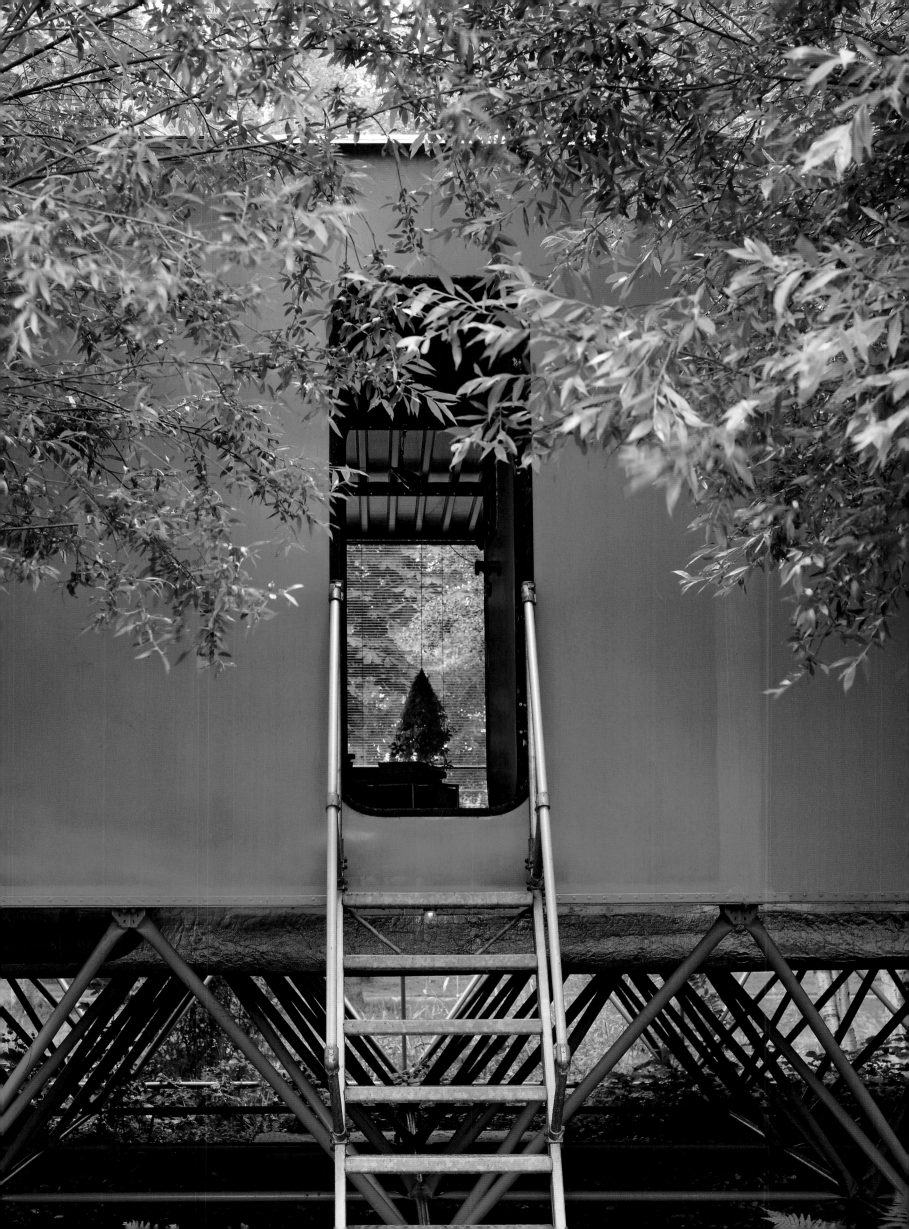

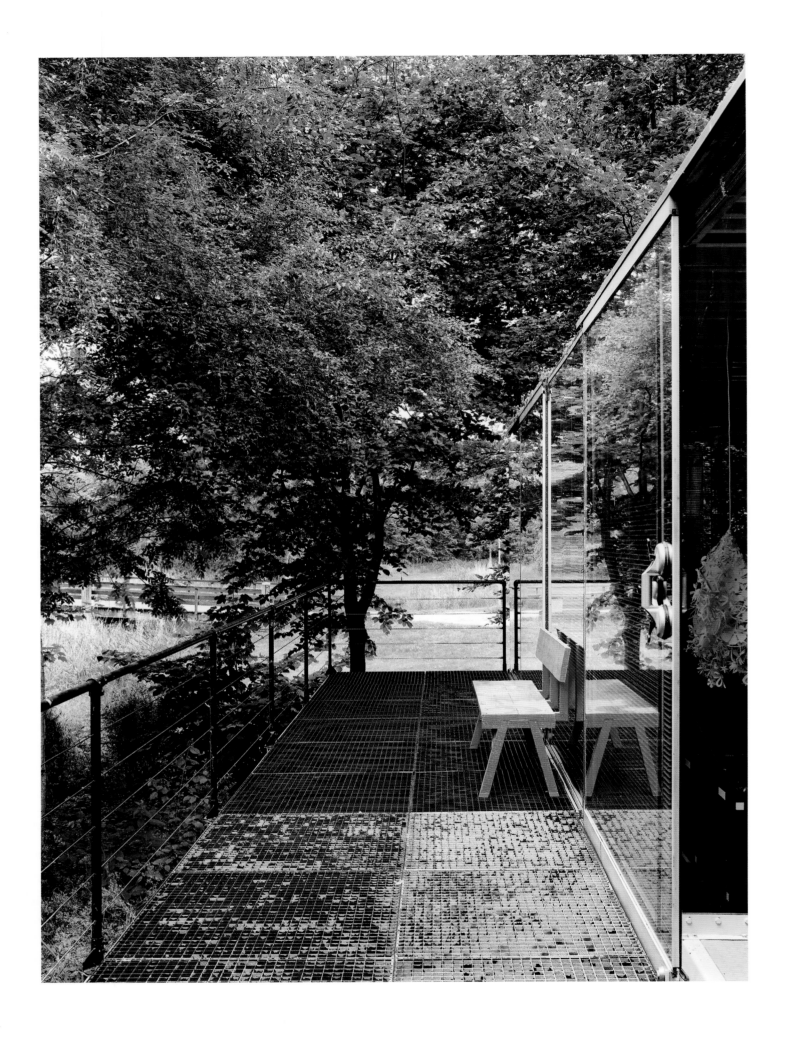

ALMERE HOUSE ——— BENTHEM CROUWEL ARCHITEKTEN

**ALMERE HOUSE
(1982–1984)**

◇

**BENTHEM CROUWEL
ARCHITEKTEN**

⋈

**ALMERE,
THE NETHERLANDS**

Architects never fail to amaze. A project can be crafted over years of slow refinement like Jørn Utzon's unbuilt Bayview house in Sydney's Northern Beaches or, equally, something wonderful can appear in a heartbeat. This modest-scale prefabricated house is of the latter variety. It was designed in hours, built in three days and was home to architect Jan Benthem and his family for more than 25 years.

The experimental house was designed as part of a new neighbourhood, built on an area of reclaimed land.

The house has an interesting genesis. In the late 1970s, the Dutch authorities, driven by a need to address an ongoing housing shortage, began to question the notion of what building types best served society. Were heavy, fixed, expensive buildings, which eventually became outmoded, the way to deploy resources, they asked. The chance to experiment came when planning a new town, Almere, east of Amsterdam, where five residential neighbourhoods were to be surrounded by green space and connected by waterways. An architectural competition was devised with the challenge to design a house that could be easily assembled by the owner and could, in time, be dismantled and relocated, leaving no mark on the land. There was no specific brief and the architects had the freedom to ignore all building codes (save those of structure and fire precautions) knowing that the house would remain on the site for five years only.

Not long before, in 1979, ex–Delft University of Technology architecture students Jan Benthem and Mels Crouwel had formed Benthem Crouwel Architekten and were working on one of their first major commissions – a scheme for a customs office on the Dutch border – when they realised that the competition would afford them the opportunity to test ideas in a very real and hands-on way. They entered at the last minute and, perhaps untrammelled by regulations and convention and driven by the spirit of experimentation, they produced one of the 10 winning designs.

'To our frustration, we studied at university for nine years and hadn't learnt anything about the daily practice of building, planning, costs, etc,' says Benthem. 'The house was an exercise in simplicity. It was the opportunity to see if we could design a house that was the bare minimum in terms of materials, details, cost and function.'

The pre-fab house does not deserve its chequered history. As architectural writer Dominic Bradbury notes, 'The goal of a well-designed, well-made, long-lasting, affordable and flexible home has proved a tough challenge, with few prototypes making it to mass production.' While Buckminster Fuller's Wichita House used lightweight aluminium, its round, rather space age design was way ahead of mainstream American public taste in the Forties and, despite phenomenal interest, only two were sold. Architect and furniture designer Norman Cherner

'The house was an exercise in simplicity. It was the opportunity to see if we could design a house that was the bare minimum in terms of materials, details, cost and function.'

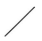

JAN BENTHEM

produced a 1957 manual, *Fabricating Houses from Component Parts*, while the line-up of architectural luminaries who participated in John Entenza's Case Study Houses programme – including Charles and Ray Eames, Richard Neutra, Craig Ellwood and Pierre Koenig – had strong hopes that quality, well-designed pre-fabrication would take home building down the route of the motor car: made in factories and assembled on-site with an honesty of exposed structure and an integrity of design.

Yet, interestingly, despite the history and pedigree of pre-fab thinking, an experimental laboratory, rather than a home, was always Benthem's goal. He was not looking to any other examples in Europe or America for direction, so it is somewhat ironic that, while in pursuit of both basic skills and experimentation, such a successful version of a home emerged. Perhaps this is what competitions are all about.

'For me, designing and building the house was not so much an experiment in designing a new type of housing that could be prefabricated in large numbers as it was an exercise in using an absolute minimum in terms of program, materials and weight,' Benthem says. 'There was a simple reason for that – the house had a limited period to spend on the site so had to be very cheap or relocatable. And it had to be strong and light.'

The architects learnt some valuable skills from it, he says, and while the focus appears to be purely on the practical and structural, the building is extremely resolved, manifesting an undeniable high-tech elegance. It is simple and graphic in form and colour, and feels like the result of clarity of thought married with a high degree of technical expertise. It is worth remembering that at this stage the architects were still in their late twenties and the industry was in the doldrums due to the European economic crisis.

The lightweight container is elevated by a veritable Eiffel Tower of adjustable steel struts. This 'space frame' is composed of octagonal connectors which bolt into four precast concrete slabs set directly on the site – and connect with the supporting frame for the floor level. From this point everything locks into place like a series of sophisticated Meccano pieces. The flooring and internal walls make use of a high-density polyurethane foam sandwiched between layers of plywood – a light, strong insulating material used primarily in refrigerated trucks and containers. The way one climbs the external staircase to the front door is rather like entering an aircraft. It is, of course, lightweight and practical, but at the same time it speaks of transition and of modernity.

Internally, the division of space denotes a clear emphasis of use. The rear of the building is enclosed, with small windowless rooms, or compartments, for sleeping, cooking and bathing, while the rest of the external walls employ reinforced glass structurally to give the large open living space the optimum amount of light and air. The internal and external doors are like those of a boat or submarine with rounded edges that don't meet the floor. Therefore, the movement between rooms is conscious and deliberate. Internally, banks of fine aluminium shutters modify light and provide necessary privacy. Three doors open to the outside, with only one, from the kitchen, having a corresponding staircase – the others were for emergency use only, in which case you, presumably, jumped.

The house is rather like a racing yacht stripped to its bare essentials until only the functional remains. 'I left out everything that was unnecessary, not only in the plan but also in the materials and detailing,' says Benthem.

Moving in immediately after completion, Benthem adapted the house for his family over the years. 'When our two children grew up, I extended the house by adding three two-metre

Jan Benthem's
collection of iconic
furniture includes
Osvaldo Borsani's
P40 chair.

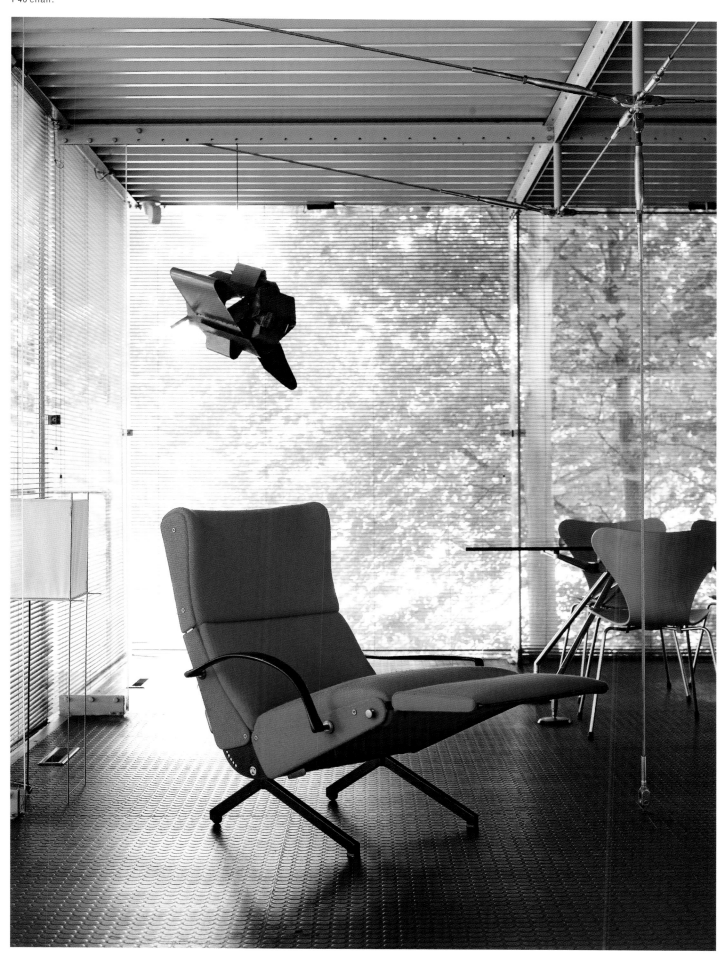

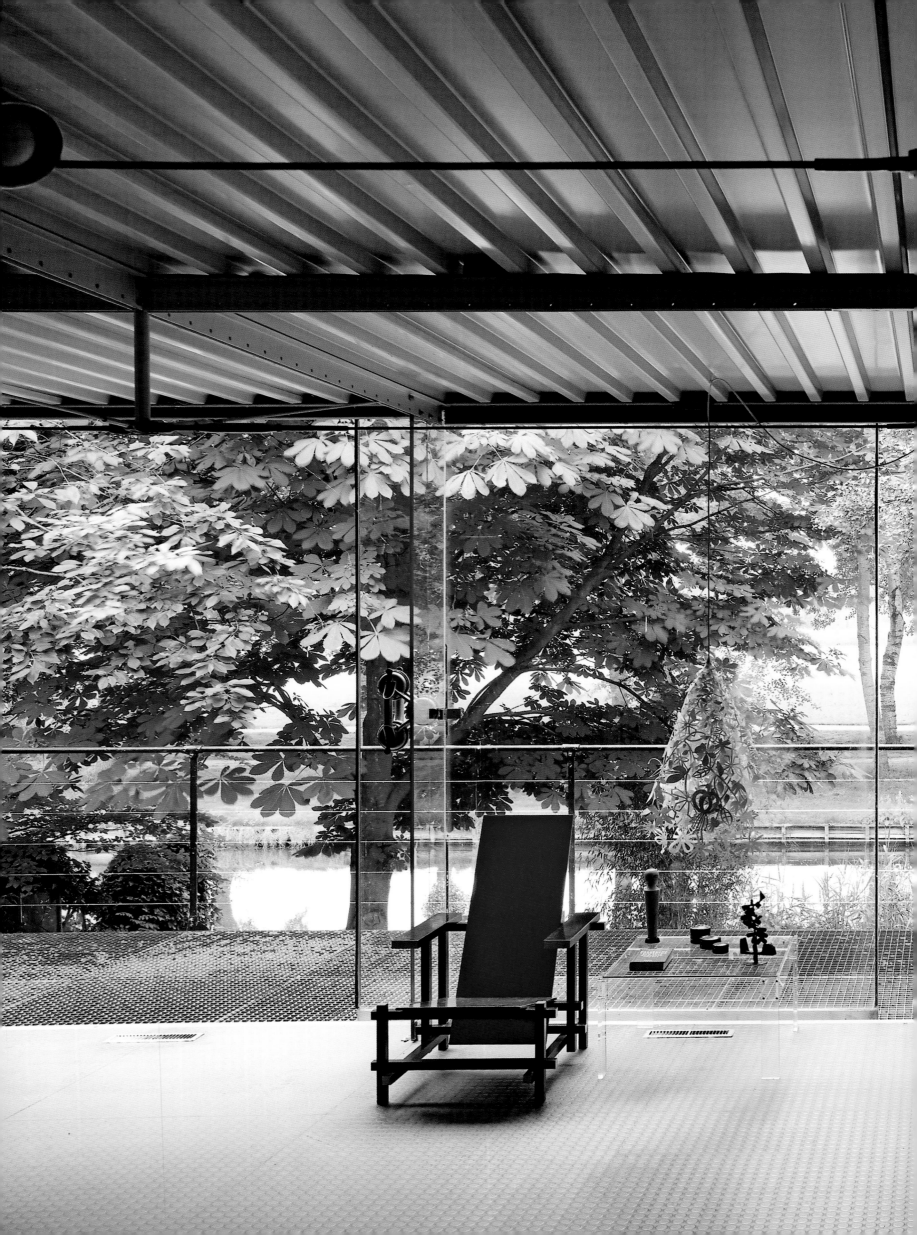

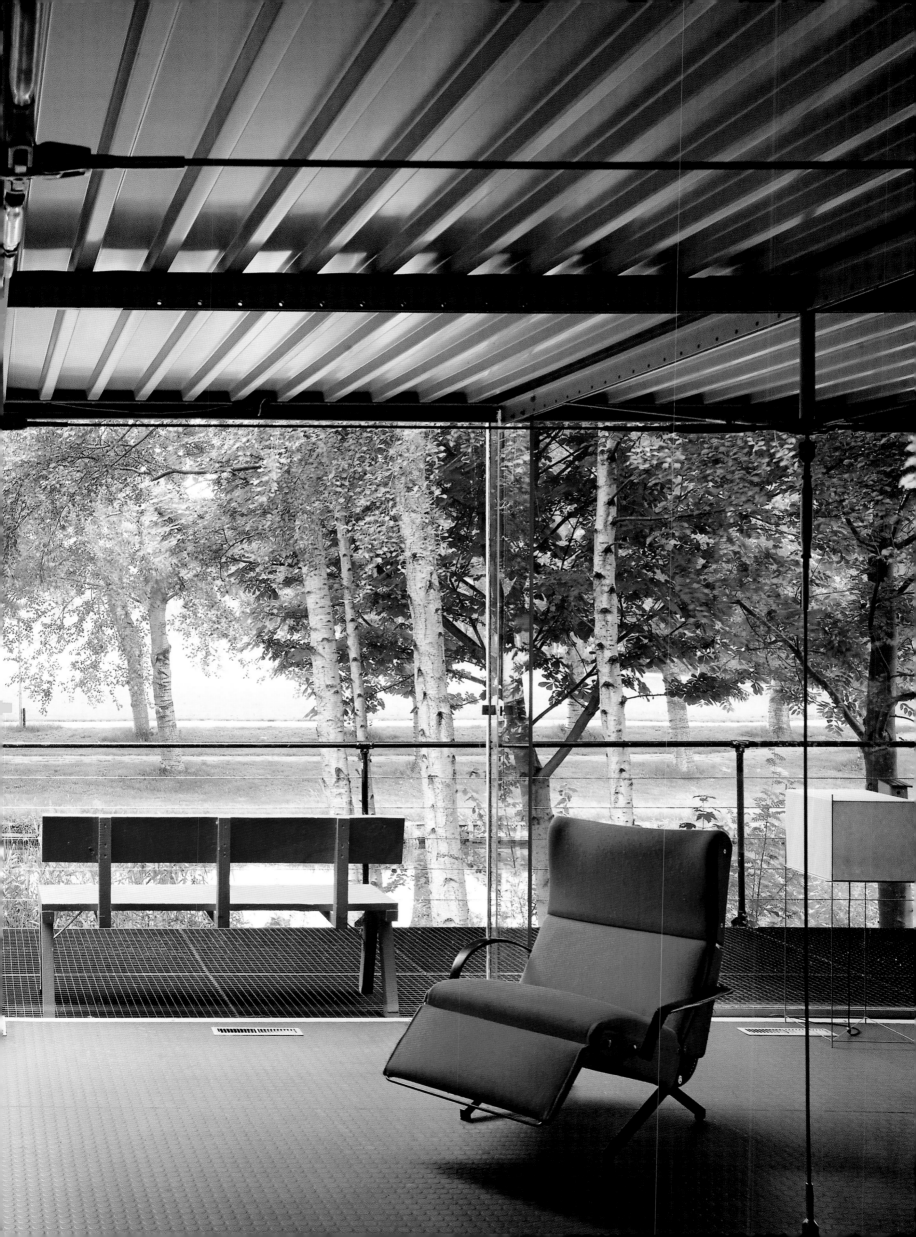

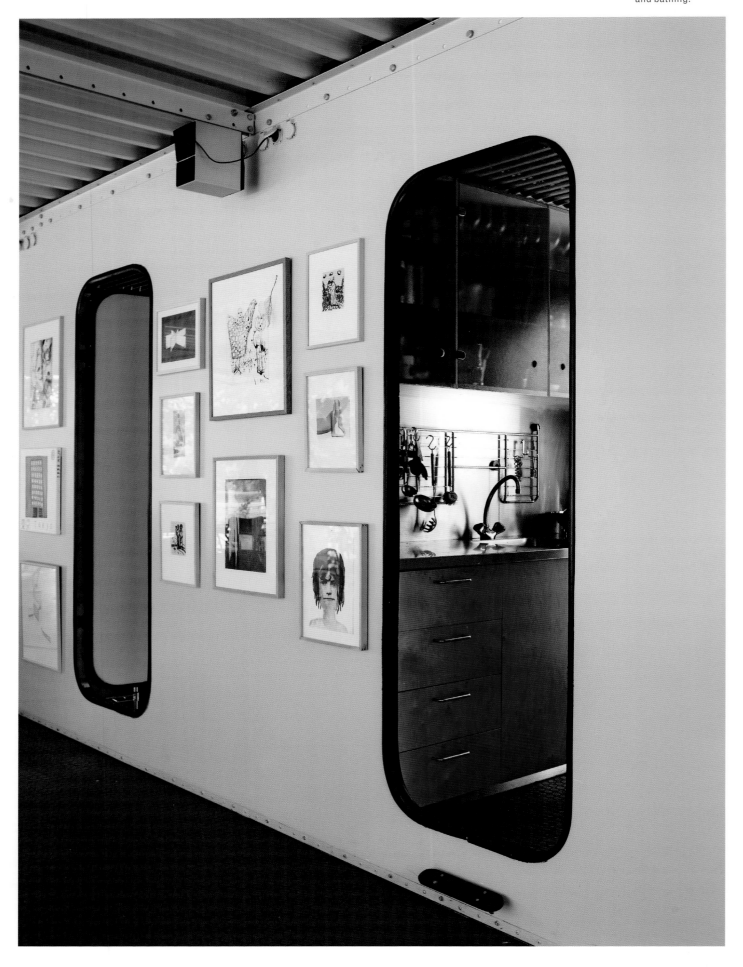

Ship-like openings
connect the living
area to capsules for
cooking, sleeping
and bathing.

ALMERE HOUSE —— BENTHEM CROUWEL ARCHITEKTEN

modules so each would have their own room, with its own entrance from the garden which they used frequently, like our five cats used their own Staywell cat door.' Benthem and his wife, Francisca, he says, always slept in the living room.

The house is sparely but interestingly furnished with iconic design pieces that are philosophically related to the house – a Gerrit Rietveld Red Blue Chair, the articulating Osvaldo Borsani P40 chair and the D70 sofa, the high-tech Nomos table by architect Norman Foster and the revolutionary Wink chair by Toshiyuki Kita. 'I like simplicity. I don't want too many things,' says Benthem, while acknowledging the irony that he may well have gathered 'too many things'. A shipping container sits in the garden housing items that have no place in the main building.

The project was such a success the house was allowed to remain on the original site, settling into the waterfront block as foliage gradually obscured the supporting structure to leave the lightweight box floating in the garden. Benthem notes how the landscape has altered over the years. 'One of the attractions for me of living in the *polder* [reclaimed land] is the extreme development of the landscape,' he says. 'Within only part of a lifetime, the site has changed from desert to lush parkland.' When the house was built, Almere hardly existed; now it has 250,000 inhabitants and a city centre planned and built by Rem Koolhaas's OMA.

Benthem Crouwel is a socially aware and rigorous architectural practice that, after the Almere house, has worked on a diversity of projects from the large infrastructure undertaking of Schiphol Plaza (1992–95) and Schiphol Airport (1992–95) to the sensitive extension of the Anne Frank House (1999) and, more recently, the extension of the Stedelijk Museum in Amsterdam (2012).

In Jan Benthem's words, 'The innovative architect produces new ideas and new techniques or regenerates existing ideas and techniques and applies them in new and unexpected ways.' One has the sense that Benthem has the ability to practise what he preaches. ▄▄▄▄

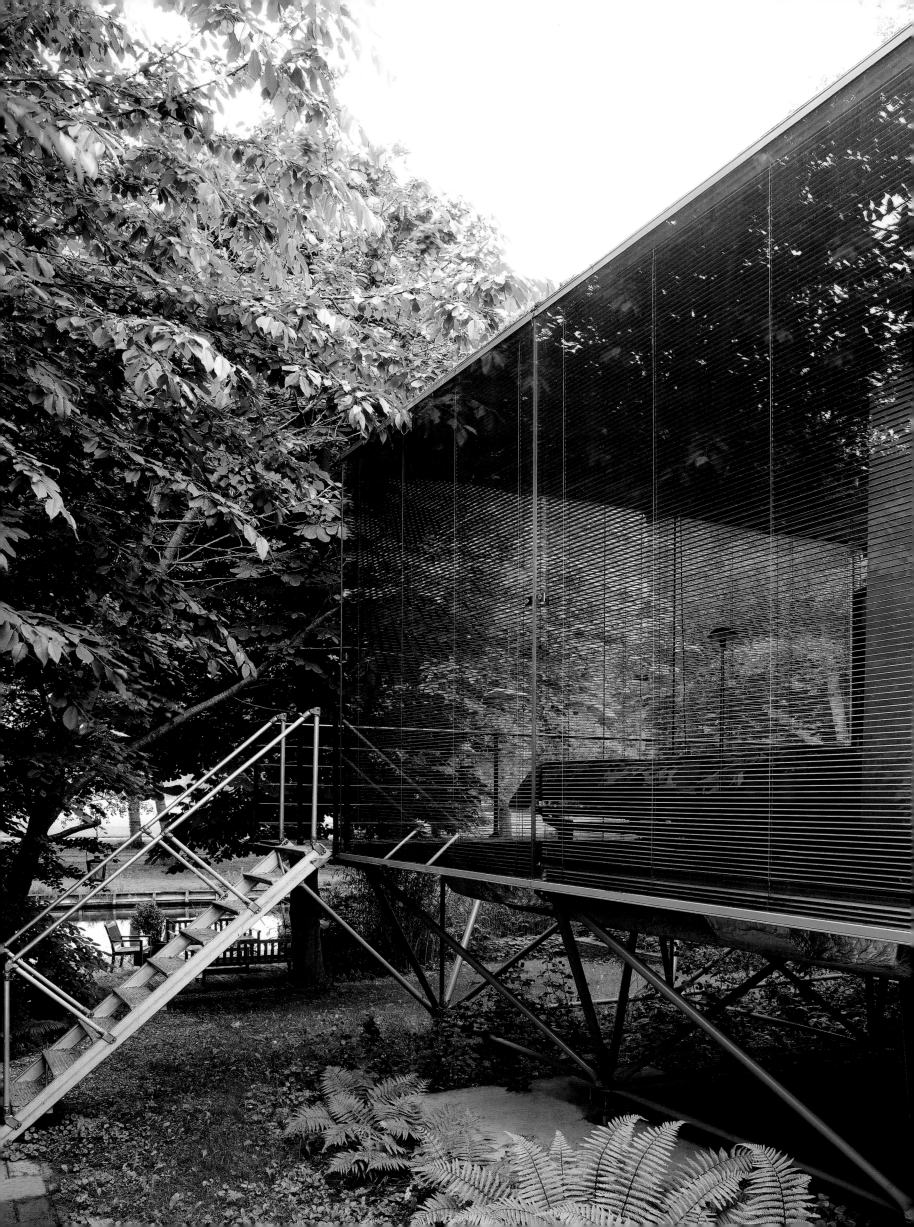

Components of the Almere House fit together like Meccano, meaning it could be dismantled.

A shipping container, in keeping with the philosophy of the house, is used for extra storage.

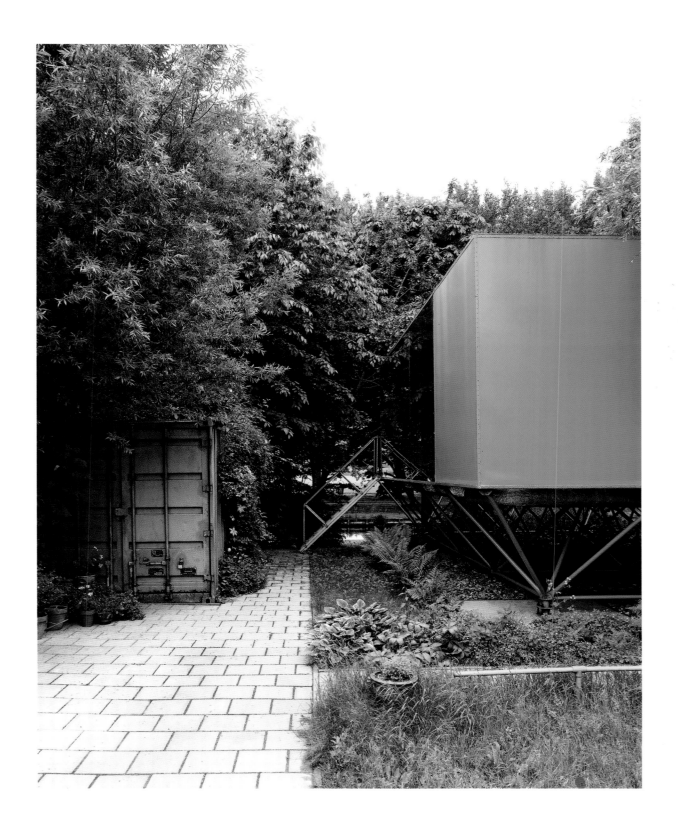

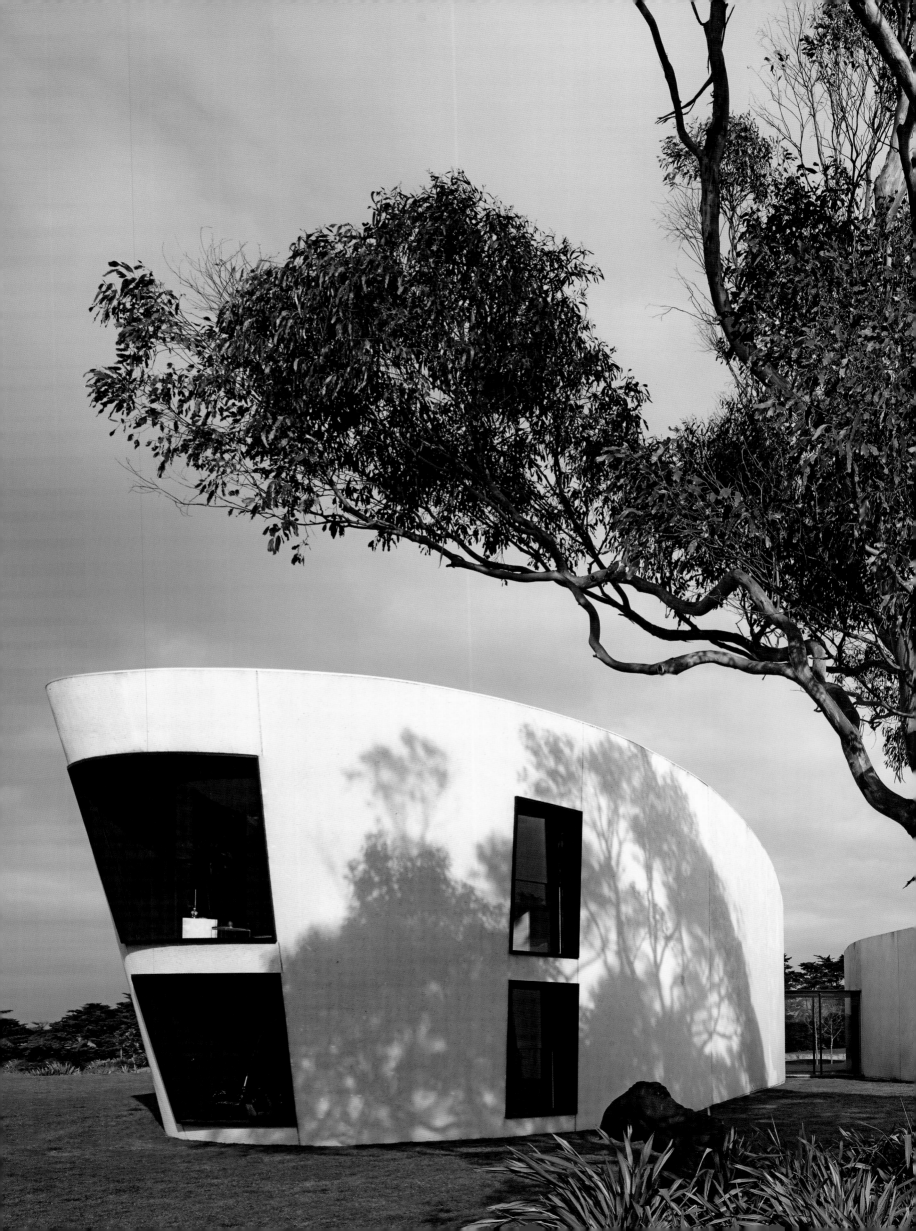

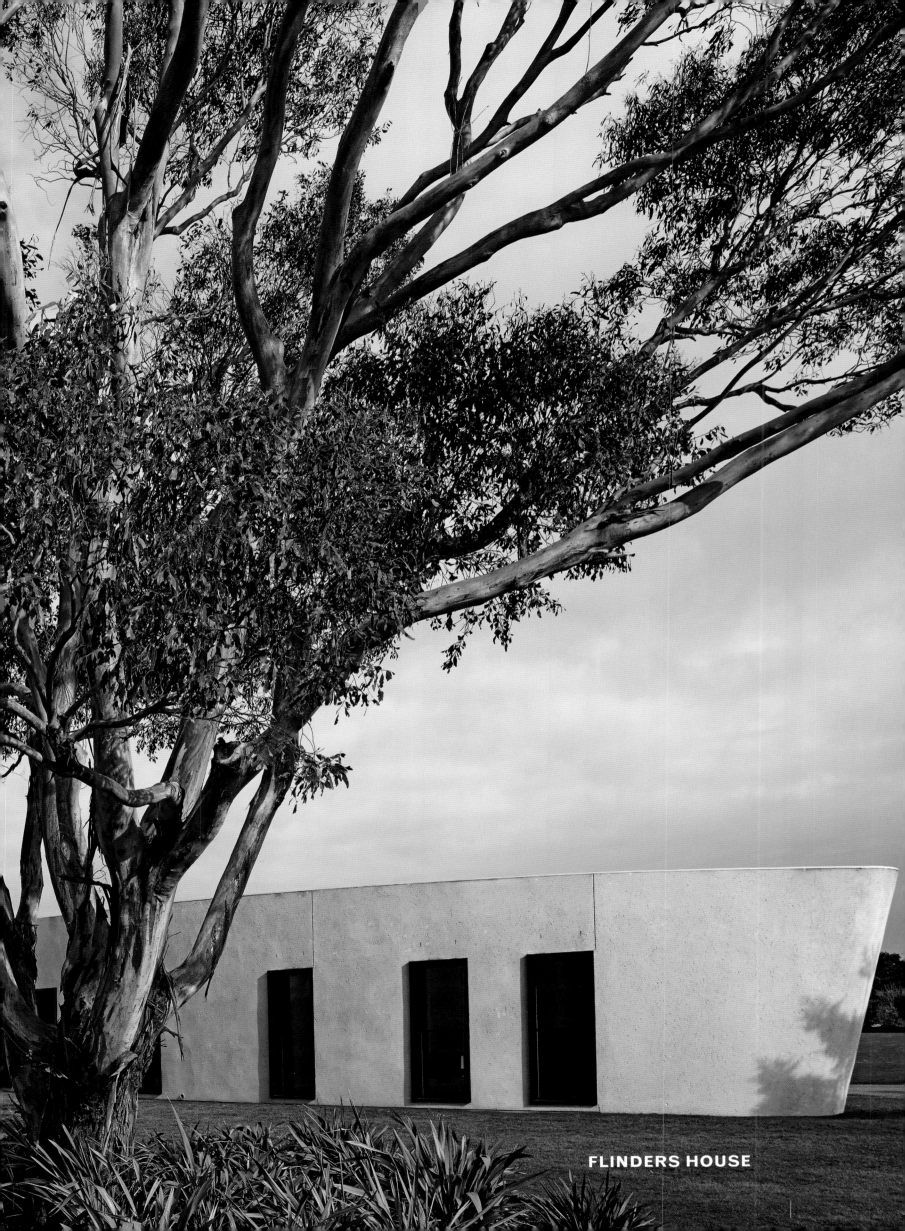

FLINDERS HOUSE

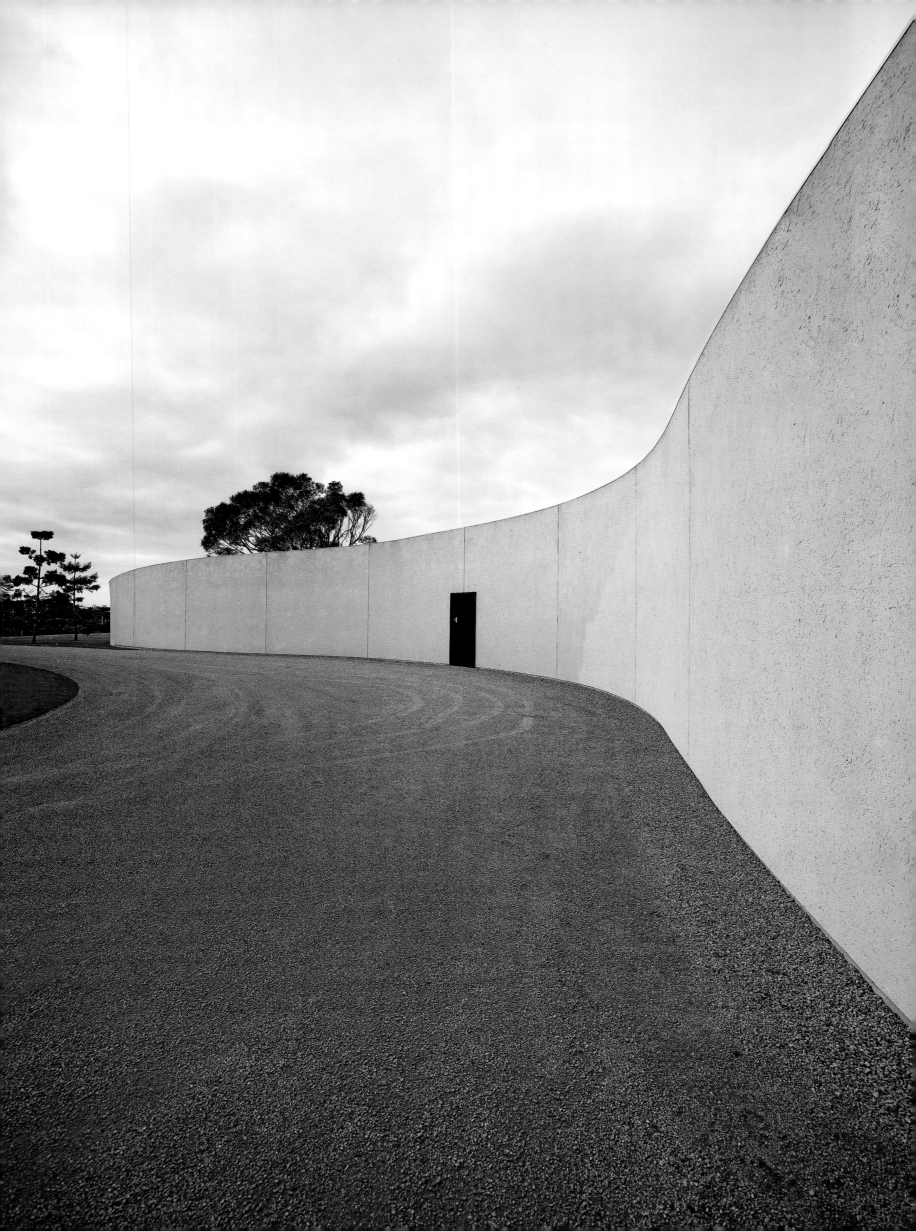

An enigmatic front
door, characteristic
of Wood Marsh, is
in the sweep of a
rendered wall.

The elliptical
pool is located for
protection from
winds coming off
the Bass Strait.

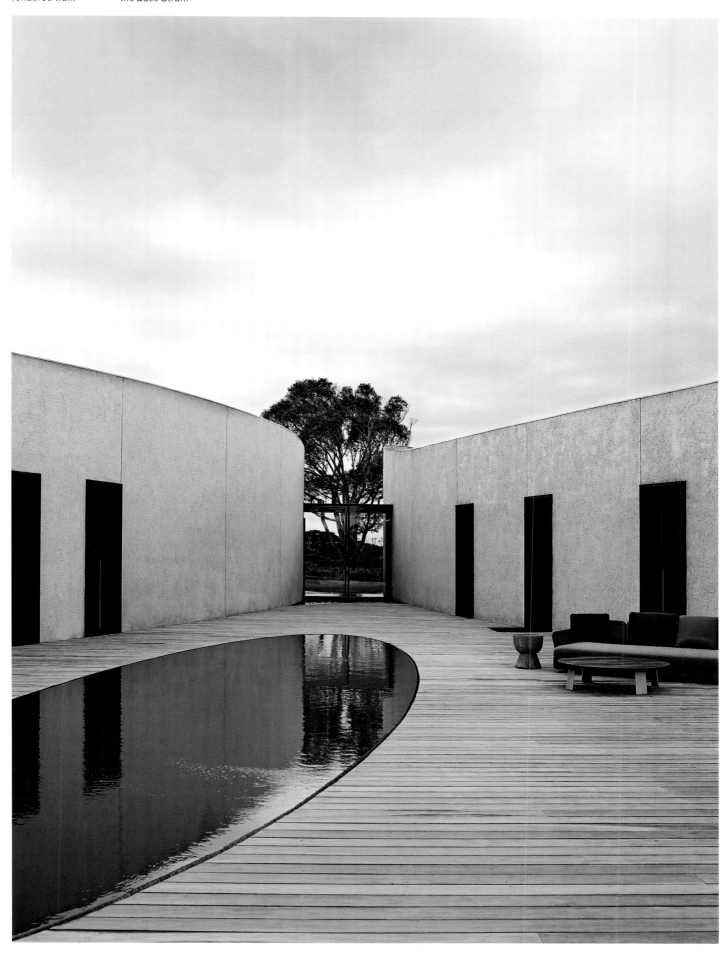

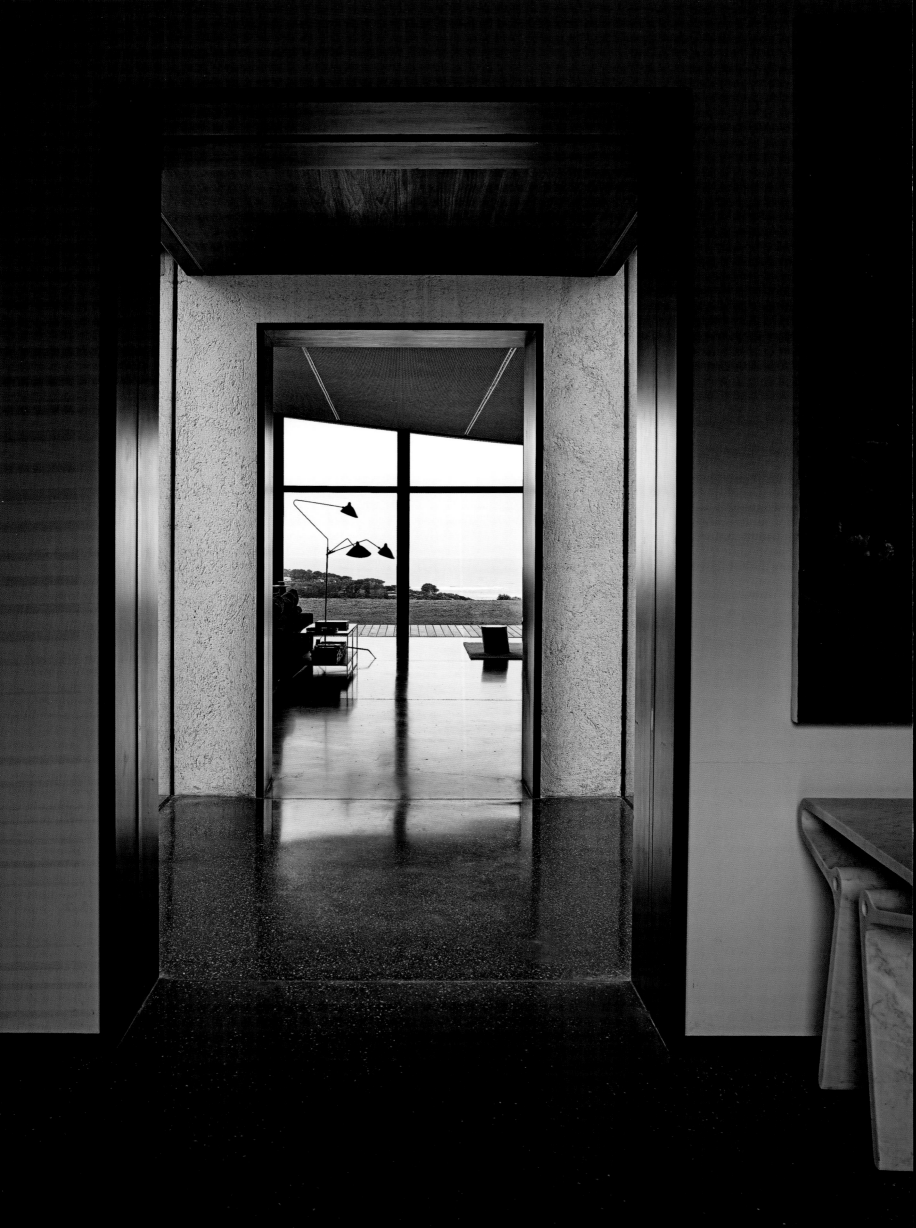

FLINDERS HOUSE
(2012)

◇

WOOD MARSH
ARCHITECTURE

⋈

FLINDERS, VICTORIA,
AUSTRALIA

Not many houses can claim to have inspired a piece of music. But when a close friend of the project architect saw an aerial photograph of Wood Marsh's Flinders House, with its remarkable butterfly form, she composed a work to be performed at a music festival.

Moving through from the entrance to the house, there's a sense of being drawn towards the ocean view.

In truth, from the air would be the simplest way to instantly understand this enigmatic house, as it refuses to declare itself readily to the onlooker from the ground. 'At no one point do you get a sense of the whole building,' says Randal Marsh. 'It has a three-dimensional character that can only be really understood by moving through and around it.'

The Flinders House sits on a high swell of land looking out, uninterrupted, towards the Bass Strait and Phillip Island. The architects Roger Wood and Randal Marsh visited the site with the clients and determined, almost immediately, where the house would be best positioned and how the rhythm of the landscape would inform the planning. The prehistoric form of the land, with its secondary dune systems, creates undulations in the landscape and shaped the thinking of how to balance weight and softness in the building itself. 'We were clear that the house would not be like a pile on the hill,' says Marsh. 'Our reference points were more of a remnant pulled out of the landscape, a crustacean or whale bones, washed up and deposited by the sea.'

And that analogy has real resonance. Wood Marsh are renowned for the highly sculptural nature of their work, be it a public building such as the architectural icon ACCA (Australian Centre for Contemporary Arts) (1998), a dramatic structure in Corten steel; the Gottlieb House (1990), a monumental concrete residence in suburban Melbourne; or the curvaceous high-rise apartments, YVE (2006), in Melbourne's city centre. While they create intrigue through form, they like to achieve it through the use of a restricted palette of materials. 'Our interiors and exteriors work completely,' says Wood. 'It is not just a shell that you fit out; there is connectivity to the landscape.'

The Flinders House expresses itself through a warm textured external render, which Wood briefed to be the colour of porridge cooking, and black-stained timber battens which emphasise the sinuous curve of the internal walls. 'The combination of oxides and sands for the render creates an opalescent effect of abalone shells, and reflects the mauves, lilacs and pinks in the sky beautifully,' says Wood. As with many Wood Marsh projects, there is an understanding of the effects of weathering and how, over time, surfaces alter. 'The pock-marked surface will gain patina with age and increase the sense of chiaroscuro as lichen settles to the south and it lightens to the north,' explains Wood.

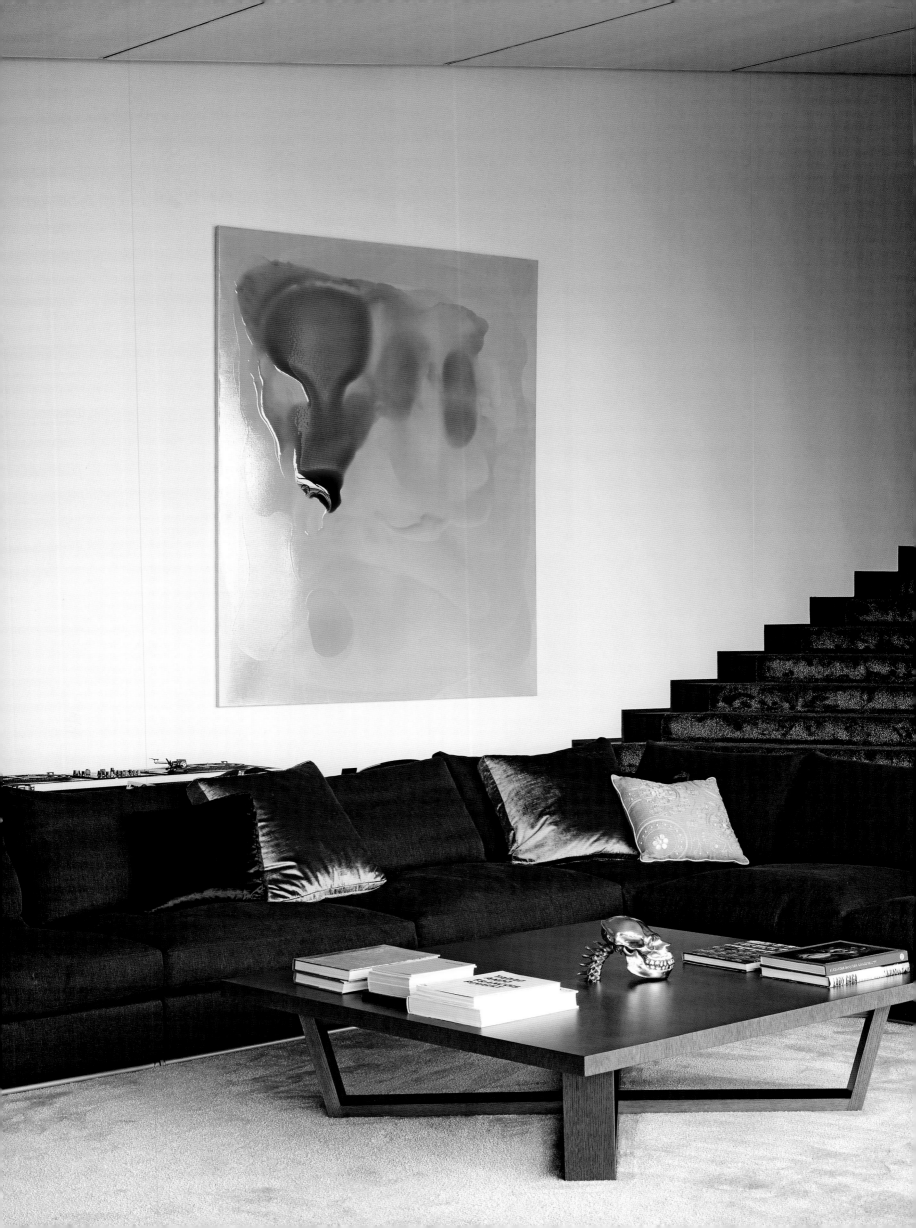

Rooms with
unexpected punches
of bright colour are
contained within
a batten-clad pod.

Both internally
and externally,
the Flinders House
is an exercise in
complex geometry.

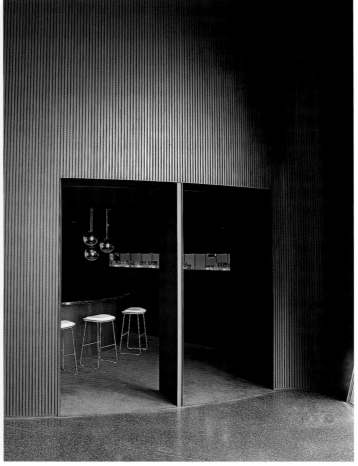

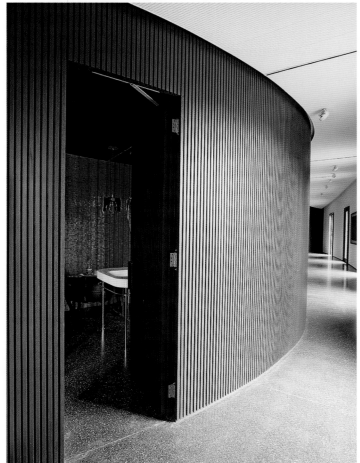

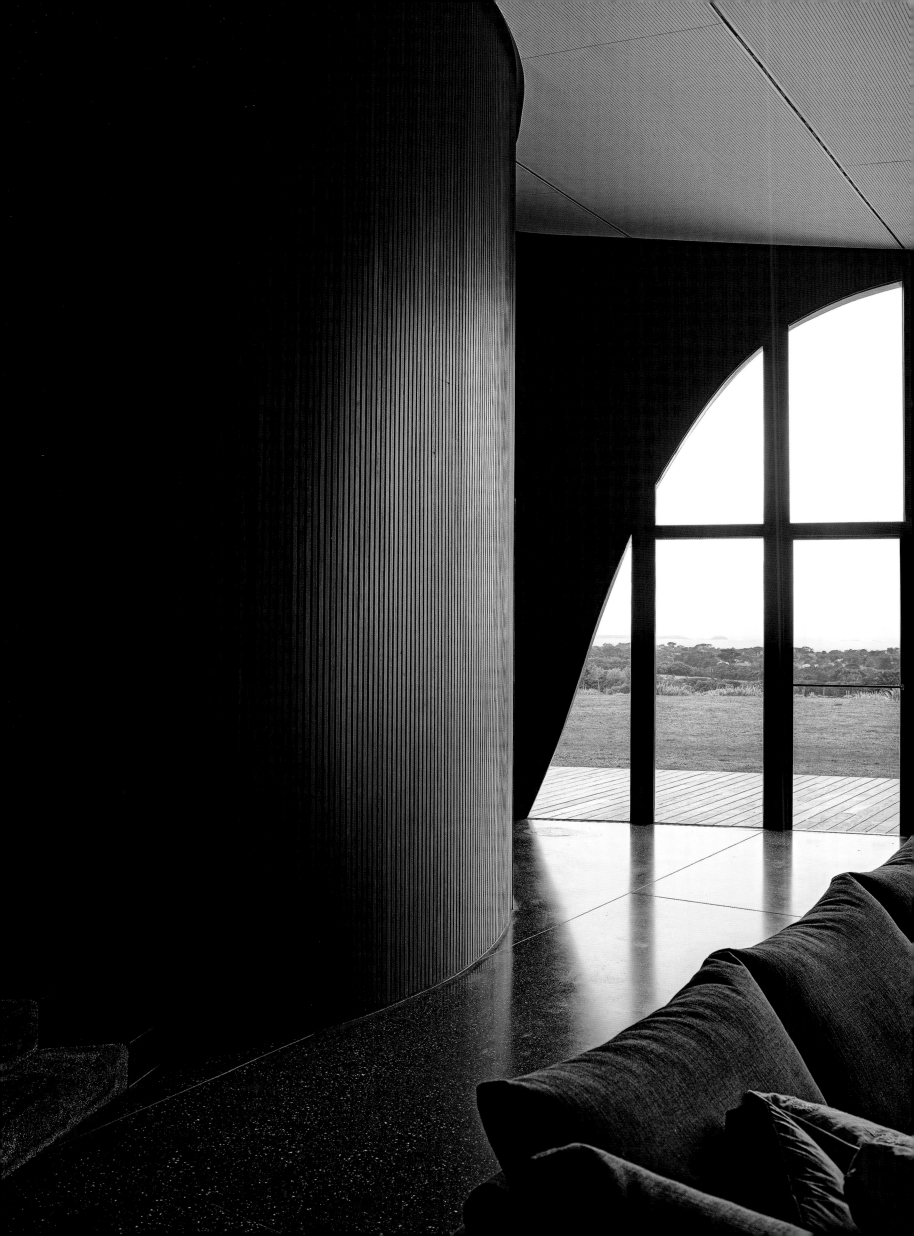

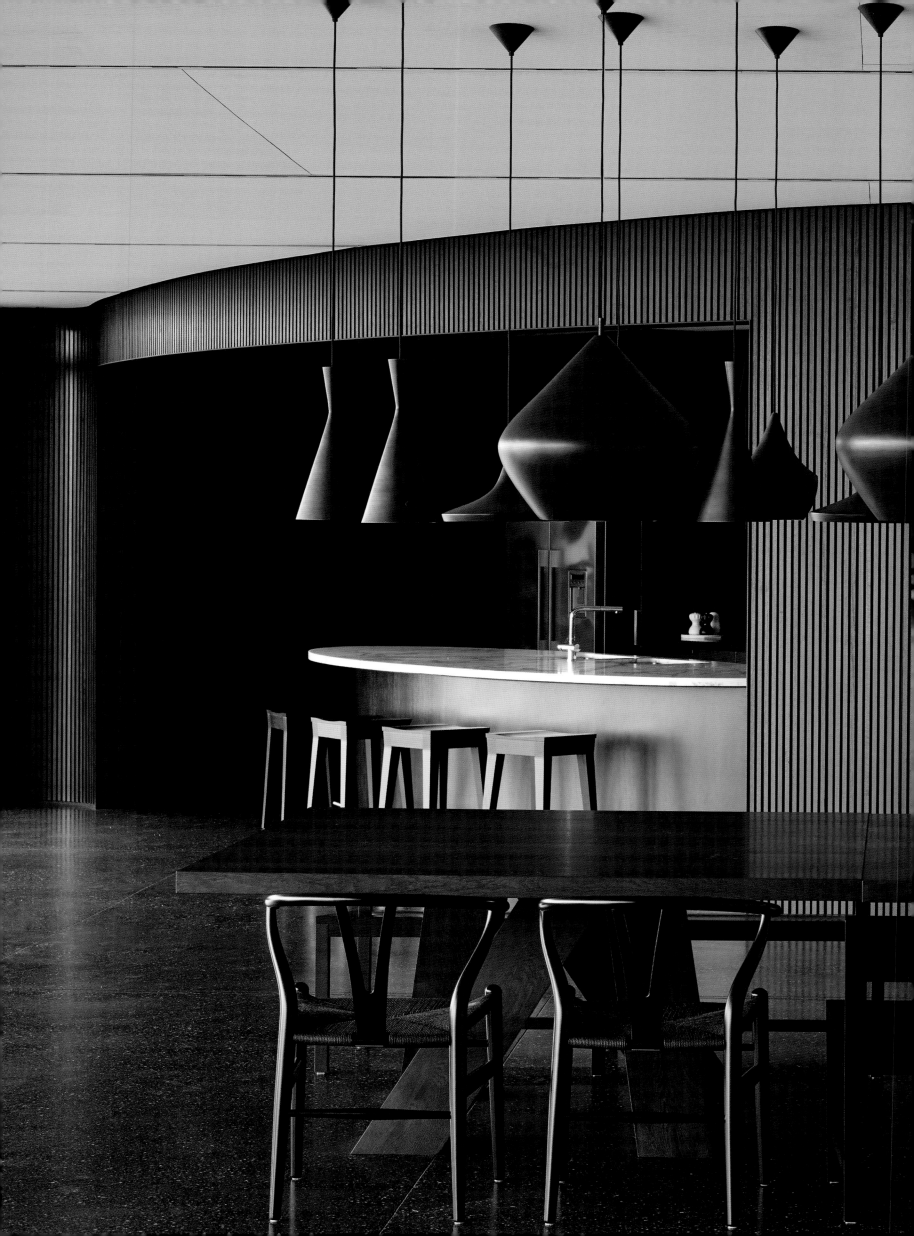

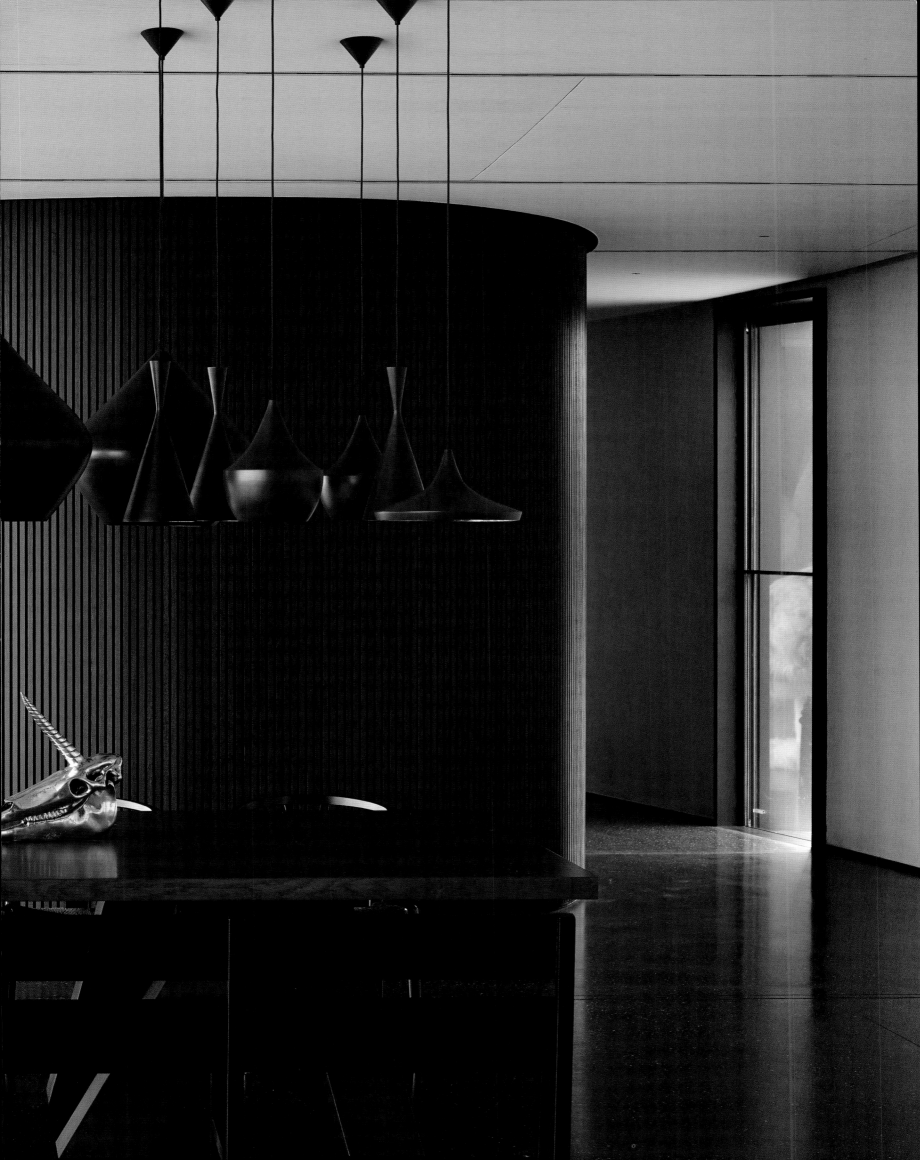

Using a limited
palette of materials
allows the sinuous
forms to exert
a quiet power.

As one approaches the house, there is nothing obvious that signifies its domesticity. Marsh points out that it is only scale separating their thinking between residential and larger commercial projects. Indeed, the nearby Port Phillip Estate Winery, also by Wood Marsh and conceived and built almost in parallel, is three times the size, yet many of the same principles apply and many of the same materials are deployed. 'We try not to distinguish,' he says. 'We ask "What does it need to do?" and develop our concept from there.'

The Flinders House has a characteristic Wood Marsh signature – an enigmatic entry, in this case a door that barely announces itself, set within the sweep of a rendered wall. Up close, however, the door speaks of quiet luxury as hardwood battens, stained black, are complemented by a leather-clad handle, designed with all the craft of an Hermès bag.

The entrance corridor connects the two wings of the building, with the guest wing to the left and, to the right, the service wing of laundry, gym and bathroom with access to the pool. Yet none of this is immediately evident. It is an intentionally puzzling house with an unfolding character that reveals itself as one journeys through it. The batten-clad walls curve to create the sinuous line of an old-fashioned roll-top desk converging at the end of the corridor. Doors to connecting rooms, employing the same batten-clad treatment, simply disappear.

The atrium leads directly to a 'pinch point', a glazed section framing the landscape, with a well-positioned blue gum to the left and the protected pool area to the right. From here, there's a sense of being drawn ahead into the main living space and the dramatic view beyond. 'On arrival, the house presents a threshold to move through, and, at that point, the view is revealed to you,' says Wood. 'A similar theatrical device exists at Port Phillip Estate.'

Wood Marsh is no stranger to voluminous domestic spaces and knows how to walk the tightrope between the monumental and the human scale. In their Gottlieb House, the grand gesture of the atrium and entertaining space gives way to family rooms with lower ceilings and a more intimate scale. The Taylor House (1996), a dramatic warehouse conversion in Melbourne's Prahran, balances volume with sculptural 'pods' that allow for private space and a degree of separation.

'At no one point do you get a sense of the whole building. It has a three-dimensional character that can only be really understood by moving through and around it.'

RANDAL MARSH

According to Wood, the Flinders House was never meant to be a holiday house. 'The brief was that it should be expansive enough to accommodate the clients' large extended family gatherings and yet be intimate enough for two people to visit.' To this end, the main living/dining space provides the jaw-droppingly expansive space that frames the view while, to the right, the kitchen is enveloped in a batten-clad pod and, to the left, a glamorous cocktail bar and den is folded into the northern end of the building. Hence, a party for 60, or for two, can equally be played out.

Wood Marsh understands the power of a great staircase and, in the Flinders House, it is described by editor Fleur Watson as a '*Gone with the Wind*–like gesture, celebrated within the form'. It sweeps majestically from the ground floor to the only double-height section of the house, the parents' suite, and is designed to make a good old-fashioned, theatrical entrance. There is an element of glamour threading through the space – there's the use of regal purple fabrics; mosaic tiles in seductive shades of rose pink and sage green line bathroom walls; and silvery silk strands blend through the carpet, contrasting the texture of the polished concrete but mimicking its speckled effect. It is at once subtle and sensuous, grand and intimate, earth-bound and ephemeral.

The climatic conditions, including the bitter winds from the Bass Strait, were a reason for avoiding the Australian tradition of a deck off the main

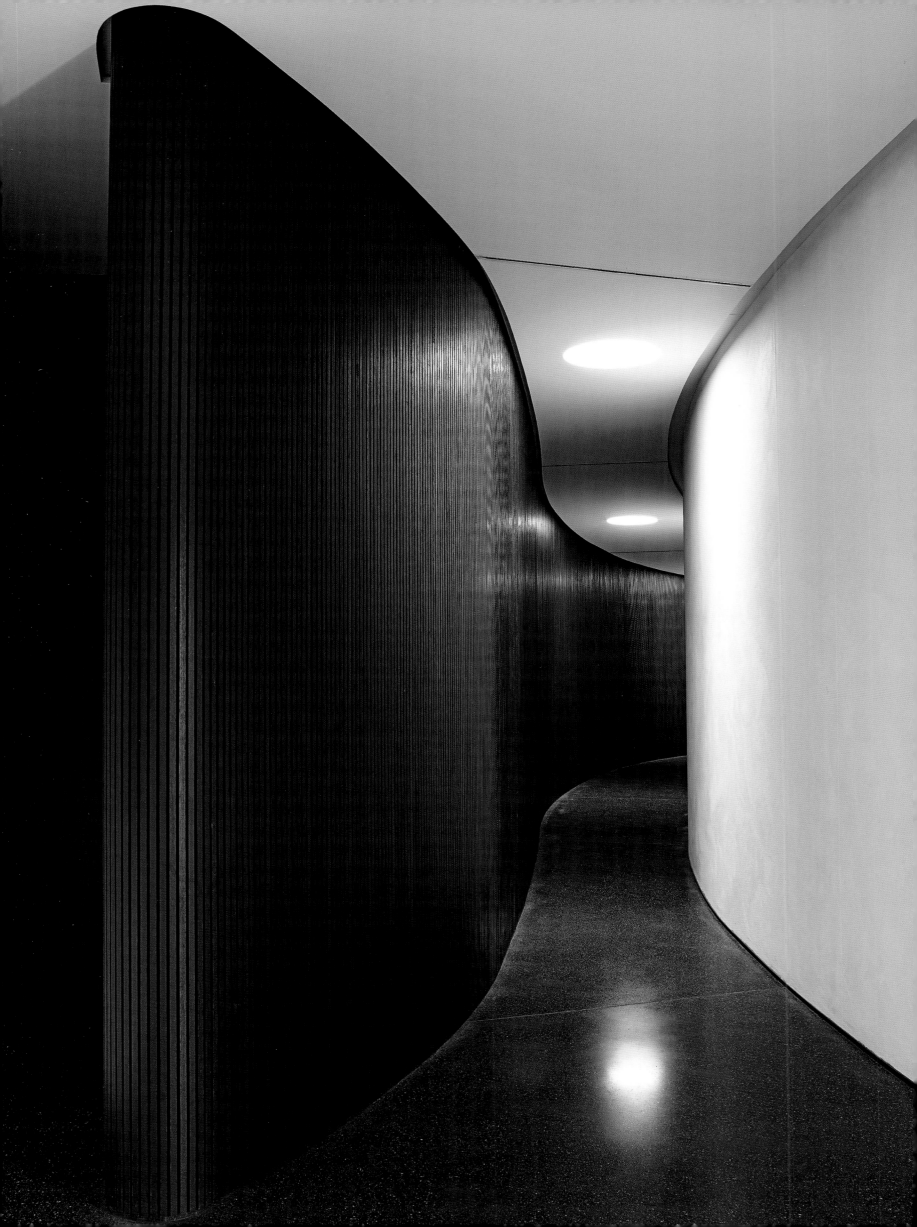

living space facing the view. 'Many houses in this area face where the worst weather comes from,' says Wood. Instead, there is what Marsh describes as a 'fringe', a delicate timber surround intended as a visual transition between house and garden rather than a space to be used. The pool, too, is sited for protection, positioned between the family and guest bedroom wings. Its elliptical shape is that of a lazy late afternoon shadow and its seamless integration into the surrounding stone only enhances that effect. 'The boomerang form of the house ensures everyone has a view of the water and everyone's privacy is maintained,' says Wood.

The house, of double brick with timber windows, was entirely built by local builders. The materials are straightforward and low-tech, yet the result is a bespoke house that takes note of the brief from the clients and through a sort of architectural magic comes up with something intriguing and unconventional.

Not many houses demand that you walk through them and around them, and delivers with each view, with each perspective, a photogenic moment: the play of the shadows from the trees on the bone-coloured exterior, the subtle slope of the walls, the curves, and the fluidity balanced with the solidity.

'We wanted the house to seem like it had been here for many years and the earth had simply eroded away and exposed its form, rather than being a new addition to the landscape,' says Roger Wood. 'The building has a sense of permanence . . . it won't get blown away.' ▬▬▬

The building forms a backdrop for the owners' collection of contemporary artwork.

A sweeping
staircase leads to
the only two-storey
section, the master
bedroom suite.

From the master
bedroom upstairs,
the view is out
over the extensive
landscaped gardens.

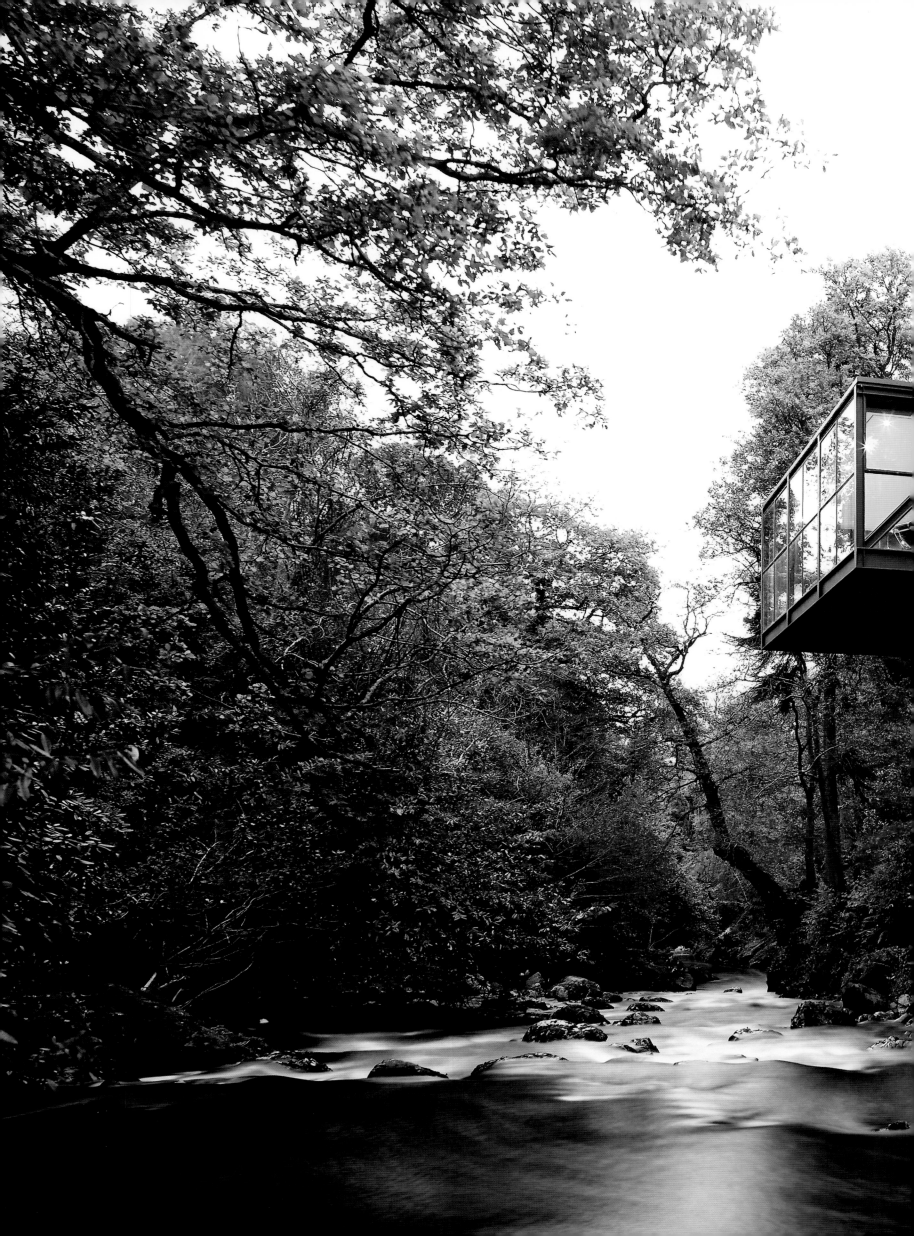

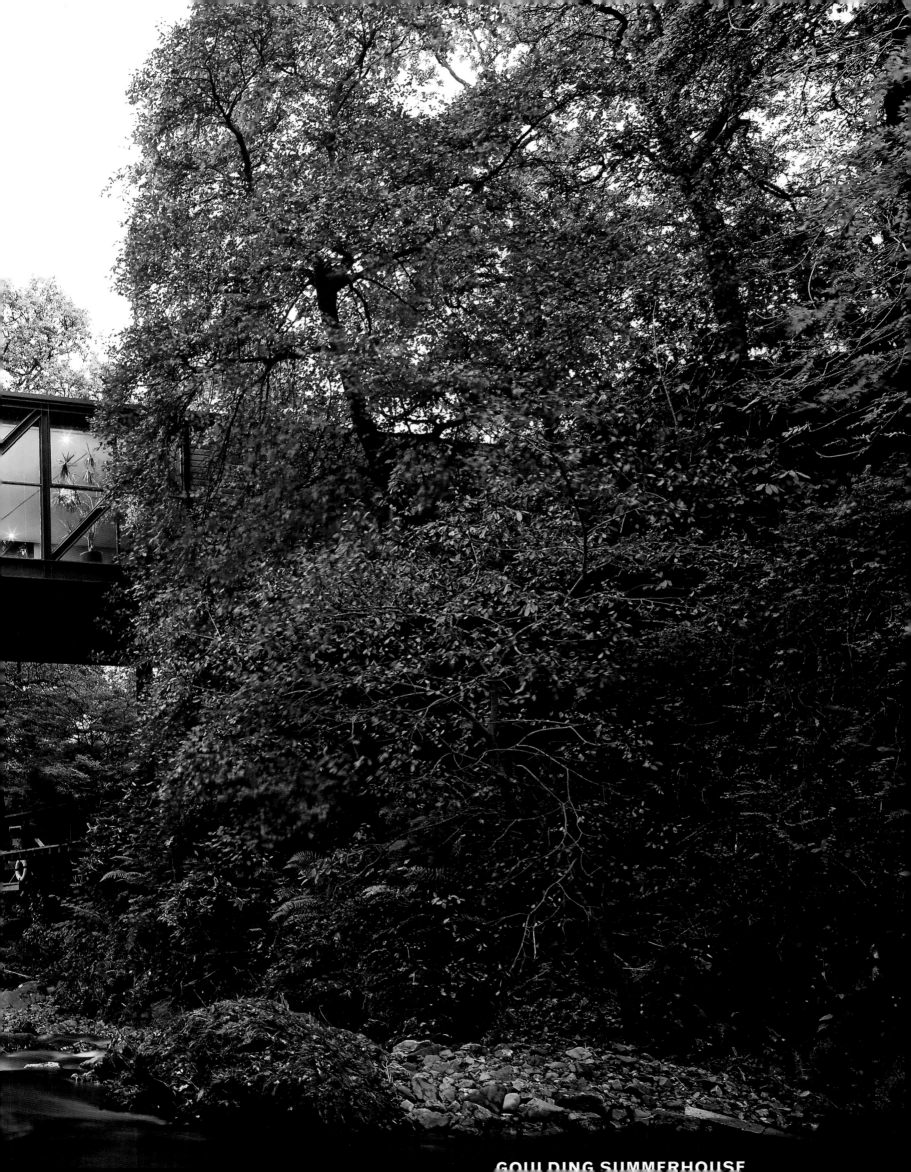

GOULDING SUMMERHOUSE

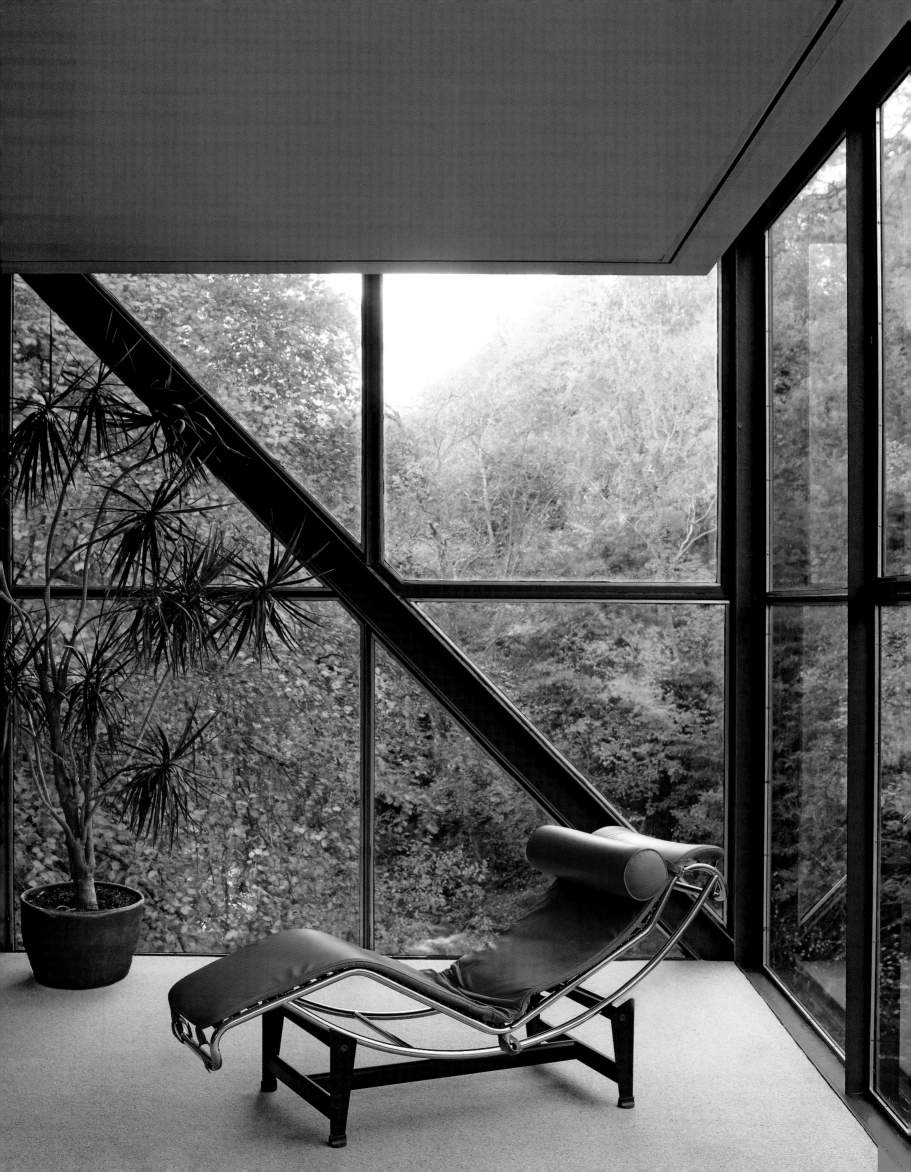

**GOULDING
SUMMERHOUSE**
(1971–1973, restored 2002)

◇

**SCOTT TALLON WALKER
ARCHITECTS**

⋈

**ENNISKERRY,
CO WICKLOW, IRELAND**

'The house and garden cannot be divorced from one another. Each is dependent on the other. The house is like nature itself, like a tree branching out . . . it has its own structural validity just as nature has its structural validity,' said Ronald Tallon of the remarkable house he designed, which seemingly defies gravity as it cantilevers audaciously over the Dargle River.

The Miesian simplicity of the summerhouse was culturally significant for Ireland in the Seventies.

The Goulding Summerhouse was designed and built in the early Seventies, the very period in Ireland in which I grew up. When I saw images of the house, I was astounded that it was located in County Wicklow, for this was not an architecture I associated with Ireland. My visual memory is of low-lying, white, thick-walled cottages, of Victorian-era Belfast and Georgian Dublin but not of a pared-back pavilion, paying homage to Mies van der Rohe, spare both in its concept and materials.

The Goulding Summerhouse came about as a result of a perfect creative storm – an enlightened client, a friendship, a dynamic architectural firm, a picturesque site, a challenging brief and world-class engineering expertise.

The client was Sir Basil Goulding, a businessman who had returned to Ireland at the end of World War II – during which he had been a wing commander in the RAF – and bought the Enniskerry estate. Dargle Cottage became the family home, and the land, with the Dargle River running through it, became his passion.

'My father became a businessman by default – his father died when he was 22 and, as the eldest son, he inherited the running of the business,' says Sir Basil's son Lingard Goulding. 'He read history at Oxford but his real interest was in architecture and art, and so he collected and commissioned the work of living Irish artists and was a reasonable hobby painter himself.' He also became a keen and knowledgeable gardener, cataloguing plants and trees on the property, each year extending the garden, and from this came the idea of a summerhouse.

As a collector, Sir Basil was familiar with the process of commissioning a work of art, be it from an artist or architect, and the brief to his friend Ronald Tallon of Scott Tallon Walker was twofold: make it sturdy and create minimum disruption to the precious vegetation below.

Architecture critic Deyan Sudjic points out, 'It is a pavilion that speaks of radical innovation but it was also the product of the ancient tradition of the enlightened and enthusiastic landowner constructing a distinguished work of architecture on their estate for private pleasure.' And Lingard Goulding confirms this theory, as it was indeed a great party house, with his father often taking a midnight swim in his beloved river below.

In whatever spirit the commission occurred, there is truth in Tallon's statement that to make a good building you have to have enlightened clients, and Sir Basil fitted the bill. As did his wife, Valerie. As a young woman, she was secretary to her father, the UK Attorney General, who was advisor to Edward VIII, and Valerie acted as a courier between the King and the Prime Minister Stanley Baldwin during the abdication crisis of 1936. In later years she became an advocate for the rights of the disabled, setting up a one-room clinic in 1951 during a polio epidemic and later working with Scott Tallon Walker to design the Central Remedial Clinic (1964–67) in Dublin.

As an architectural practice, Scott Tallon Walker (STW) had their fair share of such clients in all sectors of their work which, by the 1970s, included the ecclesiastical, the corporate and the educational. Their rise as a firm reflected the desire for Ireland as a state to recalibrate its cultural identity, to embrace modernity as an indicator of progressive thinking and to declare itself a serious global player.

Michael Scott had started this trajectory with the award-winning and controversial Busáras (1953–55), a Dublin bus terminal that is often regarded as Ireland's first really modern building. Ronald Tallon joined in 1956, followed by Robin Walker (after a stint in Chicago both training and working) in 1958. Scott had the foresight to see the talent in his two younger colleagues and in 1960 Scott Tallon Walker Architects was formed.

According to architectural writer Sean O'Reilly, 'Together they formed a Miesian identity for the practice . . . and embedded a pure, modern architectural tradition into a culture of a country that, in so many other ways, remained largely indistinguishable from its nineteenth-century origins.'

When you review the body of work from this period, there is remarkable clarity of form and structure – something of utmost importance to the practice. The Carroll's tobacco factory (1967–70) is a case in point. This elegant, streamlined building was constructed on a site outside Dundalk, using a modular system to allow for planned expansion. This building not only illustrates how STW used glass walls and long-spanning structures to create open, free-flowing spaces but also how they incorporated art and nature into the building. A reflecting pond is the stage for Sails, a specially commissioned mobile sculpture by Irish artist Gerda Fromel.

The desire for the summerhouse arose because Sir Basil loved a party, and while he used a rather makeshift structure of concrete platforms (romantically called 'the islands') in a pond in the gardens, the guests were exposed to the vagaries of Irish weather. The summerhouse was, naturally, a more protective environment, but still managed to have maximum engagement with its surroundings. 'My greatest pleasure was to be in the building at different seasons of the year,' said Tallon. 'The building embraces the season and its discipline contrasts delicately with the organic forms around it.'

Structurally, it adopts a modular system in that it is a five-bay house, three of which cantilever over the river. The first two bays of the cantilever are glazed on three sides, making it the ultimate viewing platform. It fulfils the client's request that it not disturb the vegetation, as the only supports are steel posts anchored into the rock below. 'What is nice about my design . . . is that it is supported off-centre,' said Tallon. 'It would tilt over into the river if it weren't anchored back into the rock of the hillside. That is what gives it its tension.' The engineers were Ove Arup & Partners, who Michael Scott originally brought to Ireland to work on Busáras, and gave them room at 19 Merrion Square below STW. They would, on the other side of the world, just be in the final stages of their work on the Sydney Opera House.

'Basil delighted in it being difficult, adventurous, not easy. You would find him out on the steel like a mountain goat.'

RONALD TALLON

The Goulding
Summerhouse
had fallen into
disrepair before it
was sympathetically
restored.

The palette of materials is limited to steel, glass and cedar, and the structure is an example of Tallon's maxim that 'a structure should stretch a material to get the maximum use out of it'. As an architecture office, STW was not an advocate of standardisation, and hence each building was bespoke, a one-off, that was 'studied from basics'. The Goulding Summerhouse is a tale of pleasing paradoxes. While employing gold-standard engineers, and an architectural firm that benchmarked itself against the best in the world, the construction itself fell to Sir Basil and his gardeners. Tallon remembers, 'Basil delighted in it being difficult, adventurous, not easy. You would find him out on the steel like a mountain goat.'

The summerhouse was internally spartan as befitted its use. As architect Frank Fahy (later responsible for its refurbishment) recalls, 'There was no ceiling, only a minimal kitchen and tiny bathroom at the core of the building, and large dance floor area.' Internally, the emphasis was on function and fun.

For a building that started with such exuberance, the late Eighties and Nineties were a bleak period for the Goulding Summerhouse. As time passed and ownership changed – and despite attempts to use it as a restaurant, a conference centre and an artist's studio – it became neglected and was vandalised before falling into complete disrepair. It took a German architect, Renzo Vallebuona, to not only take note of the dilapidated state of the house in 1998 but, understanding its architectural merit, to do something about it. 'Here was a building worthy of any European list of buildings to be protected, but it wasn't protected in Ireland,' he said.

Alongside colleague Desmond Byrne, he galvanised students at the AA in London to research all available information from STW and Ove Arup's original files and create structural and virtual models. They even organised an exhibition, devoted solely to the house, in the Davis Gallery, Dublin, to bring its plight to national attention. Fortunately, the current owner, Johnny Ronan, undertook renovations, re-engaging Ronnie Tallon and project architect Frank Fahy to bring it back to life, 30 years after its original construction. Given so much of the building work had been carried out by Goulding himself, Fahy marvelled at the perfection of the execution, the precision of the cedar sheeting and the accuracy of the joints.

'We upgraded and rearranged the internals of the summerhouse to create a galley kitchen, a pull-down bed and a proper bathroom,' he says. A ceiling was installed, the areas between the steel supports were plastered, and an undyed wool carpet laid. 'Basically we made the summerhouse comfortable inside but everything else was simply restored to the original.'

Given the tremendous scope and scale of the work of STW, now with thriving offices in London and Saudi Arabia, it is interesting that the two structures with the greatest poetic resonance are both tiny – the commemoration of the 1798 Wexford Rising, Tulach a' tSolais (1996–1998), created in collaboration with the artist Michael Warren, and the Goulding Summerhouse. Both are simple, spare and awe-inspiringly beautiful – one creates an internal quiet that eschews the outside world and one sits within the context of nature's mutability.

In the words of architectural historian Shane O'Toole, 'Tallon's achievement was to capture both these things – Mies's seductive idea and that optimistic, golden air of Californian "possibility" – and transplant that, effortlessly – spectacularly – to a rural Irish setting. Here, too, was the modern world.'

In December 2010 Dr Ronald Tallon was awarded the James Gandon Medal, a new lifetime achievement award from the Royal Institute of Architects of Ireland; in the citation he was called 'one of the most influential Irish architects of the last century'.

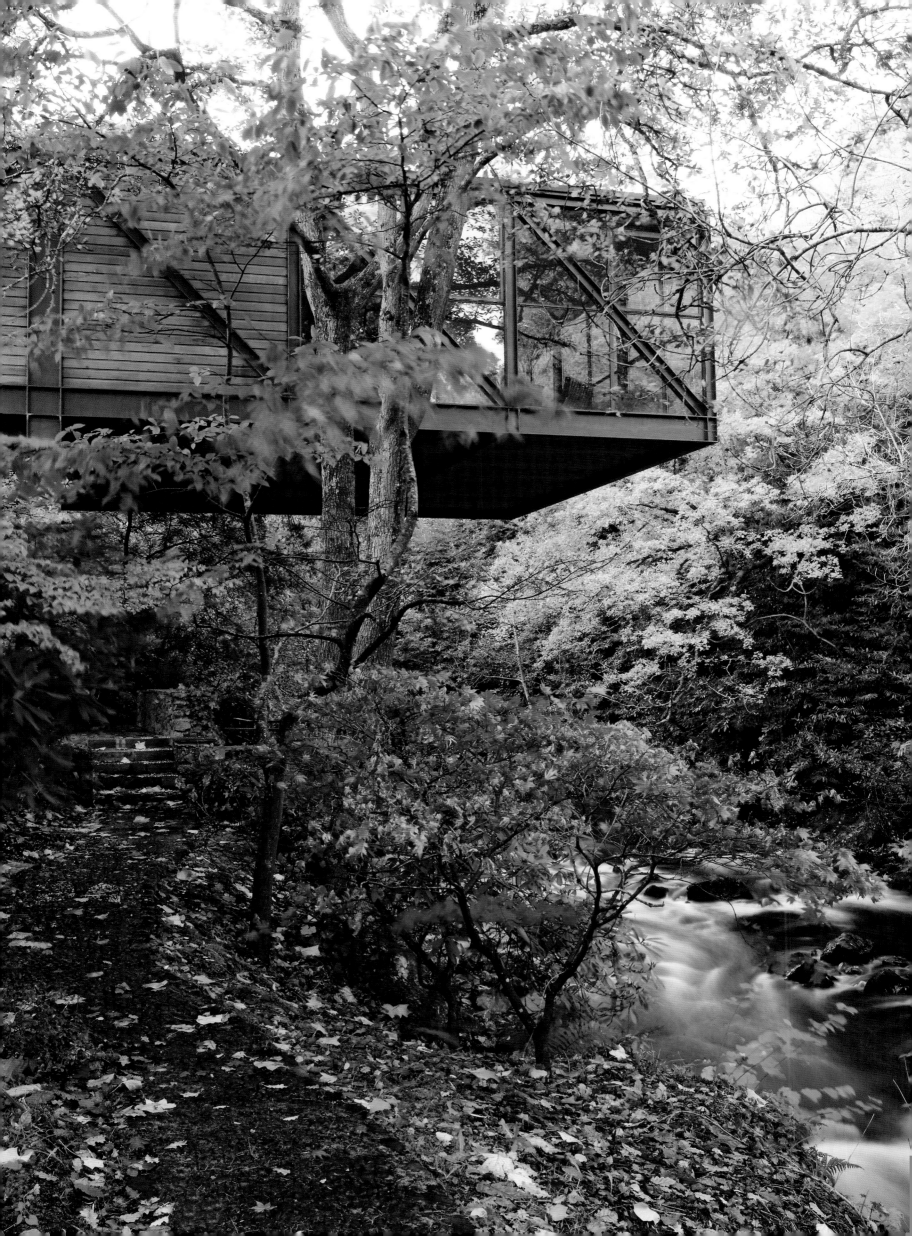

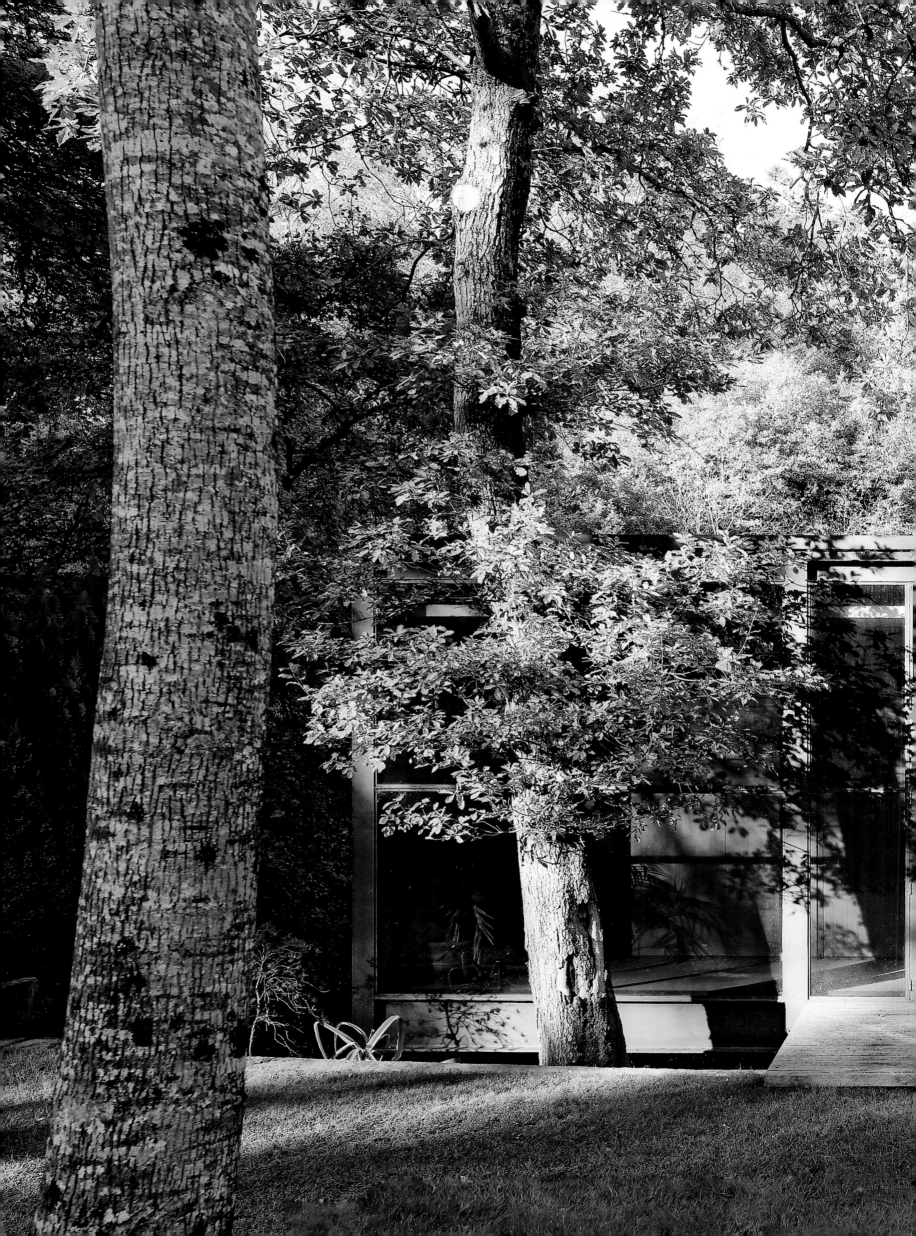

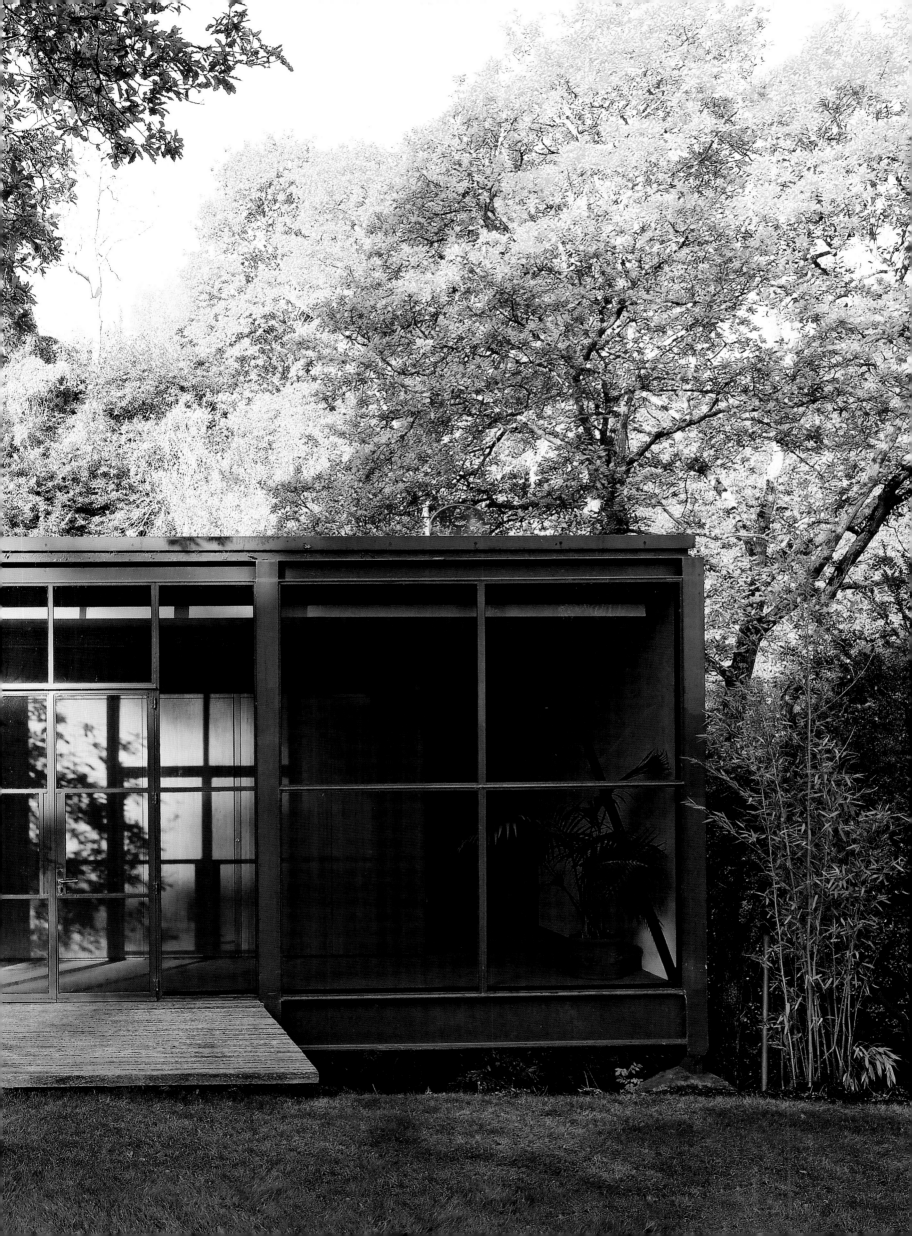

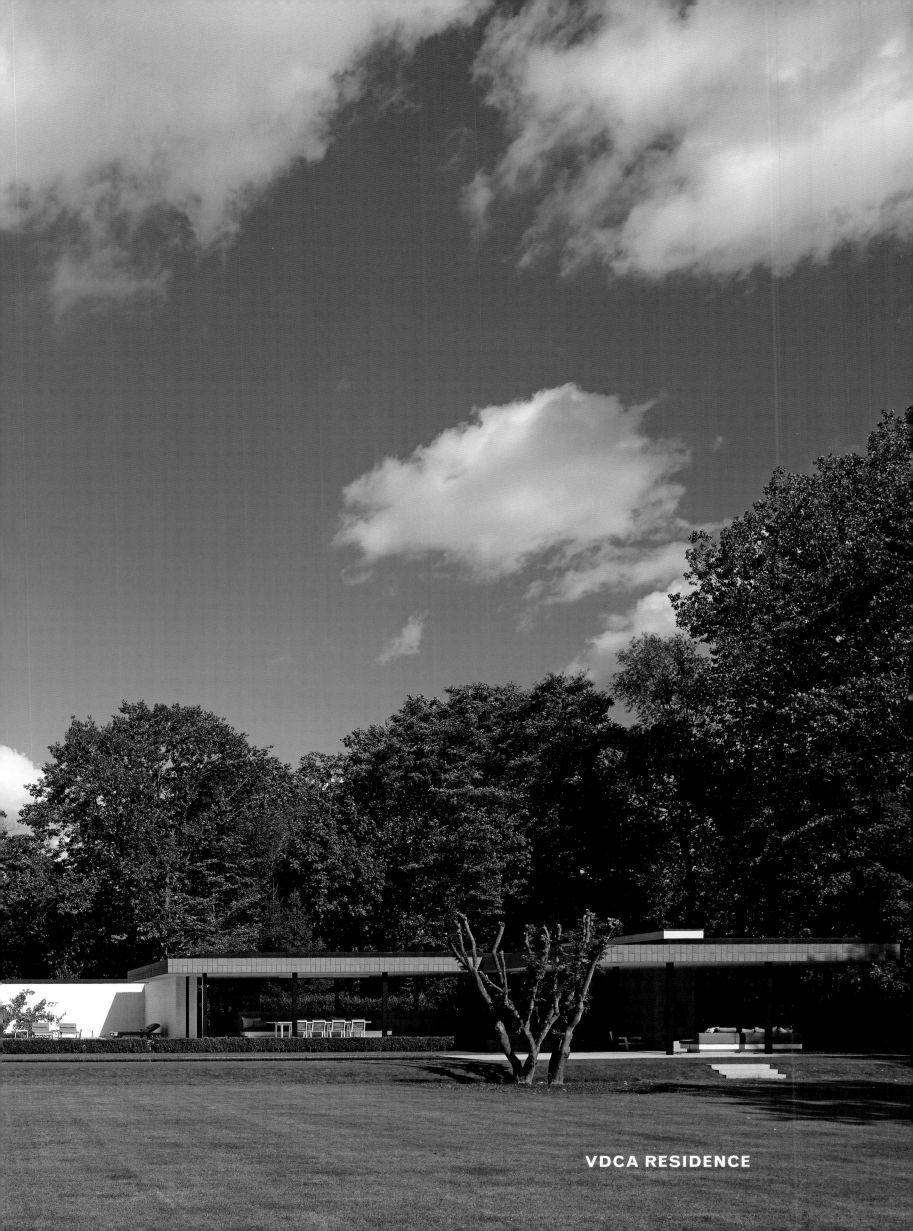

VDCA RESIDENCE

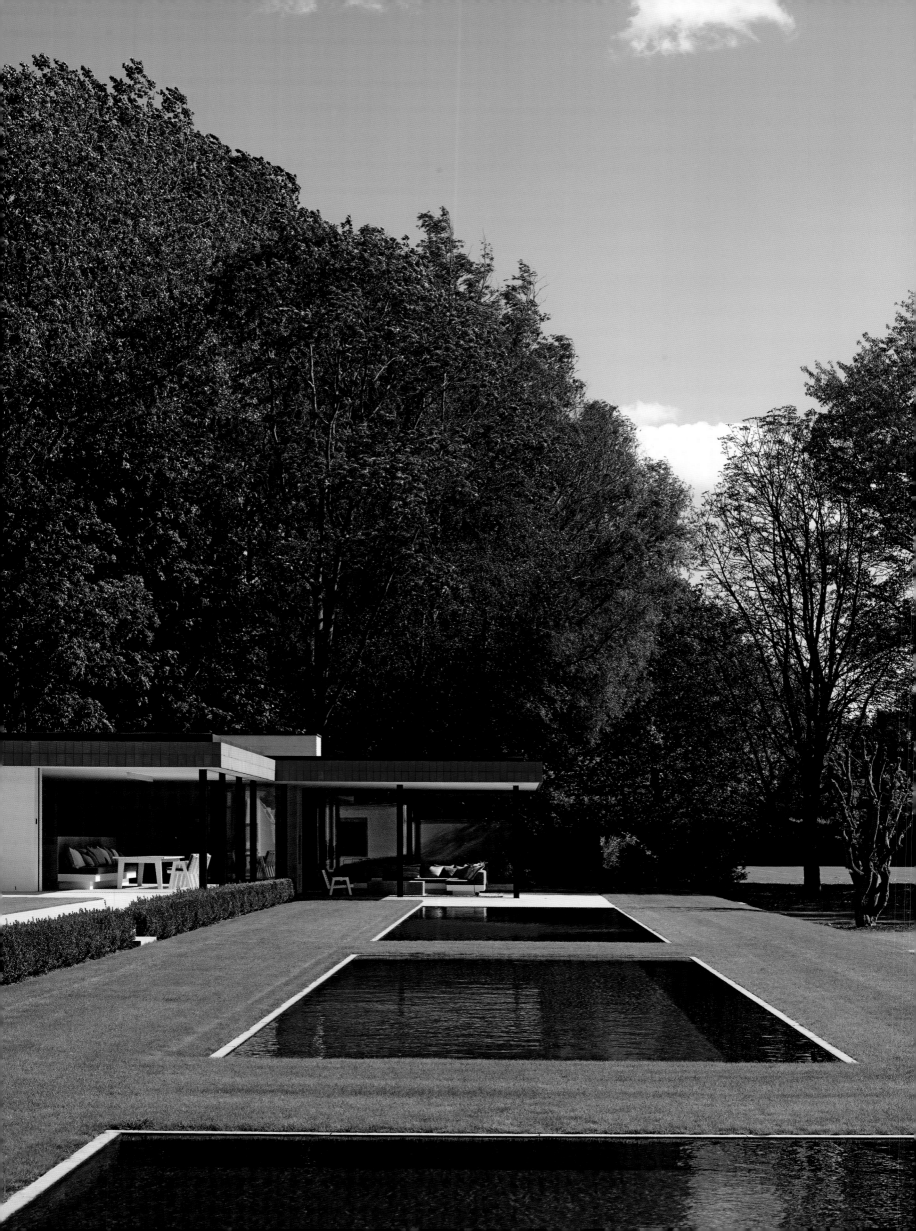

VDCA RESIDENCE
(2005–2010)

◇

VINCENT VAN DUYSEN
ARCHITECTS

�elocation

KORTRIJK, BELGIUM

'Here was a designer with a sound grasp of materi-
ality, someone who could take materials that were
not in the lexicon of "modern" and make them new,
while at the same time creating a modern that was
warm and muscular,' wrote ex-editor and designer
Ilse Crawford on the experience of coming across the
work of a young Belgian architect called Vincent Van Duysen in the early 1990s. As editor of
British *Elle Decoration,* she saw thousands of homes but was struck by his rare ability to create
warmth, atmosphere and beauty through his careful attention to the inherent qualities in
materials and how they sat, both with one another and in the space itself. Van Duysen's own
apartment, in Antwerp, was photographed by Martyn Thompson and appeared on the pages
of *Elle Decoration.* I remember the quiet stir it caused at the time. The spare beauty made it
modern but the materials, the light and the furniture choices made it comfortable and elegant.
In the process, the word 'comfort' was dragged from its dusty corner and once more became
a design-relevant term.

With the passing of two decades, his grip on these essential qualities has, if anything, grown
tighter, and the skill he employs in evoking sensation is even more assured. From his office
in Antwerp, his work spans large-scale retail projects, residential and office buildings, which
can be seen locally as well as in New York, Milan, London and Beirut. Within each differing
context he remains true to his signature – a modern refinement of materials – or, as expressed
by designer Patricia Urquiola, 'A silent sophistication that doesn't need to show off.'

Influenced by converging aesthetics, his inspiration came from Roosenberg Abbey at
Waasmunster in Belgium, designed by Benedictine monk, Hans van der Laan (1904–1991),
whose innate understanding of rhythm and sobriety created an austere beauty enriched by
light and shadow. 'Space, form and measurement should form one big harmony,' said van der
Laan, and Van Duysen took this to heart. Another key influence was the fashion designer Rei
Kawakubo whose Comme des Garçons retail space in Paris (1982) redefined the genre with its
utterly restrained, monastic approach. Both these examples evoke an emotional response, and
Van Duysen's architecture is defined accordingly. He chooses materials carefully and proceeds
to draw out their inherent beauty, allowing them to become the form and content of a space.
His work has a tactile richness that, while spare, is never minimal or devoid of character. 'Vincent
has a flair for harmony, materials, textures, colours, warmth and detail, and an understanding,
second to none, of how to deliberately showcase some elements and conceal others,' says writer
Chris Meplon. With this defined line of creative development, it is hard to pick the young,

The three pools are
used as a linking
device between the
original house and
the addition.

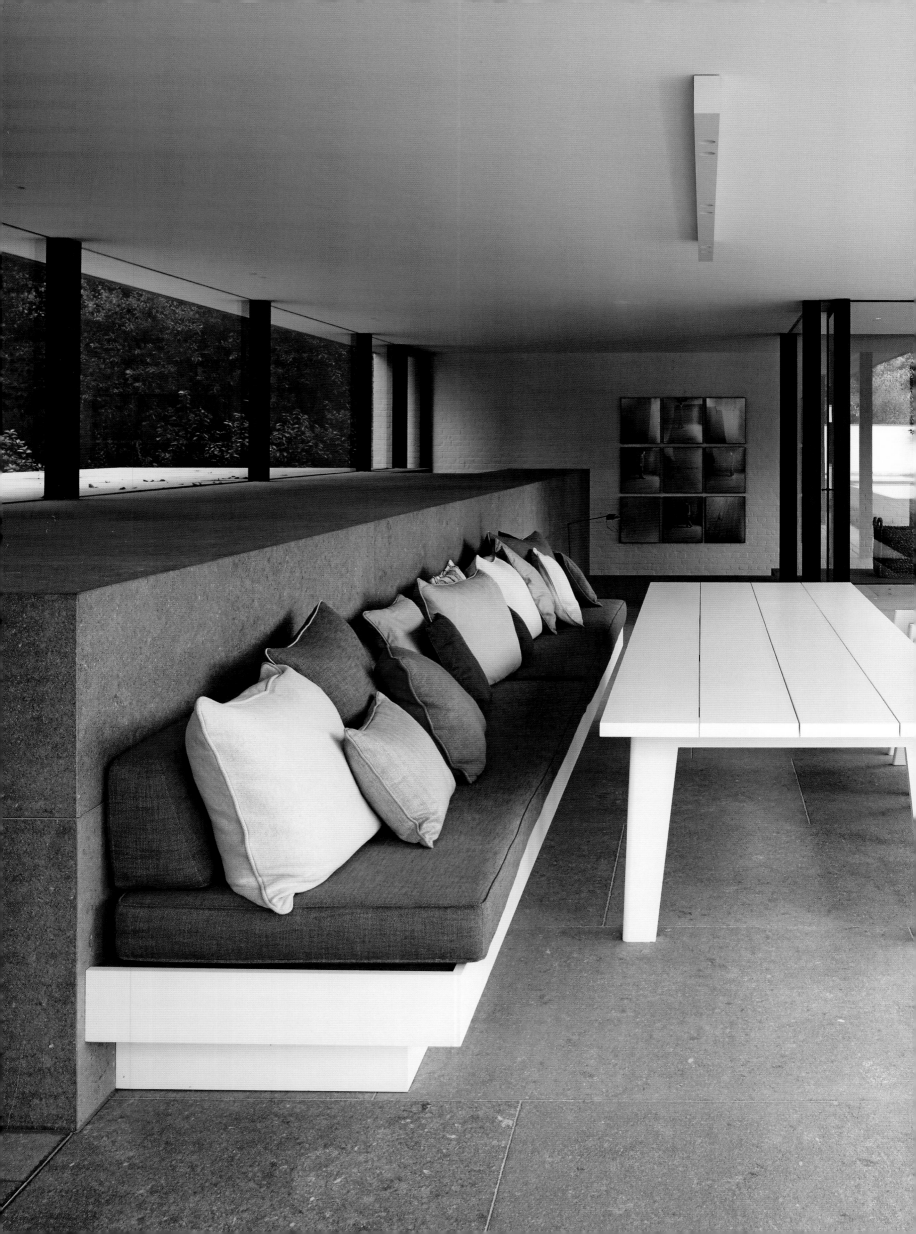

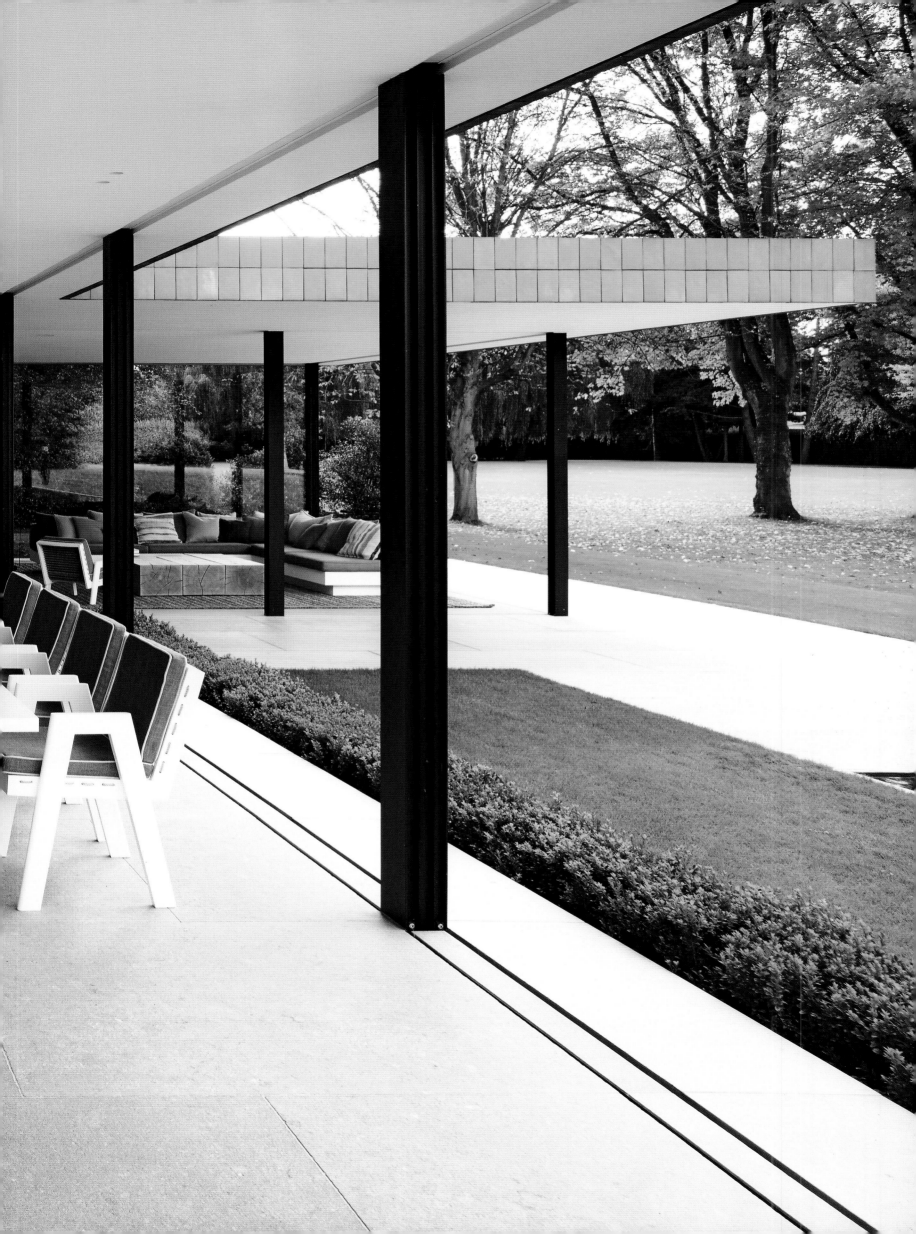

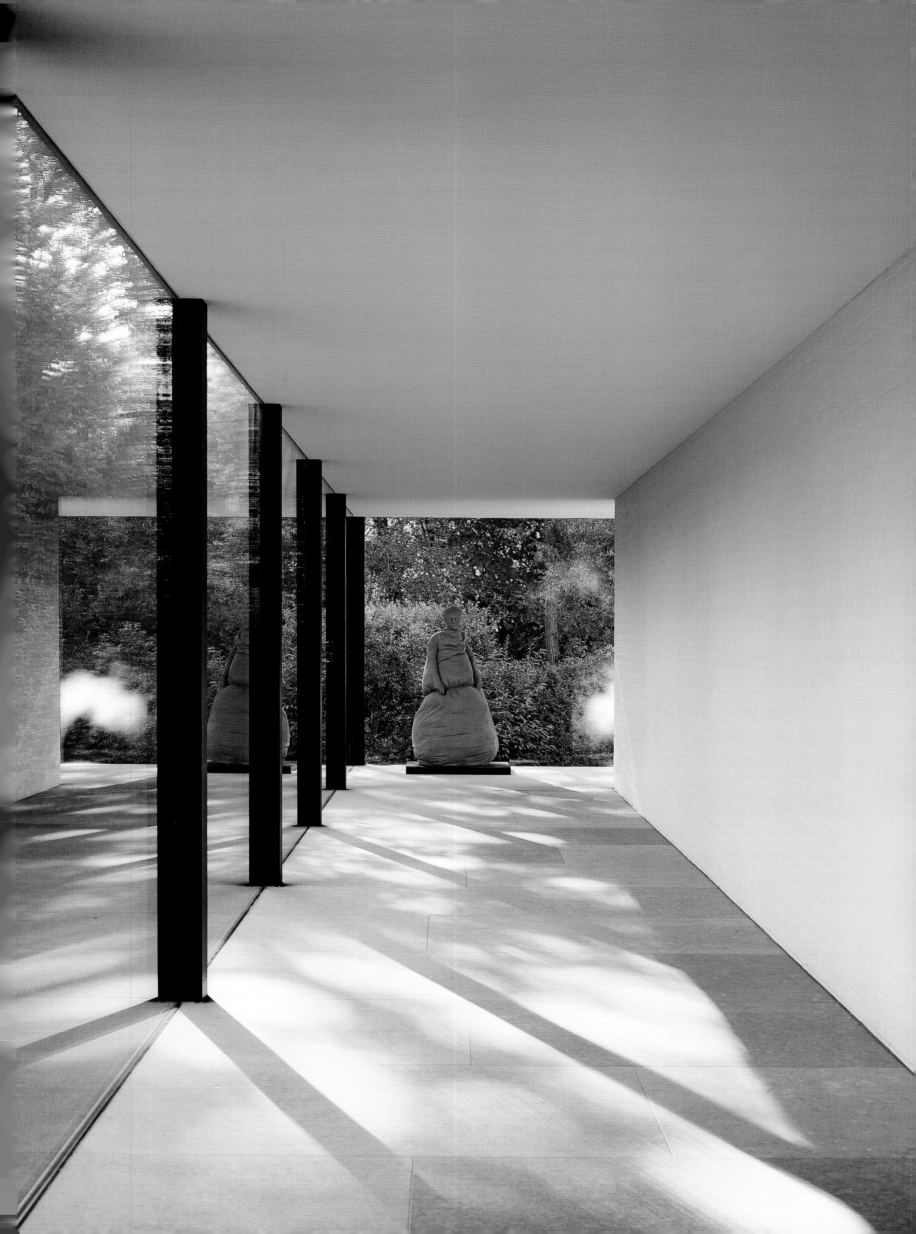

A colonnaded
walkway leads from
the original house
to the pool house.

Painted brickwork
combines with
precisely worked
bluestone.

Through the use of natural materials, Van Duysen explores the contrast between old and new.

postgraduate Van Duysen as assistant to Aldo Cibic in the studio of Ettore Sottsass in the late Eighties. With his outlook broadened in Milan, he returned to Antwerp in 1990 and set up his own practice.

Van Duysen applied his refined sensibility to small but significant projects, such as the Copyright bookshop (1996) in Antwerp and Natan (1995–96), a fashion store in Brussels, alongside new houses and re-imagined apartments. The client's aspirations are always at the top of Van Duysen's concerns, with their involvement paramount as he seeks to create 'tailor-made homes, designed with complete comfort in mind'.

Other projects at this time included an elegant new brick building, the DB-VD Residence (1994–97) in Sint-Amandsberg, and M Residence (1996–97) in Mallorca, Spain, a reinvention of a rural Spanish house. And his career has continued along this path, with new buildings becoming larger and more significant – such as his noteworthy Concordia Offices at Waregem – while his ability to reinvent existing spaces becomes more acute as he instinctively edits, alters and adds to create a seamless new space entirely geared to the needs of his clients. He renovated his own townhouse, built in 1870 as a notary's office, to appeal to the senses through manipulation of space, light, form and surface. In this instance, he draws out the sculptural beauty of the existing staircase and utilises a central courtyard for light and the integration of nature in the form of a large Japanese maple tree. His work is an exemplar of the space where spare and sensuous meet.

This was very much the case with the VDCA Residence at Kortrijk. The original house, built in 1950 and sited in majestic park-like grounds, by British landscape designer Russell Page, of established oak and sycamore trees, was designed by a Belgian architect, Joseph Viérin, in the fashionable style of a French villa. It is built of brick, painted white, and has a distinctive terracotta-tiled pitched roof. Over the years it has had some additions, including a rather remarkable study fitted with cabinetry and lighting by celebrated Belgian furniture designer and interior architect Jules Wabbes. Wabbes was famous for his skill with timber and metal, which combine in sophisticated, timeless designs (many of which have been reissued by Belgian company Bulo). The essence of his work is embodied in the office space in Kortrijk – his signature cabinetry and desk, bookcases, tables and seating are all in immaculate condition, and it was Van Duysen's job to protect and restore this cultural gem at the heart of the renovation.

'Vincent has a flair for harmony, materials, textures, colours, warmth and detail, and an understanding, second to none, of how to deliberately showcase some elements and conceal others.'

/

CHRIS MEPLON

For Van Duysen it is important 'not to forget about the past and what has been done already, not making it about boring perfection, but achieving the balance a modern vision brings where space and light are the main protagonists'. Not only was Van Duysen to remodel the existing house but was also briefed to create a pool house and wellness area that was both separate from, and linked to, the house. He worked with landscape designer Paul Deroose to devise a series of three water ponds sited in front of the existing house and the dining area of the pool house, encouraging the eye to see the relationship between the two. This linking is furthered by two key elements – a brick wall, painted white, extending from the side of the house to create a courtyard (an idea of Deroose's), and the ribbon of handmade terracotta tiles that delineate the large cantilevered roof of the simple Miesian structure. While this unifies at roof level, on the ground Belgian bluestone flagstones run from the kitchen out to the courtyard, continuing into the pool house to form the entire surface of the subterranean hammam. The flow is unbroken and the visual and physical connection is clearly apparent. It is a material with which Van Duysen is very familiar having

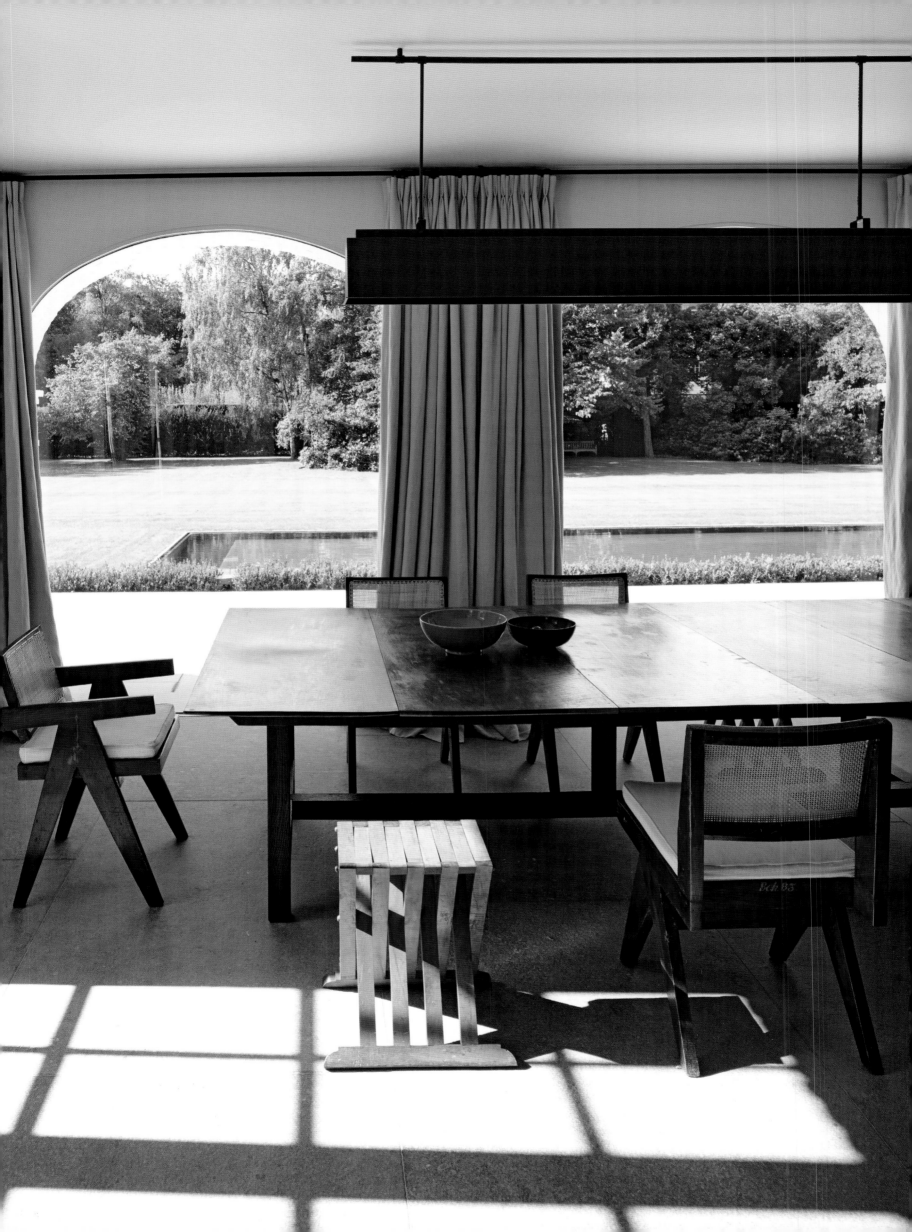

Acknowledging heritage is an intrinsic part of Vincent Van Duysen's finely tuned aesthetic.

The original panelling has been left unvarnished, giving it a contemporary humanising touch.

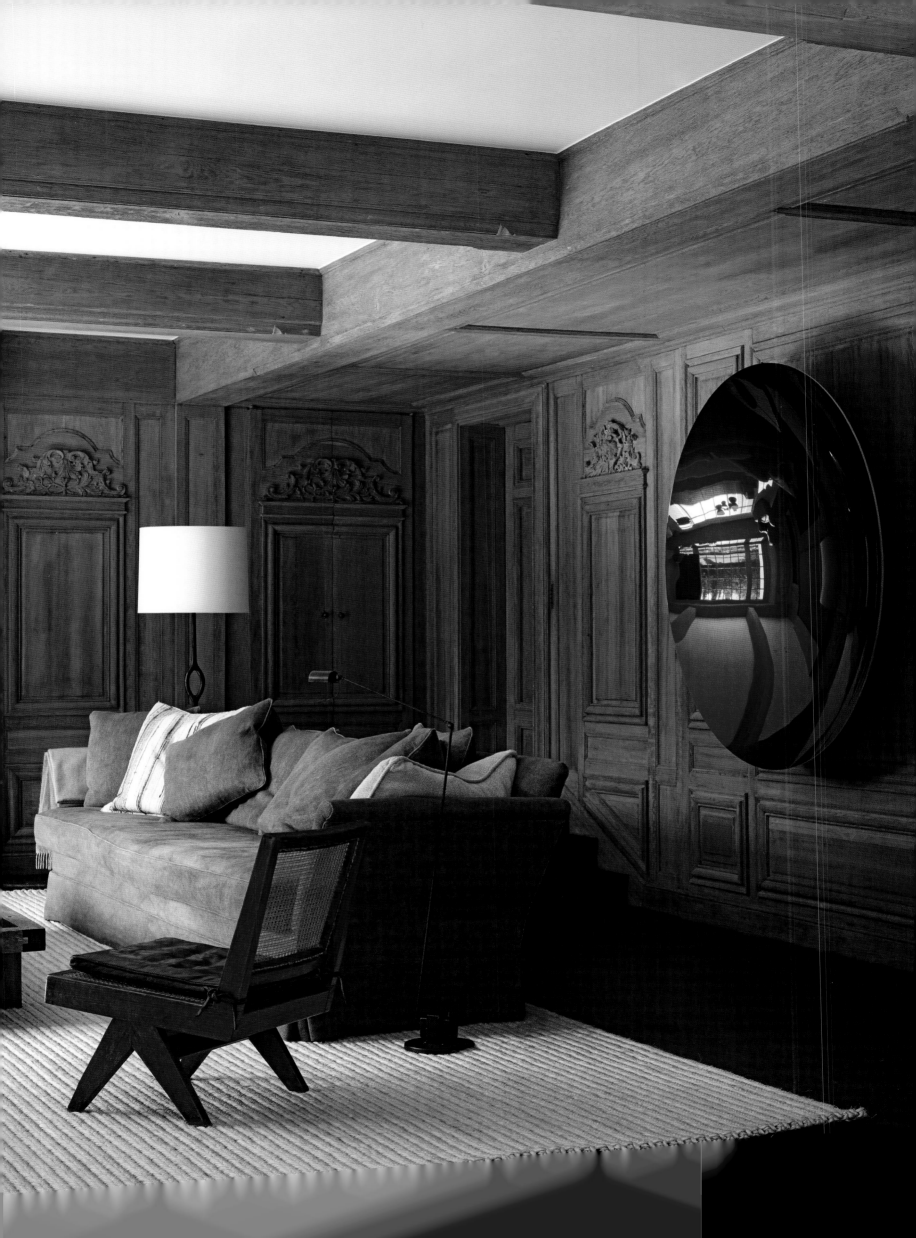

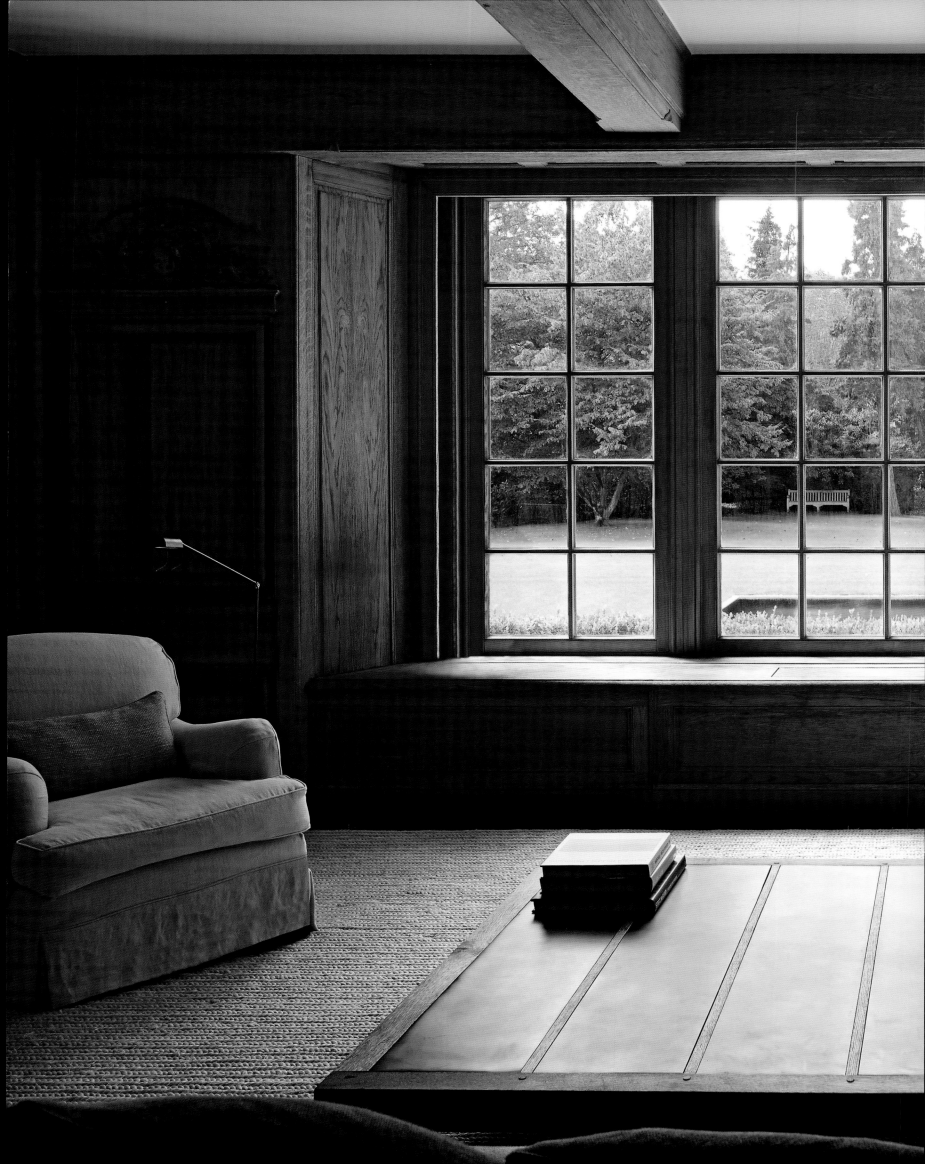

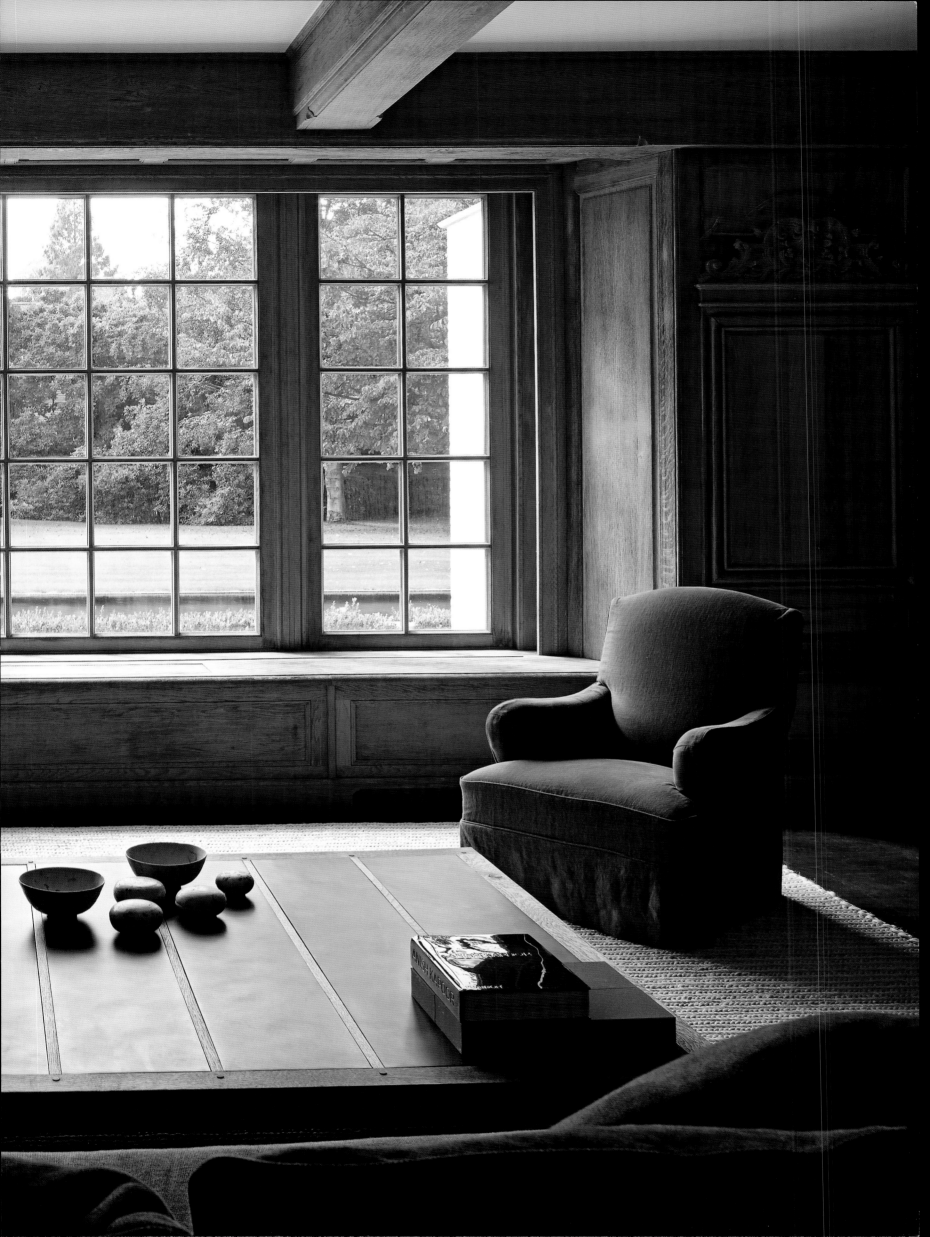

Paring back and leaving only the essential elements has created a contemplative space.

In the light-filled summer living room, elegant proportions are matched with soft and subtle colour choices.

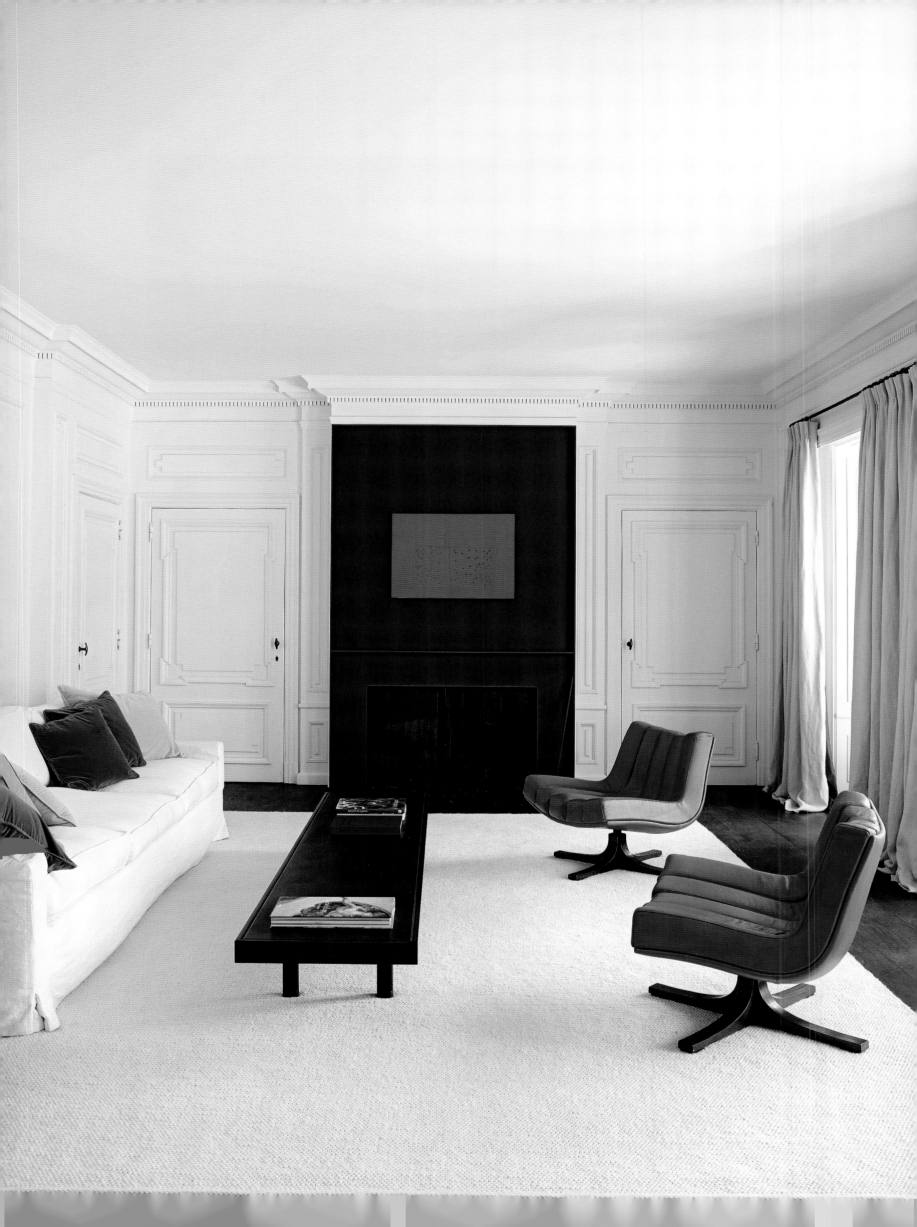

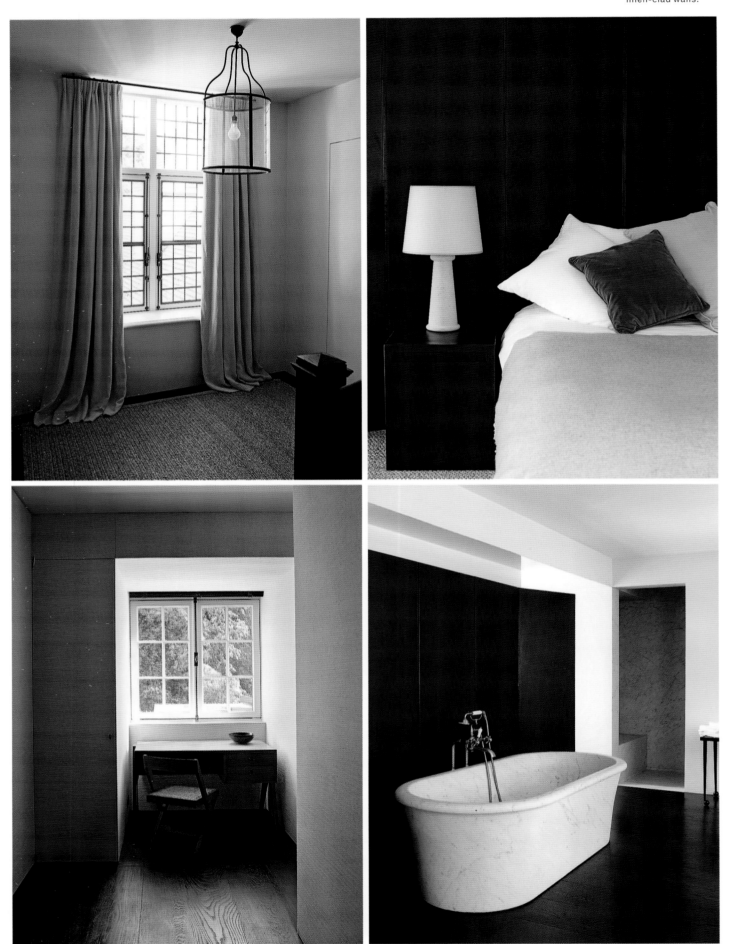

In the master suite, quiet luxury comes through the use of leather, marble, and linen-clad walls.

VDCA RESIDENCE —— VINCENT VAN DUYSEN ARCHITECTS

used it many times before, most significantly in his 160-bed youth hostel (2011) in Antwerp, which is entirely clad in bluestone. The pool house, complete with dining, lounge and kitchen at ground level and a wellness area in the basement, becomes home to the family in summertime. The entirely glazed building, with ceiling heights in excess of three metres, closes up in winter, but in summer, at the touch of a button, these immense walls of glass sink down into the earth, completely disappearing and leaving the relationship of inside and out entirely unfettered. What seems so effortless for the user actually involved the excavation of underground rooms that house the mechanics and provide a place for the glass to rest when not in use.

When it comes to manufacturers and craftspeople, Van Duysen is very clear in the value they bring to a project. Early in his career he realised that, for him, there was no divorcing the concept from the execution, and so the focus on detail, on materials, their natural attributes and how to enhance them, extends to those who produce and craft them. He has developed relationships with manufacturers, and craftspeople whose artisanal skills he brings to bear on every project. Van Duysen describes the project at Kortrijk as 'a masterpiece of craftsmanship with every trade a small contractor, an atelier, of people living and working locally'.

Internally, it was to the arrangement of space and the flow that Van Duysen first turned his mind. What was originally a colonnaded walkway has been glazed to form a conservatory-like area facing the garden. Although there is no formal dining room in the house, a massive reclaimed timber table from Axel Vervoordt, surrounded by Pierre Jeanneret chairs of rare pedigree, fills the space. A large custom-made horizontal light hangs above the table and generous curtains in heavyweight Flanders linen pool on the floor. It is a typical Van Duysen interior with few elements but each chosen for its unique character. 'It is always about old and new, but in a contemporary way. Contrast and tactility are very important to me,' he says. He mixes up treatments – new floors will be finished in a way to give them a refined patina, old walls painted in gloss to sharpen them, and thick textured matting placed on timber floors. The palette is calm and serene but never dull. 'For me, starting with wood or stone or fabric – layers of texture – is very authentic and then I add subtle twists.'

Interior architecture has long been his strong suit and he has designed furniture and objects for companies such as B&B Italia and When Objects Work (for which he created his influential coloured ceramic and timber-lidded stacking bowls), with a new range of furniture for the Herman Miller Collection recently released. At the VDCA Residence, Van Duysen designed all the outdoor furniture, referencing older modernists by keeping shapes simple and painting the timber white, covering cushions in Flanders linen and expressing their handcrafted quality in the form of 'stitching' running down the sides of the chairs. Van Duysen worked with longstanding collaborator Catherine Huyghe on the interior, sourcing much of the interior furniture from Axel Vervoordt, whose authentic aesthetic the owners appreciate. Other remarkable pieces include, in the light-filled summer living room, the Granada chairs by Javier Carvajal, for the Spanish Pavilion he designed for the 1964 New York World's Fair.

In contrast, the winter living room retains the original panelling, which has been left matt and unvarnished and provides the perfect backdrop, in terms of contrast, to the Anish Kapoor with its rich, reflective surface.

When Van Duysen is asked whether he feels the time for a broad appreciation of his aesthetic has come, he replies, 'Certainly it is the time for warm minimalism, and an understanding of the mix. The humanising aspect of not forgetting the past and acknowledging heritage is important.' Or, as Spanish architect and admirer of Van Duysen's work, Alberto Campo Baeza puts it, it is 'not so much that less is more but more with less – just enough – like well-chosen words of poetry'.

Much of the subtle detail of the house comes from the artisanal skills of local craftspeople.

Part of Van Duysen's talent is in the balance of materials with their surface treatment.

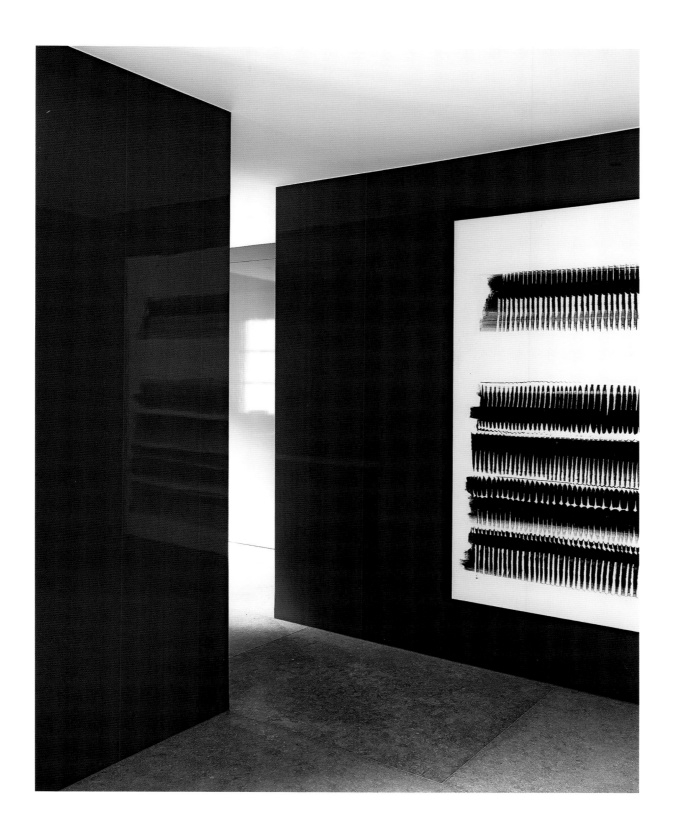

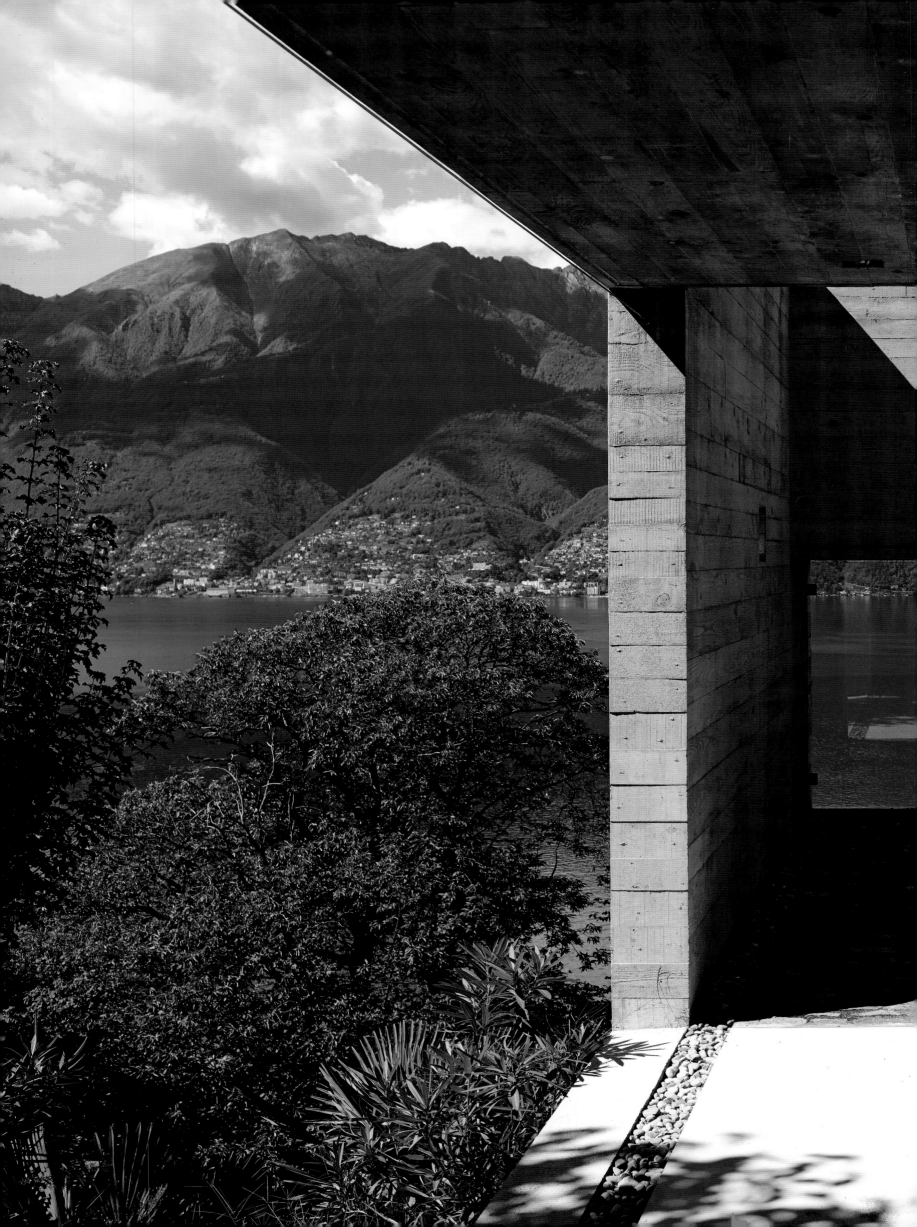

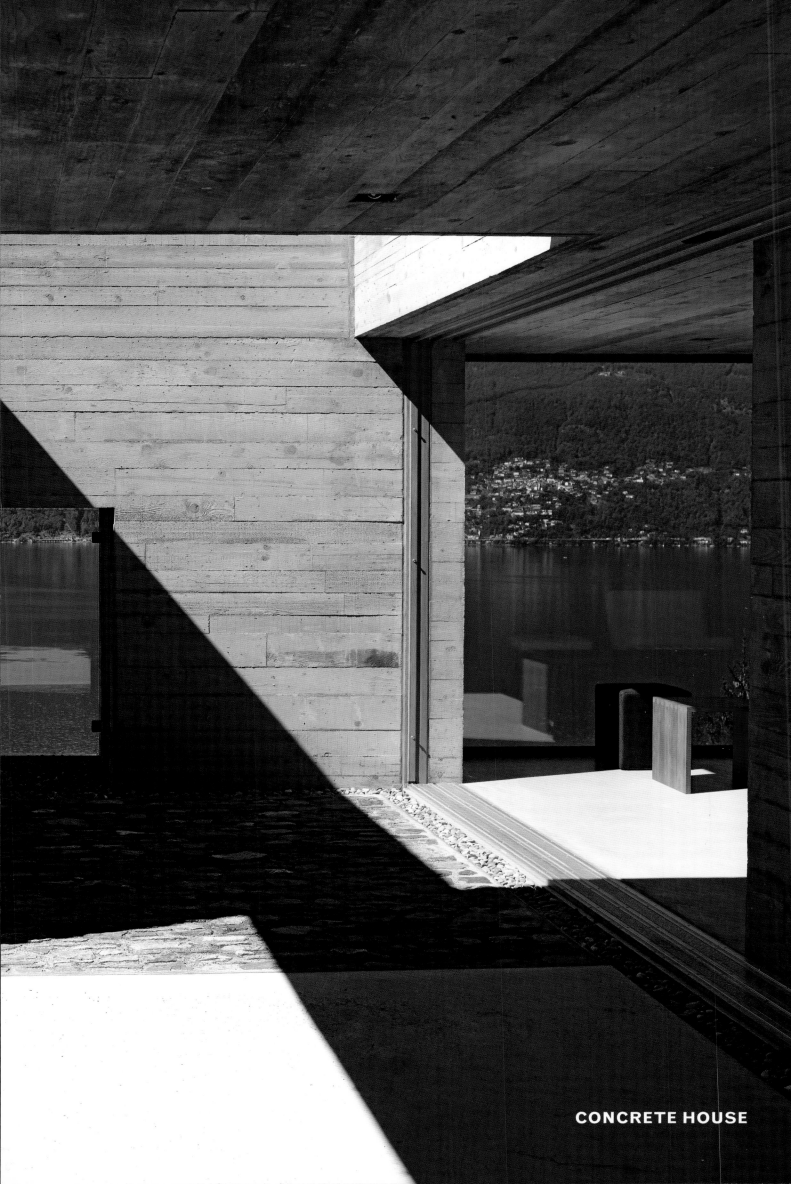

CONCRETE HOUSE

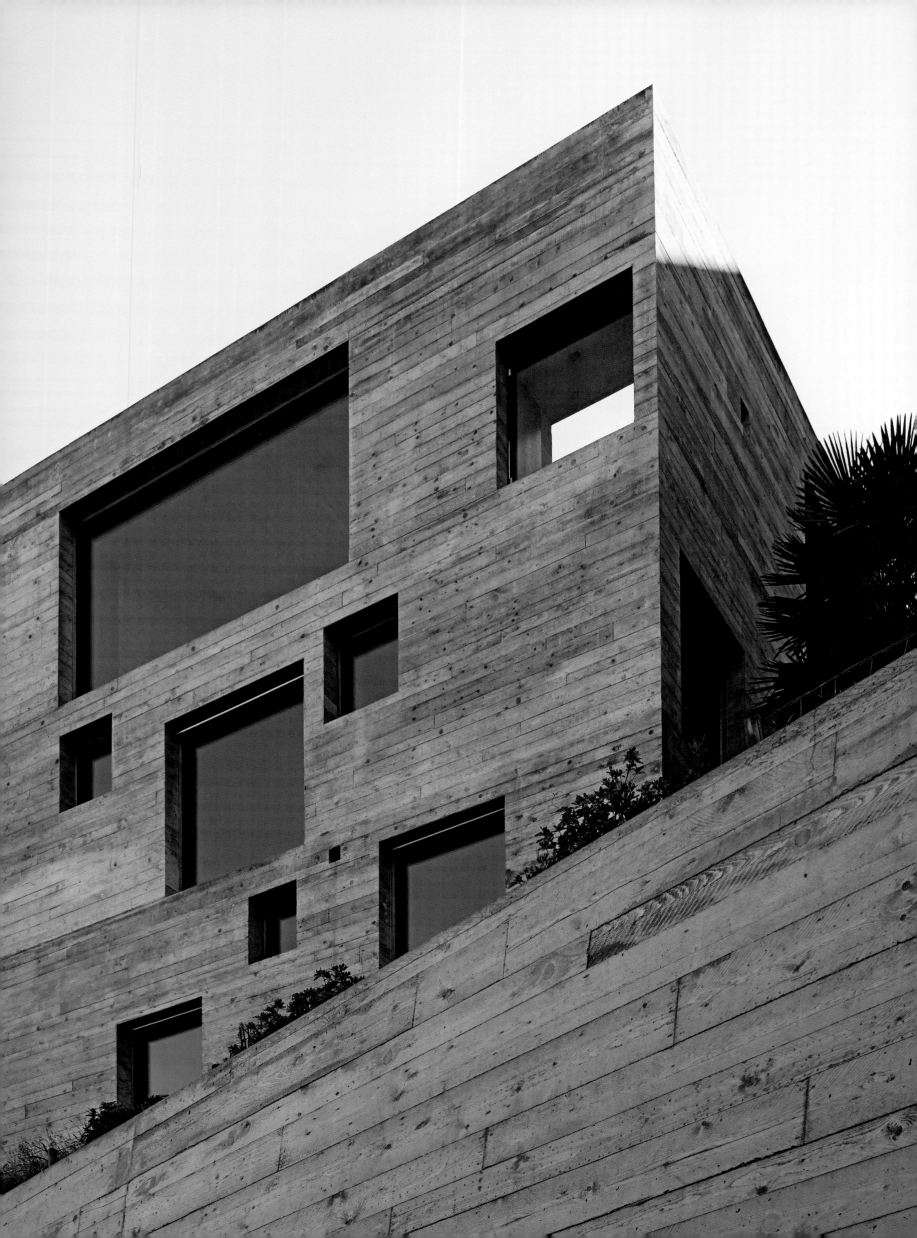

**CONCRETE HOUSE
(2012)**

◇

**WESPI DE MEURON ROMEO
ARCHITETTI**

⋈

**SANT'ABBONDIO,
SWITZERLAND**

When Jérôme de Meuron used the word 'concen-trated' to sum up the Concrete House at Sant'Abbondio, it struck me as entirely apt. While the photographs emphasise the expansive nature of the house, the direct experience is much more contained, controlled and deeply considered. And it is all the more beautiful for it. The sense of connection to the locale manifests itself in many ways, great and small, giving this essentially spare space layers of subtle meaning beyond the immediately apparent.

The journey from Lugano to Caviano, where the offices of Wespi de Meuron Romeo Architetti are housed, is partly alongside the spectacular Lake Maggiore and through narrow winding roads as we head into Caviano. This gives time to absorb something of the uniqueness of the setting. The intense colour of the lake, framed by snowcapped mountains, is almost too scenic to be real: it is the stuff of digitally enhanced holiday posters.

The offices of Wespi de Meuron Romeo are hard to find, and say much about the discreet philosophy of the practice. Located on a little local road, there is construction work at the street front where de Meuron is building a family home on a tight but picturesque block. The office is housed at the top of a tiny tower house, reached by cutting precariously through the site, along builders' planks, and up several flights of narrow staircases. The view, through slatted timber, is of the lake. Markus Wespi, Jérôme De Meuron and Luca Romeo work, according to de Meuron, as 'almost three generations of architects' in a practice where all the design decisions are collaborative. 'If one of us disagrees, we start again and rework until we are all satisfied,' says de Meuron. He acknowledges it may take longer at the initial stages of a project, but is convinced that all issues are fully resolved early on in the process.

Much of their work is local, predominantly new houses around the lakes, alongside the revitalisation of existing buildings, such as a stone barn in the Italian countryside. 'We learn so much from old houses: how they function and how they are made,' says de Meuron. 'They give space a character that is meaningful to people, and we are always looking for ways to do that.'

Some of these devices play out in the Concrete House. The effect of a deep wall enhanced by a change of texture as natural stone pieces are set into an alcove, the use of a courtyard to extend living space, and the introduction of honey-coloured oak to warm the limited palette of stone, concrete and raw plaster. 'The house is robust and the materials will weather with time, improving as green moss grows and the concrete blackens and gains character,' says de Meuron.

Structurally, this is a very modern building set into a challenging site, a subdivision from a neighbouring property, which is both steep and unstable and has the added difficulty of

The facade is punctuated by seemingly random window openings.

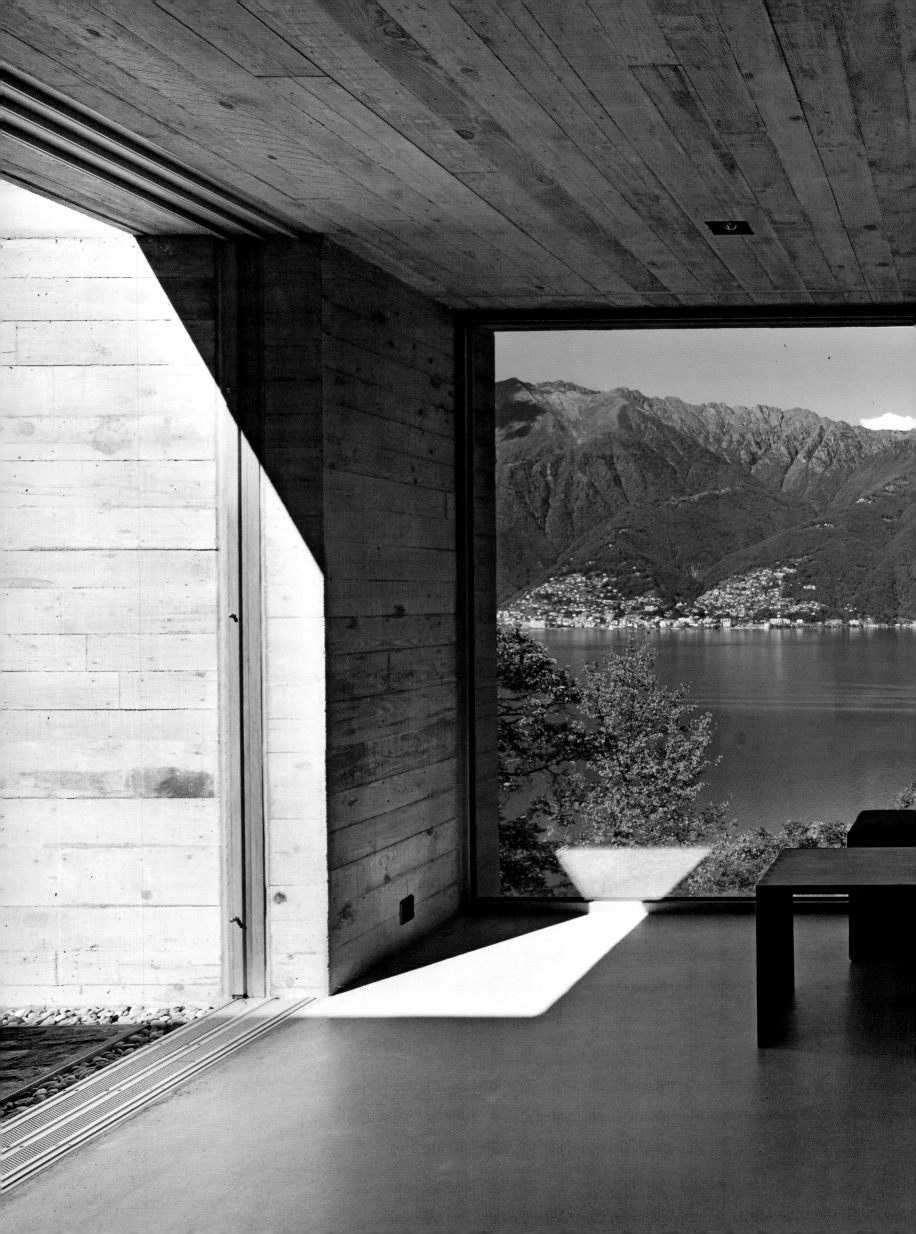

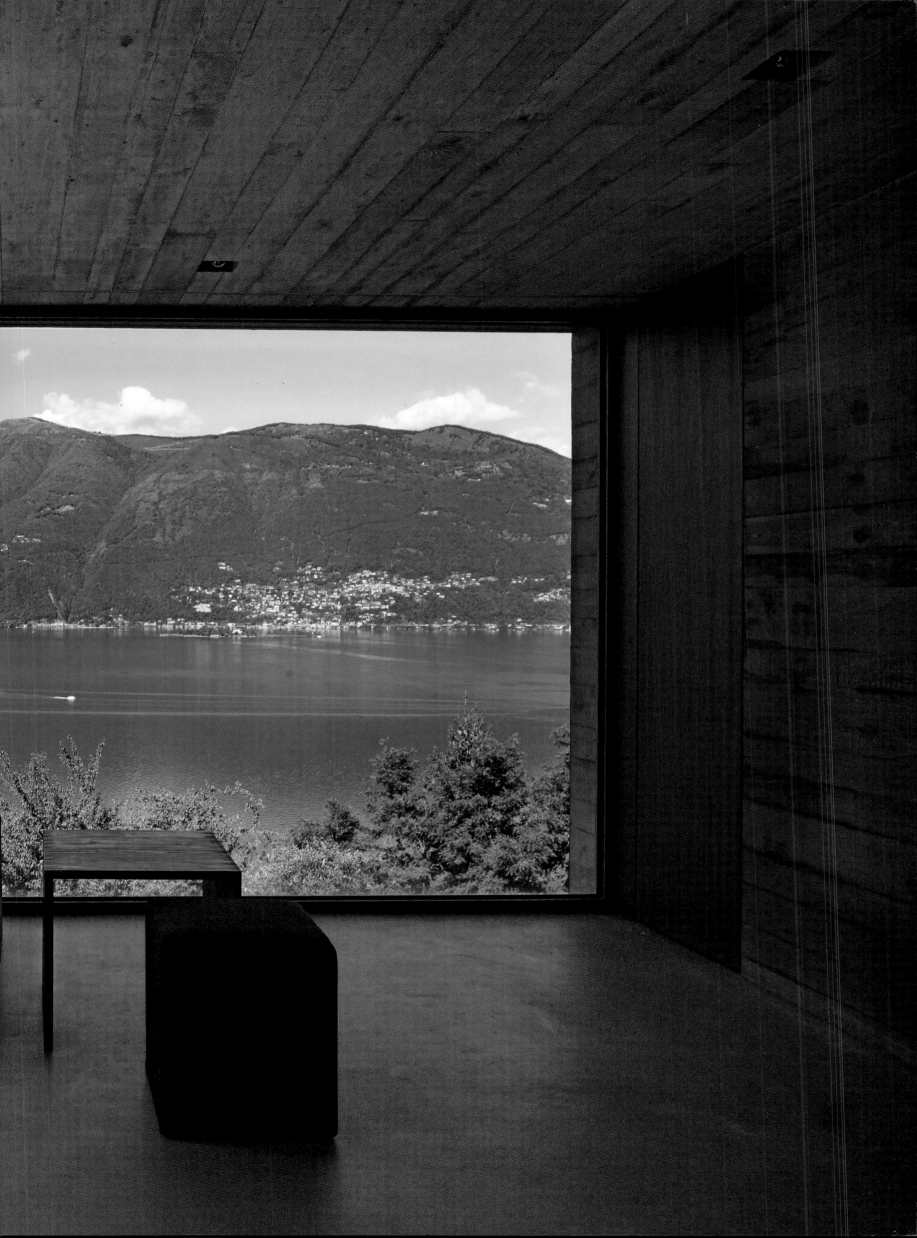

The recessed
window, with
a floor of local
stone, emphasises
the solidity of
the building.

restricted road access. 'Construction was complicated as there was considerable excavation, and the earth had to be taken off-site, whereas all the concrete had to be formed on-site as there was no other space,' said de Meuron. The concrete was poured into formwork of untreated pine, transferring all the character and texture of the timber onto the structure. A crane was shared with the house being built next door, fortunately by the same construction company.

The logistics of building also served to inform the design of the house, working vertically in layers from the twin guest rooms flanking a shared bathroom at the base to the master suite with an adjacent room used as a gym, and upwards to the main living, dining and kitchen area. There is a door to the external steps at each of these three levels and, in time, should the owners tire of the climb, they can install an exterior lift.

The internal staircase parallels the external journey but, in this instance, it is the sense of enclosure that is the dominant sensation. The stairwell width is the Swiss regulation minimum of 90 cm and without this limitation de Meuron admits they would like to have reduced the dimensions even further. 'The village roads around here are dark and tight and we liked the idea of relating to the context of the area by combining restricted spaces with open vistas.'

The rooms on the first two floors are cabin-like and functional hence, theatrically speaking, they are the supporting act to the main living space, with its triple-glazed picture window and access to the exterior courtyard. The engagement of the house with its setting is a well-considered one. The architects understood the importance of the dramatic delivery of what is a remarkable, uninterrupted view of Lake Maggiore but, in other instances, there is an almost Japanese quality to the management of aspect. In one of the small guest bedrooms there are two windows – one framing the mountain peaks, the other, set low in the wall, directed at the treetops to capture their seasonal changes. At another window, the exercise bike is positioned in front of a steep mountain view, making it the nearest thing to an outdoor experience.

A remarkable achievement is the balance between the internal and external expression of the window placement. Internally, they need to make sense, according to human scale and interaction with the landscape, but it is the positioning of the windows that determines the geometry of the facade, punctuating the concrete cube in a way that gives the house a certain sculptural poetry.

It is a house of many squares and rectangles, from tiny recesses in the ceilings for light bulbs to timber square drawer fronts in the hallway. They gain scale as storage cupboards, windows and voids, increasing in size up to the structure itself. There is no formula, no sliding scale of use but, rather, each dimension is chosen as appropriate to the task. It serves, alongside the confined palette of materials, to create a feeling of order and calm.

The house has a sense of retreat, with few possessions required to live well. For instance, an oak dining table, by the architects, has been designed in two moveable parts, so that a section can be used outdoors, avoiding the need for a secondary table. Built-in elements, such as the two-sided fireplace and a monolithic kitchen island bench of concrete and timber, emphasise the lean interior space, where not much is required in the way of extras. This sense of retreat is also enhanced by the planning, with a storage area secreted in the deep wall adjacent to the recessed window in the living area for books and games. Curtains are also hidden in this space and can be brought into play should the sun glare or additional privacy be needed.

'We also consider the management of future views,' says de Meuron. To the west there is a garden, but in time it might become built up and the owners can at least partially screen it with a curtain.

'The house is robust and the materials will weather with time, improving as green moss grows and the concrete blackens and gains character.'

JÉRÔME DE MEURON

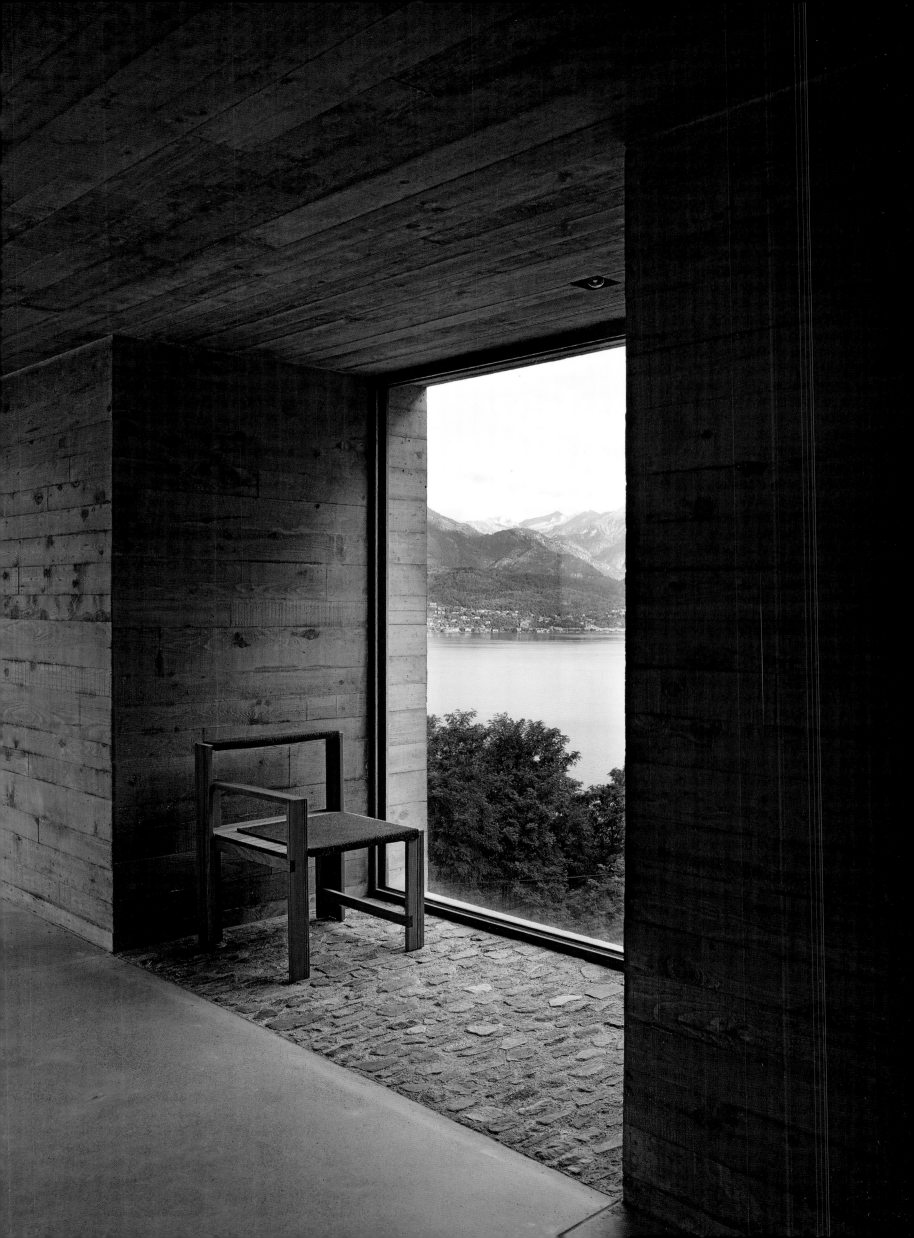

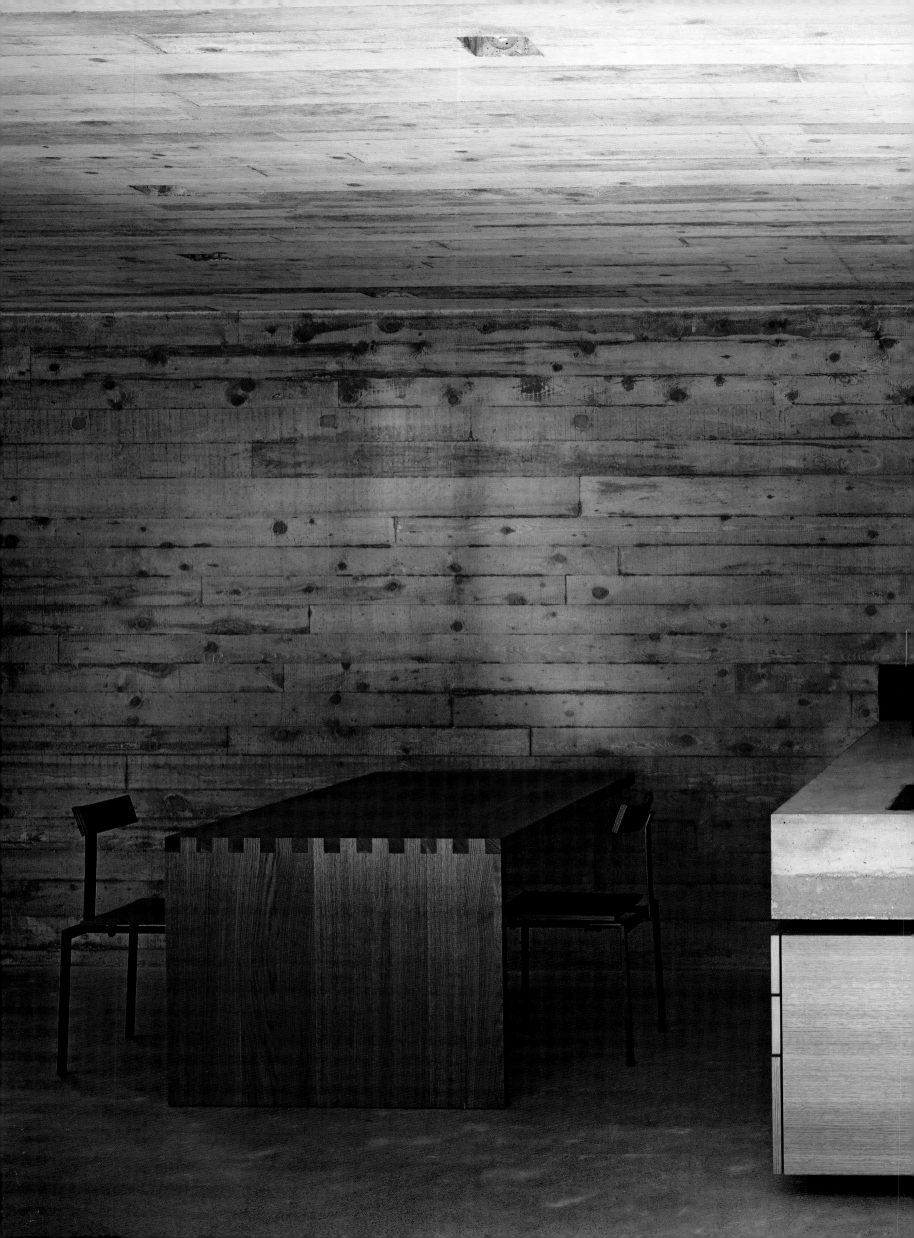

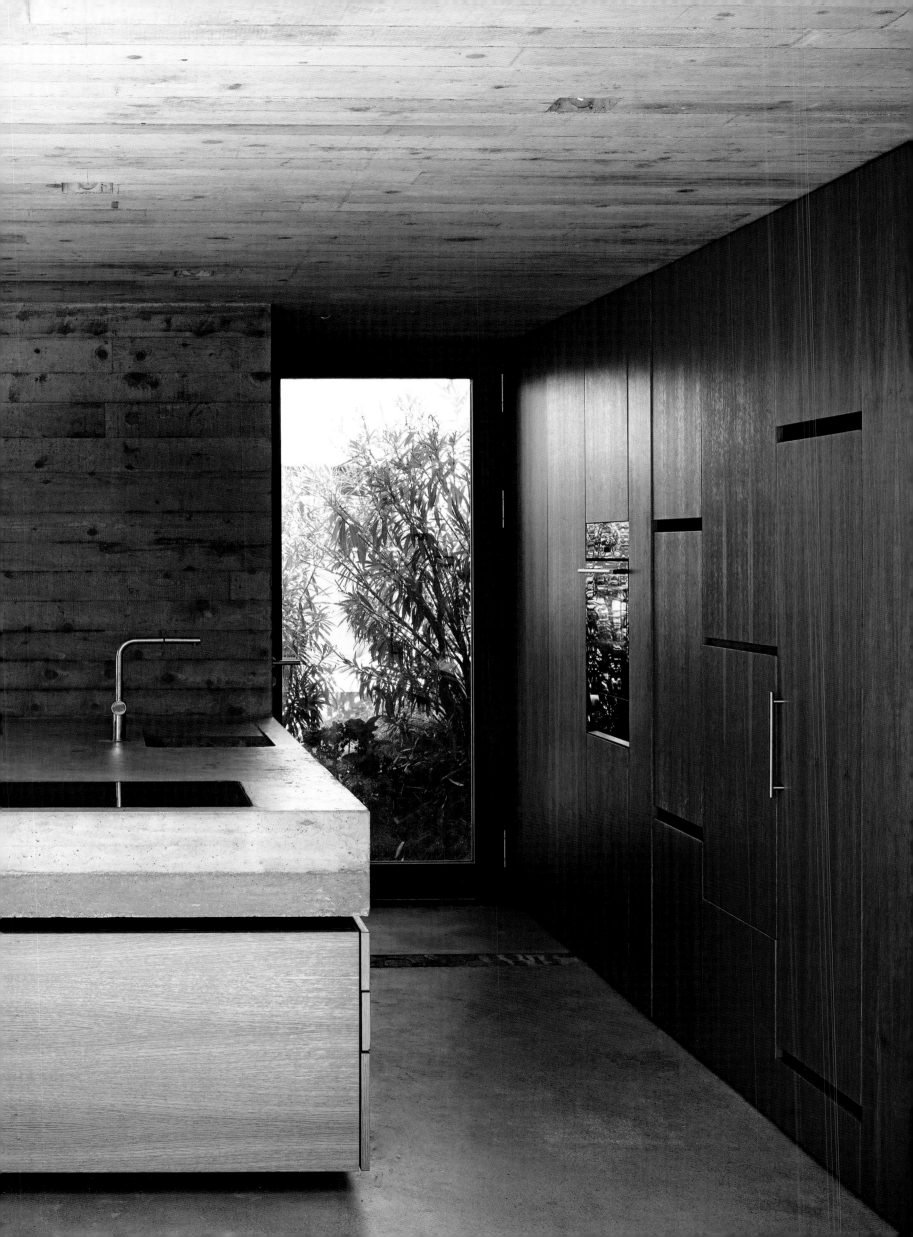

There was a lot of discussion with the clients about how they wanted to live. They looked at other Wespi de Meuron Romeo houses, responding to what they liked and didn't like, but ultimately trusting the process. Much of the fluidity of the house comes from their requests. The access to the courtyard is via three enormous sliding glass doors, each 3.5 metres long, which can be configured according to weather. The courtyard is partially covered, making it possible to sit outside even when it is raining. Its flooring of local stone echoes the vernacular Swiss buildings in the area. Pebbles run around its circumference, creating another subtle change in texture and denoting the movement from indoors to out.

A crucial consideration for the architects was orientation for sunlight. The house faces northwest and so needed to open up to the light from the south via the courtyard. 'It was important to have two sides to the house – the view and the sun,' says de Meuron. 'We changed the direction of the openings so that the house becomes animated and warmed by the sun.'

It is a house that closes up in winter, the centrally positioned fire heating the main living room, and underfloor heating warming the rest of the house. In summer it can completely open up to the outdoor experience. This sensation can be experienced to its fullest in the rooftop garden, accessed via narrow white concrete steps ascending to the most thrilling and expansive view. The oak boards have weathered to a muted grey and meld with the off-form concrete, as does the low planting in a soft green/grey shade. The strong horizontal of the roof, with a glass wall divider that is almost invisible, ensures the experience of the setting is unimpeded. This perspective also reveals how the building balances solidity with meaningful voids that allow light to penetrate the body of the house.

At 148 square metres, the house is modest, with ceiling heights in the lower two floors conforming to the Swiss minimum of 2.3 metres (the upper floor is 2.4 metres). Hence, it is in the choice of materials, the manner of their use and the links to exterior space that creates the sense of expansiveness. Externally, the house is monumental and sculptural, yet the internal spaces are full of warmth and character, respond sensitively to climate and, most importantly, are serene. As de Meuron says, 'It is boring to have houses that just look at nature but don't give anything back. We have carefully integrated this house into the territory and give something back to the landscape.'

There is a constant
play between
controlled spaces
and expansive views.

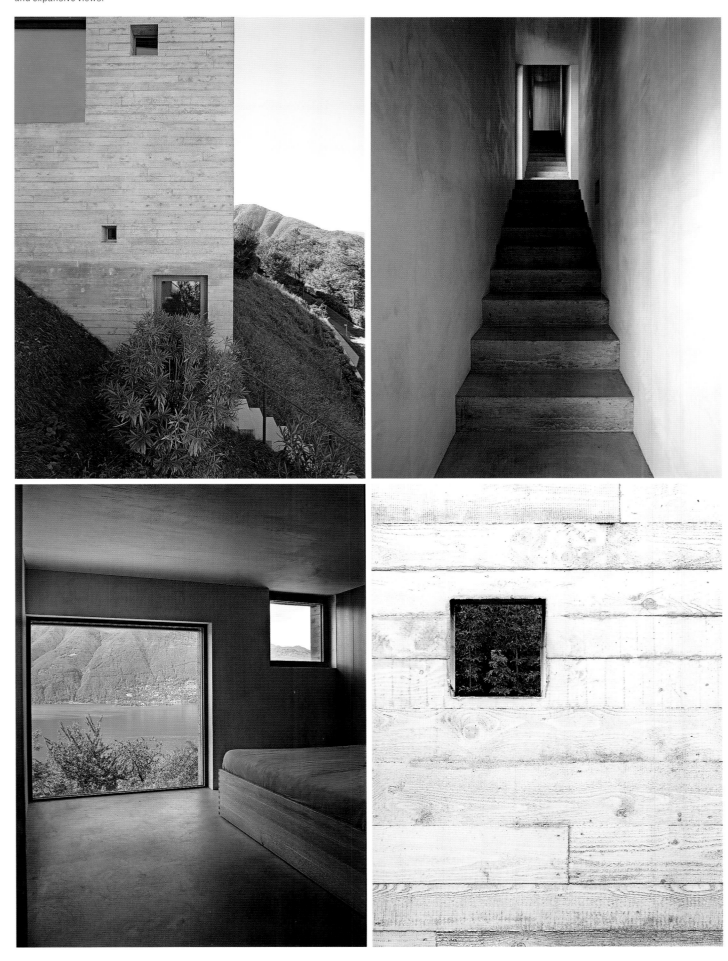

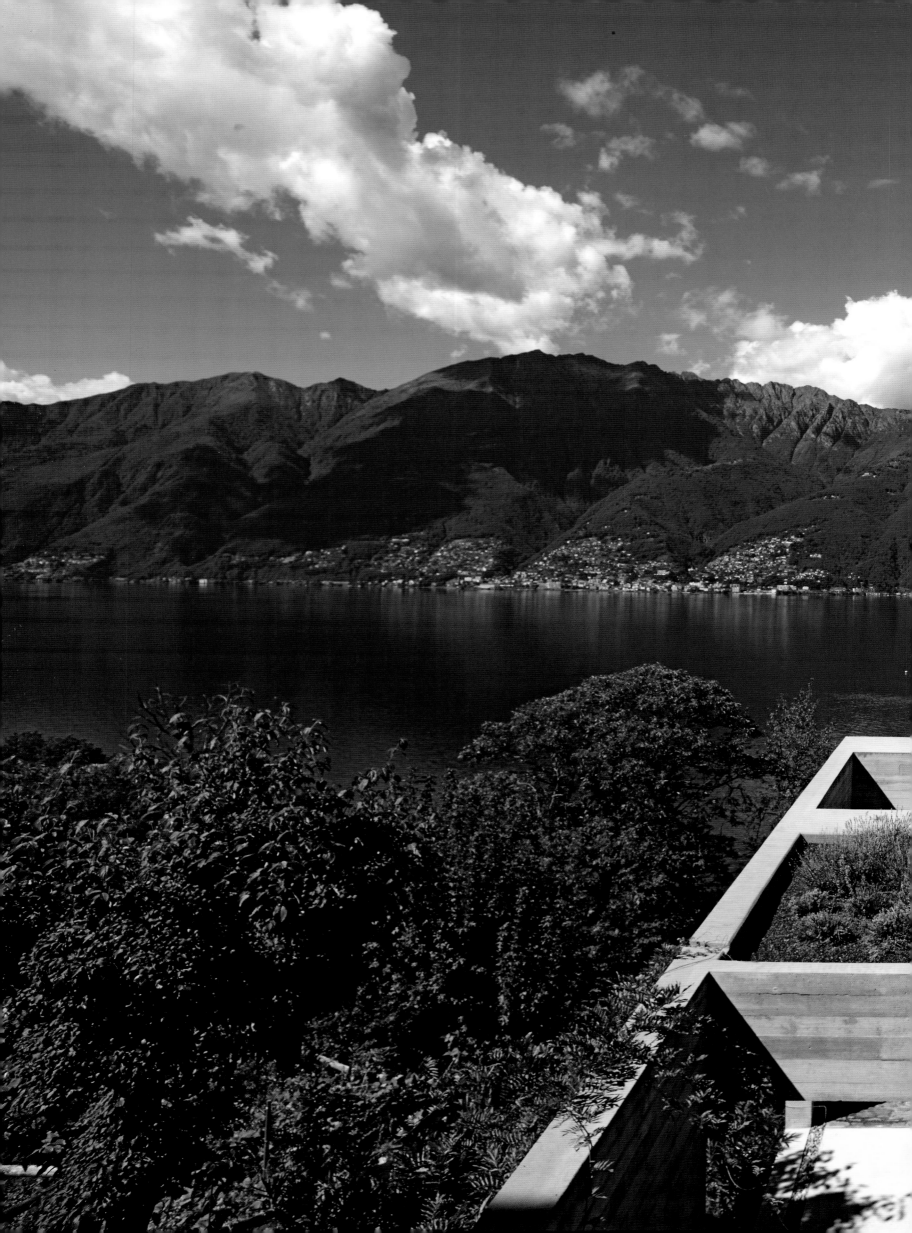

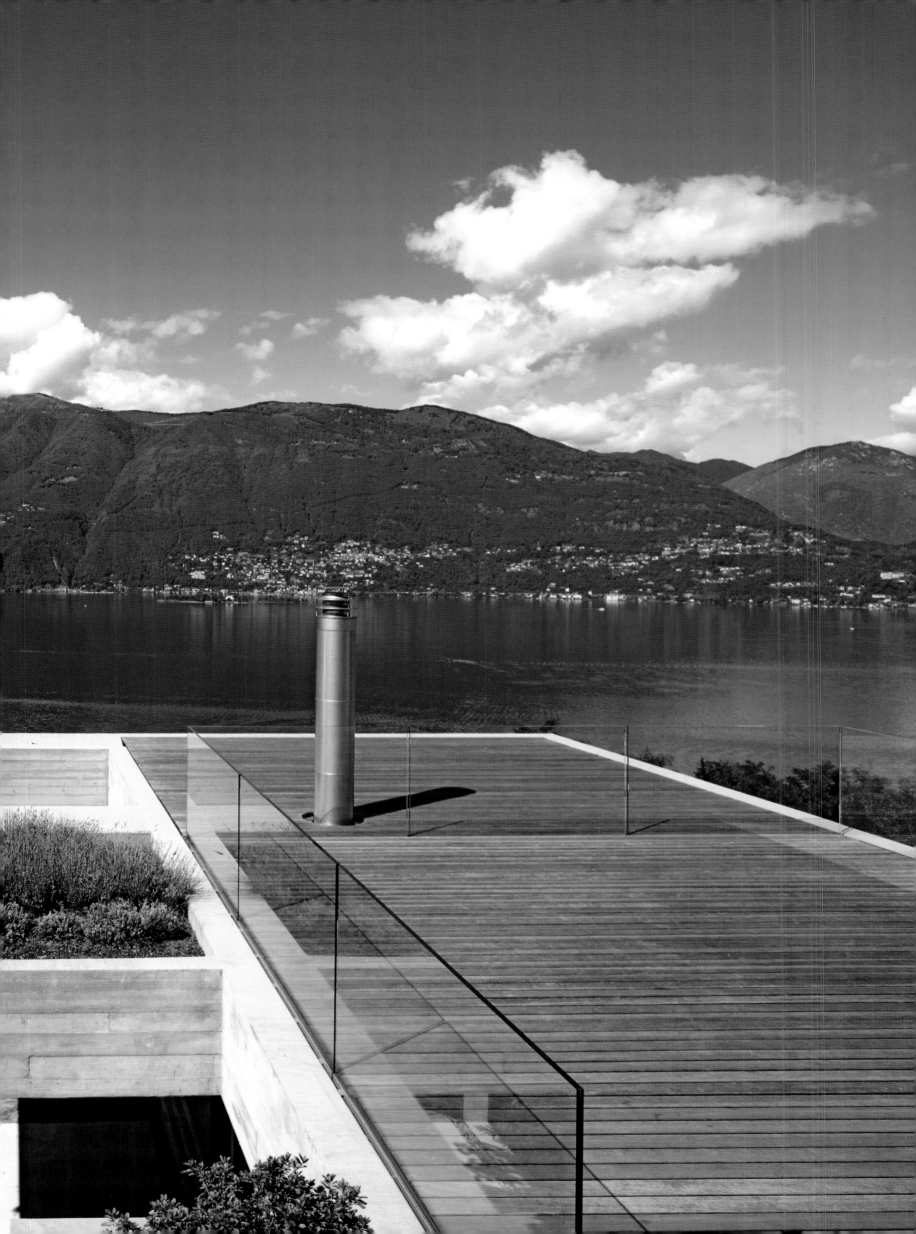

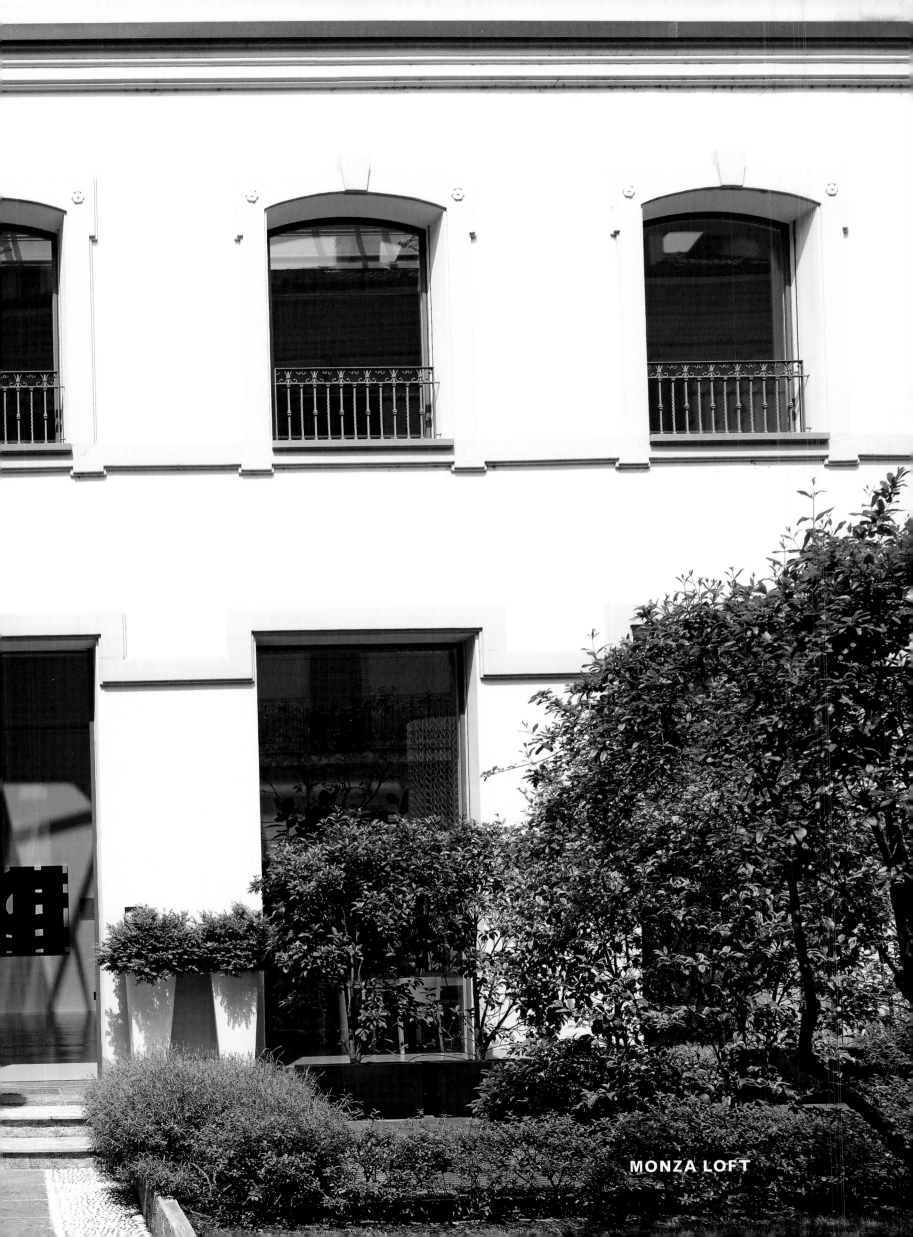

MONZA LOFT

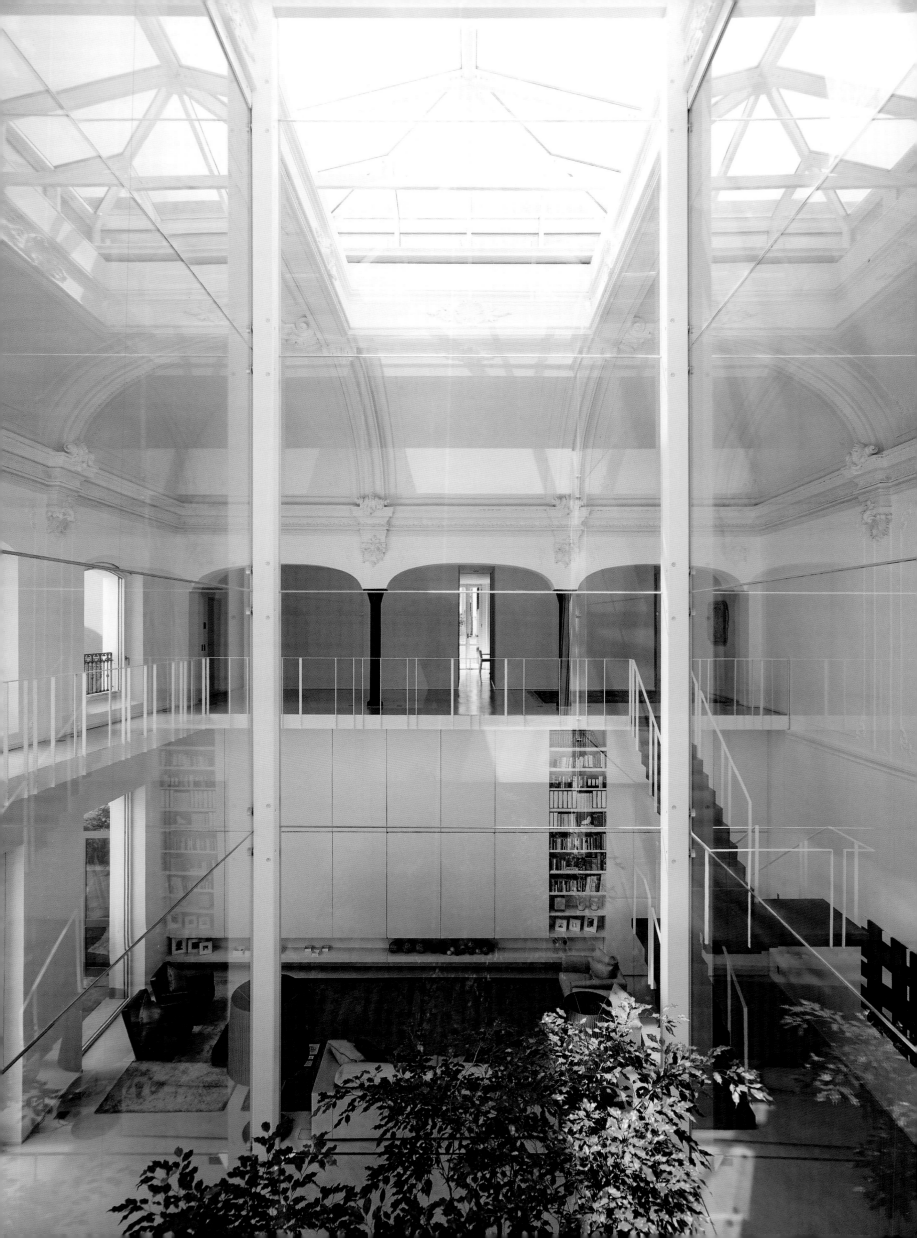

**MONZA LOFT
(2009)**

◇

LISSONI ASSOCIATI

⋈

MONZA, ITALY

'My most special pleasure is when I have to sew, like a tailor, old parts of houses or old buildings and connect them with the new one,' said Piero Lissoni of the Conservatorium hotel, Amsterdam, completed in 2012. In the hotel scheme, a soaring glazed atrium, housing a dramatic Corten steel staircase, abuts the nineteenth-century building that once housed the Sweelinck music conservatorium.

While the Monza loft did not involve an external link, it did require a combination of reverence for the old and an absolute commitment to the new.

For Lissoni's clients it is mandatory that they understand his 360-degree vision as akin to buying a car or a jacket. 'Even with architecture,' he says, 'you choose your model.' He views the idea of 'total design' as part of his Milanese culture. Graphics, art direction, product design and architecture are all part of Lissoni's lexicon, having grown up under the inspirational guidance of Marco Zanuso, Ettore Sottsass, Achille Castiglioni and Vico Magistretti.

He takes this notion further: 'Italian culture is a humanistic one. If we are an architect, we are at the same time a sculptor, a writer, a photographer, a builder and maybe even a poet.' From designing a watch to a piazza, a chair to a yacht, nothing is outside the scope of Lissoni's remit.

Hence his output is prodigious, and to juggle his many and varied commissions, he has two arms to his practice – GraphX for graphics and Lissoni Associati for architectural projects.

Lissoni is a global player with major projects located in Istanbul (Bentley Hotel), Jerusalem (Mamilla Hotel), New York (a residential tower on 5th Avenue) and a hotel in Miami in the wings. In Italy his expertise in navigating complex restoration of Milan's Teatro Nazionale (2005–9) won him many accolades. There is not enough space here to detail Lissoni's product design, but longstanding relationships with Boffi, Cassina, Matteograssi, Living Divani and Porro have ensured his elegant, industrial style is noted the world over.

The Monza Loft is very much a local project. Situated 15 kilometres north of Milan, Monza, while known to the wider world as the home of the Italian Grand Prix, is a city of great historical significance and architectural gravitas and, as such, the project was not without its heritage issues. The building had been designed in the late nineteenth century as a theatre and, over the next century, had a number of incarnations, see-sawing between cinema, bank and theatre and back again. It was up for sale for some time, with one of its limiting factors the logistical problem of creating a second floor in the 12-metre-high space.

When a Milanese family bought it, they turned to Lissoni because of their like-minded approach to design and interiors. Lissoni's scheme is an expansive solution that celebrates

The 12-metre-high space in what was once a theatre demanded an expansive solution.

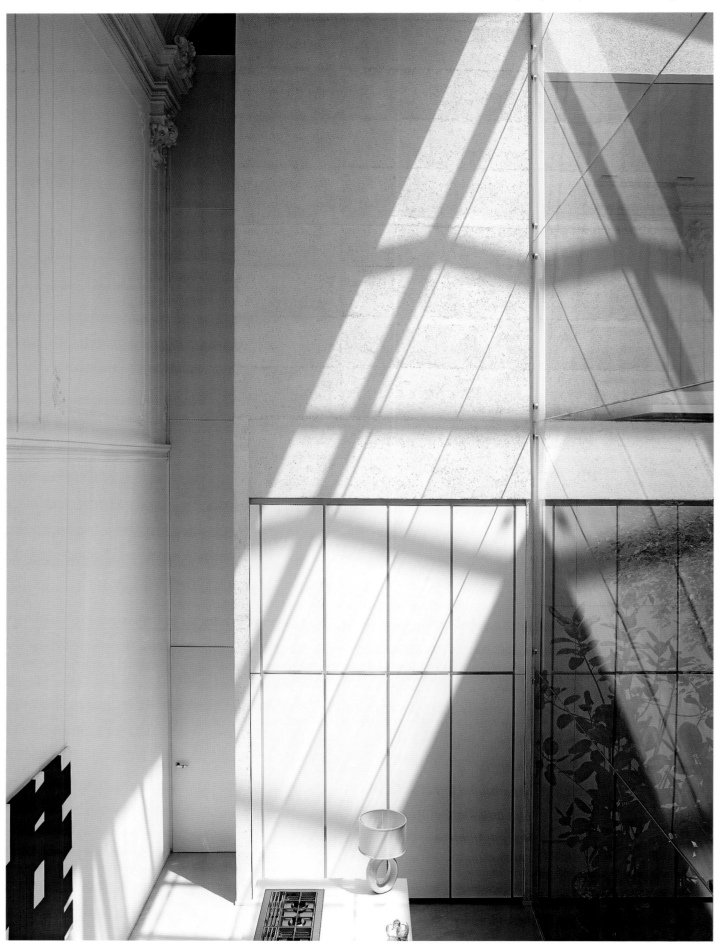

The shafts of light only serve to accentuate the cathedral-like quality of the space.

The large atrium allows for small trees to live right at the heart of the building.

MONZA LOFT —— LISSONI ASSOCIATI

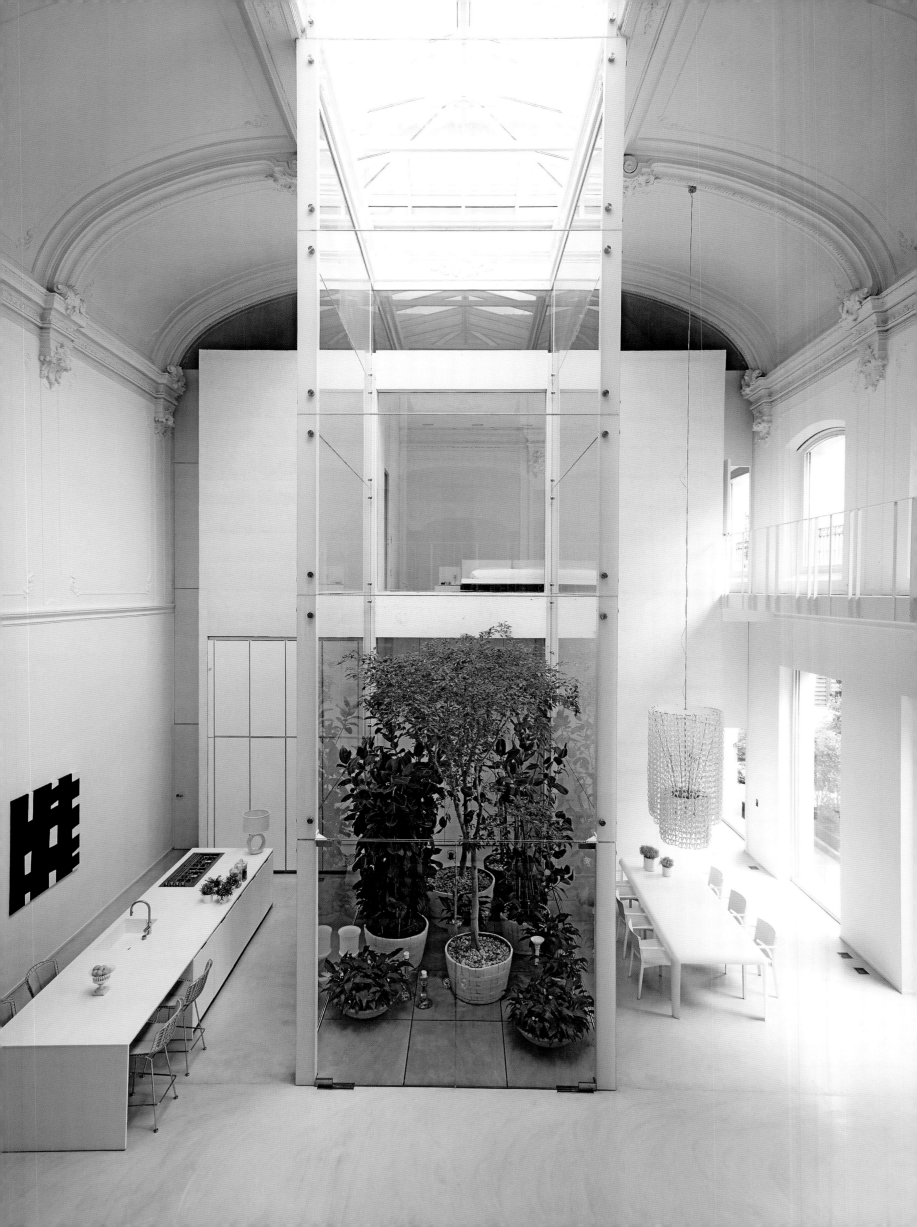

the volume but allows for human-scale and intimate space to be accommodated alongside the soaring ceilings and grandiose architectural gestures of the former theatre. 'It marries the modernity of free-flowing space with something of age and character,' says Lissoni. His skill is in combining the simplicity and purity of a broad-sweep solution with the detailing and precision necessary to deliver an interior treatment of great quality. 'I find that there is satisfaction in doing things, even apparently minor things, with a sense of dignity,' he said.

Often, his clients want to live a contemporary life but with reference to, and reverence for, the history, culture and tradition of the building. Lissoni understands this and brings his finely tuned aesthetic to bear. 'I work like an archaeologist, finding, saving and re-creating.' He shies away from the 'artificial' nature of heavy restoration. 'Some of the stucco was damaged and some we restored lightly but the rest we left as it was,' he says. 'The steel columns had been protected by paper so we just cleaned them and left the wonderful patina.' For Lissoni it is about the fabric of a building, its layers and its character. Strip too much away and its soul is lost.

By way of contrast, the new elements are declared as such. Clear-cut white concrete boxes or 'living containers' (made of white cement and ground marble) are not there to blend but to juxtapose while complementing in terms of proportion, scale and impact. The space inspires awe in a way rarely experienced outside a cathedral or gallery, and Lissoni has affected two radical and dramatic features that enhance this sense. The large atrium allows the building to be filled with light, connecting the interior to the sky, while large-scale plants and small trees, sitting directly below, create a concentration of greenery at the very heart of the space. It serves to bring the outside in; it also visually links with the glimpses of trees and shrubs in the expansive courtyard beyond the bank of three-metre-high windows that run the length of the building's northeast side.

As a former theatre, the space was, in Lissoni's words, 'blind', and after much discussion around heritage issues, he was able to cut those large window openings and link the two spaces in the way of the modern masters he admires – Mies van der Rohe and Le Corbusier. He even designed a window with the express purpose of framing the view of one particular tree.

Almost tangible shafts of light fill the spare space-giving nature a hand in the decoration. When it gets too hot, ingenious computer-controlled nylon fabric screens shade the interior. Ventilation is simple and natural, with through breezes from open windows and a geothermal system for constant temperature control throughout the year.

In contrast to the natural qualities of the atrium and internal garden is the drama and graphic precision of a manmade steel stairway linking the lower and upper levels. It's made from the same steel as the columns, 'a pure mechanical, industrial steel retaining the classic patina straight from the factory', says Lissoni.

Structurally the stairway is, in the architect's words, 'a little bit extreme', with the clients nervous to use it initially because of its 'trampoline effect'. It is however a defining feature of the space, bold and uncompromising, a piece of modernist sculpture in its gallery-like context. 'When Lissoni began taking on architectural projects, it was precisely this kind of lush, elegant, sensuous modernity that he set out to create in his interiors and buildings,' said architectural critic Deyan Sudjic.

The elemental luxury that defines Lissoni's aesthetic is evident in the generous division of space. The master bedroom, with its enormous ovoid bath, and ensuite, with vertical mirrored strips that enhance the height, are sparely but completely equipped. There is no need for extraneous lights or

'Italian culture is
a humanistic one.
If we are an architect,
we are at the same time
a sculptor, a writer,
a photographer, a builder
and maybe even a poet.'

PIERO LISSONI

The mix of texture,
from the woven light
to the high sheen
tabletop, creates
subtle interactions.

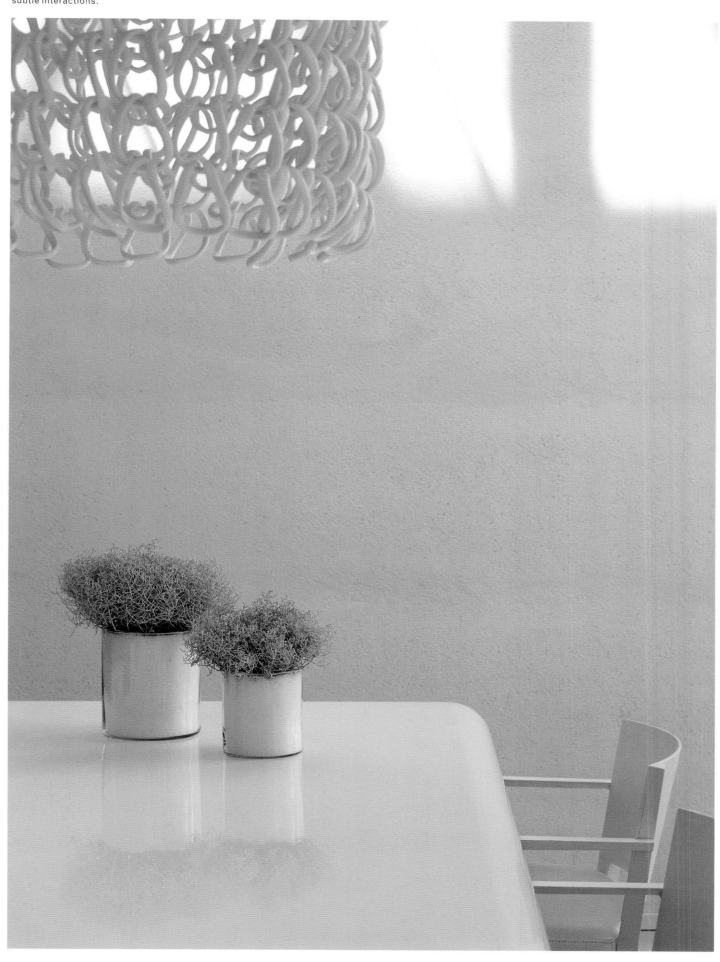

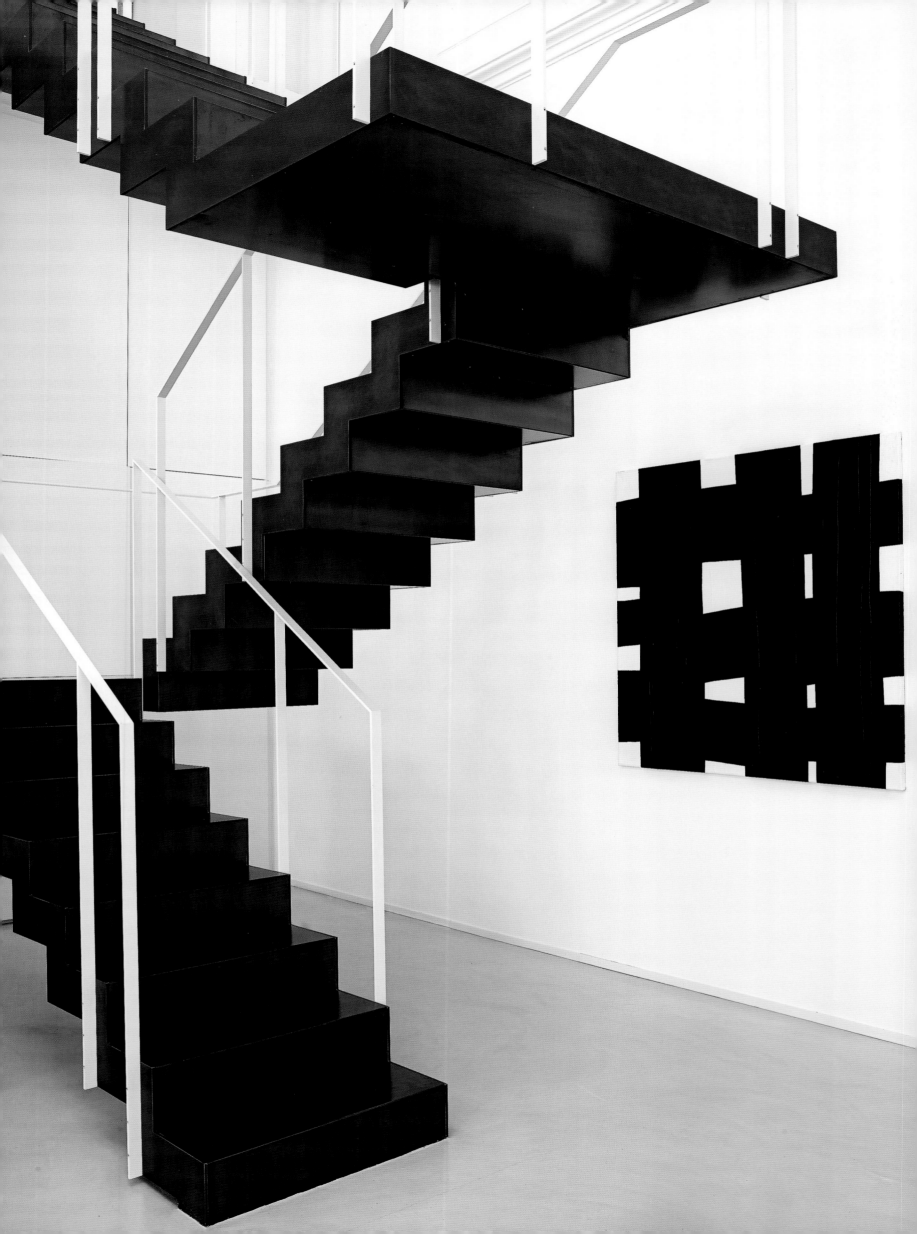

One of the defining features of the space is the industrial steel staircase.

A bank of new three-metre-high windows runs the length of the building.

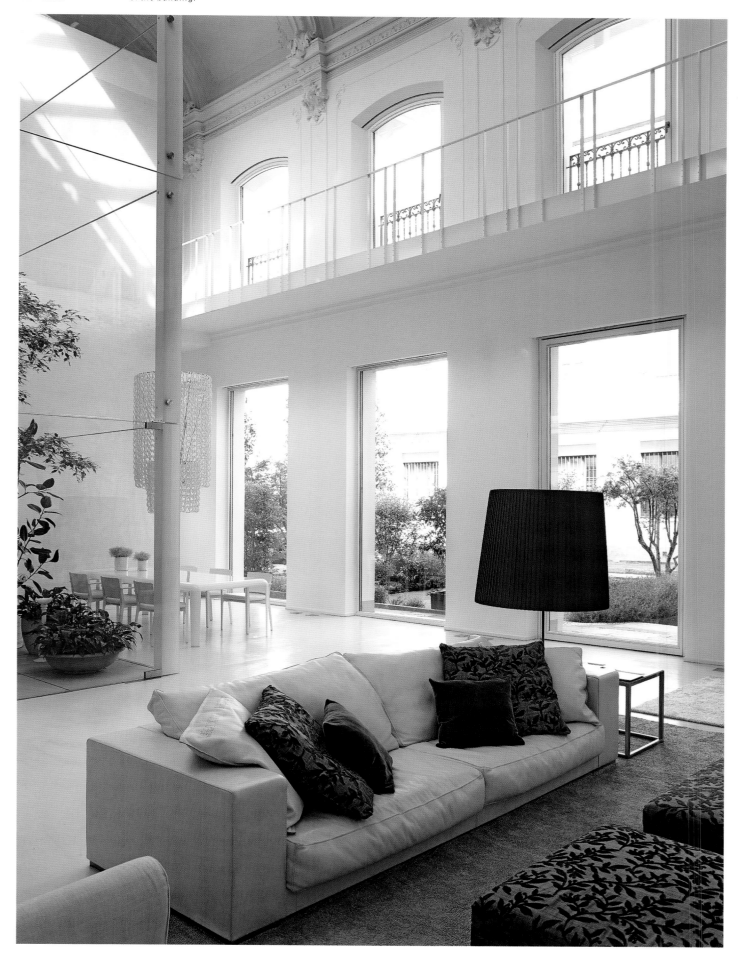

Lissoni's ability
to knit together
old and new parts
of a building is
illustrated by clear-
cut concrete boxes.

furniture – it is a bespoke fit-out with everything considered. Even the table by Porro is not off the peg but modified to perfectly suit the proportions of the dining area which is, of course, highlighted by the remarkable Lissoni-designed fibreglass light.

It is a space of many fluid perspectives that can change radically. 'You have to surprise people, move two steps and the space changes completely: some views are airy and some are cocooning,' says Lissoni. The mezzanine is a poetic trick, a stage trick – a design to create a faster connection between the two ends of the building, but without any other utility. Interestingly, it looks as though it has always been there.

And this is the skill of Lissoni – it all appears completely effortless. Like a champion skier, he operates with ease, confidence and aplomb, and nowhere more so than the Monza Loft. With a degree of self-awareness he says, 'To be simple, I think, is quite complex ... complexity is the private face of simplicity.'

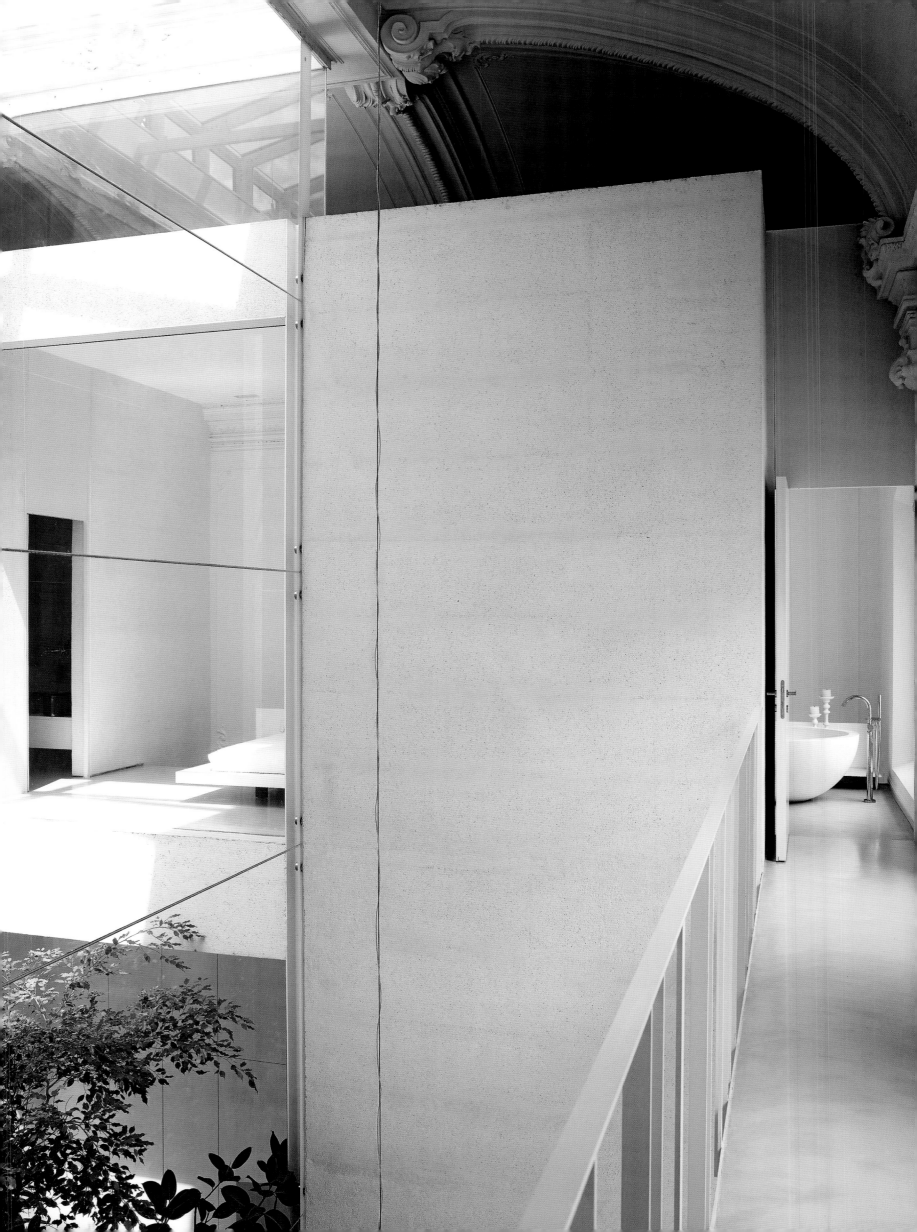

The large ovoid bath is an extremely confident modern statement in the Monza Loft.

The architect's approach is to save rather than completely restore original details.

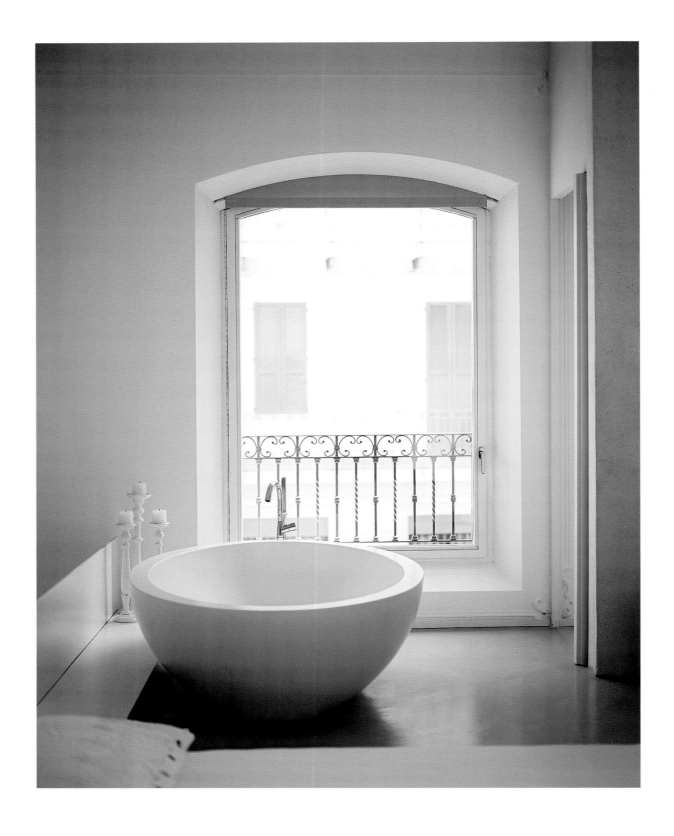

MONZA LOFT —— LISSONI ASSOCIATI

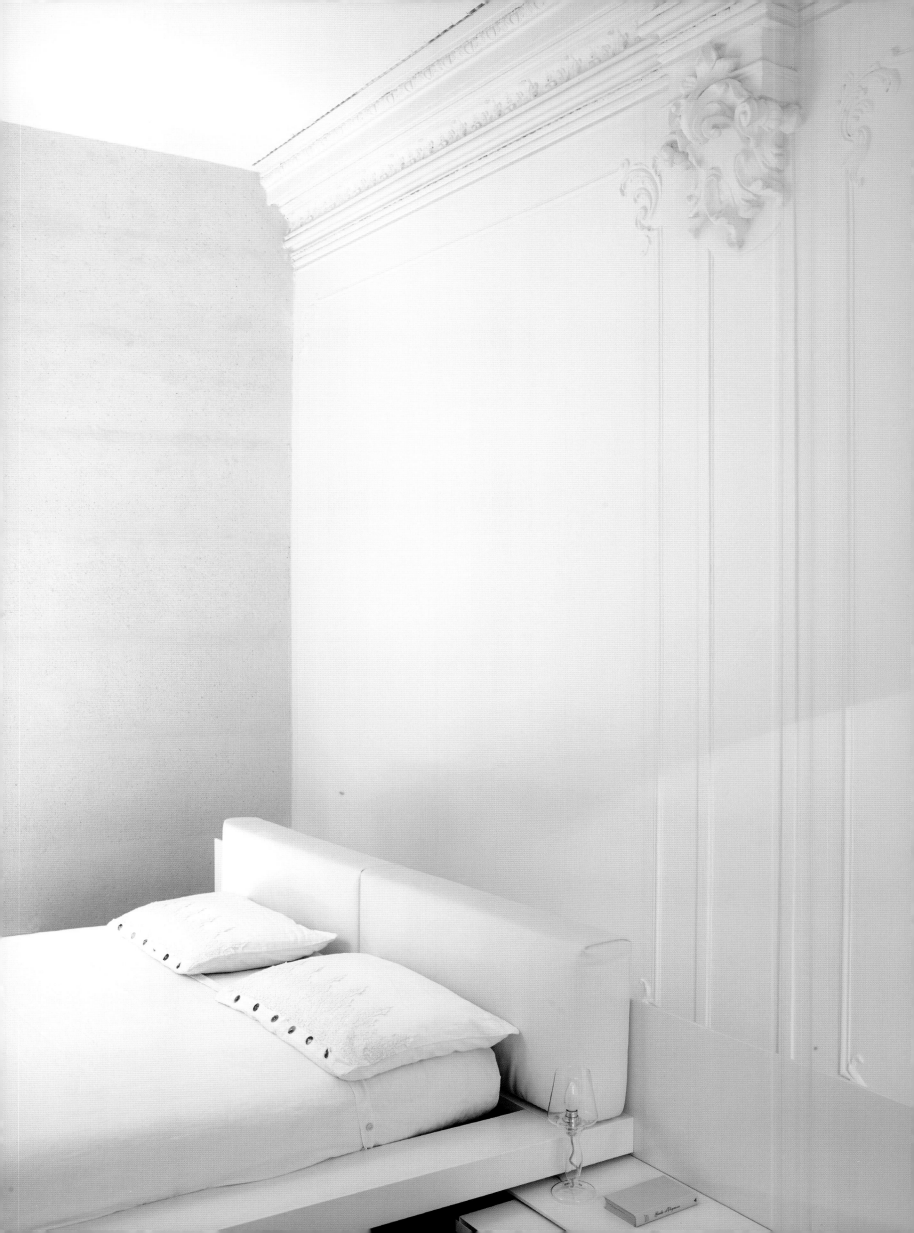

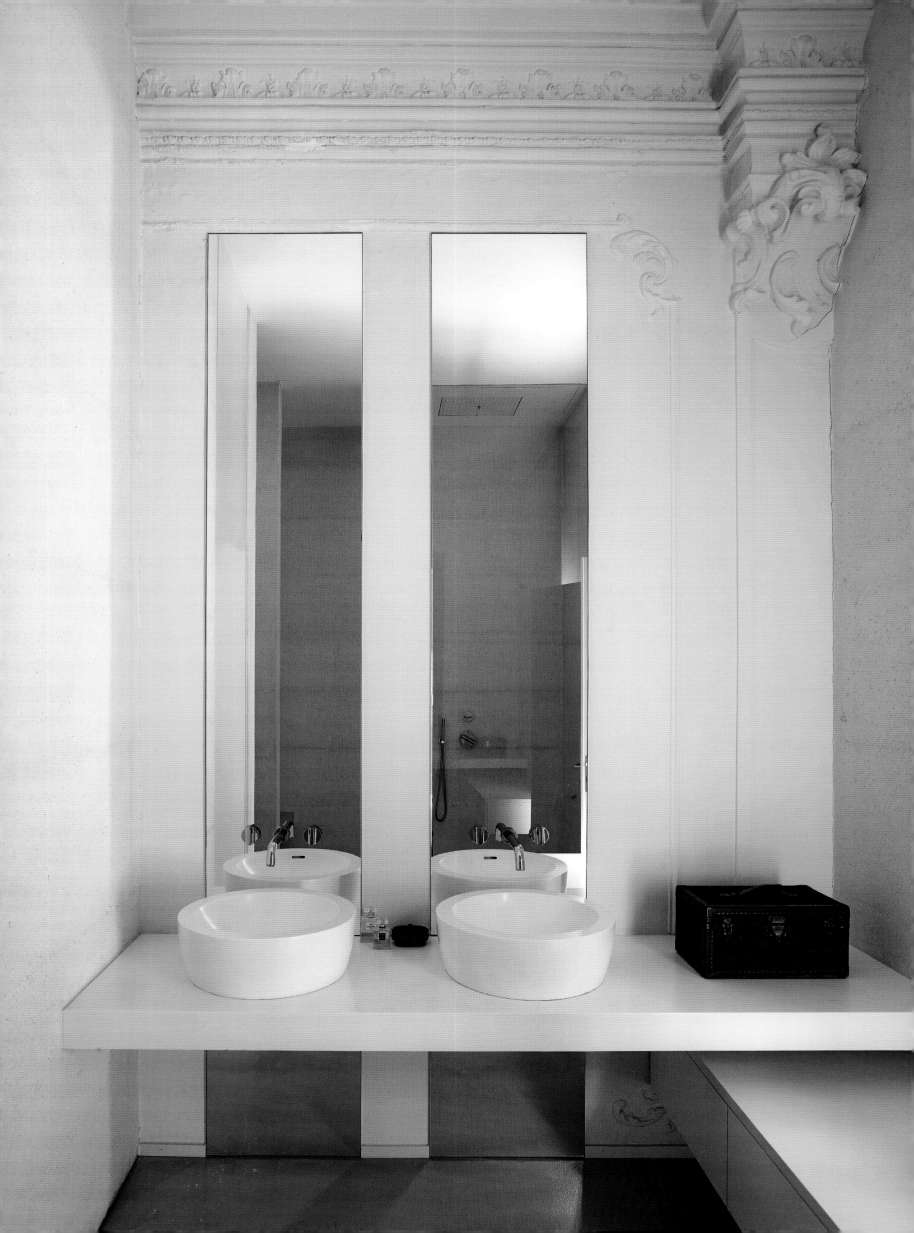

Elongated mirrors emphasise the luxury of height, space and light in the Monza Loft.

The warm patina of the original steel columns has been retained through careful handling.

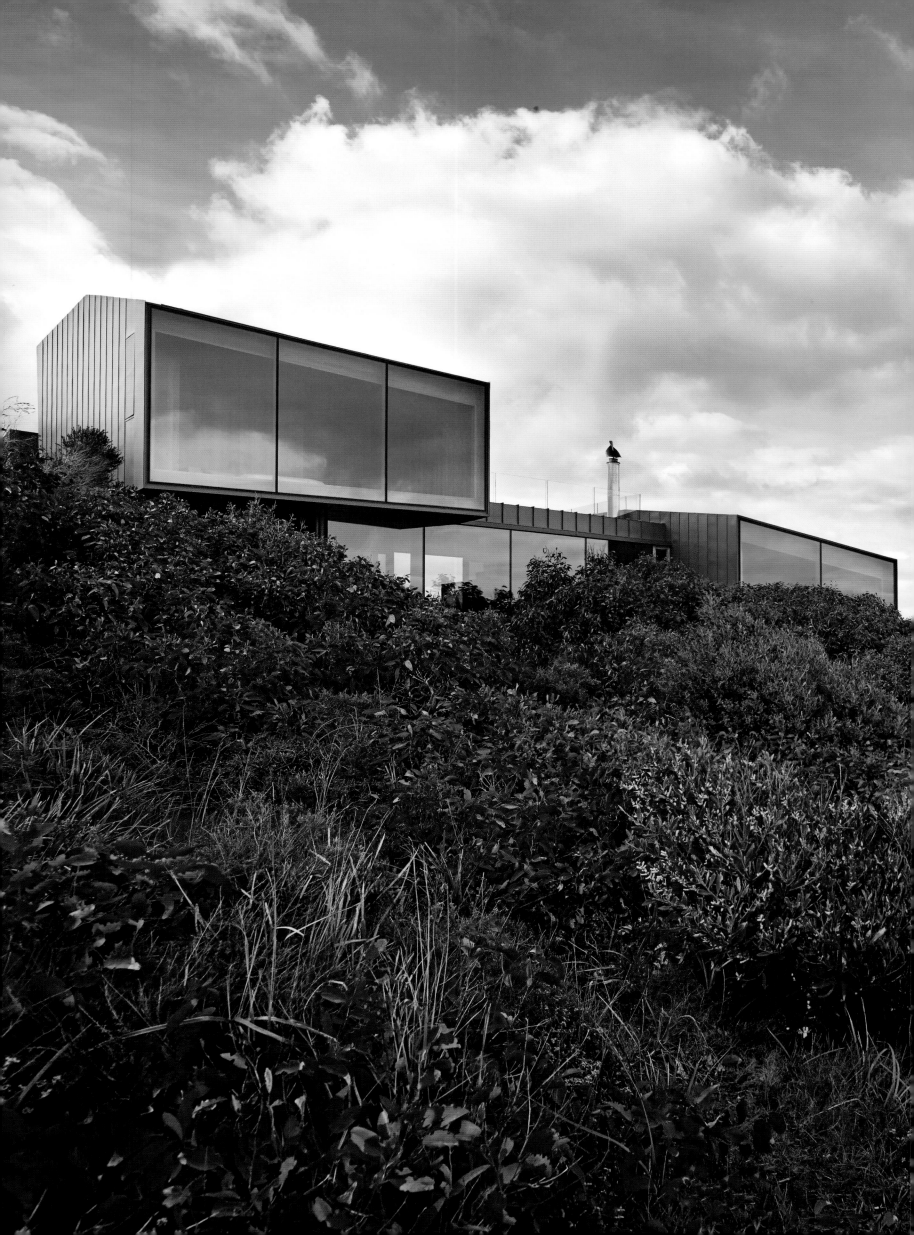

FAIRHAVEN BEACH HOUSE

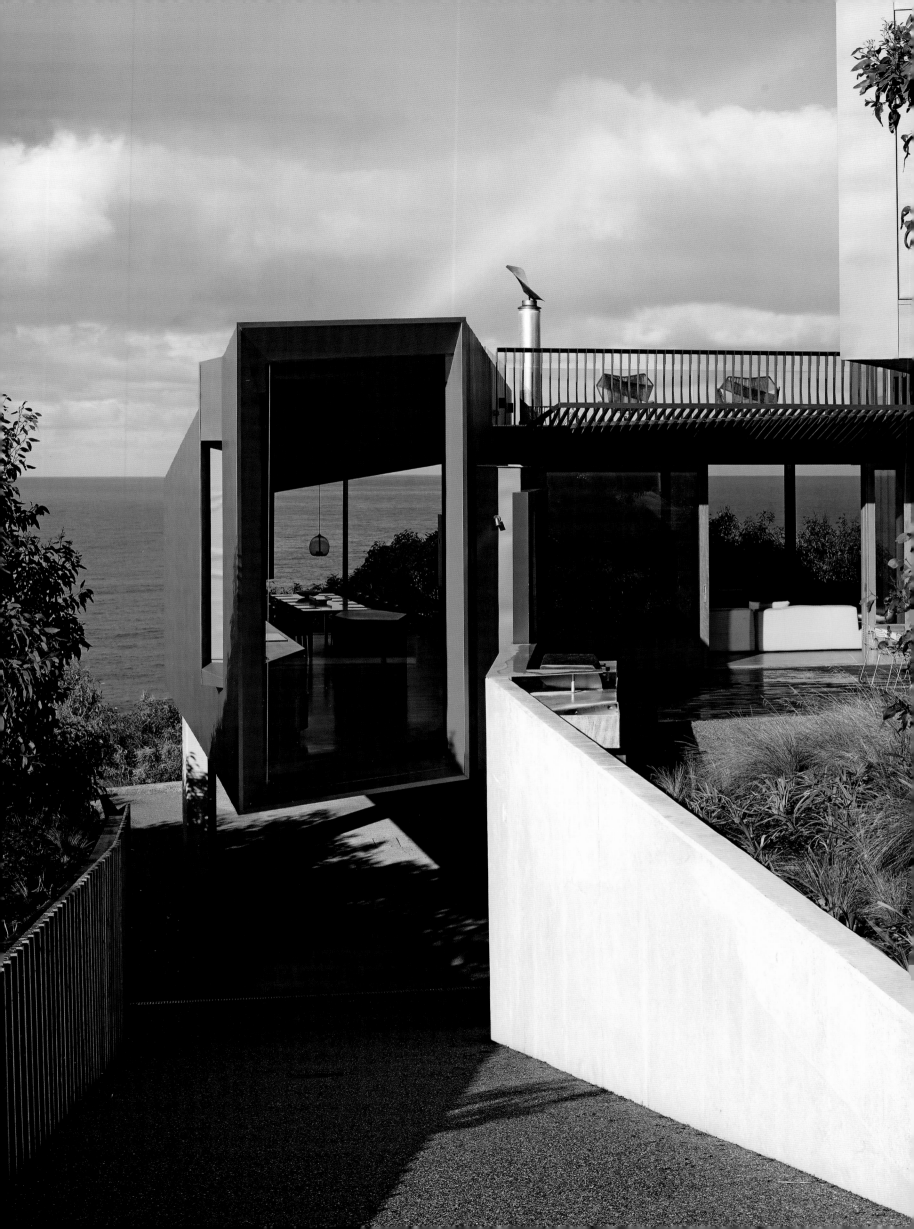

**FAIRHAVEN BEACH HOUSE
(2012)**

◇

JOHN WARDLE ARCHITECTS

⋈

**FAIRHAVEN,
VICTORIA, AUSTRALIA**

The Fairhaven Beach House is described by John Wardle Architects as nimble, which was, I thought, a strange word for a house. But when I ask Wardle to explain his description, it turns out to be entirely appropriate.

It is built on a remarkable ridge of land above the Great Ocean Road on the Victorian coastline and Wardle was determined to accord with good planning policy so that when looking at the house from the road, or the surf beach below, it would not break the silhouette of the hillside behind it. 'We had to exercise a great deal of effort as we pushed and twisted the forms, contorting volumes, both inserting down into the earth and pulling up and across various contours,' says Wardle. 'We distorted the five main chambers until the house eventually complied with this important landform that rears up above the ocean.'

Not only did he tailor the form, but the palette of materials used for the house is very much taken from the indigenous trees, plants, scrub and orange and yellow fungi found on the site. Wardle was conscious of creating a controlled and relevant material mix, and so chose to clad the building in a green/grey zinc sheet and to line the entire interior with blackbutt, an Australian hardwood. Bolts of colour reflecting the fungi and the intensity of the sky are introduced in slices – the surprise of a bright orange cupboard interior; a B&B Italia Patricia Urquiola–designed sofa in deep yellow; custom-made joinery in the bedrooms and en suite in aqua blue. These jewel-like flashes are characteristic of Wardle's playful spirit and provide a counterpoint to the sense of warm enclosure a completely timber-lined space creates.

One of the key elements in designing a house on the southern coast of Australia is that the views are to the south while the sun is to the north. Mindful of this, Wardle set about 'choreographing the volumes into a series of conduits that draw in northern sun, harness the experience of the house and thrust out to a series of composed view lines to the world beyond'. Hence the capture of light from the north for warmth and for its visual play with shadow, plus the controlled consideration of the view, are key drivers for the house plan. 'The logic is not to deliver one big panoramic view all at once but to carve it up in order to appreciate different perspectives – that of foliage, the sea, the sky – from various parts of the house.'

To that end, Wardle never designs an exterior deck between the living space and the view, as he claims, rightly, the only things you see are outdoor furniture and balustrades. Neither does he approve of the visual domination of televisions, and while this house has two – one in the living room and one in the bedroom – they are cunningly hidden in the ceiling. Outdoor space is important, especially in a house by the beach, where the experience is not confined to merely

From the street, the Fairhaven Beach House is at its most transparent, with views through to the ocean.

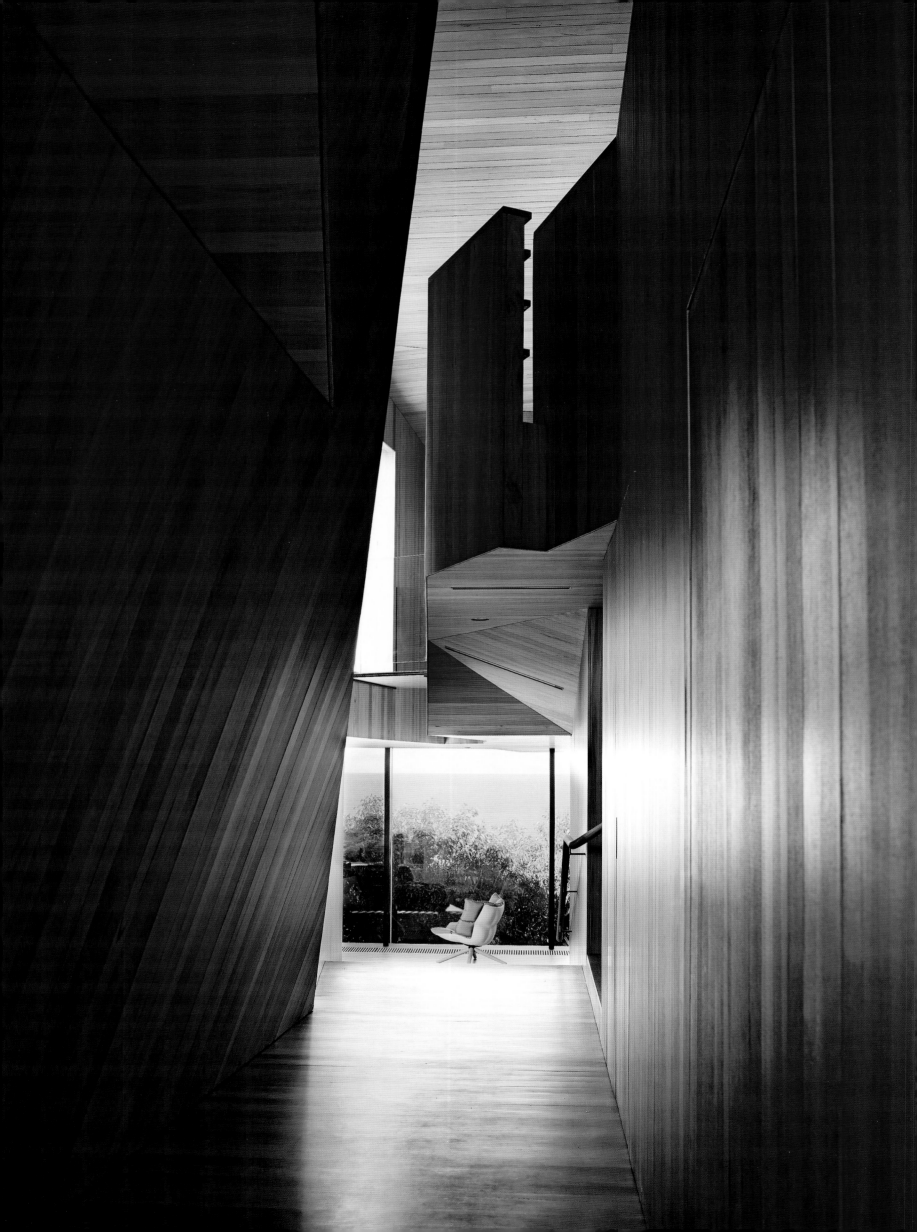

The entrance
showcases
the intricate
joinery fashioned
in Australian
hardwood.

John Wardle often
custom designs
a piece of furniture
for his houses.
In this case, it was
the coffee table.

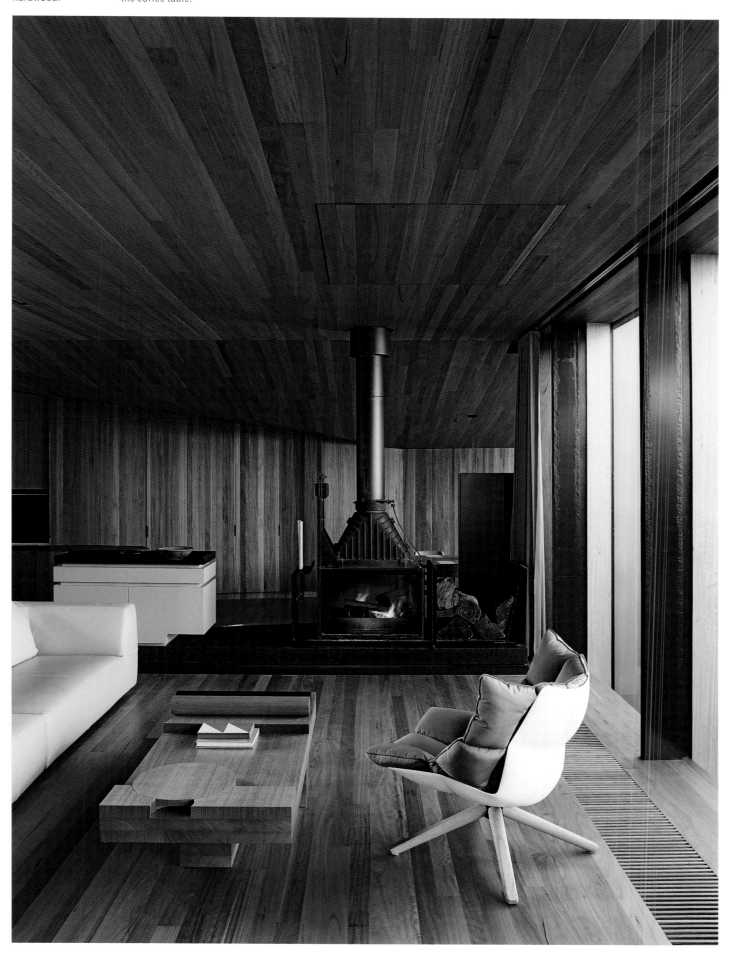

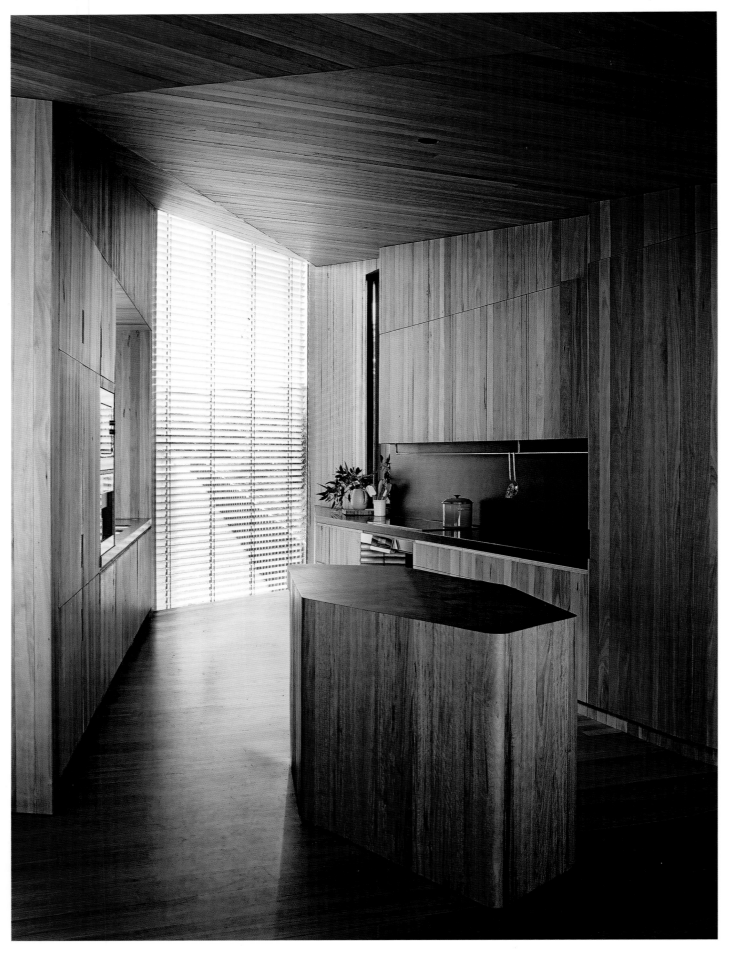

Distinctive design touches are evident throughout the house in bespoke furniture, even in the kitchen.

Absence of extraneous detail allows the experience of the view to take hero position.

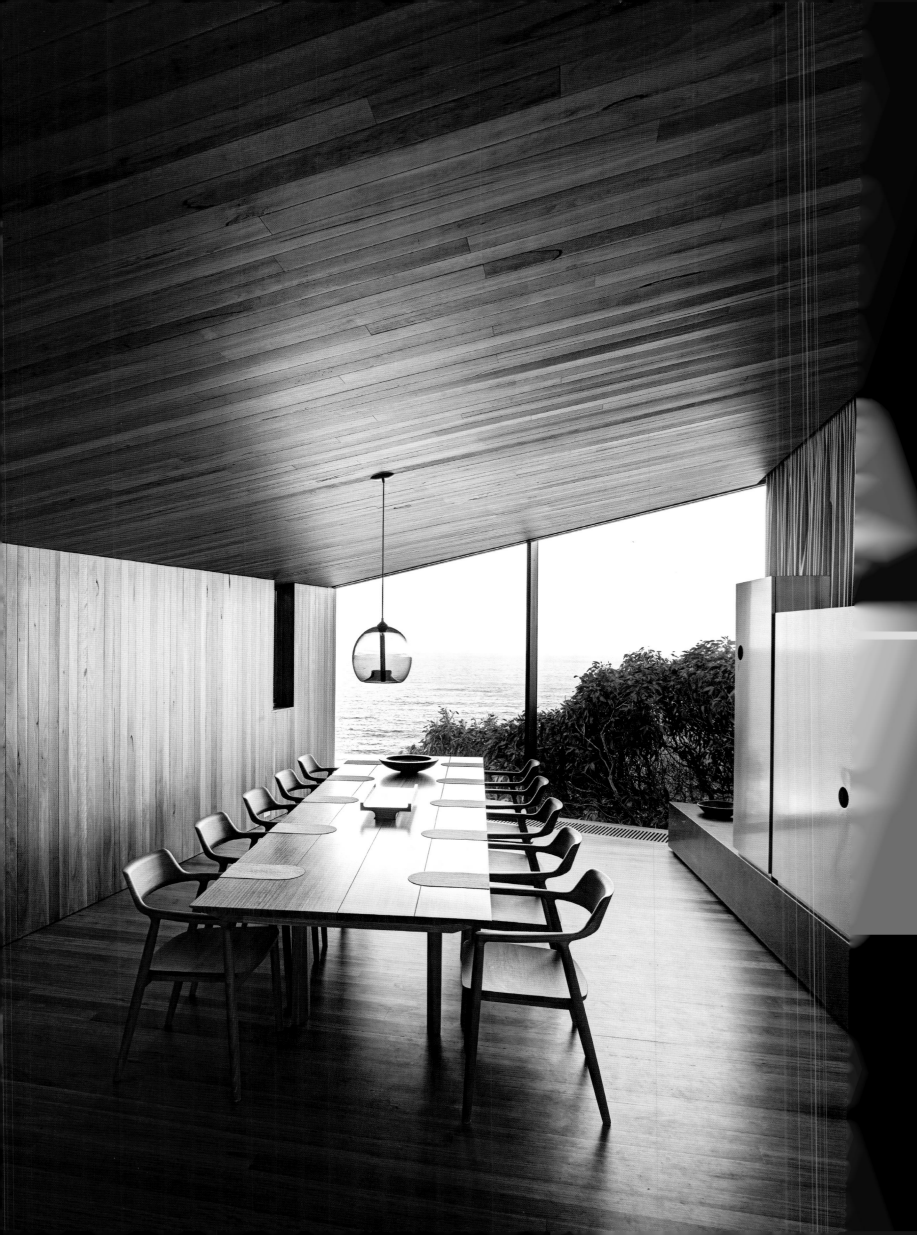

Timber seating
off the main
living area has
a crafted Japanese
simplicity that
links meaningfully
with the bush.

observing the outlook. The north-facing courtyard is walled on three sides to give protection from prevailing winds and screened from the street by dense vegetation. There is also a roof terrace adjacent to the master bedroom, facing the view, as well as a charming, contemplative outdoor seating area off the main living space, hidden behind a heavy fabric wall, which engages with the bush setting.

This in-built flexibility in terms of usage allows for sociability and informality, as a large sliding window wall in the kitchen opens up to create a bar, and links the indoors with the outdoor barbecue area. There is also the option of complete privacy in either of the other two outdoor spaces.

Wardle has an uncanny ability to extract from his clients how they want to live ('A teasing out of stories', he calls it) and interprets that information as a three-dimensional space. He seeks understanding at a very fundamental level – to get inside their heads. So while on the surface the brief might be for a three-bedroom weekender with the long-term potential to be lived in full time, he is deeply interested in the subtext. Wardle thinks first in sketch form, working and reworking, seeking the right line to define the design. His initial drawings are poetic, resembling a densely lined artwork that squeezes here, extrudes there, is pulled and pushed and elongated. But with a complex plan, as in this instance, based on five conduits and eight levels of contorting relationships, and timber that twists and folds like an origami napkin, did the clients really understand what they were getting?

'Clients who are willing to extend a bridge of trust are very important to our practice,' says Wardle. 'We produced a number of rendered images and models to show various aspects and elevations.' Paul Carter, in his essay 'Exaggeration – the Ethics of John Wardle's Design', writes of 'the see-saw relationship between the fixity of the model and the multiplication of viewpoints, and through lines, drawn on and into it'. He also notes that not only are there functional working models that help design resolution but also 'three-dimensional storyboards bearing the history of thinking'. Wardle admits to avoiding 'early clarity' and favours the philosophy of 'stretching design time' to allow for the development and exploration of ideas.

'The logic is not to deliver one big panoramic view all at once but to carve it up in order to appreciate different perspectives – that of foliage, the sea, the sky – from various parts of the house.'

JOHN WARDLE

Even through that process, the house managed to deliver some surprises, and I suspect the owners would have felt cheated if the outcome had been otherwise. Wardle's track record reveals a history of personal houses in which, in each instance, he has produced an intuitive design response. The Vineyard House (2001–04), grounded by its rammed earth walls and the analogy for grafting exploited throughout the concept; the City Hill House (2001–04), with its curtain wall of glass and exquisitely controlled view lines; the Diamond Bay House (2001–05), for two artists whose admiration for the National Gallery of Victoria's iconic arch resulted in it becoming a defining feature of their house. And so on it goes with Wardle, taking the notion of bespoke to a new level and applying his endless, inventive logic.

'As if a folded sheet of zinc has been carefully wrapped around an imaginary tree, this house redefines the art of fold, yet it is remarkably calm and seemingly modest in its geometric expression of house-as-origami,' said the Australian Institute of Architects jury when giving it a state award for residential architecture in 2013. Later the same year, it received the Robin Boyd Award for Residential Architecture at the national awards.

From the street the house is hard to read and the external complexity belies an internal simplicity in the planning and flow of the spaces. 'Our work strives to be uneven in the experience created,' says Wardle. 'Our endeavour has always been to create contrast within each project.'

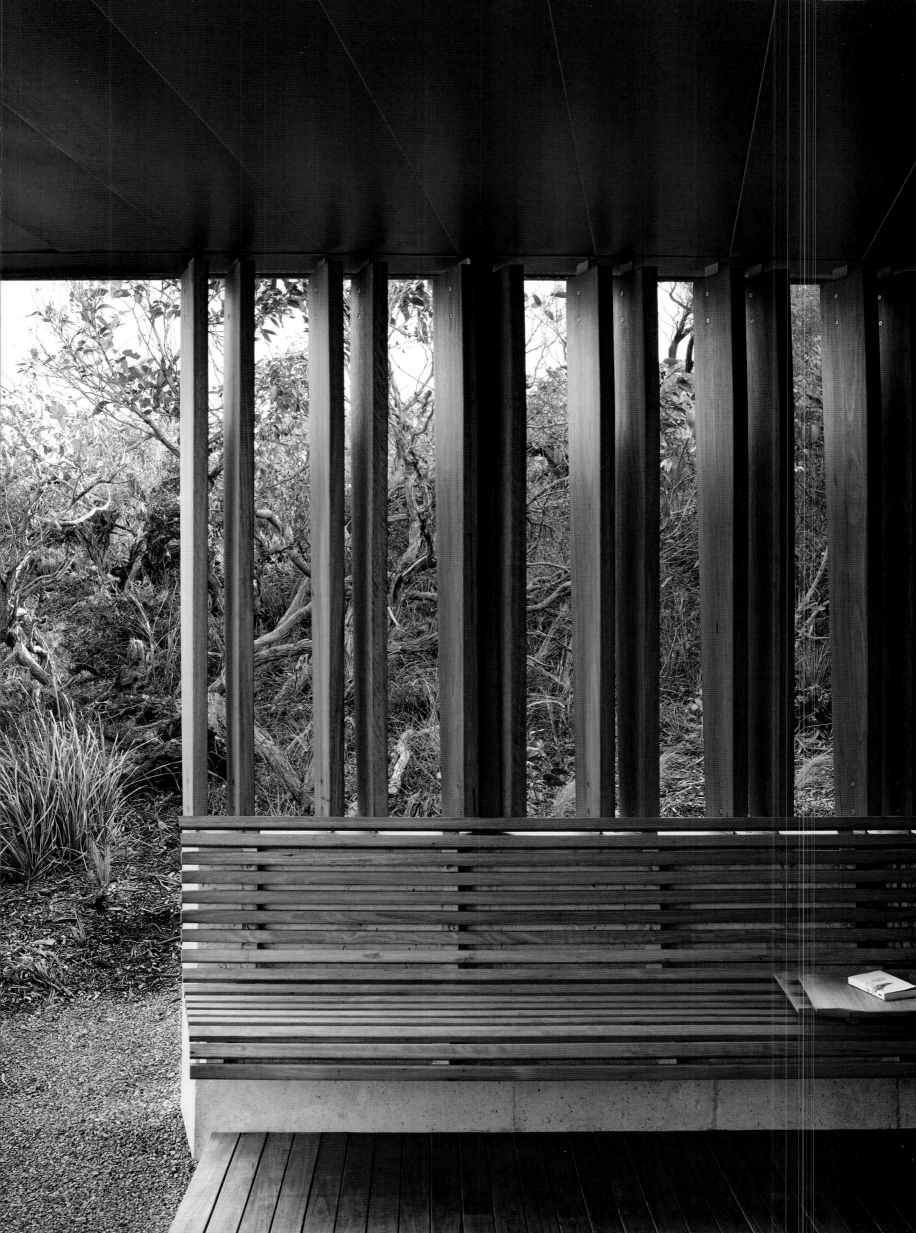

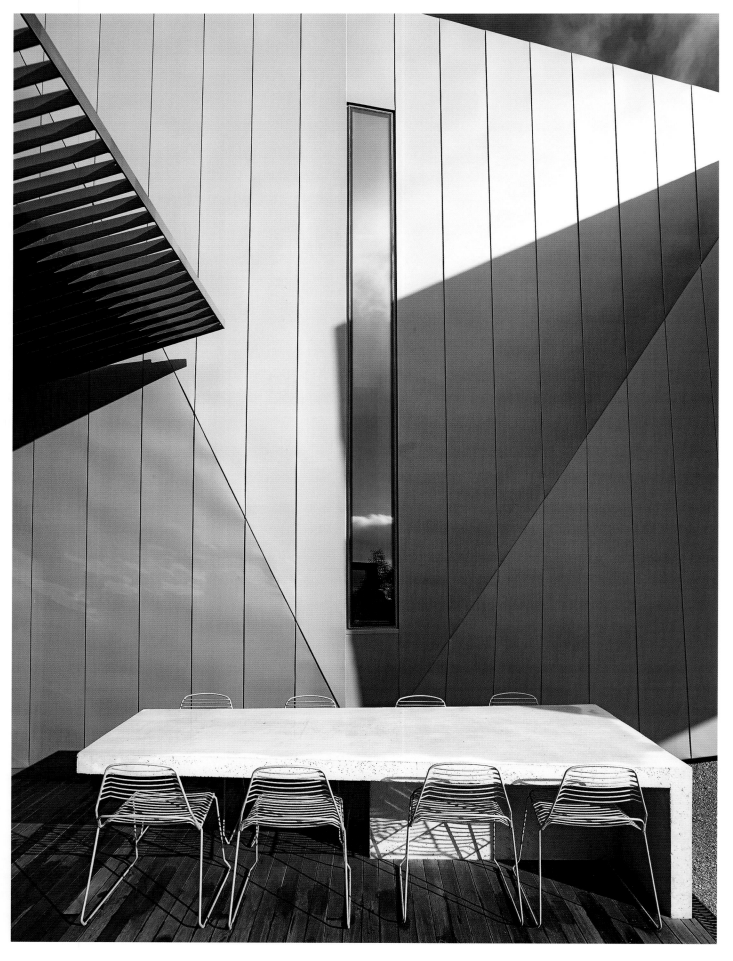

The courtyard faces north and is sheltered from the weather on three of its sides.

Ingeniously, the window slides back to create a bar, and links indoors and outdoors.

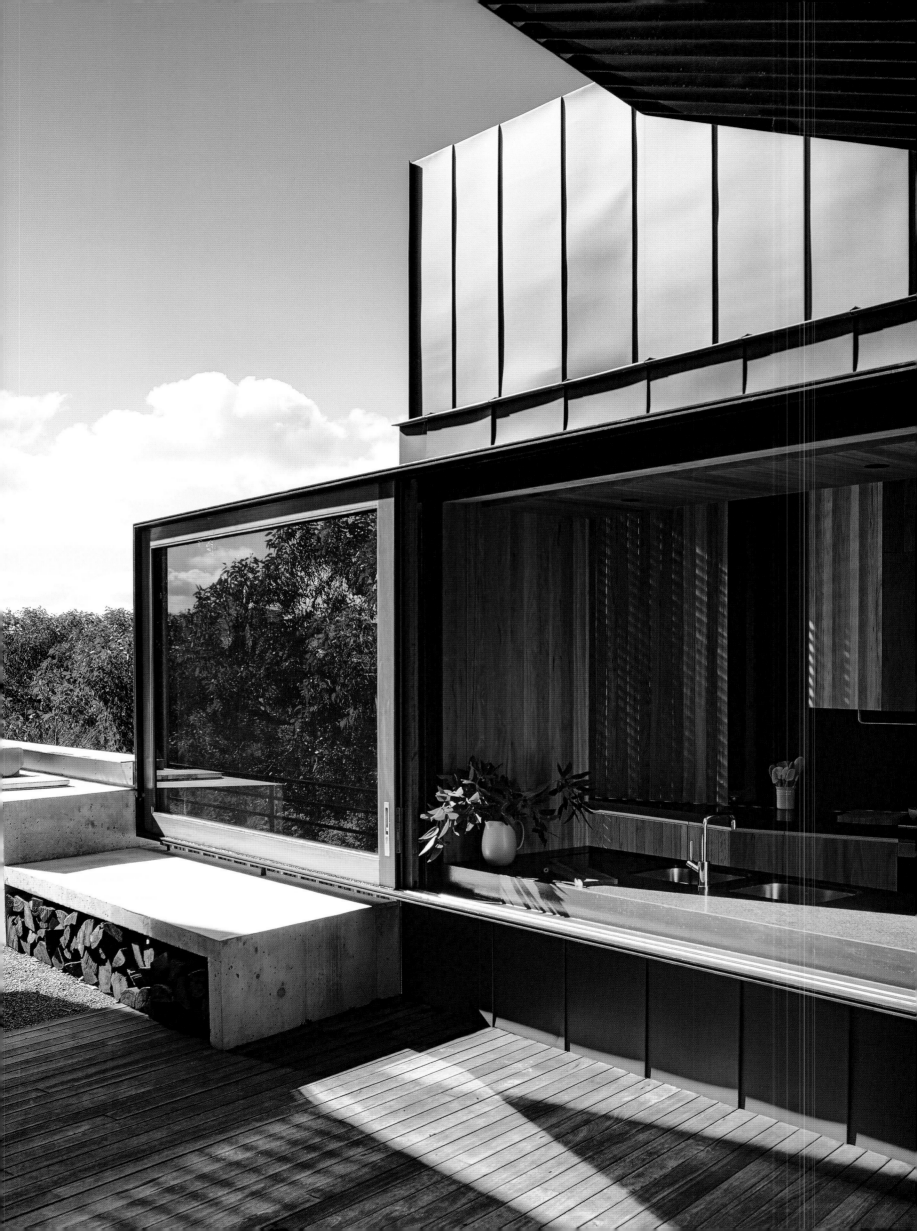

A flash of aqua blue in the bedside table and bathroom cabinetry is a nod to the beachside setting.

FAIRHAVEN BEACH HOUSE —— JOHN WARDLE ARCHITECTS

With its large-scale triangulated timber door pivoting from a central position, there is excitement even in the approach to the house. The hallway is a space to move through quickly, and so can sustain the dynamism of visually interesting geometric forms as timber planes appear to fold and pleat. Drawn forward towards the cinematic view, there's an increasing awareness of the complex beauty of this design. Conversely, the living room and bedroom are unruffled and offer respite through the measured, simple application of the blackbutt timber lining boards providing an entire wrap.

Wardle is a great collaborator with trades and crafts outside his direct ability, and pulls these talents as appropriate into his buildings. Sometimes it is a fibreglass fabricator or weaver of willow, an artist or a bricklayer, who he pushes to new levels of creativity, but in this instance he called upon the specialist skill of joiners and carpenters.

'The twists and turns of the exterior form are all reflected fold by fold in the interior blackbutt joinery, and the skill required to do this was remarkable,' he says. 'We used a country firm of builders – Spence Construction – who produced both extraordinary quality and maintained a fast program, which is a rare combination.' The timber lining boards are used strategically to trick the eye and merge spaces. The kitchen cupboards extend along the wall into the dining area but have the effect of disappearing; the televisions are spirited into the ceiling, and the side windows placed throughout the house (which are unglazed and used purely for ventilation) again are magic-ed away behind timber panels.

Wardle often designs a final piece of furniture for a house to symbolise the personalities of his clients and, while he has done that in this instance, he has also designed a substantial amount of the fixed cabinetry and the dining table, and chosen the furniture. The woodburning stove from Cheminées Philippe is a Wardle favourite; with its visible industrial workings and 'cumbersome beauty' it adds character to the space. He has custom-designed the folded steel firewood holder that sits alongside it. The two most beautifully crafted freestanding pieces in the house are designed by Wardle and made by his longtime cabinetmakers, McKay Joinery. The refined dining table has slots incised into each place setting for a felt mat to snugly fit, and a purpose-designed bowl and serving tray – both in timber – have fixed positions on the table. 'I am working with a Tasmanian potter to commission a set of tableware especially for the table,' says Wardle. Most personal of all is the coffee table with its sculptural shape and symbolic significance. 'The owners have different interests – he likes to surf and relax with a drink, she likes to read, and so the timber rollers are for magazines and book storage, and the timber circle is a rimless tray for serving drinks, but with a steady hand.'

But back to the idea of nimble. For a start the house only uses up 44 per cent of the available building envelope that, in an area of highly prized waterfront land, where houses are normally bulging at the very edges of the block, makes it rather light on its feet. Yet more important to Wardle is the relationship the house has to its setting. 'It is a very responsive house to light and to landscape. For me, it seems to pirouette and turn both this way and that to capture the views.'

The design
development of the
house was driven
by Andy Wong's
intricate models.

An assertive
angular presence
is a counterpoint to
the transparency
of the entry.

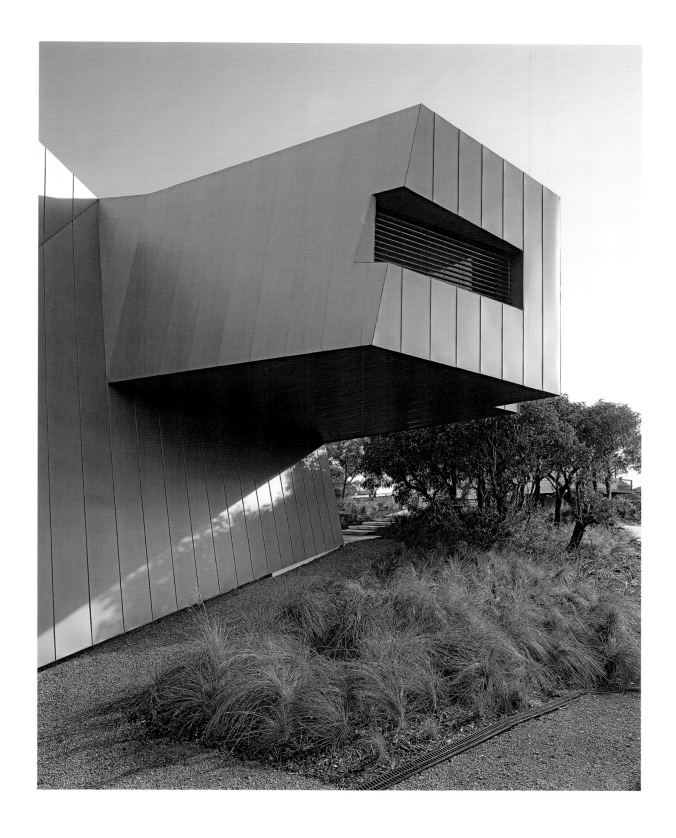

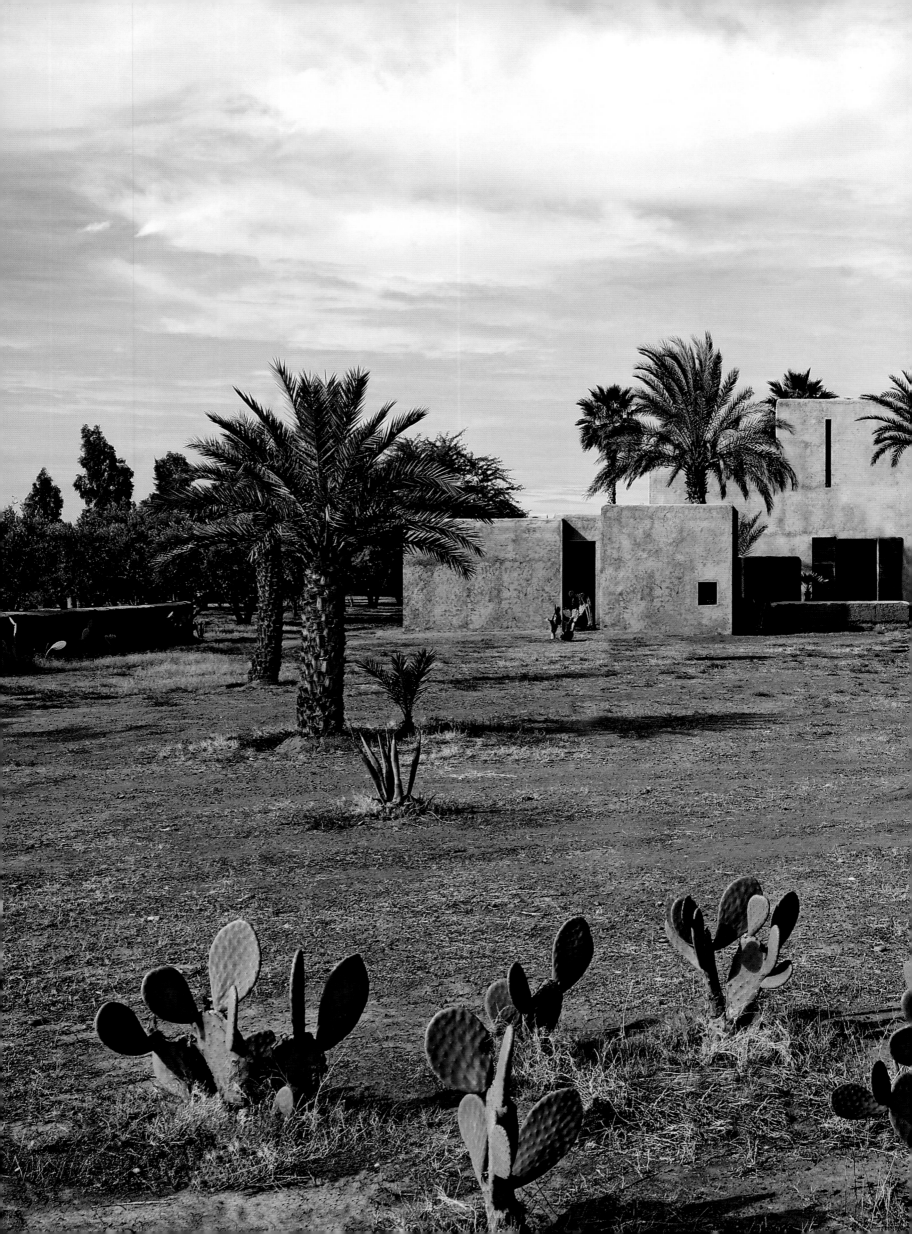

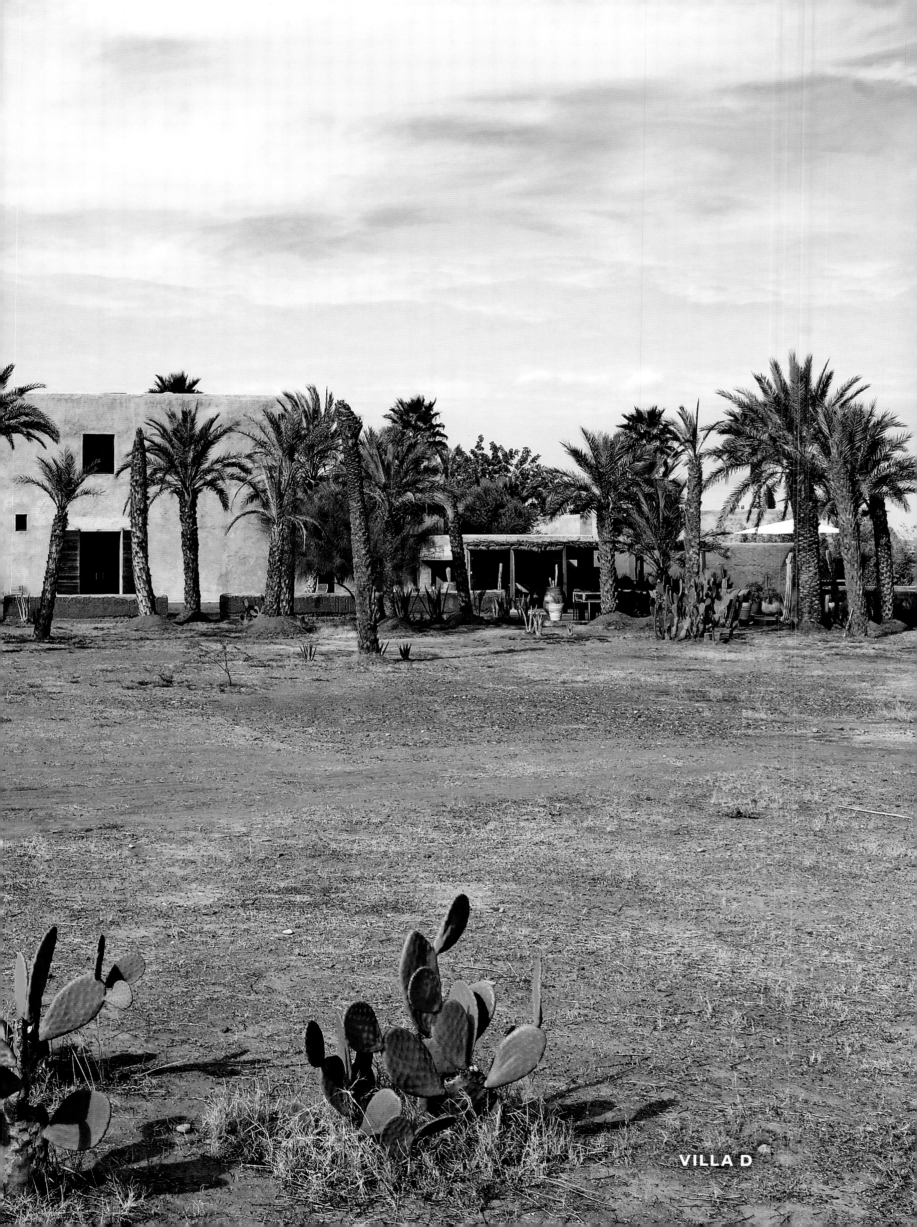

VILLA D

In its arid location, water becomes a precious commodity with elemental appeal.

Contemporary structural forms are created using traditional materials like earth bricks.

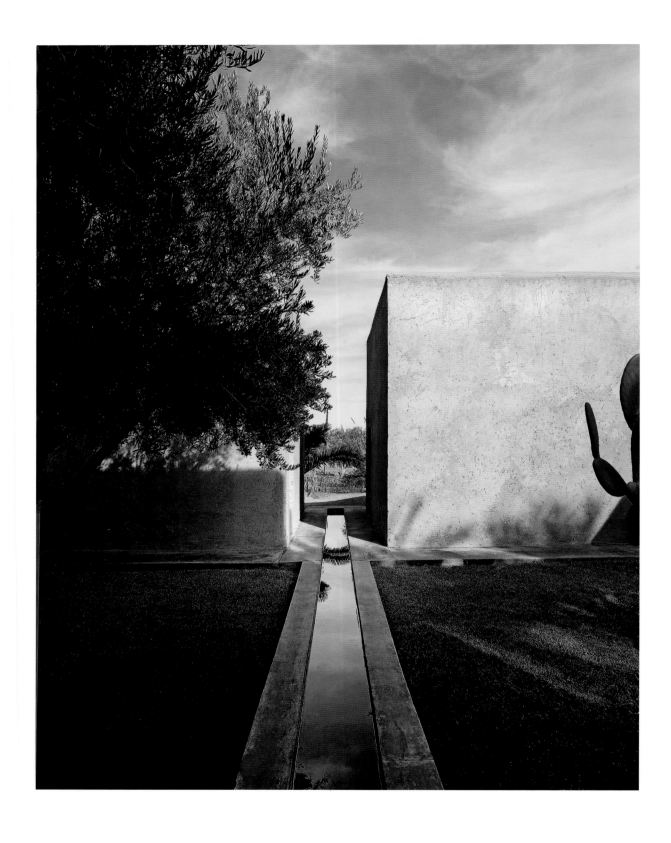

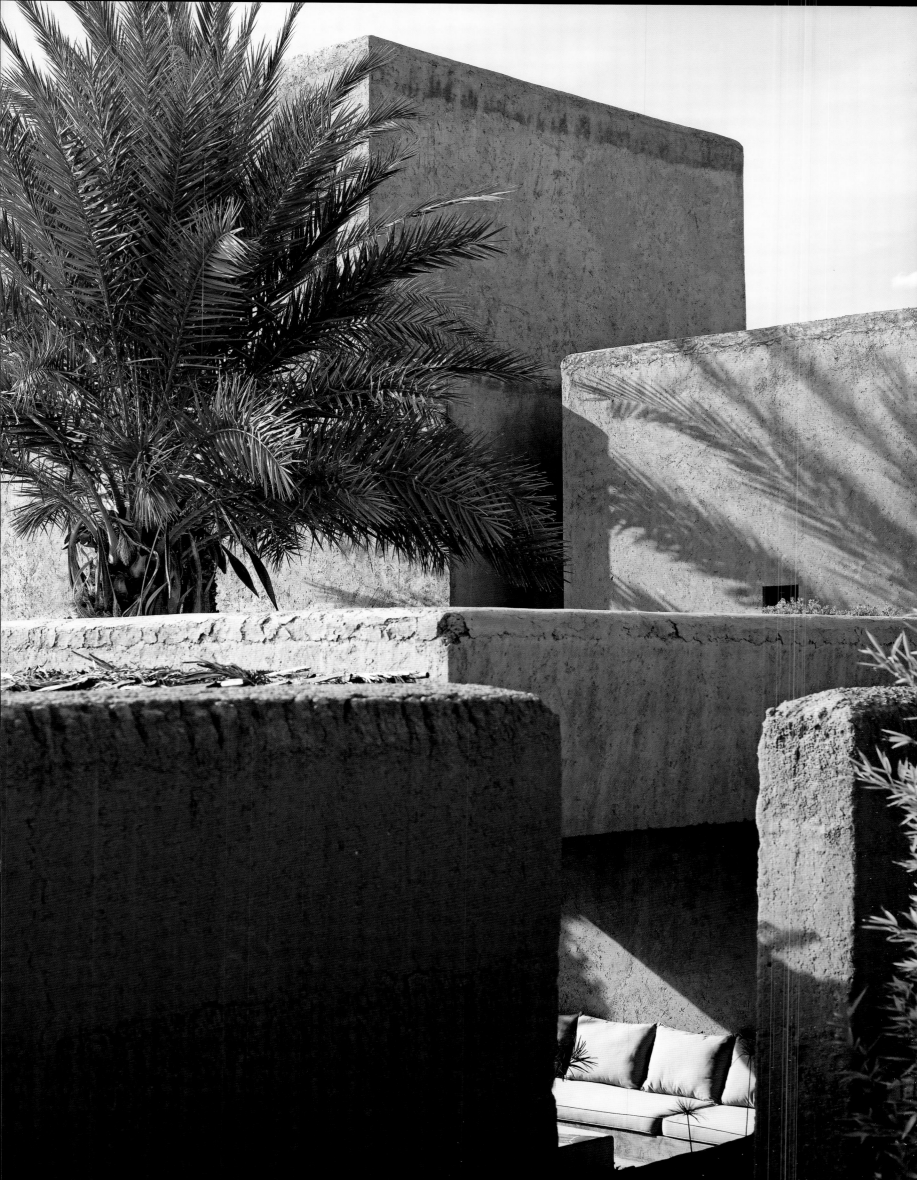

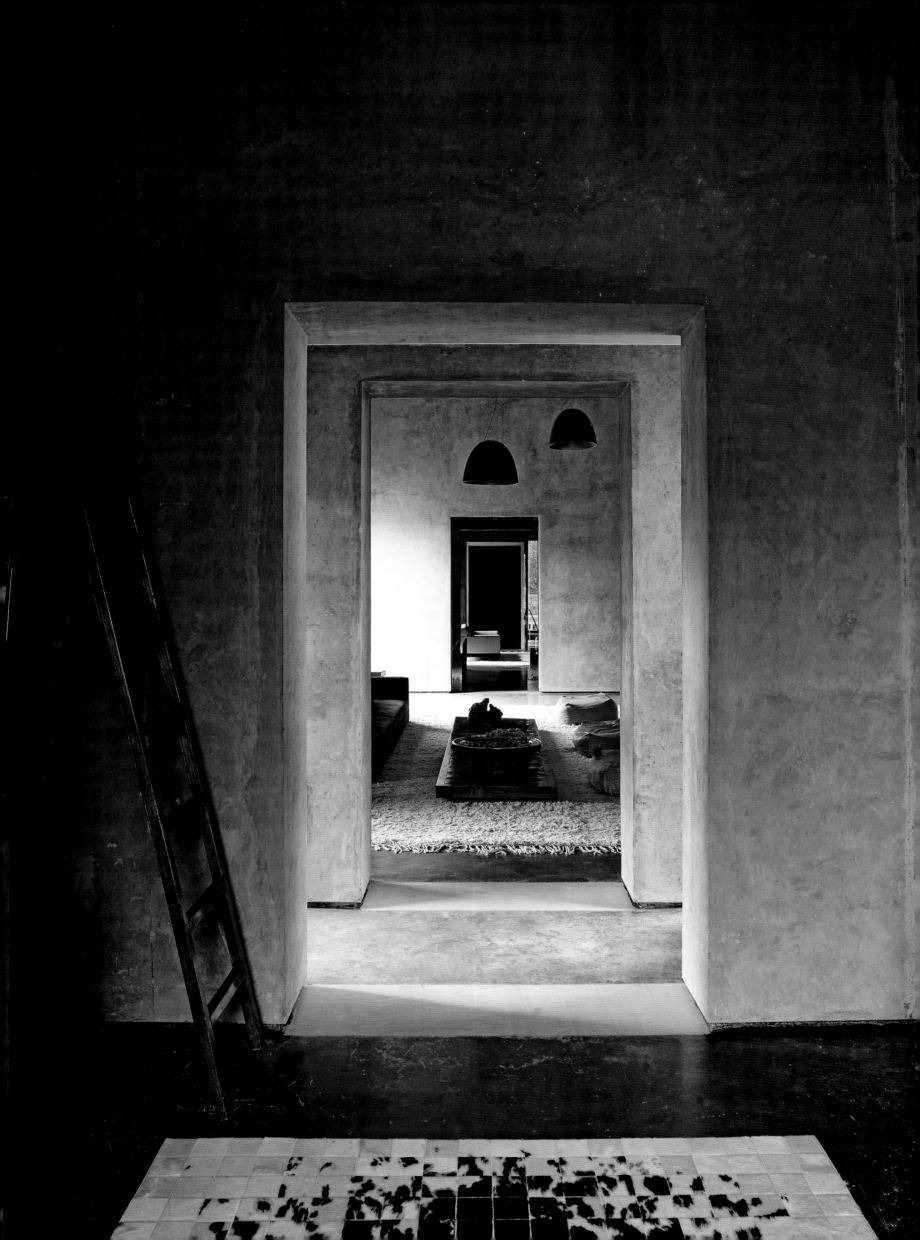

**VILLA D
(2004)**

◇

STUDIO KO

⋈

**AL OUIDANE,
MOROCCO**

A stone's throw from Renzo Piano and Richard Rogers' tour de force, the Pompidou Centre, in a tiny street in the Marais, is the office of Studio KO. The practice has a reputation for both uncovering the past and diverting from it – an approach illustrated by their working space, a nineteenth-century garment factory housing a twenty-first-century architectural atelier. Traces of the building's history have been retained but the modernity is evident in the spatial arrangement and the choices in furniture, lighting and art that declare an entirely contemporary mindset.

Immediately after Karl Fournier and Olivier Marty finished their architecture studies in 2000 at the Ecole des Beaux Arts in Paris, they opened up their own practice, Studio KO. Fournier admits, 'We pay for it every day. Usually, experience can be gained on someone else's time but for 12 years we have learnt on our own.'

Their work involves revitalising existing buildings as much as creating new ones – in both instances they are inspired by the context, be that the landform or an existing structure. In a restaurant project, Café de la Poste (2006), sited inside a colonial house in Marrakech, 'It didn't feel right or *juste* to create a modern solution,' according to Fournier. 'The existing space simply didn't feel it had the capacity to absorb something too contemporary.'

Fournier and Marty first visited Morocco as students. 'We loved it from our first contact and met people there who changed our lives,' says Fournier. 'Hence we have a strong relationship with the country and wanted to make it a more significant part of our lives.' They opened an office in Marrakech in 2001, initially to oversee a house near Tangier for a member of the Hermès family. 'It was difficult to follow construction work and so we set up a small office to do just that,' says Fournier. 'Gradually it got bigger and bigger and now, with major projects happening, it is a big part of what we do. We didn't really consciously make a decision; it has just happened of its own creation.' Similarly, a London office was opened in 2012 as demand grew for their work in the UK, including a retail outlet for Australian brand Aesop and a boutique hotel project in an ex–fire station in London's West End, for André Balazs.

The commission for Villa D came from a French couple, with four children, who wanted a home and retreat that was robust and functional but also embraced the culture in a contemporary way. Drawing inspiration from the landscape can be a challenge when the site is dry and flat with earth and palm trees as the main protagonists.

'We decided to convince the client to build only with earth, which was an ecological approach but uncommon at the time,' says Fournier. They set about using sun-dried bricks,

The house is characterised by a free-flowing plan, with wide openings between spaces.

Treating the
interior walls with
cheap kitchen oil
enhances the patina
of the natural colour
variations.

Custom-made
furniture
characterises
Studio KO's
approach to
interiors.

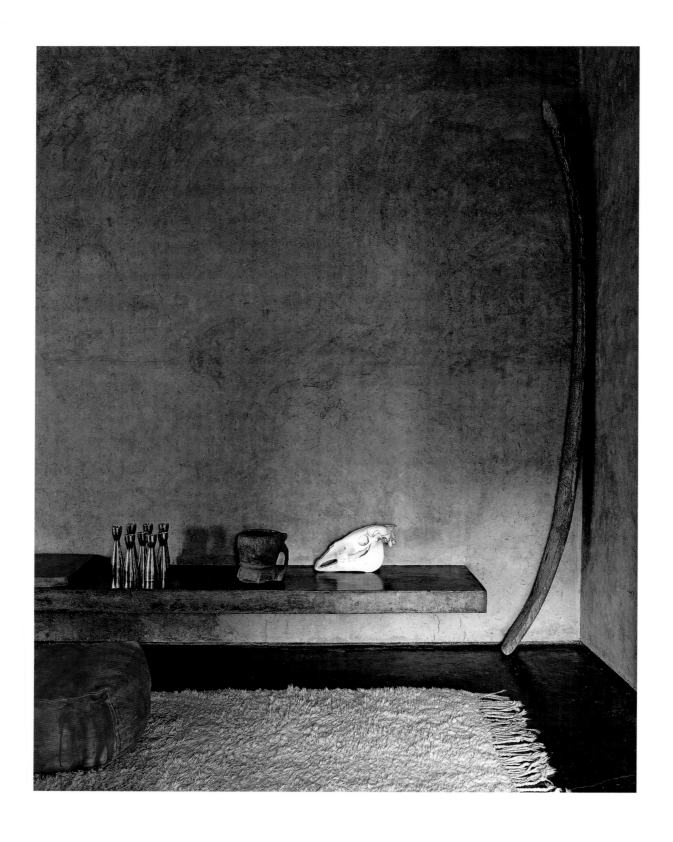

VILLA D —— STUDIO KO

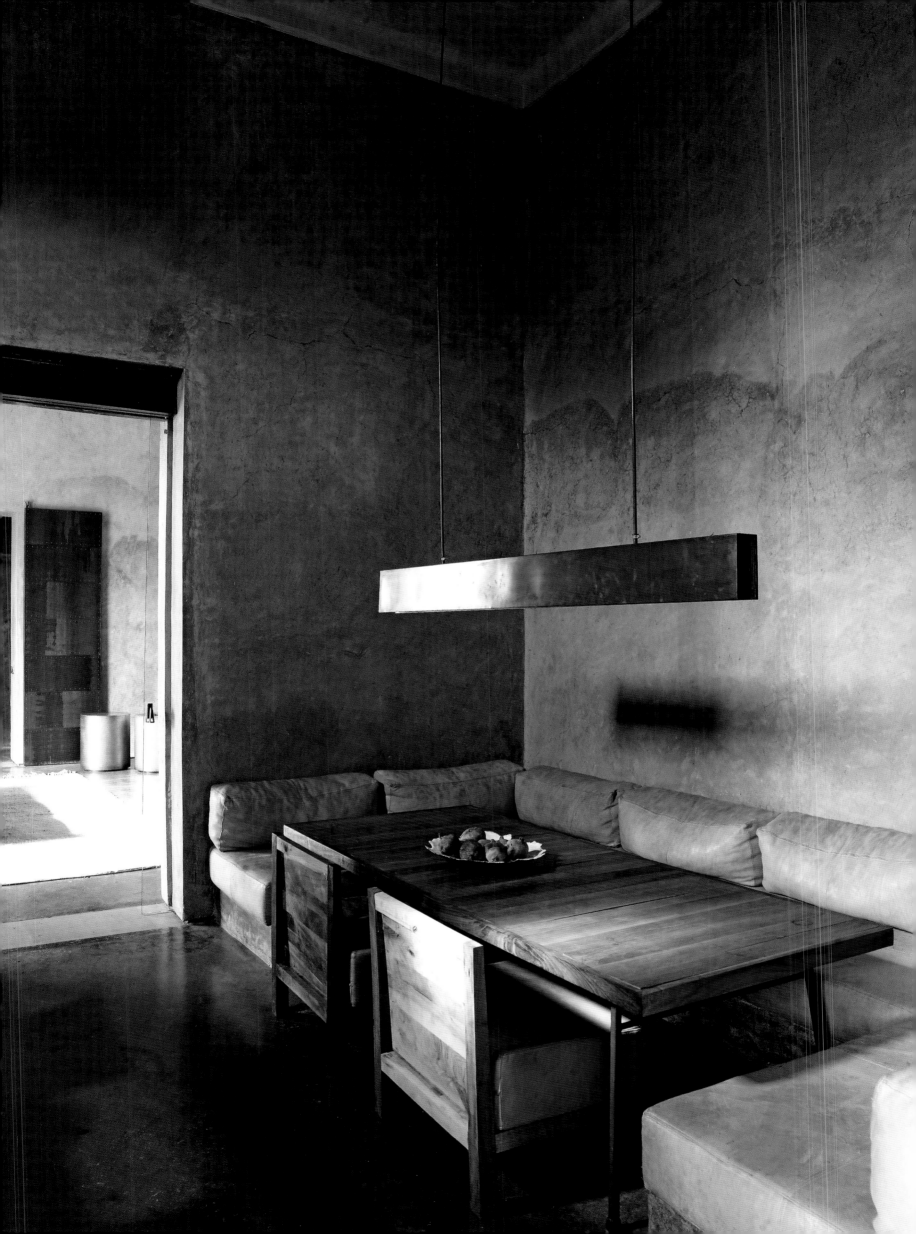

reusing the earth from the site, to give the effect that the house was not simply set on the land but was an integral part of it. 'When you see the house from far away, it is really the same colour as the surrounding landscape and has the effect of something that has emerged naturally from the earth itself,' says Marty.

The architects admit that this building was a journey for them as they undertook a theoretical study to explore the building method and use of earth bricks. 'One of the reasons we wanted to work in Morocco was to use local materials and practices about to disappear, and help protect those artisanal skills,' says Fournier. Learning from skilled local workers was part of the process. 'This was our first project, our first private house, in a new country with new technologies – it was very significant for us.'

However, Studio KO was determined not to go to Morocco and work in a purely traditional way. They were aware of the opportunity to create a new architectural language – one that is climate and site relevant, that draws on heritage and local skills, but that is appropriate for people wanting a contemporary lifestyle. 'We wanted to design for clients living in this gener-ation but with meaningful echoes of the past,' says Fournier.

Their understanding of 'modernity' is not about technologies, but about ways of seeing, an attitude, an approach, and an awareness of how to take things from the past and from the present and join them together. According to Fournier, 'It is our modernity, not a lazy white box without acknowledgement of local culture.'

Villa D is formed by a layered series of walls, volumes and window openings with an enigmatic sense of approach. That planned approach is based on the French word 'chicane', which can mean interrupted, intercepted, and, in this sense, something of a deviation. 'It is a progression, things appear, perhaps a little patio, a seating area, water, it is a journey of arrival, it is not direct,' says Fournier.

'The clients wanted a house that was elementary, meaning something that was very close to nature, using earth and water,' says Marty. 'But they also wanted the house to be sincere, and because the client didn't like large windows, we hid the windows as much as we could and designed them as a series of lines scored in the building.'

While mindful that water is both useful and rare, it is integrated into the site. The landscape is dry, and so too are the building and materials; the introduction of water in the form of ponds brings movement and attracts birds, pulling life inside the courtyard. The use of water, too, signifies the convergence of the traditional and modern, and is Studio KO's interpre-tation of the fountain commonly found in Moroccan homes.

The house is configured as a double-storey core with living rooms on the ground floor flowing from one to the other through wide openings. Scale alters dramatically, with the soaring five-metre ceilings of the two salons contrasting with the more intimate dimensions of the dining room, kitchen and library. On the first floor, the master bedroom suite, with sleeping, bathing and terrace areas, is accessed via an impressive staircase. Openness and fluidity are key to the floor plan; rooms can be closed off with sliding glass doors but more often than not are left open, while the master suite has partial dividers in an otherwise open space. Containment balances openness as the children's area, a single-storey structure with four bedrooms and a shower room, is adjacent to the main building, allowing for both connection and independence. Two buildings for guests function in the same way.

For Studio KO, interior decoration is an integral part of the practice. 'We always try to imagine a complete solution,' says Marty. 'The most

'One of the reasons we wanted to work in Morocco was to use local materials and practices about to disappear, and protect those artisanal skills.'

KARL FOURNIER

Large windows are
kept to a minimum,
opting instead for
slices of glazing
and small openings.

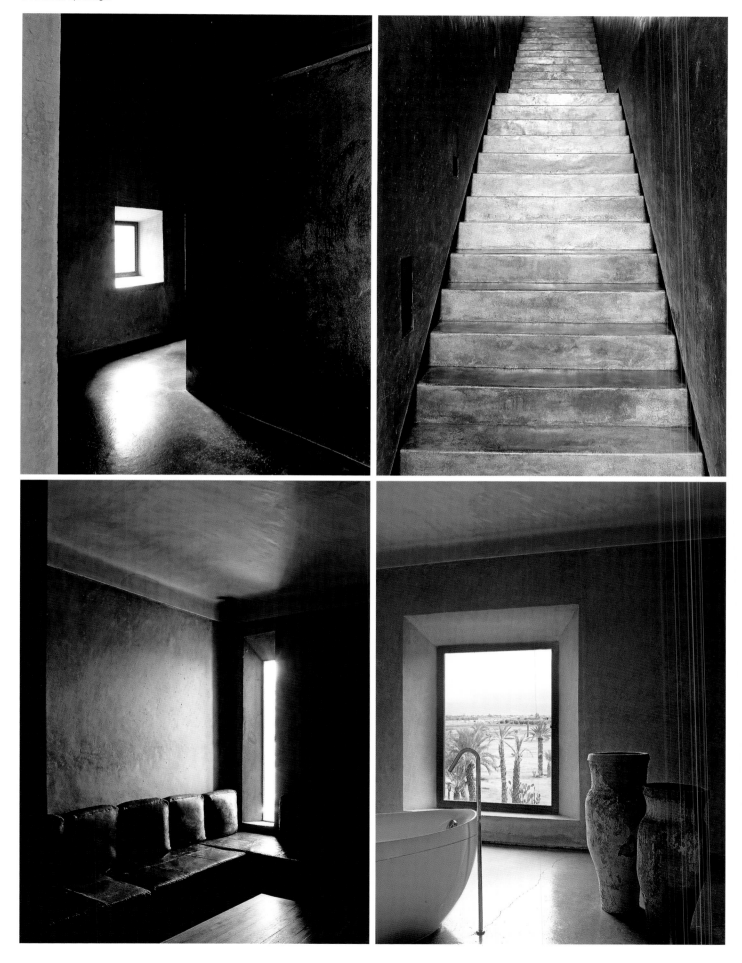

Alongside
contemporary
fittings are
utilitarian vignettes
with objects of
local resonance.

Within the house
are a number of
intimate spaces,
including a library,
to balance the more
expansive areas.

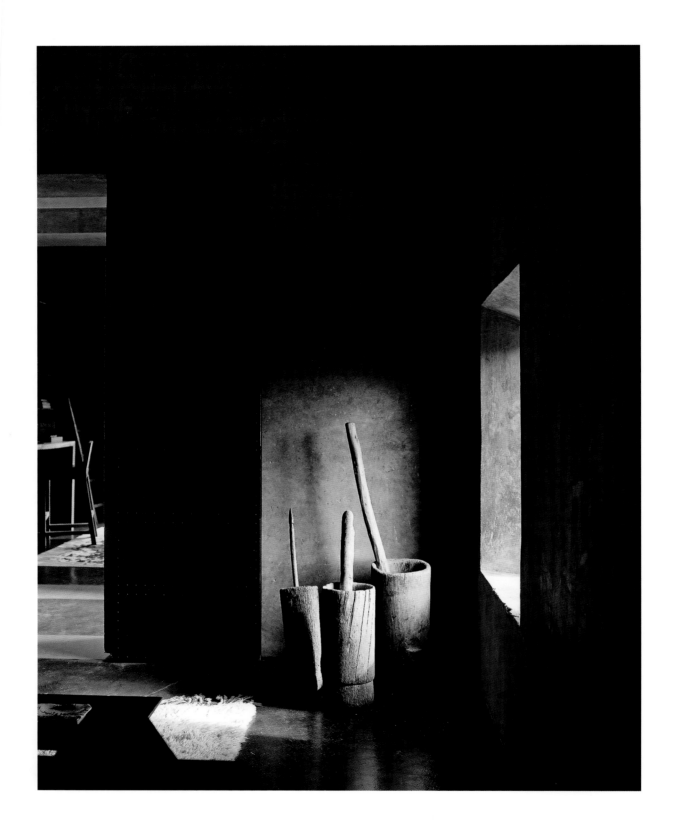

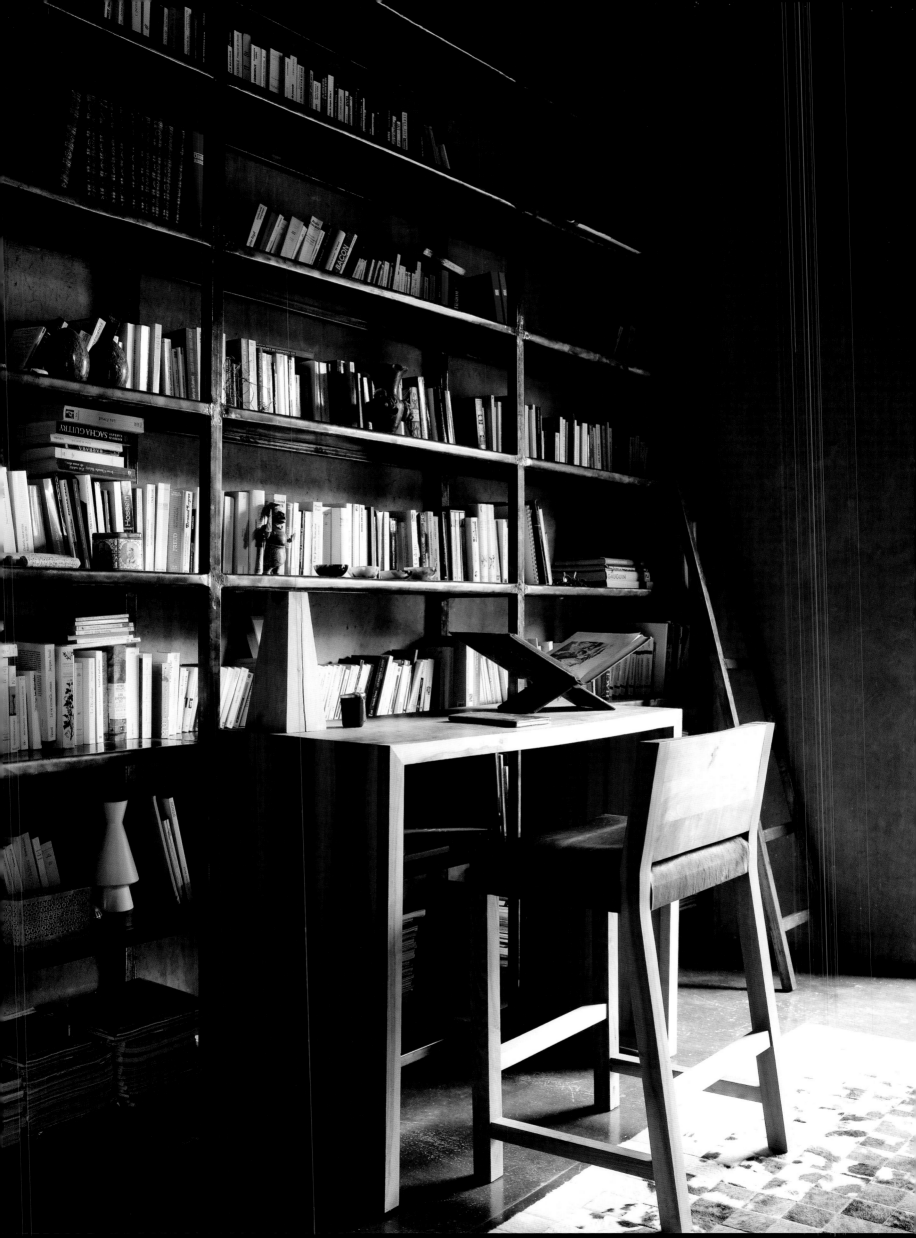

By playing
with scale and
proportion, the
elongated opening
becomes a defining
feature.

successful interiors are always considered from the beginning, because there is one driving idea, one concept throughout. It is not very satisfying for us to do houses and then hand over to a decorator. Inevitably we are always disappointed because there are two different languages in the same space, two different directions.'

At Villa D they had the opportunity for a complete execution, starting with the context created by the traditional oiling of the interior walls (using the cheapest kitchen oil) to give a sensuous low sheen. The oil enhances the patina of the natural colour variation in the earth on the walls, creating a soft finish that responds to the manipulation of light and shadow that Studio KO does so well. In some instances, plaster is used for the ceilings to reflect light down into the rooms, and elegant glazed openings punctuate the building, to allow shafts of light to discreetly illuminate the spaces.

Into the context of these free-flowing rooms, Studio KO brings a warm textural play of timber, leather and wool. Custom-designed banquettes in timber and leather, traditional Moroccan Beni Ouarain rugs and rustic objets trouvés mix with simple designer lights and contemporary fittings. Due to the linear connection between rooms, the interior palette needs to be consistent, as it is possible to stand in one room and take in the interior of several others.

Villa D has been important for Studio KO on a number of levels. According to Fournier, many people have seen it and, to this day, it still draws people to the practice. It has also been the genesis of a strong ongoing working relationship between families and artisans who continue to partner with Studio KO on projects – each time taking these skills to a new level. Villa E (2013), a recently completed project in Marrakech, features a burnished stainless steel door that could have been there for centuries but is equally modern; striated earth wall treatments become more sophisticated as workers suggest new approaches, and bespoke designs in Moroccan leather and woodwork are locally produced.

'Artisans are proud to be part of a project reviving old techniques with new usage,' says Fournier. And, in turn, Studio KO has managed to do what they set out to do a decade ago – redefine what a contemporary house in Morocco can be; local and international, traditional and modern, spare and warm, robust and enduring. ━━━

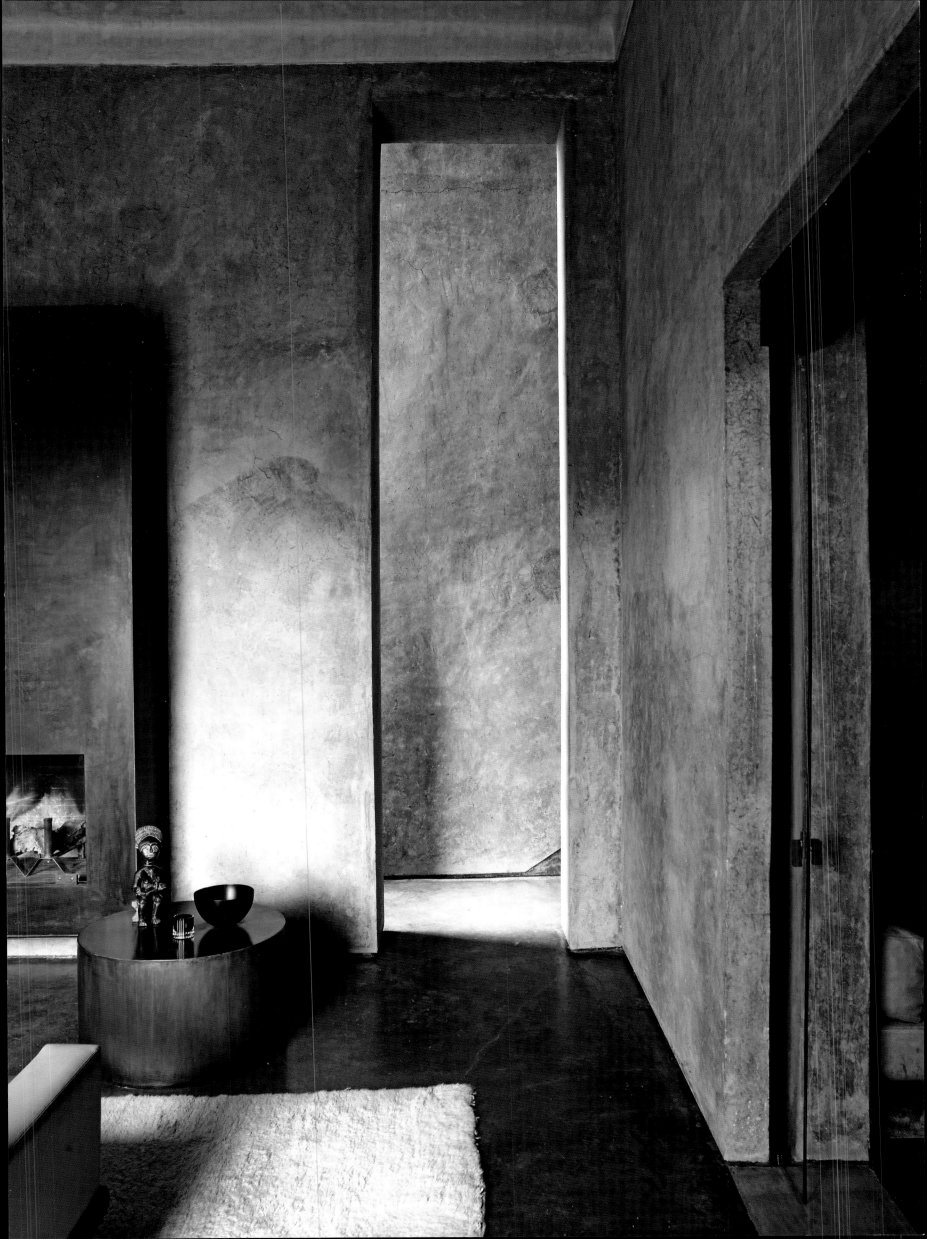

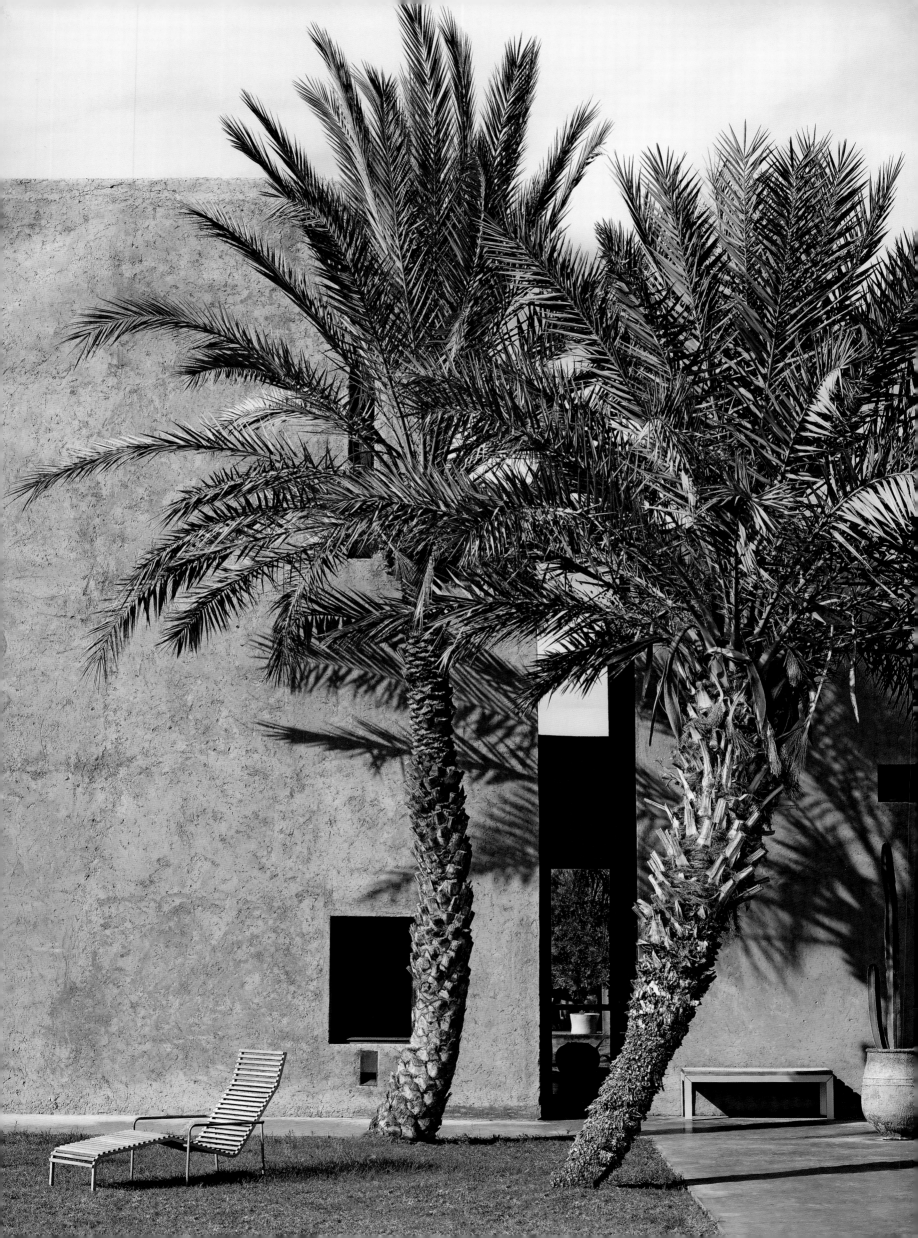

Taking inspiration from the earth and palm trees, the house exploits both beautifully.

While the massive window illuminates the staircase, it essentially remains a contained space.

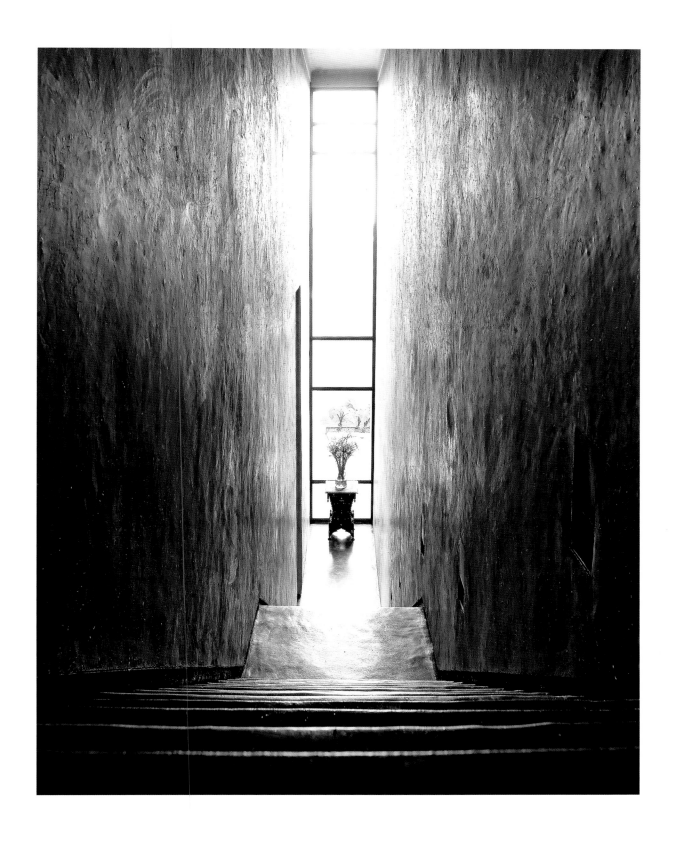

Approach to the
house involves a
journey of arrival,
with detours along
the way.

Introduction
of water brings
birdlife, as well as
a tranquil element,
into the compound.

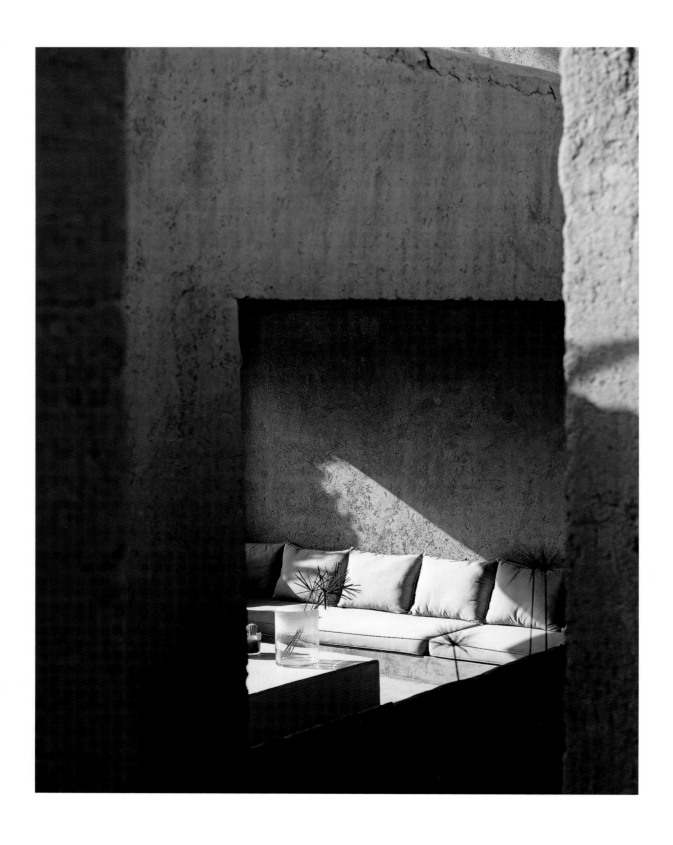

VILLA D —— STUDIO KO

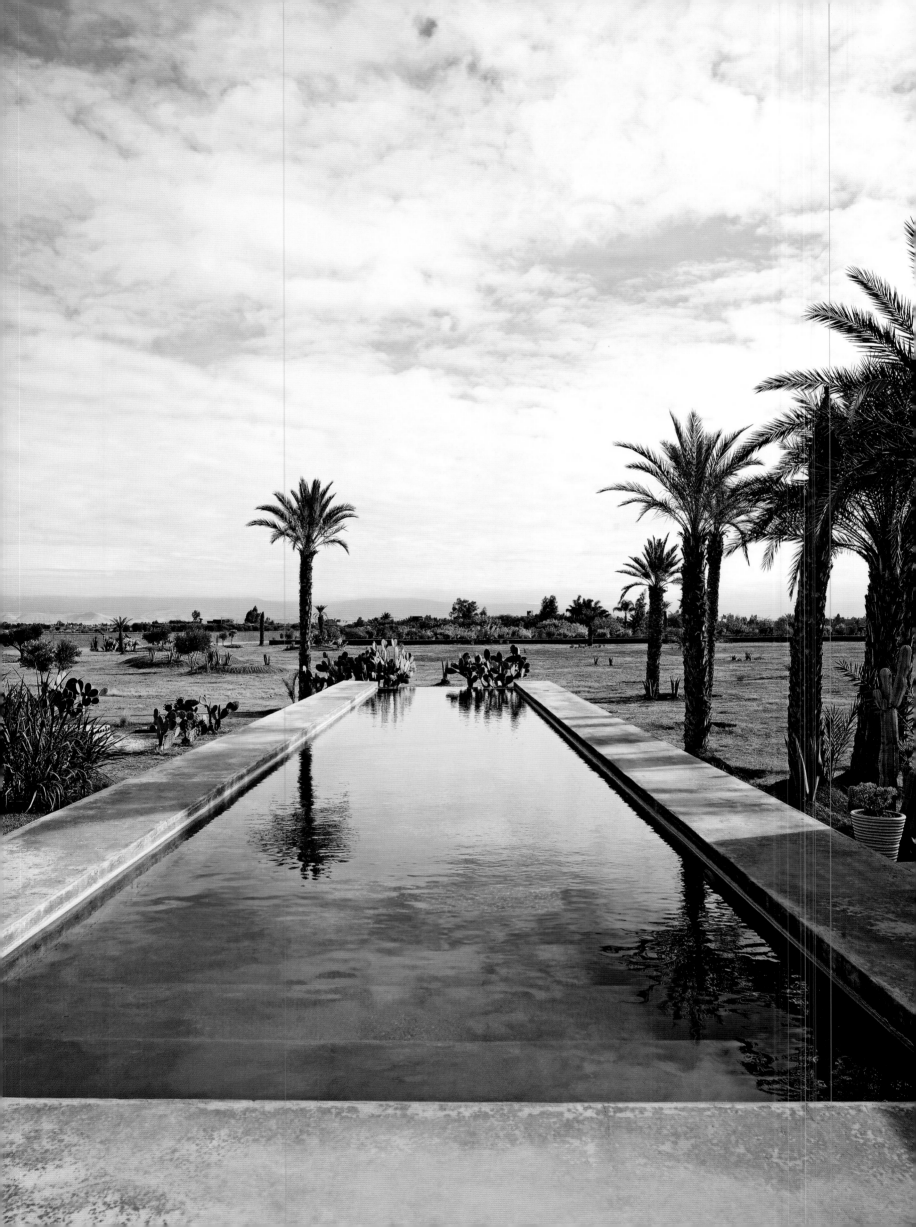

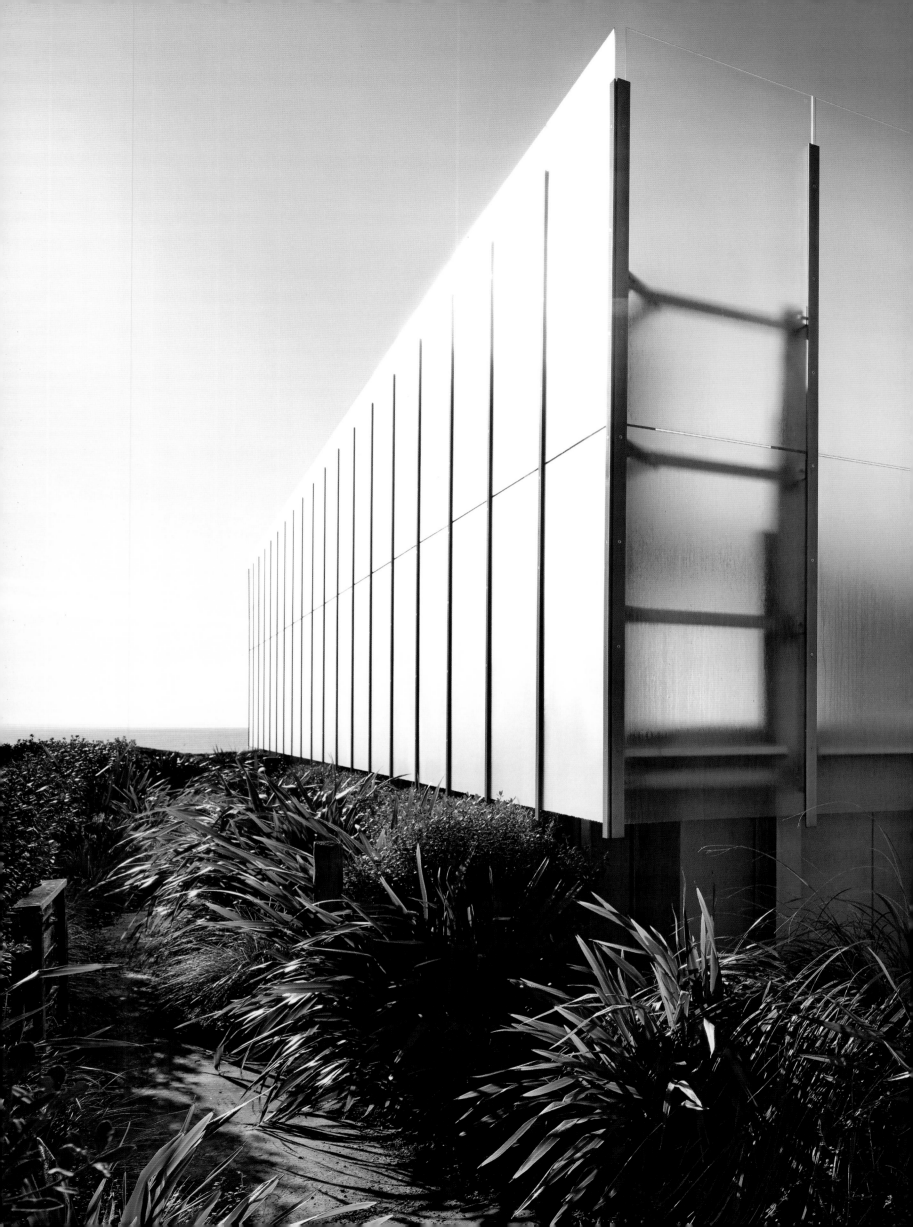

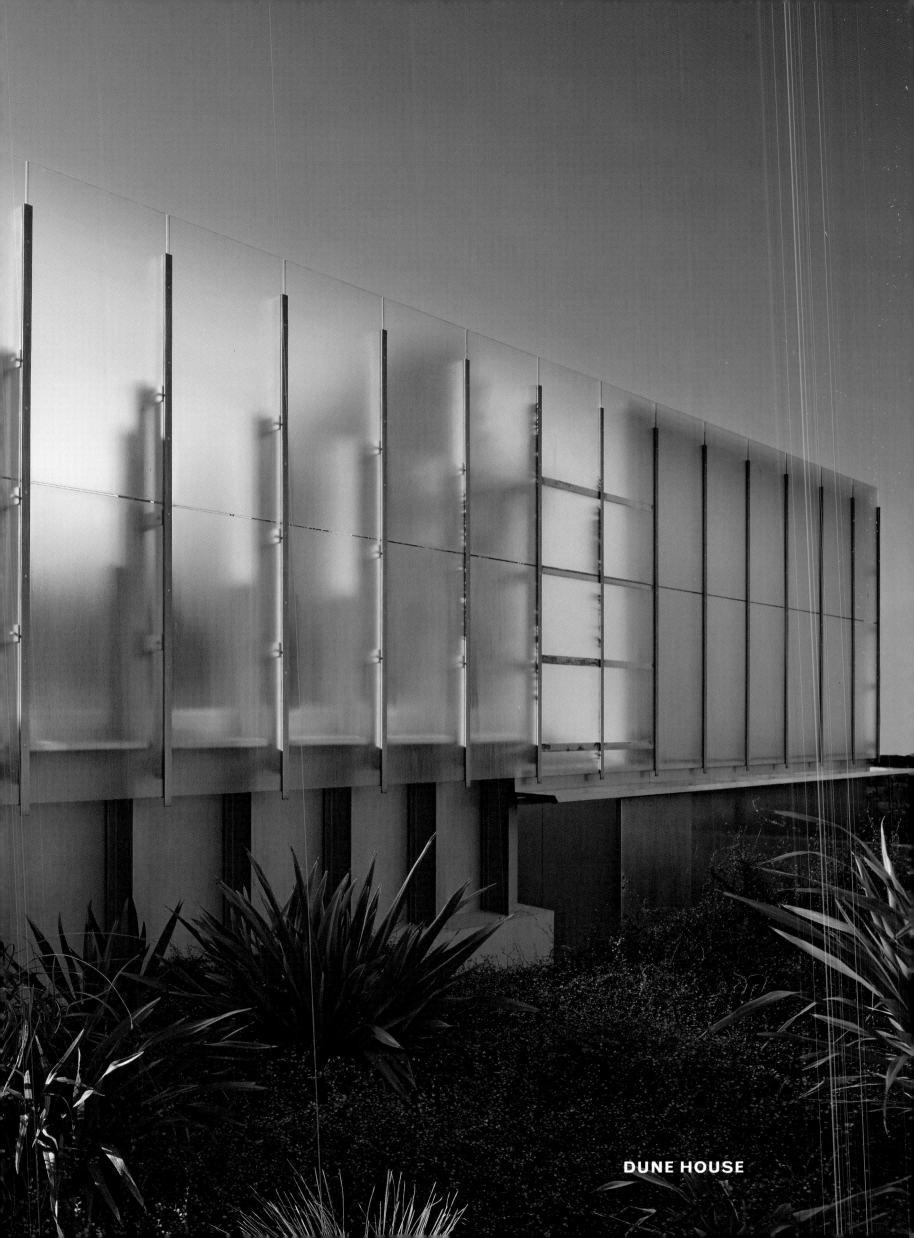

DUNE HOUSE

The dominant feature is a protective glass box, which takes on its own characteristics.

In the popular beachside town of Omaha, privacy was a key priority for the client.

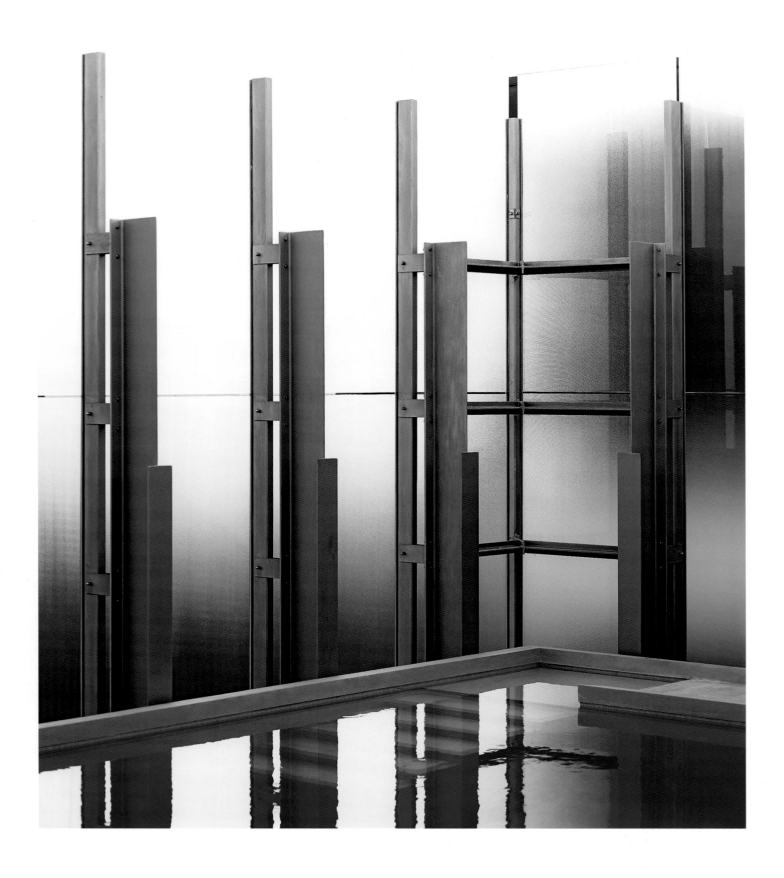

DUNE HOUSE —— FEARON HAY

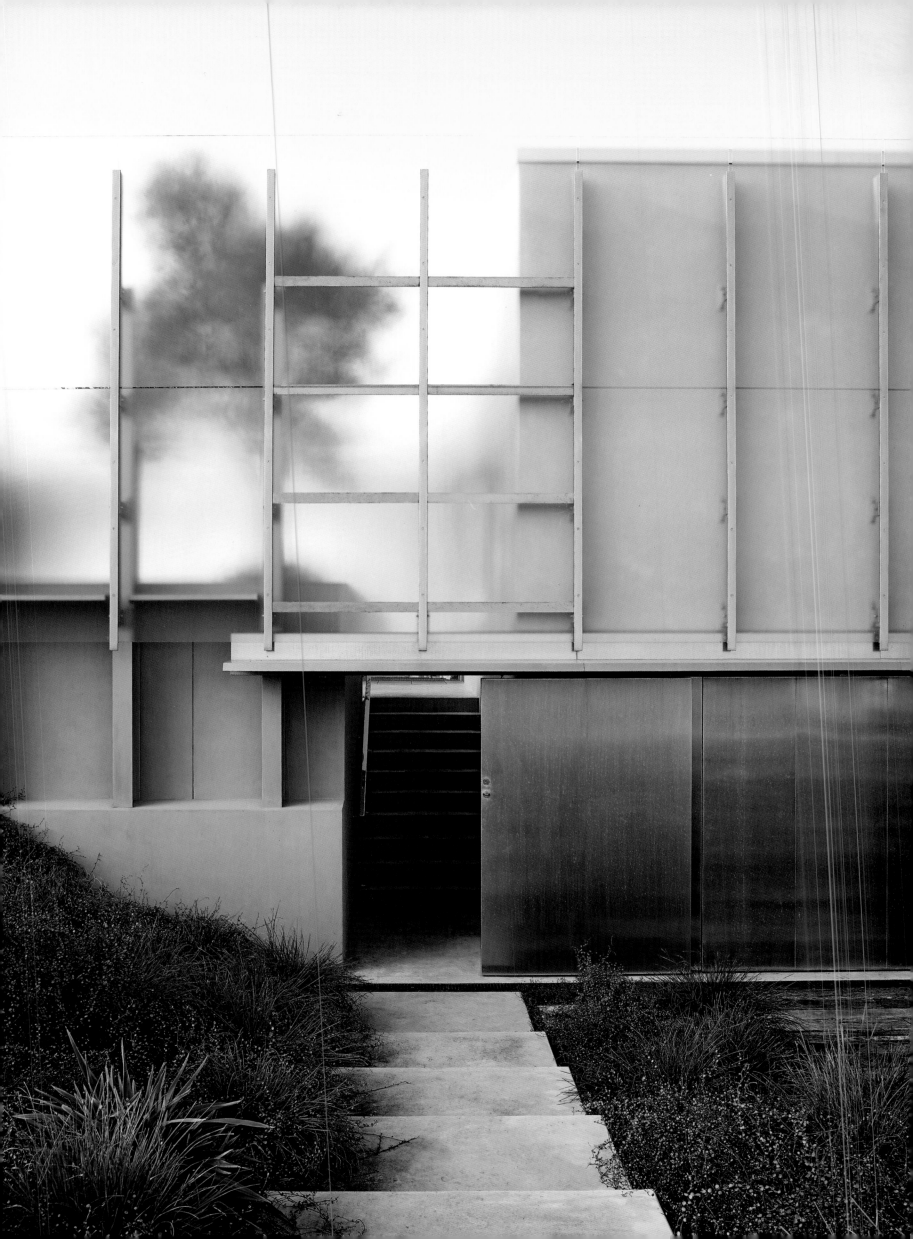

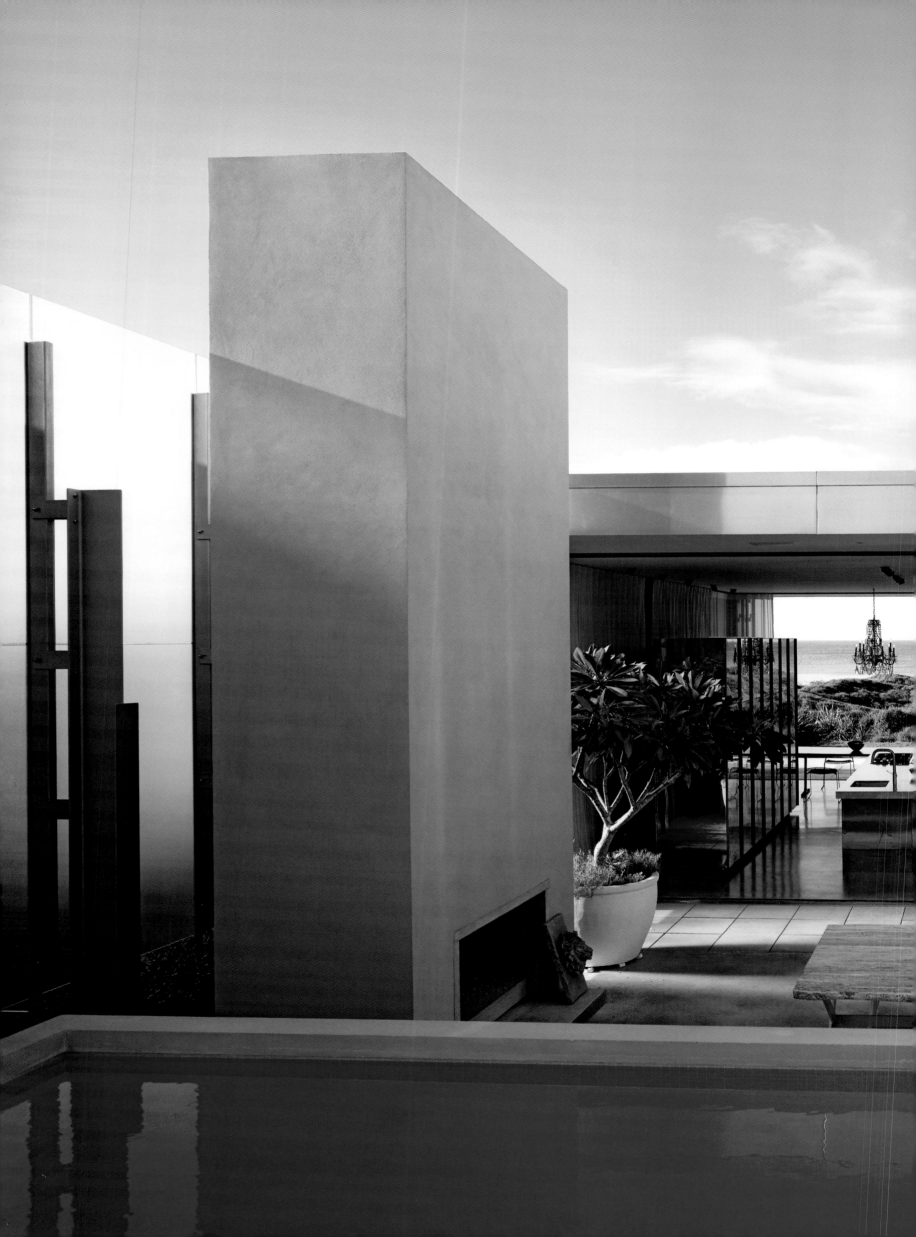

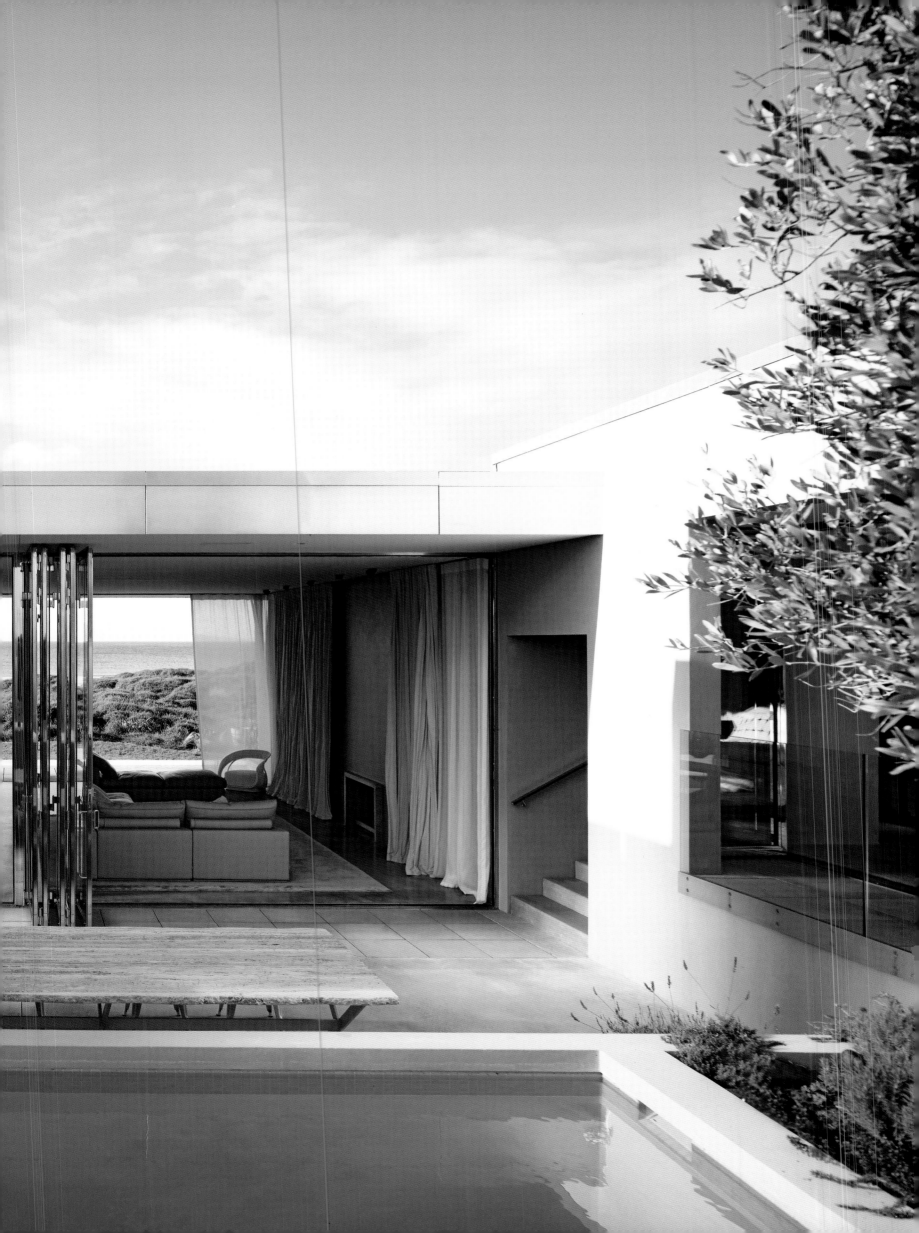

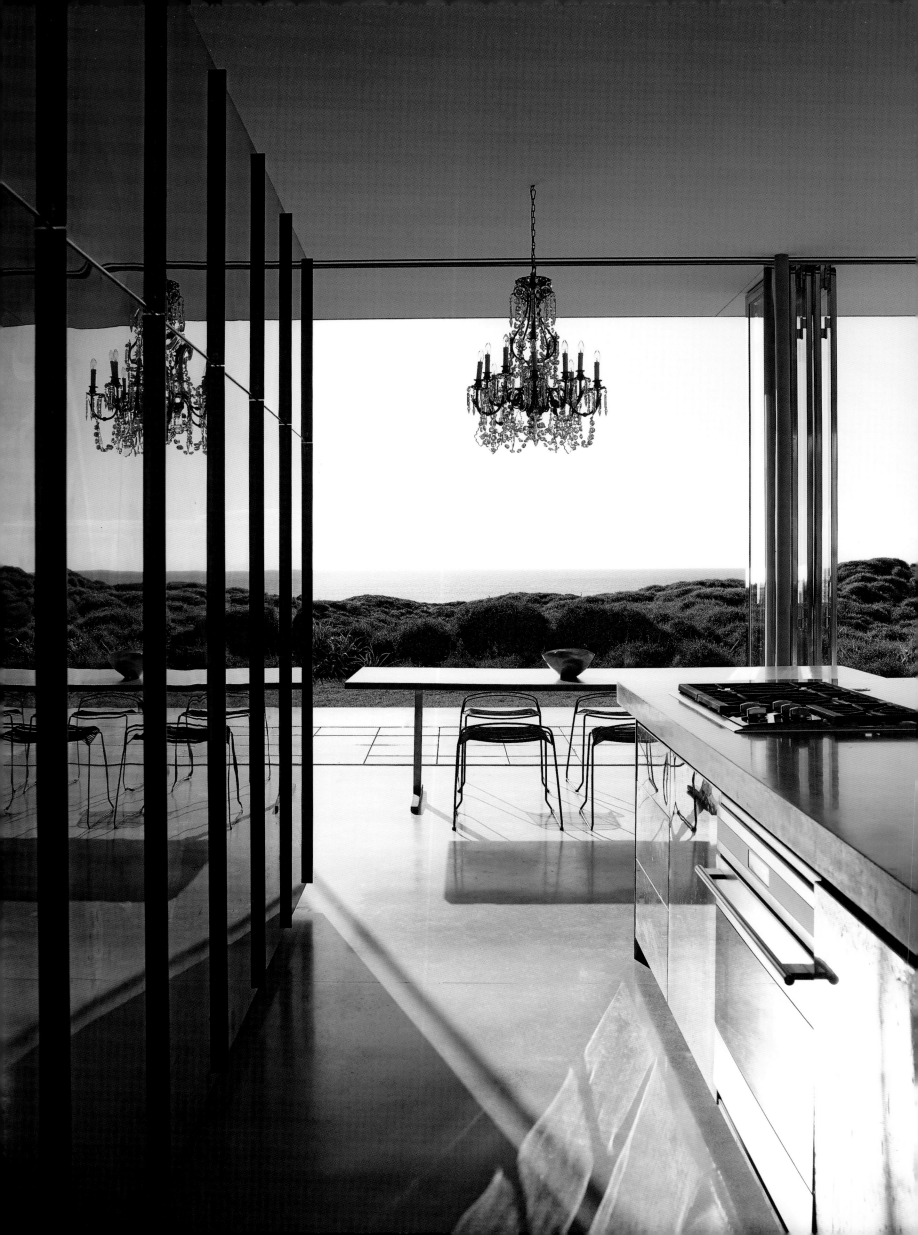

DUNE HOUSE
(2013)

◇

FEARON HAY

⋈

OMAHA,
NEW ZEALAND

One of the things that has struck me during the research for this book is the often tenuous relationship between the design and build of a house and its interior treatment. I have sought to feature houses that have something to say in both instances and are not just beautiful shells. This, as I said in the foreword, has proved challenging for a number of reasons, including the sometimes strained relationship between architect and interior designer. I always remember an architecture award ceremony where the interior design category award was given to a cattle shed. It may have been a beautiful cattle shed but there is no doubt the choice made a clear point to the other finalists.

I mention this because Fearon Hay is a practice that excels at interiors. They understand the importance of a truly holistic approach and, as a result, their buildings have a completeness and confidence that sets them apart. Tim Hay believes that what they do is 'better encompassed by the word "design" than architecture'.

Their critical thinking, he says, 'starts in the landscape, then we create the building, and then move inside and keep on going. That is why we have a reputation for control. We are passionate about how a building responds from a lifestyle point of view.' Working with design partner of 15 years, Jeff Fearon, this is a practice that determinedly shares authorship of all its buildings.

Add to this mix Tim's sister, Penny Hay, who manages projects in which the client appreciates that the interior scheme is key to the design from the very outset. 'I like to be involved in the very early meetings,' she says. 'That way interior considerations are managed and budgeted for at the outset. I need to build a rapport with the client and they need to understand and value my role.'

The fourth, and perhaps most important member of this group, is the client. Tim Hay admits there is a sort of compatibility stage they go through with new clients rather like that of a dating process. 'We use role-play by coming up with enough of a design strategy to place them in it. They see a plan and we can understand what they do during the day, and develop responses around how they will use the building.'

The client of the Dune House tells a story that explains her decision to choose Fearon Hay as the architects for her project. She had taken a number of images torn from magazines to another firm, but they had paid scant attention to her ideas. When she went to the Fearon Hay offices and saw the very same image she had of an olive tree from French interiors magazine *Côté Sud* on their wall, she was convinced, and the match was made. Aesthetically, she felt, they were on the same page.

Unexpectedly luxurious elements help define this as a house at the beach rather than simply a beach house.

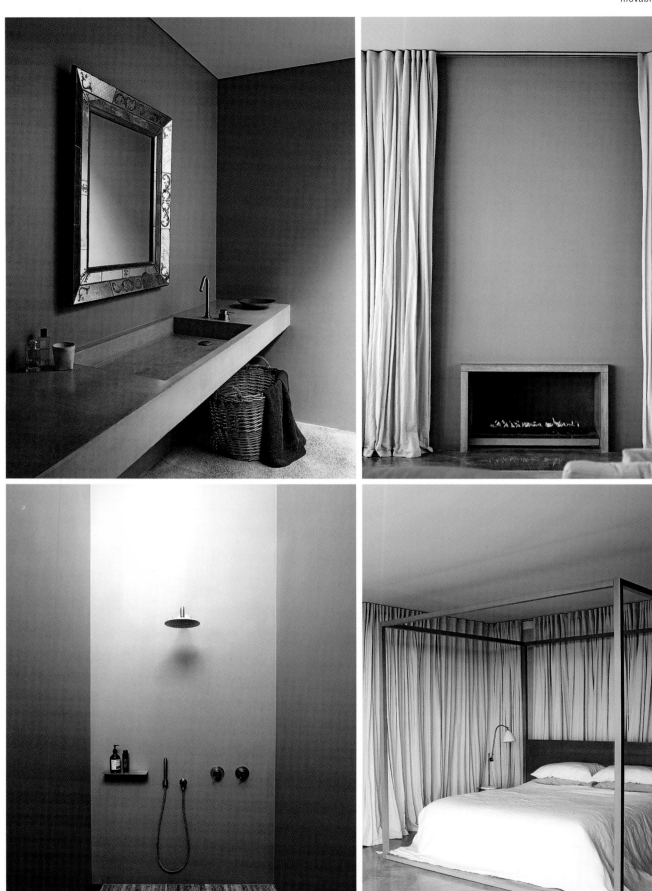

A subtle play of
theatre is evoked
through the
generous use of
movable fabric walls.

DUNE HOUSE —— FEARON HAY

The brief from the client was for 'a house by the beach, not a beach house', and that is what she got. 'We didn't approach this thinking what a beach house should look like, we thought about what they needed to get from the house in terms of light, amenity, lifestyle, view, protection and shelter,' says Tim Hay. 'So our approach doesn't start with how it should look but from how it will perform.'

Traditionally, in simpler times, New Zealanders favoured 'baches', which are basic timber holiday shacks, often set on beautiful sites. The Dune House is located in the coastal town of Omaha, an hour north of Auckland. While it may once have been home to baches, in the past decade it has become fashionable and has developed quickly into something of an enclave of architect-designed houses in quite a flat suburban setting. Fearon Hay has worked on some remarkable mountainous and lakeside sites – their Mountain Retreat (2008) in Central Otago is so completely integrated into the landscape as to be barely visible, while the Brancott Estate Heritage Centre (2011) in Wither Hills, South Island, has been described as 'physically stitched into its environment'. But in the case of the Dune House, the architects rather enjoyed the challenge of balancing protection and exposure on this previously unbuilt block facing the water. 'The positioning on, and belonging to, the dune system was fantastic,' says Tim Hay. 'We spent a lot of time standing on the roof of the car trying to get the levels right.'

It is a house of several levels that seamlessly transition from one to the other, creating areas for both separation and more communal engagement, yet skilfully pulled under one unifying roofline that relates to the ground. The planning is more complex than one appreciates. 'It was not just about visual screening from the built context of Omaha,' says Jeff Fearon. 'It was about protection and light, accessing the sun at all times of day and being able to use the courtyard and live on both sides of the house.'

From the street, the house presents as a series of rhythmic opaque glass panels taking on the cloud movement of the sky and, when covered in early morning condensation, creating an abstract artwork of the olive tree within. Coming in under the screening and ascending the concrete steps to the main living area – both outdoor and in – is to leave the setting of Omaha behind, for here is a contained world linked to the site and to nature with uninterrupted views of the ocean and Great Barrier Island.

There is also a sense of calm. The Dune House has a quiet luxury that comes from a controlled palette, as more inherently masculine materials, such as concrete and glass, are enriched with the rich gleam of brass and the femininity of indulgent linen drapes that form movable fabric walls. 'There is very much a process of dialling, or tuning, our material mix until we feel we have achieved just the right balance,' says Tim Hay.

One of the design solutions of the house is its ability to respond to the mercurial changes in weather through the manipulation of four walls of floor-to-ceiling sliding doors. The house is only one main storey (as Tim Hay points out, there was no desire to exploit the permissible maximum of the planning laws), but the beauty of the house does come from pushing the single-storey volume to the impressive height of 3.6 metres. The 35 doors in electroplated steel are designed specifically for a marine environment and so combine aesthetics with practicality. Their high shine gives a sensuous quality far removed from the more prosaic aluminium version, and they become one of the defining factors of the space. Penny Hay's introduction of the twin track for the hanging fabric walls (one fine cotton and one dense Dominique Kieffer linen) works with the doors to create innumerable options for openness and enclosure.

'There is very much a process of dialling, or tuning, our material mix until we feel we have achieved just the right balance.'

TIM HAY

The master
bedroom is in
a separate zone,
accessible by
indoor and outdoor
concrete stairs.

The interior palette is extremely easy on the eye while delivering subtle, significant design touches. The hero is the reflective brass cupboard that anchors the space and becomes a significant part of any experience within this main room. It is the backdrop to the kitchen bench, it reflects the living area and sits alongside the dining table. The plan is for it to weather and gain an interesting patina over time if the client can resist tackling it with a toothbrush. The tables, indoors and out, are bespoke, and have been designed by Penny Hay.

'The Carrara marble table is made from an unpolished and unfilled single slab,' says Penny Hay. 'We just had the sharpness taken off the edges but left it irregular. The stone ages beautifully with the sun.' Part of the modernity of her aesthetic is to surround this spectacular bespoke table (that had to be hoisted over the glass wall by 10 men and with a lot of anxiety) with unassuming Tolix stools. 'Not everything has to shout,' she says. And, indeed, many of the best touches merely whisper: the strip of brass along the top of the custom-designed bed, the just-so plaster colour of the walls, the touch of playfulness in the cane chair, Eva by Vittorio Bonacina. 'I like interiors to have their own identity, one that isn't just taken from a showroom,' says Penny Hay. 'This particular story can't be rewritten.'

The master bedroom is in its own zone – accessed internally or externally via concrete stairs, it takes on something of a loft space, elevated and with its own distinctive view of water and vegetation. The sweep of fabric wall surrounding the contemporary four-poster bed and the tonal linen sheeting combine to make it romantic while completely bypassing the girly.

As well as this elevated area, there is a lower level housing functional rooms – a laundry, a third bathroom and a cave-like guest bedroom, which is still linked to the view via a narrow strip of well-placed glazing. It has a different character to the breezy light-filled living space but takes on a feeling of protection and functional design thinking. For example, hinged stainless steel panels fold down from the wall in the laundry to create flat tables for sorting clothes, and there are racks for hanging wetsuits, and space to prop surfboards. A similar philosophy is applied to the kitchen – the cooktop is in the public space but the preparation areas and sink are all behind the brass storage unit, hidden from view. It all comes back to how Fearon Hay interprets the lives of their clients and creates a built response accordingly. 'We like to have an expectation that clients come to us for a comprehensive strategy – ideally for it all,' says Tim Hay.

The sky in New Zealand is always on the move, and one of the most striking things about this house is the effect of light on the glass enclosure. It is quite magical, varying through the day, whether in sunlight or shade, and at night often taking on a completely different character. After we had left the house, the owner emailed me some pictures of the setting sun turning the glass bright orange and deep pink. It is one aspect of the house that she constantly marvels at. 'I wanted to give you an idea of how unbelievably amazing it is in the courtyard,' she said. ▬▬▬▬

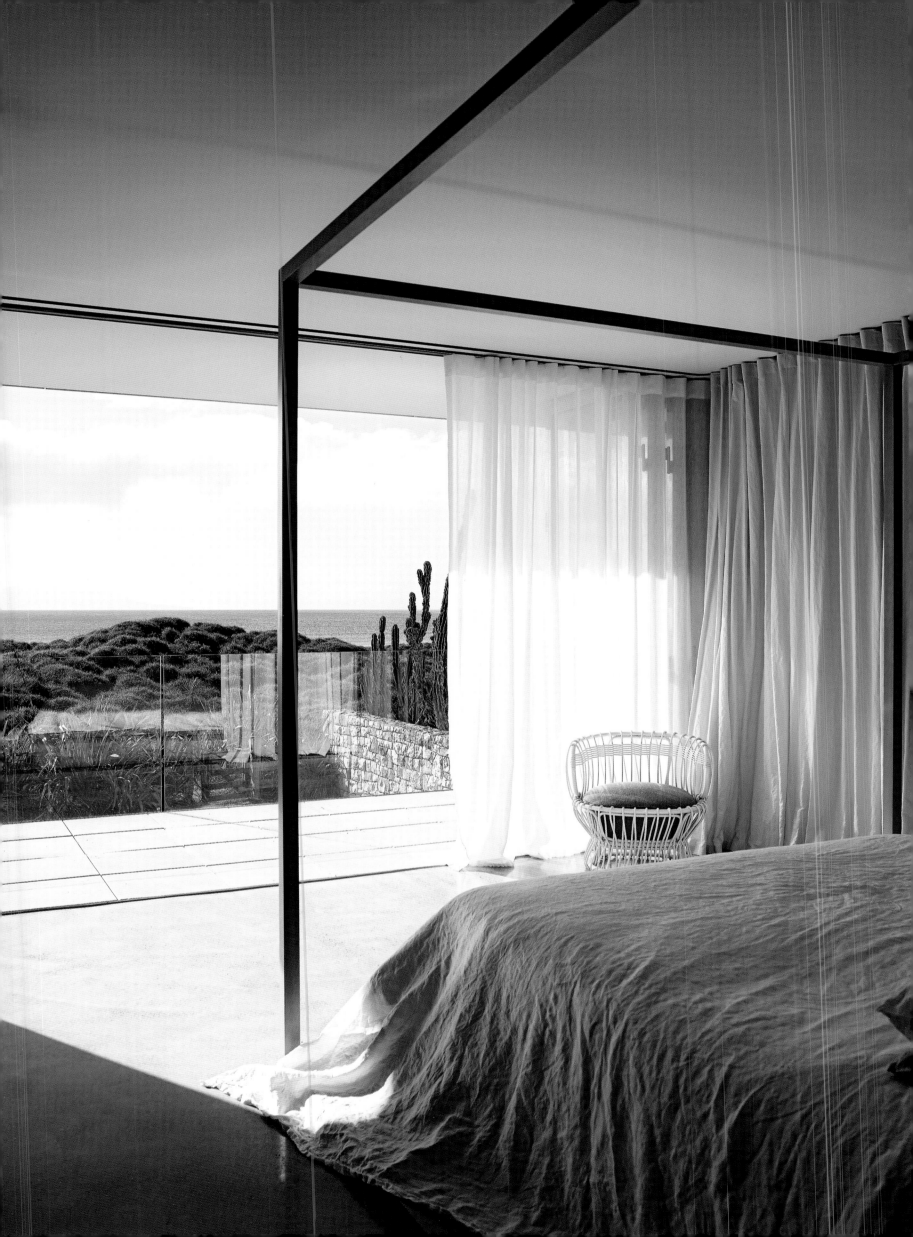

The positioning of the house screens exposure to other houses and maximises views.

The protective glass box acts as a lightbox, responsive to varying light and weather conditions.

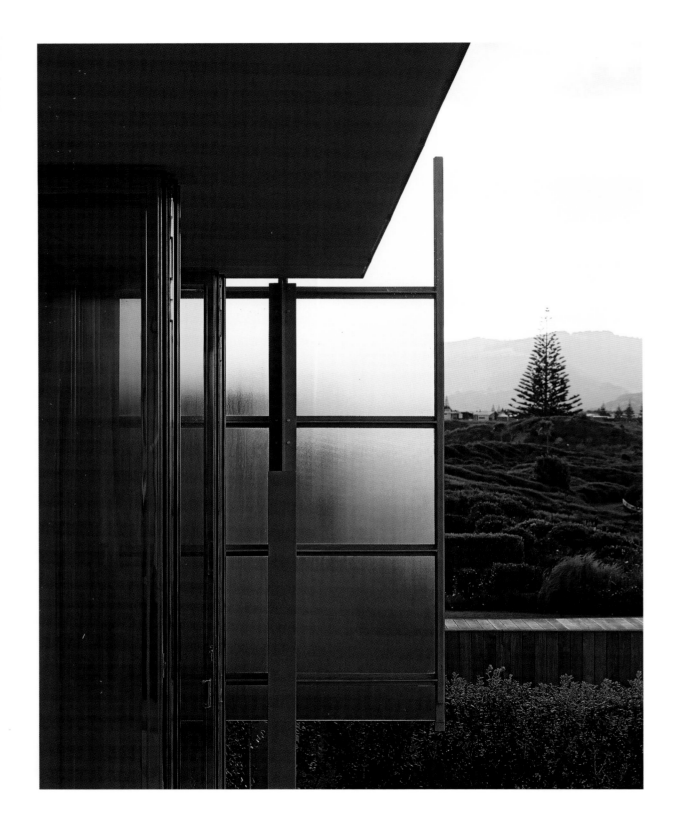

DUNE HOUSE —— FEARON HAY

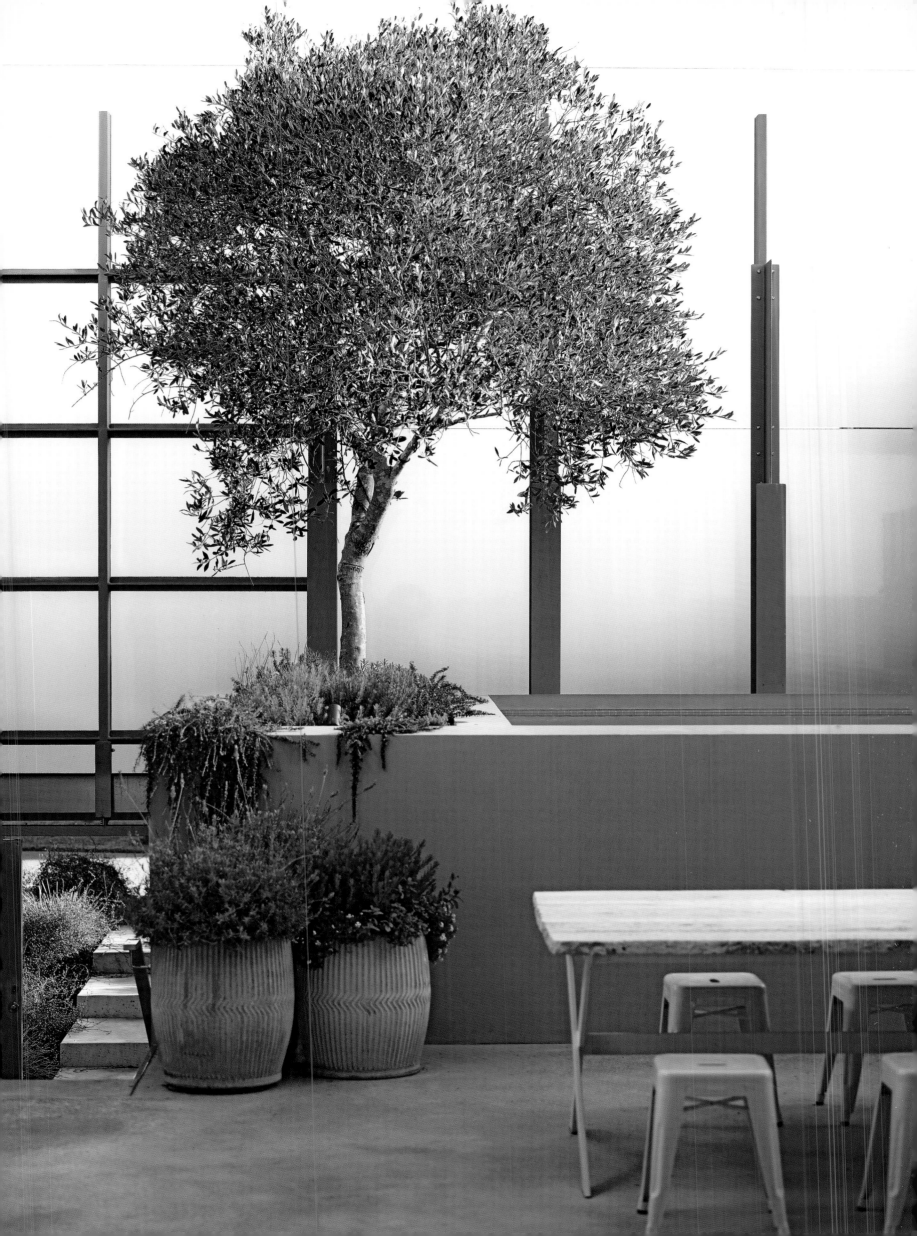

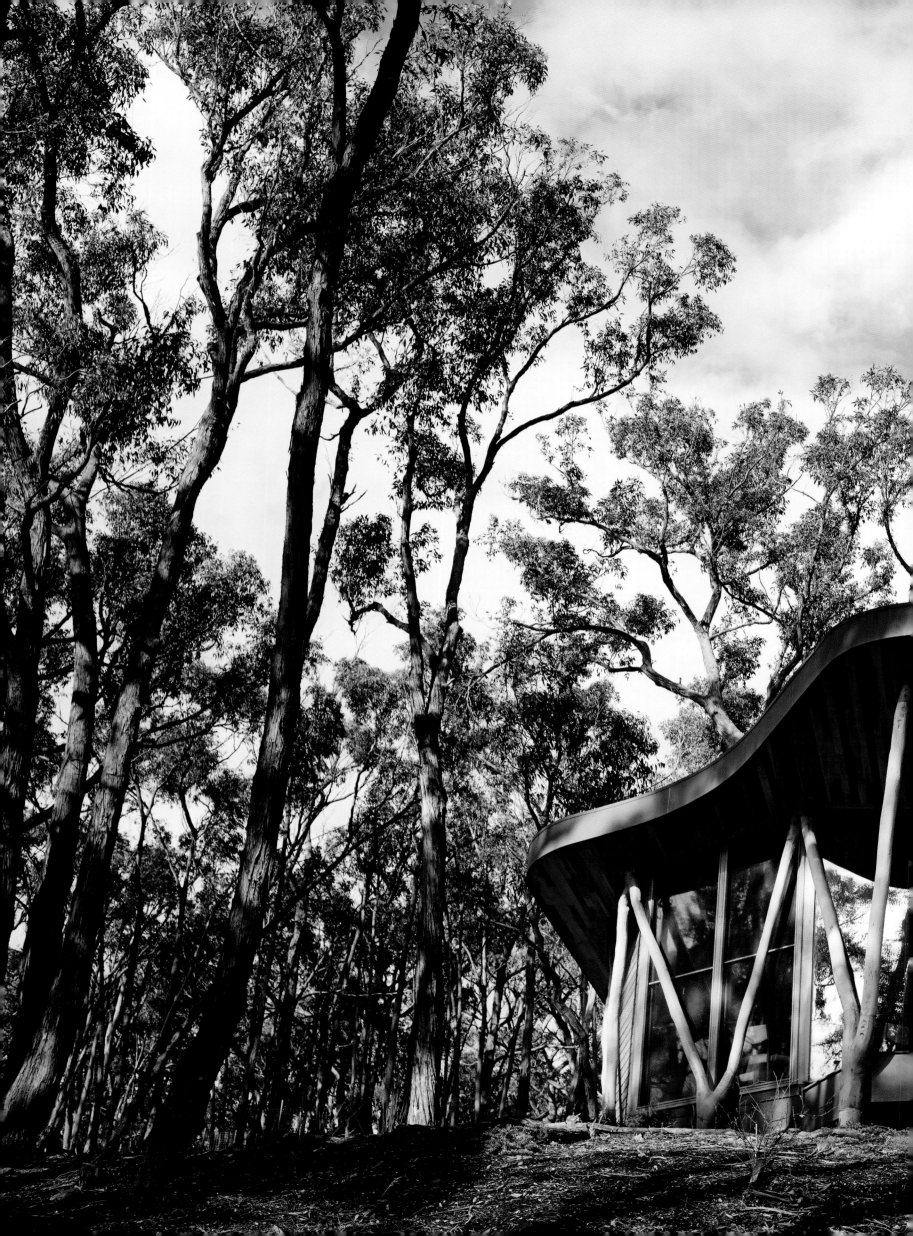

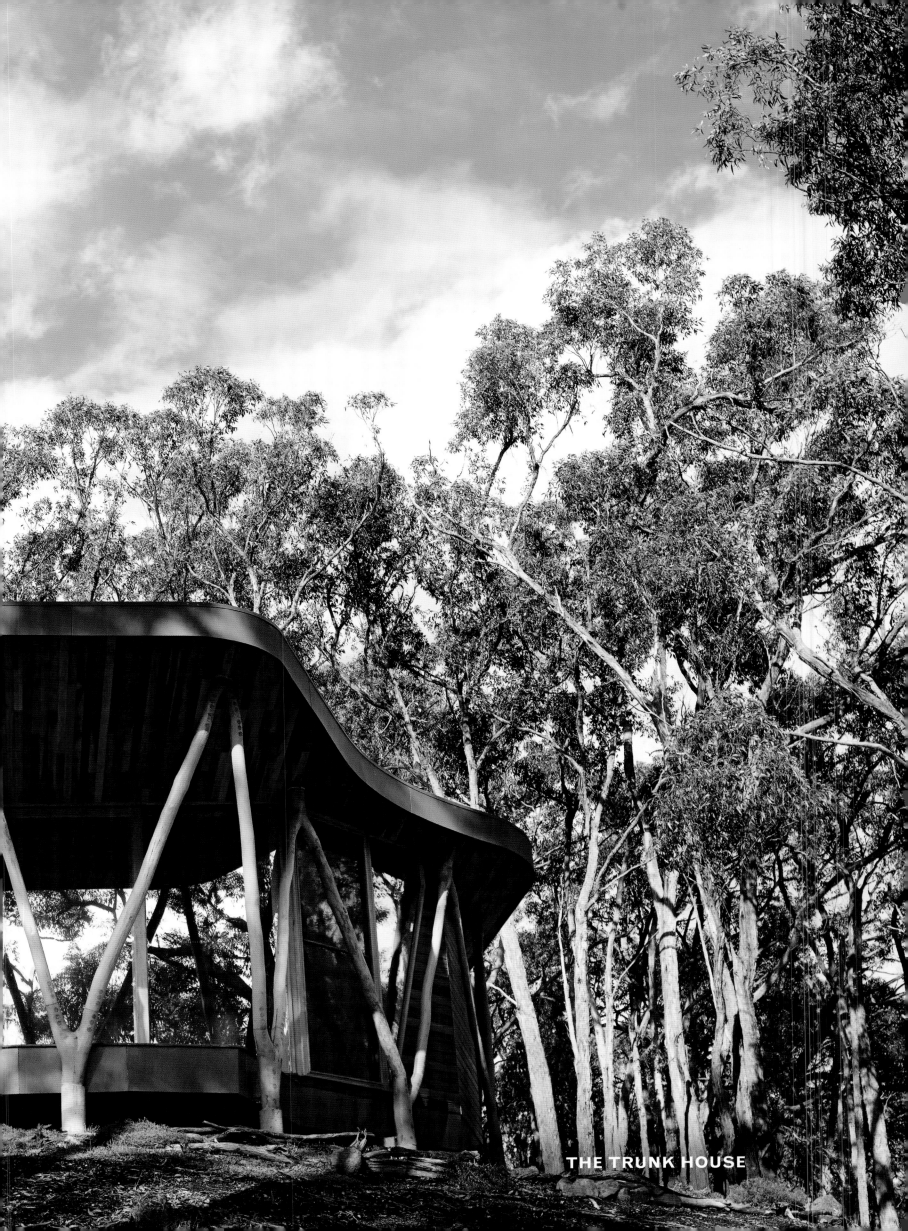

THE TRUNK HOUSE

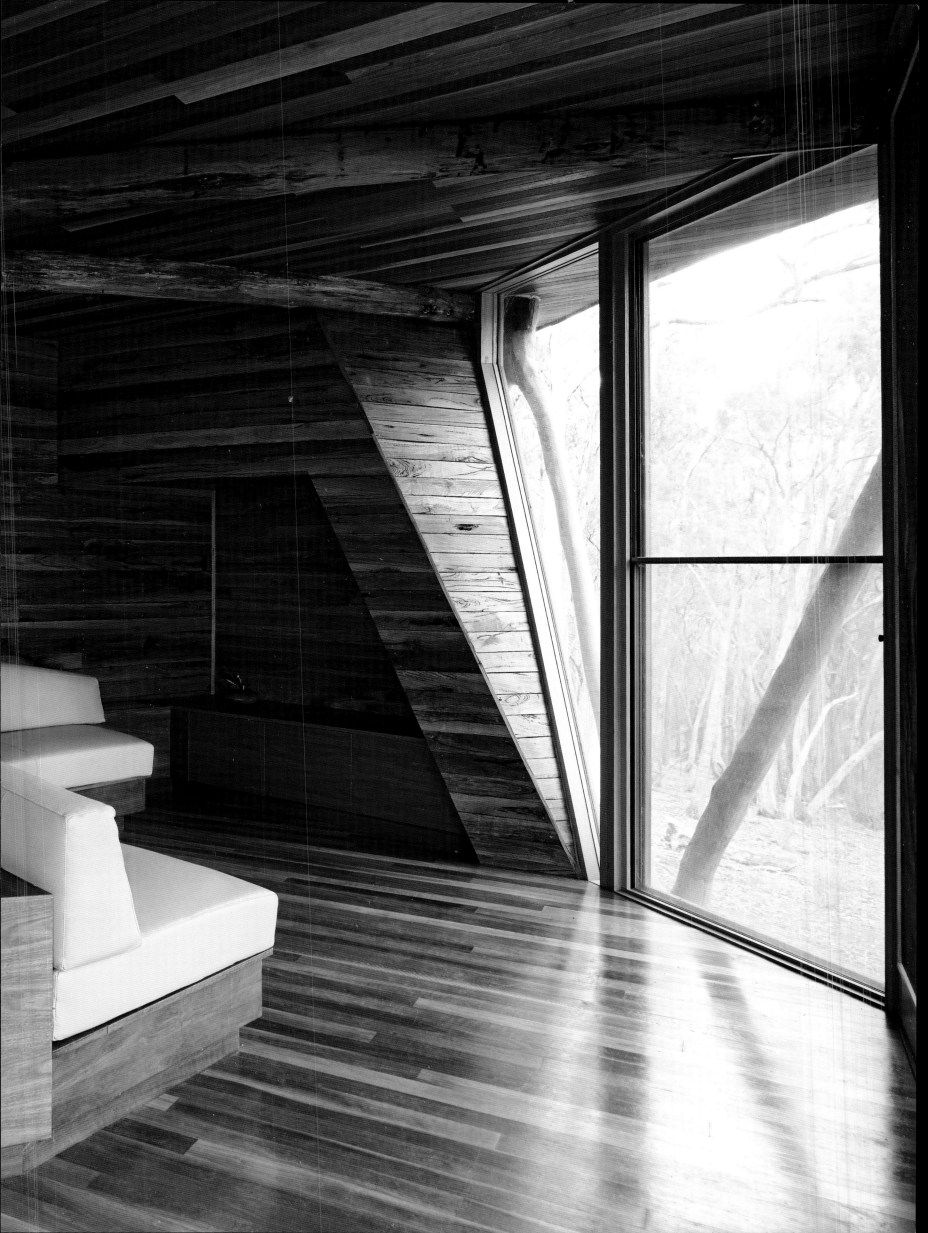

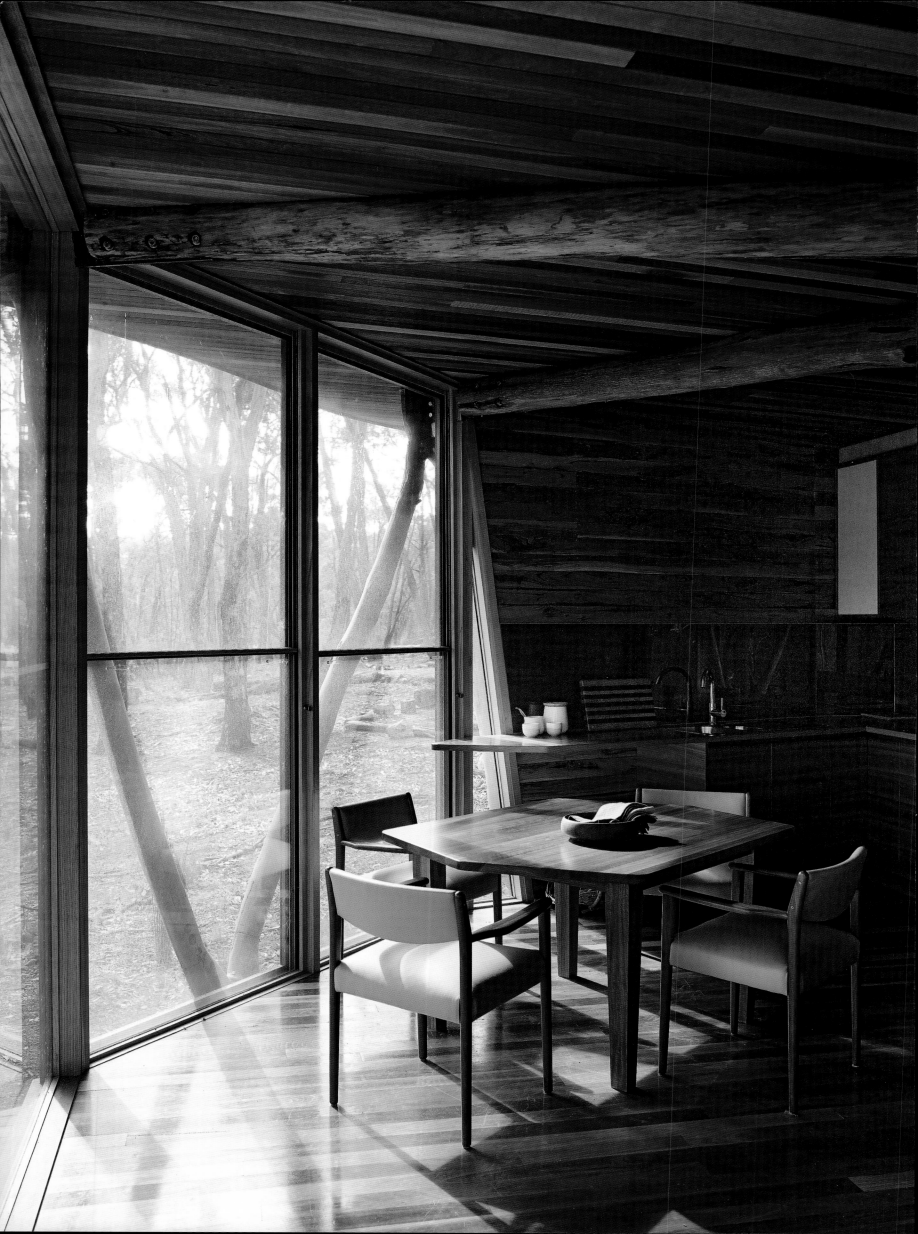

**THE TRUNK HOUSE
(2011)**

◇

**PAUL MORGAN
ARCHITECTS**

⋈

**CENTRAL HIGHLANDS,
VICTORIA, AUSTRALIA**

Interestingly, residential architecture is not the driving force behind Paul Morgan's Melbourne practice: educational and government buildings, alongside council rejuvenation projects, are at the heart of the innovative firm's work. Maybe that is what makes this architect so good at the small number of houses he has undertaken – they are the exception, not the rule.

Unpretentious timber furnishings complement the stringybark-clad interior.

The Cape Schanck House (2006), designed as a weekender for his and his sister's families, was an experimental project that won awards (2007 Robin Boyd Award for Residential Architecture in the National AIA Awards) and attracted global attention for its combination of innovation coupled with sustainability. As Helen Kaiser pointed out in *Mark* magazine, 'What makes this an example of noteworthy architecture is its utter subjugation to the big idea.' And in this instance, the big idea is an enormous white metal water tank in the shape of a bulb, or teardrop, forming the central feature in the living space. Rest assured, it works, visually and practically, both as a sensuous sculptural form around which the rest of the space pivots and for gathering rainwater and creating ambient cooling in summer.

The house is set on a small coastal block in a glade of tea trees in Cape Schanck, an enclave at the lowest point of the Mornington Peninsula where the air from the Southern Ocean is pristine but fierce enough to sculpt the vegetation. 'I am very interested in the organic patterns in nature – how trees grow towards the light, and the kinetics of the environment, how wind flows through the site,' says Paul Morgan. He responded to the slope of the land, to the climatic considerations and the native vegetation to produce a building form that impressed the awards' jury. 'The resultant shaping provides a drag co-efficiency bettered only by a Citroën CX,' the citation notes. I explain the Cape Schanck House only because it informs both what the Trunk House is, and what it isn't, with differences and similarities each holding equal weight in the concept and design.

As is often the case, the clients were friends of friends and the brief was for a bolthole, a cabin in a forest near Ballarat, in the Central Highlands of Victoria. 'They were very clear in their expectations in terms of atmosphere, number of rooms and the relationship to the natural environment,' says Morgan. 'As medical practitioners, and experts in their field, they expected the same from me as an expert in mine.'

His clients were architecturally literate having recently visited Gaudí's Sagrada Família in Barcelona where the skeletal, biomorphic structure had appealed to them. In order to draw out more fully from his clients a sense of the design approach, Morgan did a wise thing and suggested

Bespoke joinery,
precise in its form,
contrasts with
the structural
tree trunks.

they have a weekend in his house in Cape Schanck. 'I wanted their frank and open responses – what they liked and didn't like, what applied and didn't apply. I was also keen to open their eyes to the sheer possibilities of what architecture can be, and for them to be aware that they didn't necessarily need to limit themselves to conventional forms and building materials.'

The design process was not straightforward, with Morgan aware that a solution couldn't be forced upon a site. He explored certain design approaches used by the practice – flattened, extended forms – which he came to realise simply weren't working because the forest 'contained' the building and the wind flow was tempered by the dense tree canopy. He took a step back to first principles and began to think about making form, taking inspiration from the bones of sheep and kangaroos found on the site. 'I was working with a great conceptual engineer, Peter Felicetti, who suggested bifurcated tree forms as analogous to bone, so we began exploring that solution,' says Morgan.

As a result of the clients staying in the white-walled, gallery-like space of Cape Schanck, they knew they wanted a timber solution, something that felt 'of the forest'. Morgan explored the idea of metal-covered materials to mimic bone before settling on the idea of trees themselves. He engaged a sculptor, Mike Conole, to source and prepare a number of bifurcated eucalypts strong enough to hold up the house. 'With his mix of skills as sculptor, artisan and woodworker, Mike was the only one who could have done this,' says Morgan. 'He found all the trees nearby – on his own property, local farmland and in national parks where he had a licence to take timber.'

It took time, 10 months to be exact, to source and season pieces that combined strength, form and beauty, and had no rot or borers. They are the defining element of the house and, as such, the care and consideration taken in their selection was paramount. While they appear as nature intended, the bifurcated supports are, in fact, strengthened with metal dowels, countersunk and then filled in so as to disappear. 'There is an interesting confusion when you are inside looking out – a blurring of line between structure and the living trees in the forest.'

Morgan interviewed 26 builders until he found the right firm for the job in terms of skill, availability and budget. Karsten Poulsen had worked with such architects as Peter McIntyre and Kerstin Thompson before, so was fully aware of the processes and consultation required for the relationship to work.

In the spirit of creating a building 'of the forest', a mobile milling machine was brought onto the two-hectare site and the cleared stringybark trees were milled to form lining boards for the main living space. 'We seasoned the timber for eight months and when it went up it had this strong characterful grain,' says Morgan. 'We simply oiled it to give it depth.' It is no wonder that this six star green-rated house leaves a low carbon footprint.

But this sustainable approach, sensitive scale and innovation did not guarantee a smooth passage through council's bureaucratic processes. 'I think they were confused by it, and their lack of understanding led to unnecessary conversations and delays,' says Morgan.

Due to Morgan's interest in the idea of a total environment, the interior solution is as conceptually cohesive as its exterior counterpart. 'I use the term "mise en scène" from the world of theatre to mean the overall effect of the set design, the costumes, the lighting etc, and I think the same applies in architecture.' The interior mixes timbers in an unique way: tree trunks, used structurally, radiate from a central point, smooth but essentially still more tree than timber; the lining boards have a slightly rough texture from the on-site milling, while the built-in furniture is refined and exploits a soft geometry in its design.

'I am very interested in the organic patterns in nature – how trees grow towards the light, and the kinetics of the environment, how wind flows through the site.'

PAUL MORGAN

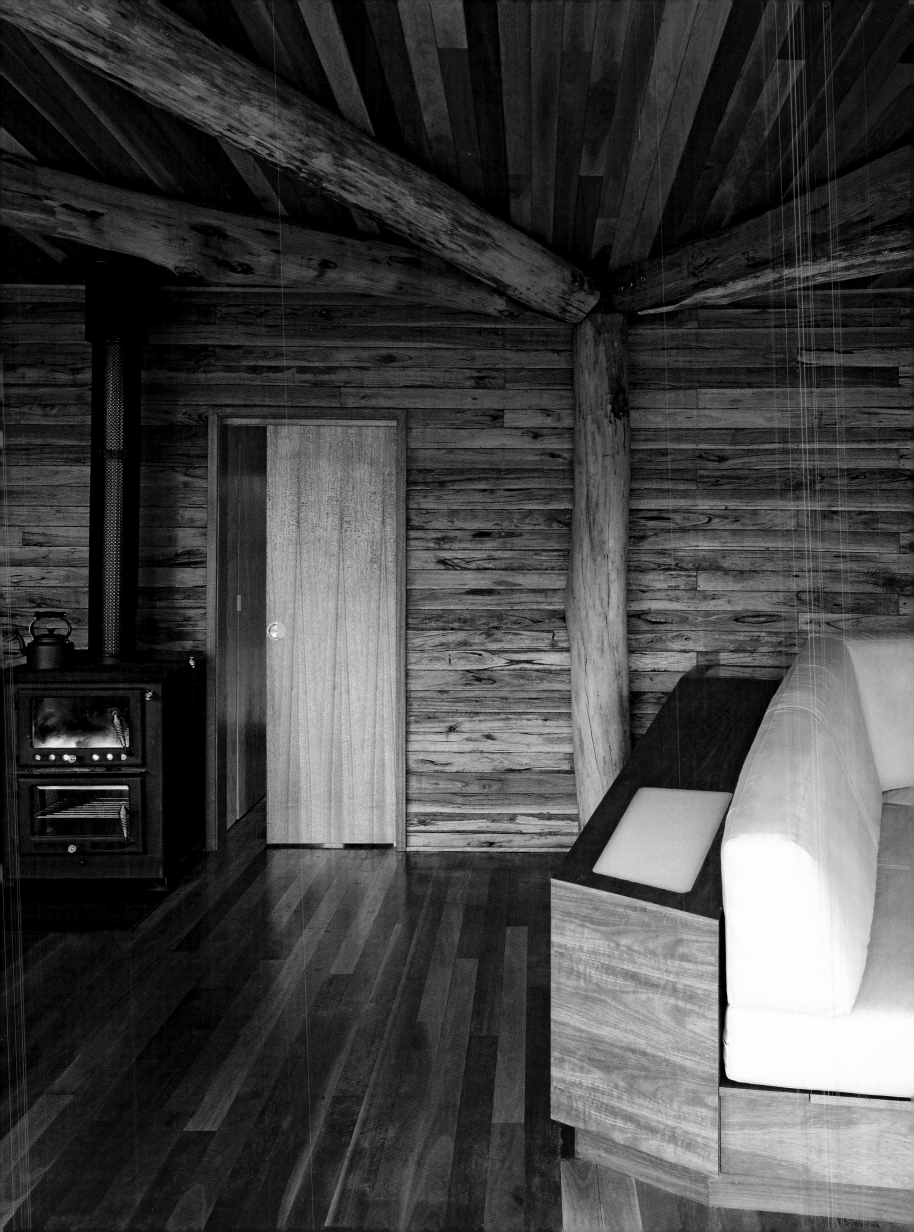

Set within a tangle
of trees, the
bifurcated supports
create a pleasing
confusion between
constructed and
natural forms.

The space is divided into two adjoining zones, of living and sleeping. In the living zone, a loosely L-shaped seating configuration turns its back on the kitchen to create a contemplative area for reading and relaxing. The seating unit is both functional and a piece of interior sculpture with built-in lighting flush with the timber surface which, when it glows, emphasises the angle of the seating. The kitchen benches and dining table were again designed by Morgan, reflecting a slightly fractal, modern feel that denotes the space as contemporary. Old waiting-room chairs of simple Danish design were re-covered in leather to match the sofa cushions, giving the space a quiet, spare feel through a limited palette of materials. The angles and textures of the timber become all-important as light filters through the trees and into the room.

The back section of the house – two small bedrooms, a hallway and a bathroom – is clad in limed ply, a pale timber that helps lighten the area. There is a sense that these are functional spaces playing second fiddle to the crafted beauty of the main living space. The hallway houses a fridge, and storage for clothing and cleaning items, while the simplicity of the bedrooms highlights the V-shaped windows that align precisely with an external bifurcated trunk, visually linking the interior and exterior.

This tiny cabin, set on the crest of a hill in a dense forest of trees (286 were surveyed as part of the submission to council), is both entirely new in its concept and execution and yet manages to forge a link, through an indirect association, with Victorian architecture of the Fifties and Sixties, particularly the experimental ethos of Kevin Borland and Chancellor and Patrick.

Morgan is conscious of this handing down of a collective philosophy, and acknowledges his own direct debt to Peter Corrigan, Howard Raggatt and Ian McDougall, his tutors at RMIT in Melbourne. There is something to be said for the idea that to truly look forward it is helpful to glance back, just a little. ▬▬▬

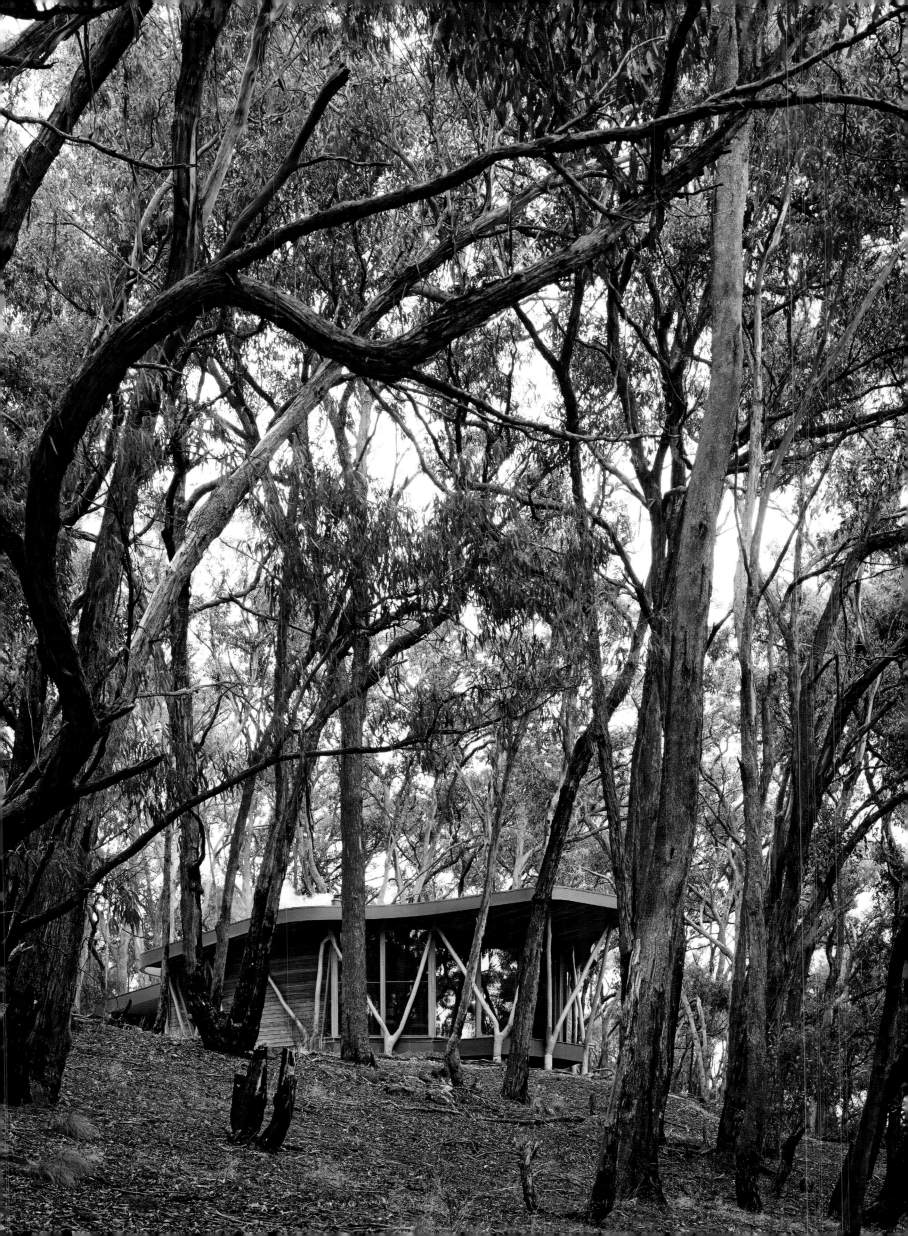

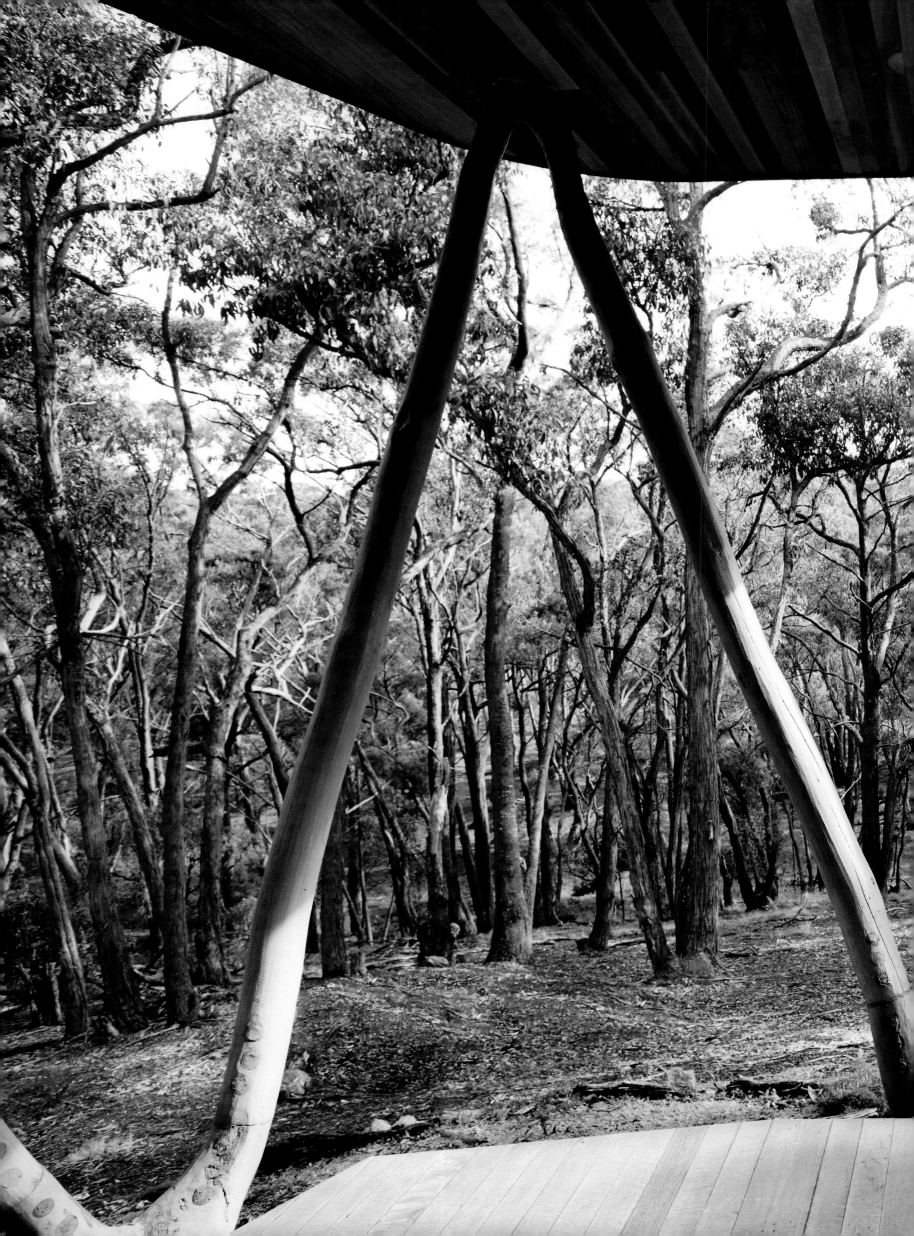

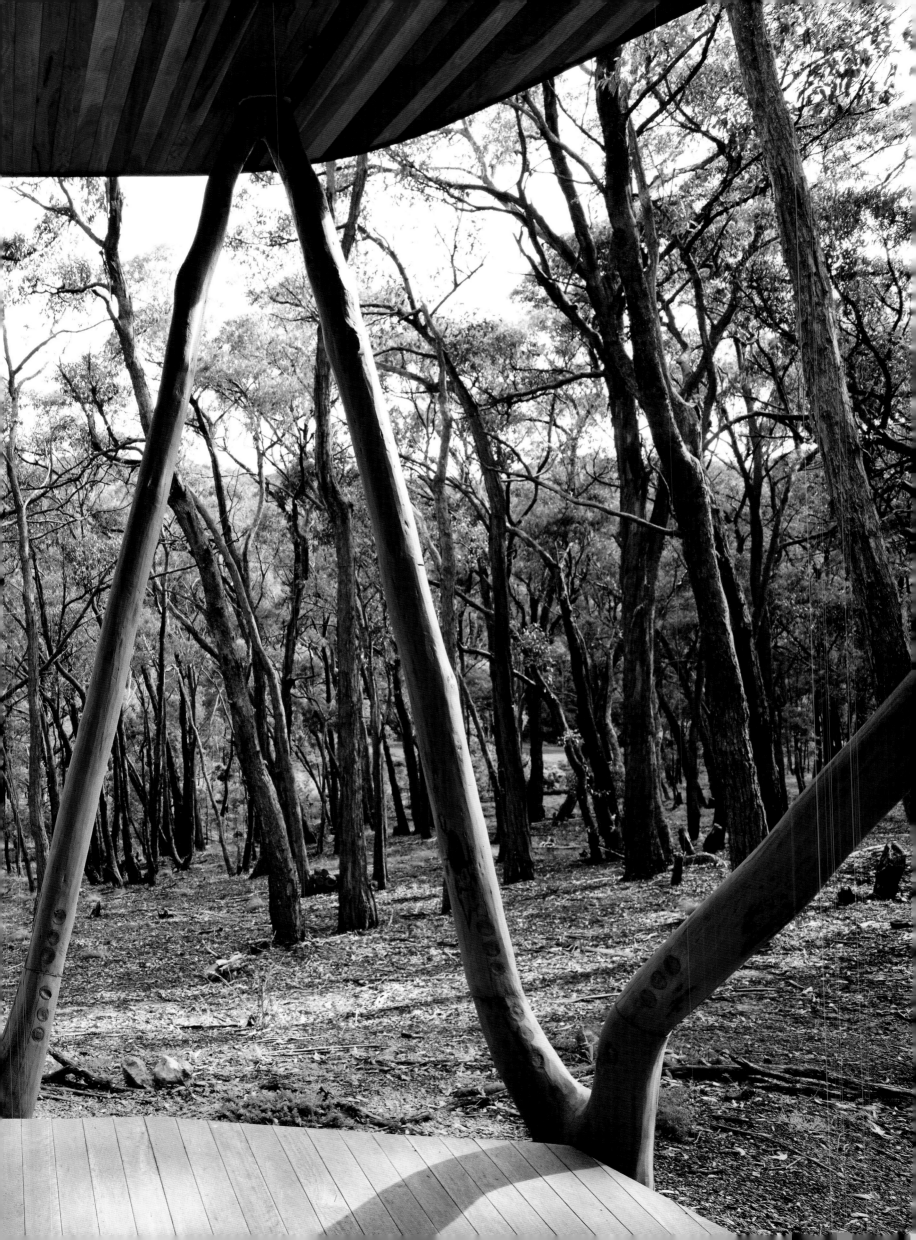

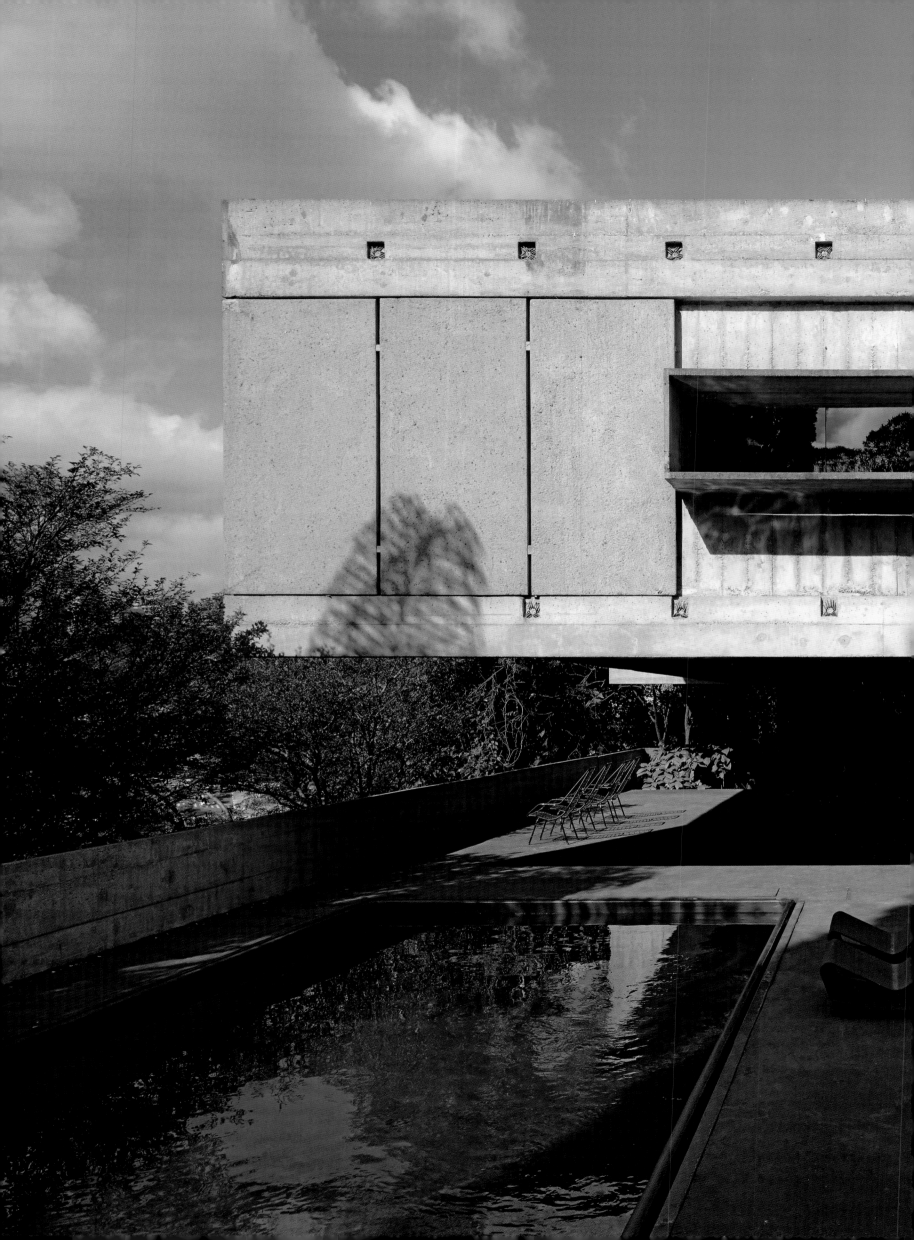

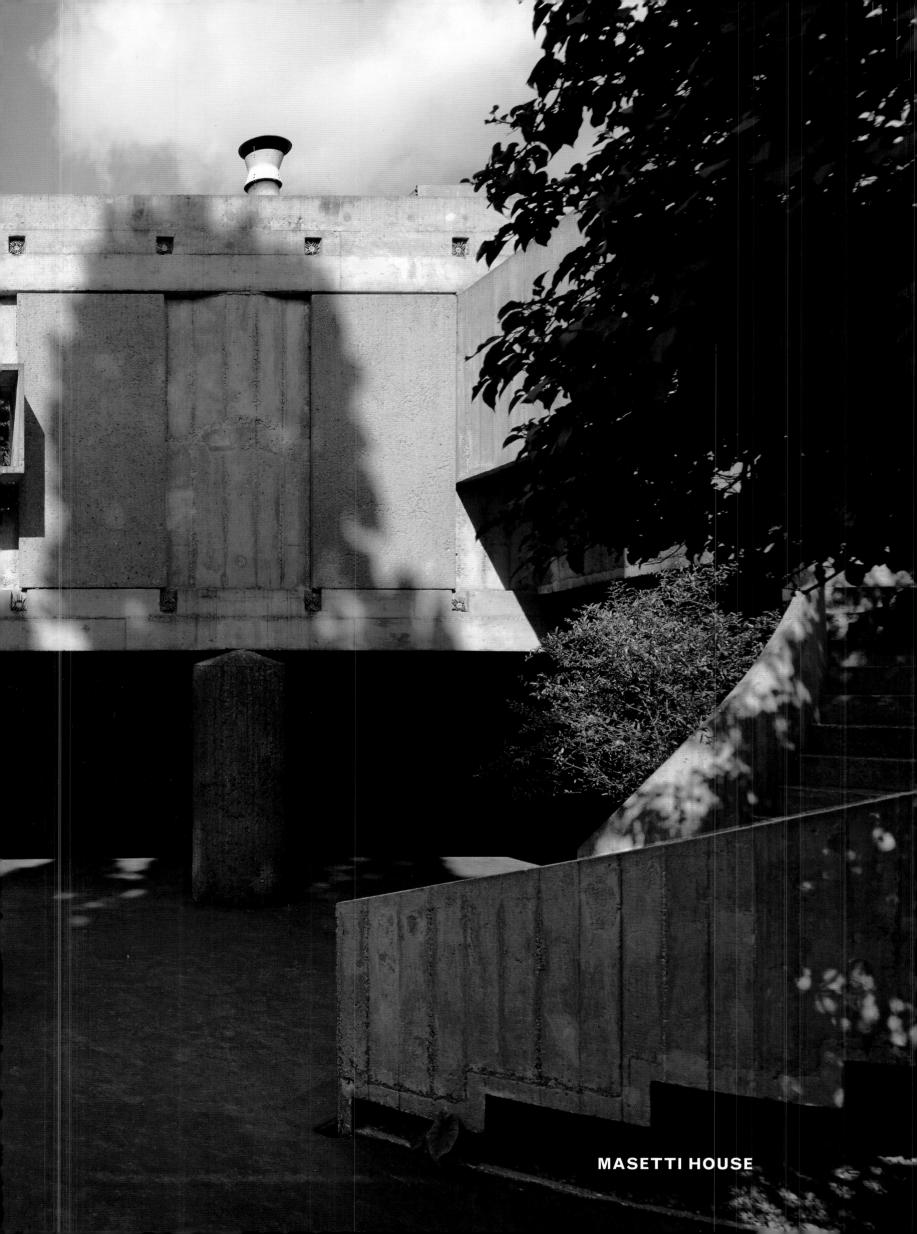

MASETTI HOUSE

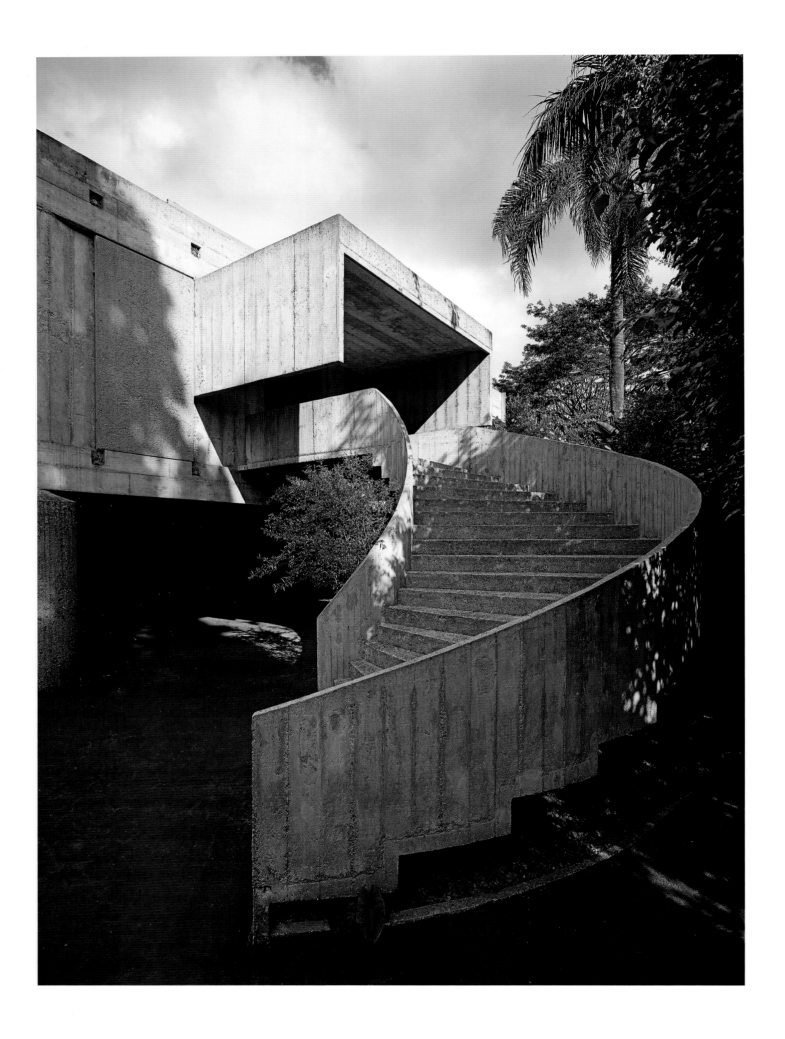

MASETTI HOUSE —— PAULO MENDES DA ROCHA

**MASETTI HOUSE
(1969)**

◇

PAULO MENDES DA ROCHA

⋈

**SÃO PAULO,
BRAZIL**

When much celebrated Brazilian architect Paulo Mendes da Rocha won the highest accolade his profession could bestow, the Pritzker Prize in 2006, the judges' comments were very revealing. 'Inspired by the principles and language of modernism, he brings a renewed force to each of his projects through his bold use of simple materials and a deep understanding of the poetics of space,' commented executive director Martha Thorne. Juror Karen Stein noted how he was 'consistently pushing the sculptural limits of structural form to surprising and often poetic effect', while Carlos Jimenez praised how he 'transcends the limits of construction to dazzle with poetic rigour and imagination'.

The key word running through their critique of his work is 'poetic', which is an interesting response to an architect whose philosophy is rooted in the Paulista Brutalism of Brazil in the Fifties, working with monumental, uncompromising forms, raw unadorned concrete and the honesty of exposed services. But therein lies his genius.

A review of his body of work reveals that poetry is something he intrinsically understood early on. Graduating from Mackenzie Presbyterian University architecture school, São Paulo, in 1954, he was clear that his vision had developed through the school's combination of the 'consistency of technique of engineering' and the 'critical scrutiny engendered by the same line of thought as underlies the philosophy faculty'. Mendes da Rocha's work is often praised for its humanity and social engagement while not shying away from the structural bravado that immense confidence in one's technical ability brings.

This very combination of attributes is illustrated with Mendes da Rocha's award-winning entry in a national competition to design the Paulistano Athletic Club Gymnasium (1958) in São Paulo. Engineered to hold 2000 spectators, the design comprises reinforced concrete and an ingenious metal covering suspended by iron cables. It is a dynamic structure, with futuristic geometry that takes into account light, crowd movement, the building's relationship to the street and access to the club's inner gardens. 'The Paulistano Athletic Club's circular marquise, with its six supporting columns, is distinct from the Greek epistyle,' said Mendes da Rocha. 'Nevertheless it was equally driven by the desire to establish a clear distinction between interior and exterior, a way of harbouring certain types of behaviour, experiences and human meanings.' It went on to be awarded the Presidential Grand Prize at the São Paulo Biennial's International Exhibition. Mendes da Rocha was 30 years old.

A lifelong relationship with teaching began in the 1960s when João Vilanova Artigas, one of Brazil's pioneering avant-garde architects, asked Mendes da Rocha to join him at the University

On a cliff edge, the Masetti House demonstrates a high degree of technical expertise and architectural bravado.

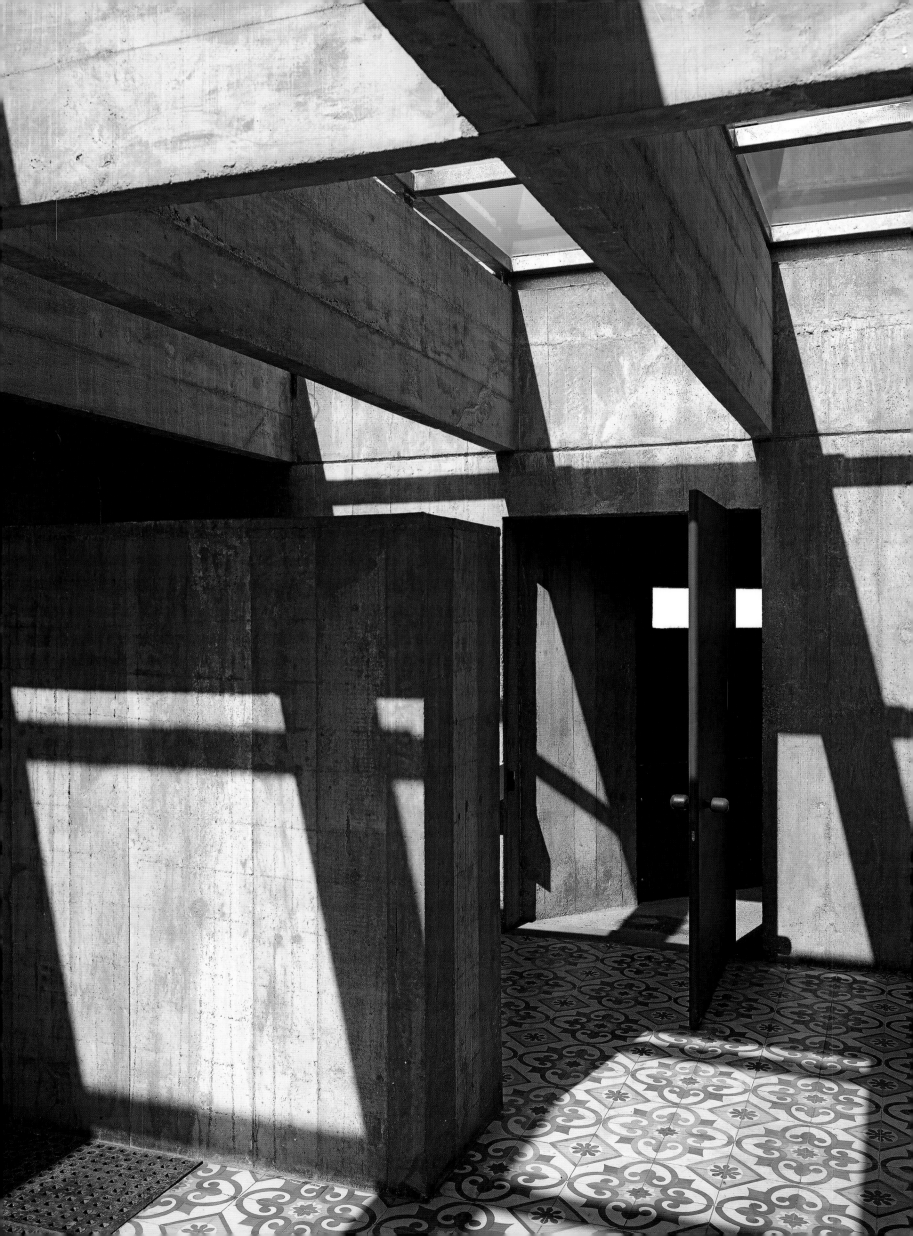

From the front door, the combination of Portuguese tiles and use of concrete is established.

The articulation of windows is one that Mendes da Rocha also used in his own home.

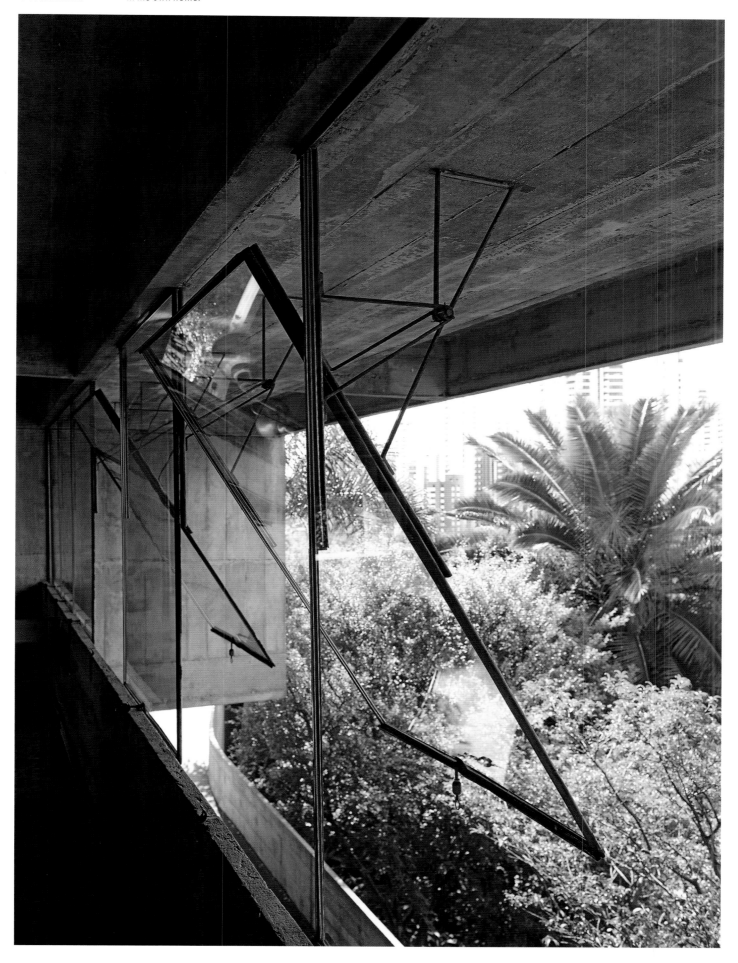

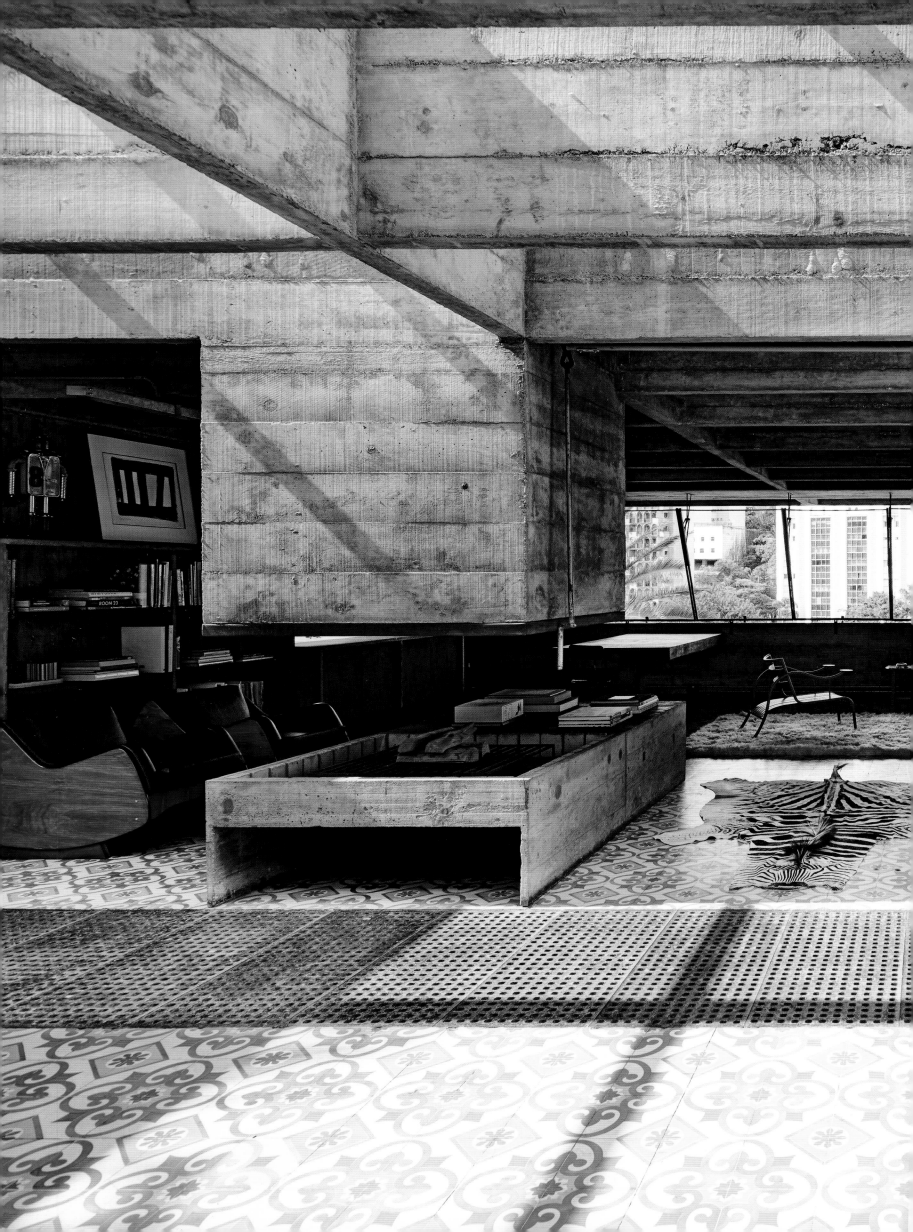

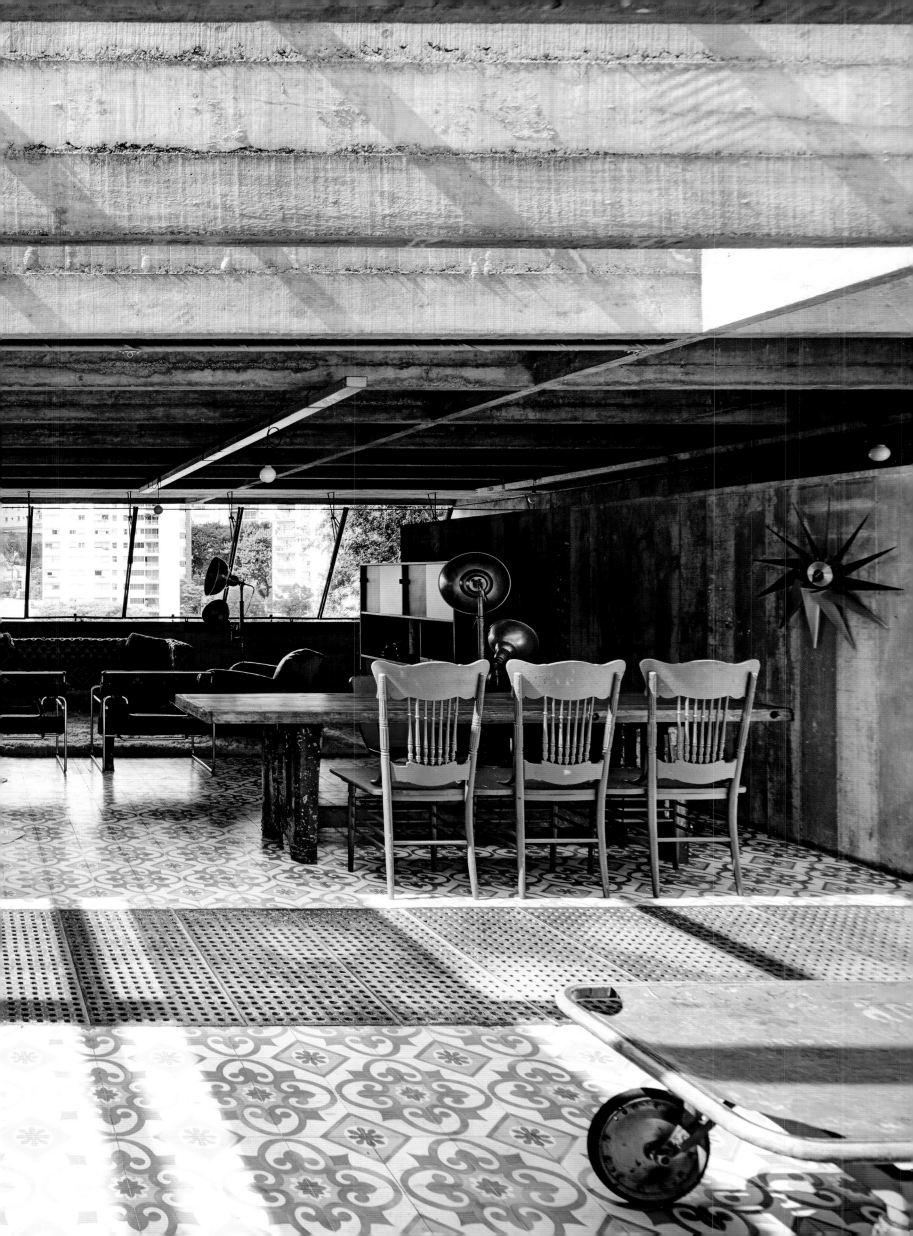

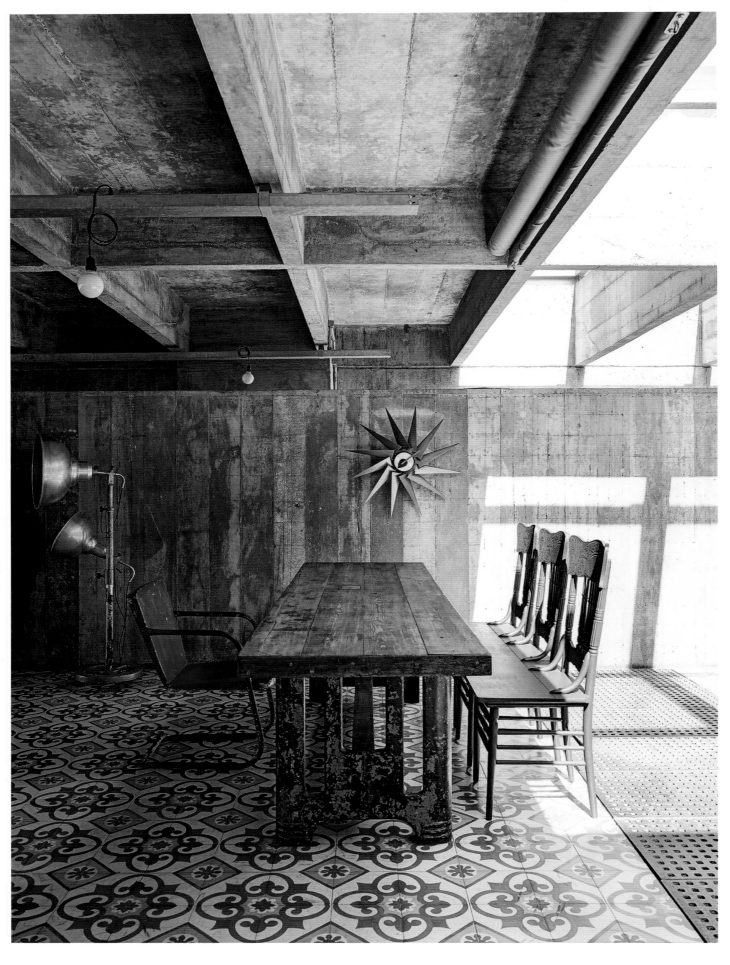

Skylights enliven
the interior with
ever-changing
shadows and
shafts of light.

Even with a number
of built-in elements,
the interior is robust
enough to be open
to interpretation.

MASETTI HOUSE —— PAULO MENDES DA ROCHA

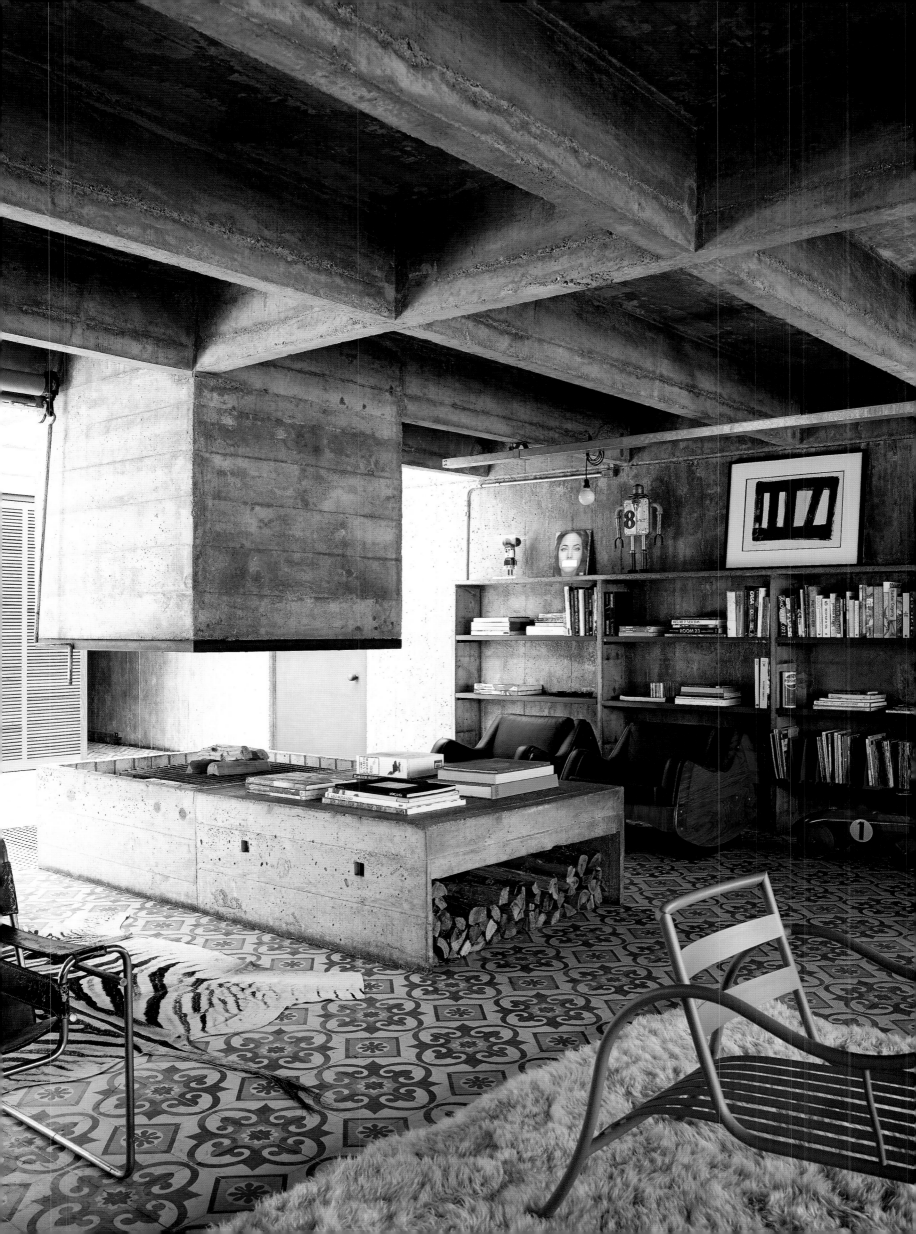

The present owner
was determined to
restore the house
in line with Mendes
da Rocha's original
design intent.

of São Paulo. He was a professor there until the military dictatorship forced him to resign in 1969, the very year he designed the Masetti residence.

The Masetti commission was around the tenth private house Mendes da Rocha designed and, by this stage, he clearly understood the visual language he brought to the domestic space. Before him, Vilanova Artigas had challenged the notion of what a bourgeois house should be, illustrated clearly by his ground-breaking Bittencourt House (1959). Its large, encompassing roof is vital to the structure. Bedrooms, kitchen and service areas are positioned at the front, while the back allows for expansion of open-plan family living spaces. Internal gardens between the two zones bring the outside in. It is how we want to live now – in São Paulo in the late Fifties, it was revolutionary.

Mendes da Rocha's approach was no less radical – João Masaokami noted that he 'reassesses the concept of domestic life and of what should be considered familiar, emotional and close at hand'. He lived as his clients lived, and the house he built for his family in 1964 is notable for the many design traits that play out in the Masetti House five years later.

Mario Masetti, a civil engineer, was perhaps the best client to understand the structural and technical expertise needed to site a house on a cliff edge 30 metres above the ground. São Paulo is a high-rise city and this is a high-rise house, its elevation creating an impressive urban view from the main living space. It is essentially a simple single-storey volume with its weightiness and monumentality balanced by the flourish of a curved staircase from the pool and parking area to the entrance. Well, nearly to the entrance – it stops short, and just enough to give pause for thought. 'The house has an extraordinary structural delicateness and an incredibly precise equilibrium. It is a union of art, science and technology,' said Mendes da Rocha.

The technology comes in the form of two horizontal pretensioned concrete beams which support the entire volume and form the base of the structure. This is then set on four massive concrete columns. It sounds simple – crude, even – but it is the combination of the deft sense of proportion, the manipulation of angle against curve, of concrete against glass, of pattern against plain that give its beauty.

'The house has an
extraordinary structural
delicateness and an incredibly
precise equilibrium. It is
a union of art, science
and technology.'

/

**PAULO MENDES
DA ROCHA**

Its present owner, Houssein Jarouche (who also owns the design store MiCasa), bought the house from the Masetti family. A longtime admirer of the architect's work, Jarouche's friend Edward Leme had commissioned Mendes da Rocha to design his art gallery, and gave him the heads-up that the Masetti property was for sale. 'I was drawn to the way the house floats above the natural landscape,' Jarouche says. 'It is brutalist but very light.' He had no intention of making over what he knew to be a masterpiece; instead he set about a process of restoration with the aim of 'maintaining everything that was original and rebuilding everything that had been changed'.

Mendes da Rocha visited the house and found its robust design and construction had stood the test of time, and the works required were not extensive. He asked Eduardo Colonelli of São Paulo Studio of Architecture, a longstanding collaborator and one-time student of his, to oversee the restoration. Colonelli recalls that, while principally intact, 'some aspects were damaged by use, [including] the structure of the skylight and electrical installations; inappropriate painting of the walls and many points of deterioration of the concrete'.

Internally, the house is very much about the ceiling and the floor. The floor is covered with traditional patterned Portuguese tiles made of tinted cement, which have become more beautiful with use, while the ceiling is a series of repeating concrete beams forming a measured regularity.

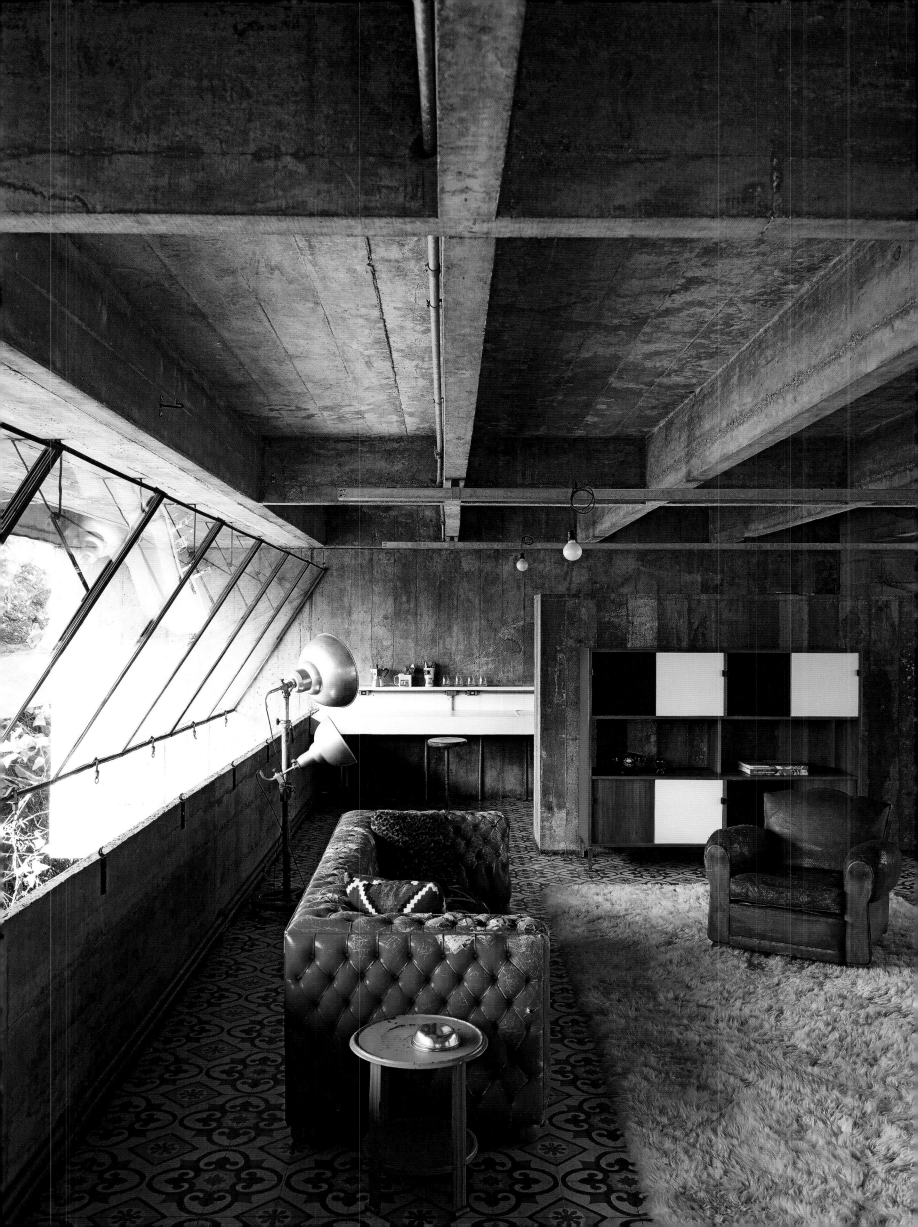

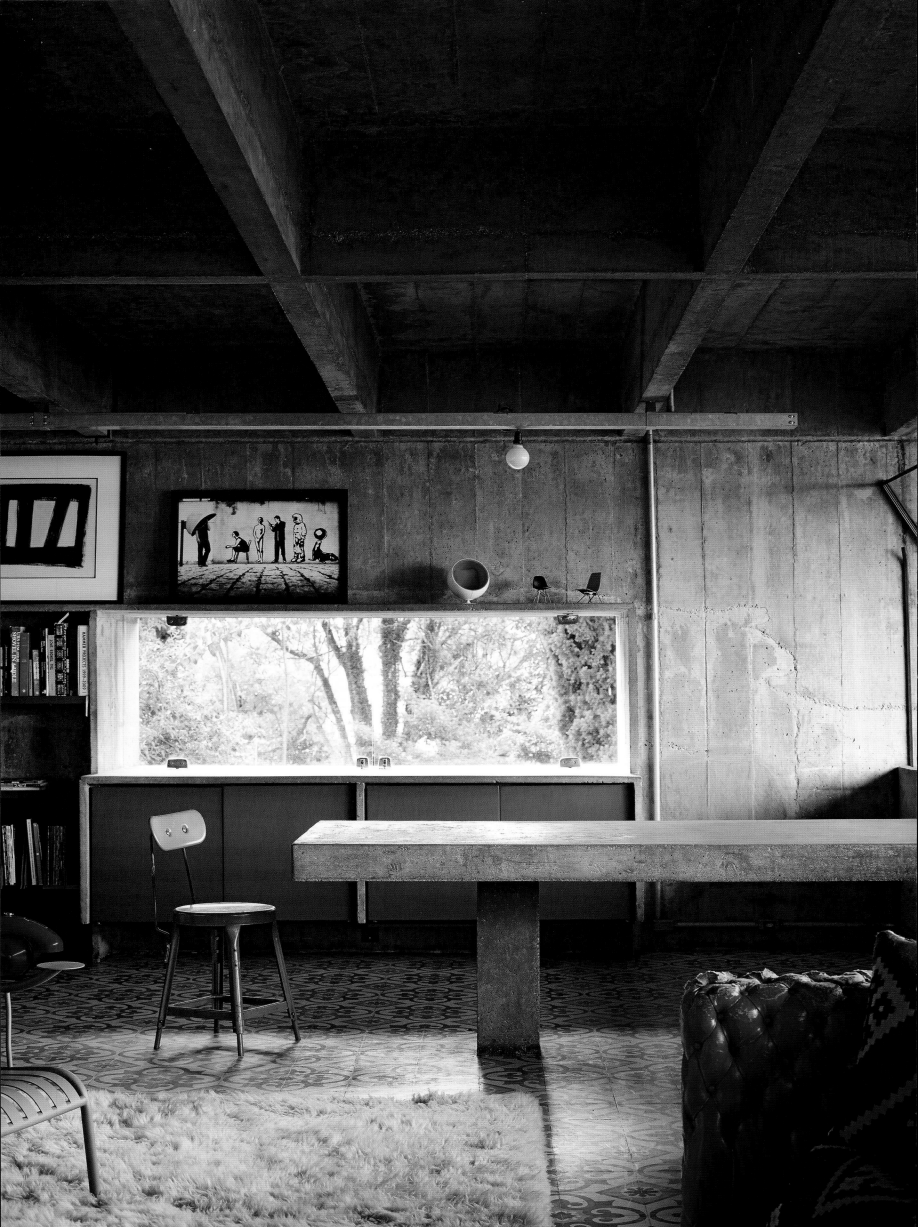

The built-in
concrete dining
table, emerging
from a side wall, is
an original feature.

The current owner,
who has a design
store, has brought
in an eclectic mix
of furniture pieces.

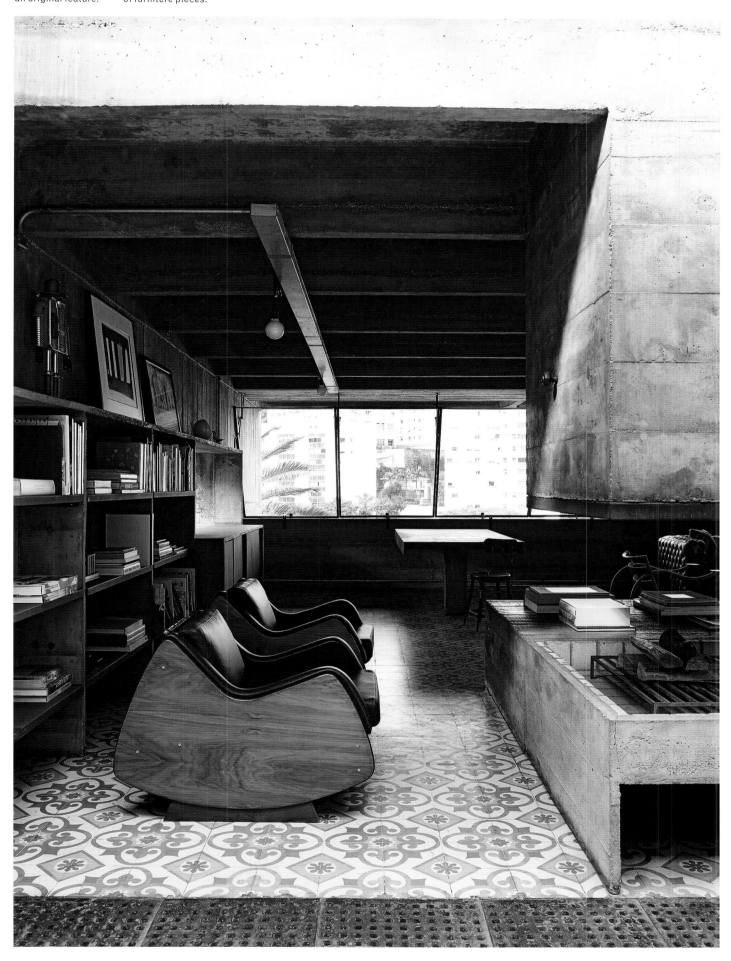

With an industrial
sense of honesty,
services are left
visible throughout
the house.

The importance of these two planes is emphasised by the fact that internal walls are partitions, not ever reaching the ceiling. Skylights set into the ceiling were replaced as part of the restoration, as was the bank of glazing that runs the length of the main living space. The clever articulation of these windows, through a system of pulleys, is the same as in Mendes da Rocha's own home. 'The intense natural light that comes in through the skylight, the design of the windows and the use of materials *in natura*, the transparency and visual relationship between interior and exterior and the "lifting" of the house to liberate the ground area' are just some of the defining factors, according to Colonelli.

The streamlined, spare feel of the house succeeds through the integration of various functional elements directly into the structure. The fireplace, with its three-dimensional solidity in the centre of the living space, the concrete dining table emerging from the side wall and the exposure of the plumbing pipes all contribute to a sense that the house is ready for living. Even the bathrooms, located in the bedrooms, are self-contained concrete capsules with showers and bent copper pipes forming sculptural towel rails. 'Architecture does not desire to be functional,' said Mendes da Rocha. 'It wants to be opportune.'

While the concrete adds texture, which comes from the timber grain of the moulds, and the timber brings warmth, colour plays an important role as a counterpoint to the overall grey palette. The soft patterning of the cement tiles, the bold primary blue of the front door and the pea-green of the pendant lights introduce highlights of colour as originally intended. Jarouche could have brought in any number of designer lights but, in keeping with his desire to restore rather than renovate, he chose to keep the originals.

Similarly, the louvres were replaced in timber as originally intended, and the swimming pool was painted a dramatic black, as Mendes da Rocha had always wanted. He just had to wait 45 years to have his wish granted.

'The house doesn't need too much, it is really living in contact with the architecture and the landscape,' says Jarouche, who feels it is like a cottage in the sky. He uses it as one would a holiday house (which just happens to be in the city), inviting friends for barbecues, watching his son run around in the garden and indulging in his love of music and his hobby as a DJ. In an area on the lower level, where there were once rooms for staff, he has made a small dance floor.

There is no doubt there is a meeting of minds. Mendes da Rocha's philosophy suits Jarouche's aesthetic. 'It is not rigorous,' says the architect. 'It's very free. You can put a chair here, a bookshelf there – bring in a piano, whatever you like. Anyone can live there.' And while it is true, Jarouche's access to great design pieces and the way he places them, with the air of the seemingly casual, brings it to life, emphasising the timeless quality of the architecture. A twentieth-century icon has become a twenty-first-century home. ▬

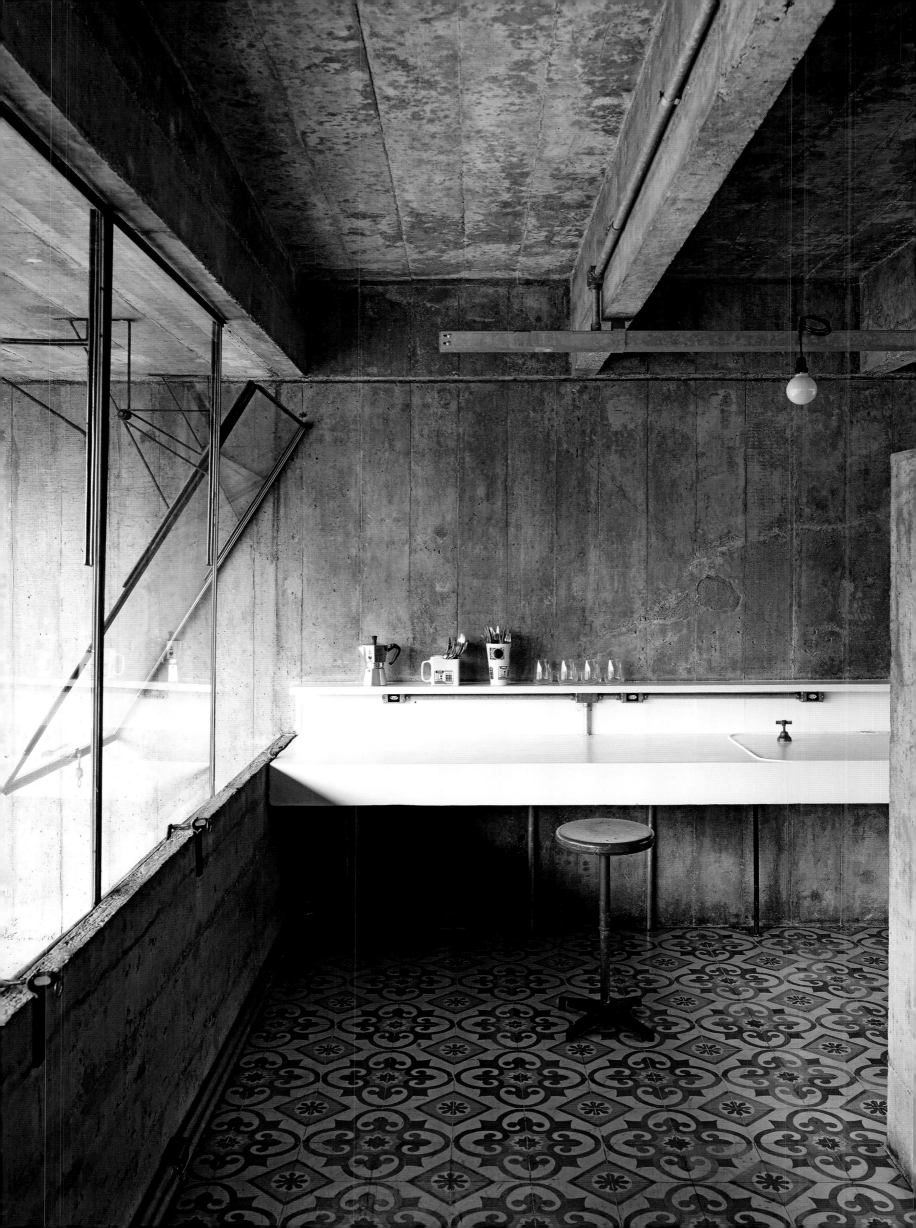

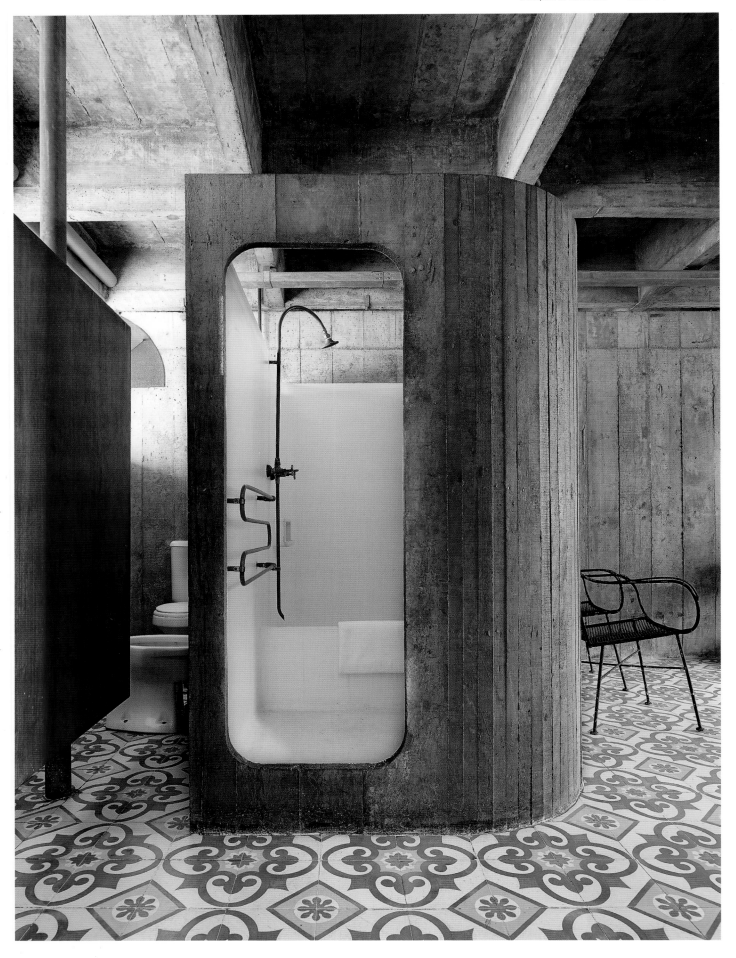

In the shower
pod off the main
bedroom, even the
towel rail is a single
sculptural element.

The rhythm of
concrete beams in
the ceiling plane is
uninterrupted by
internal walls.

MASETTI HOUSE —— PAULO MENDES DA ROCHA

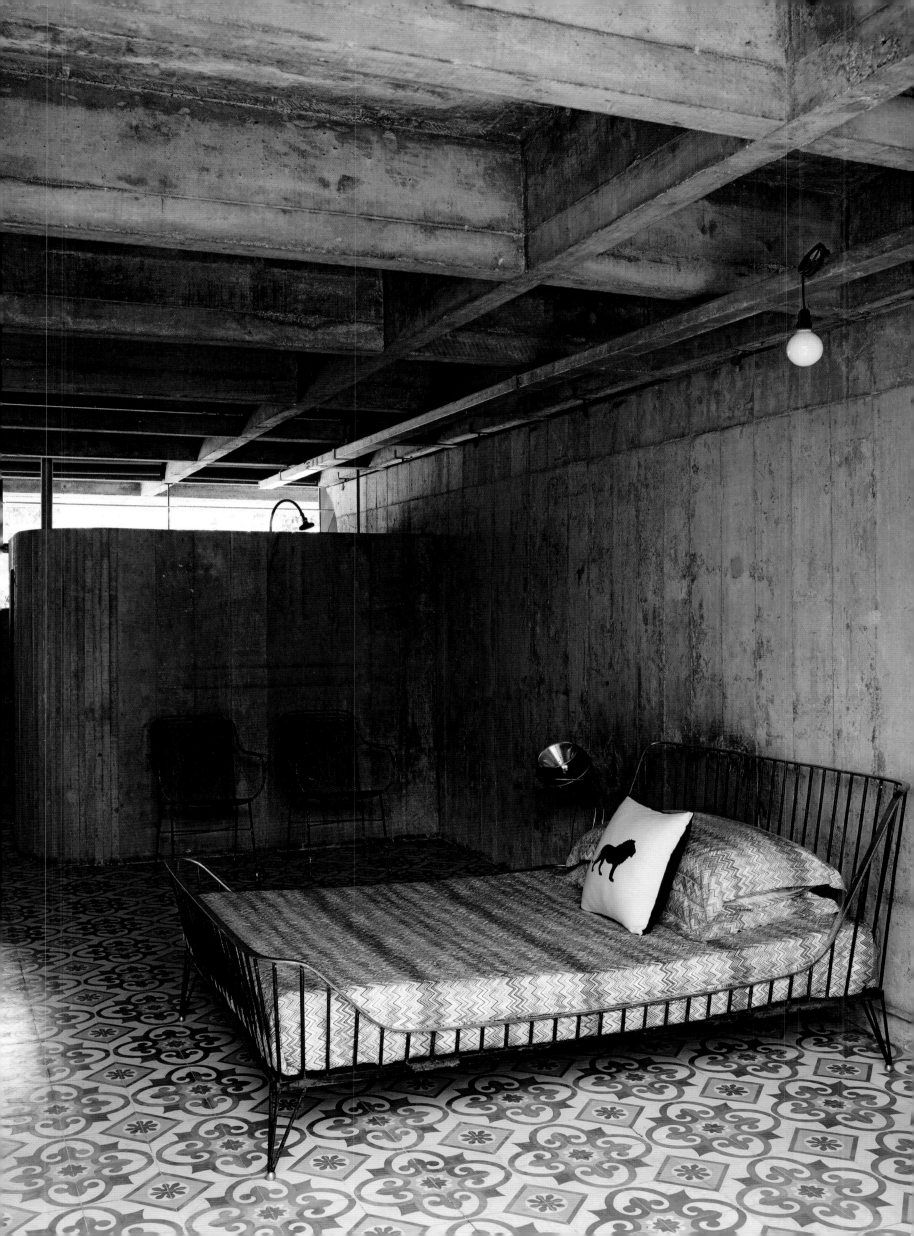

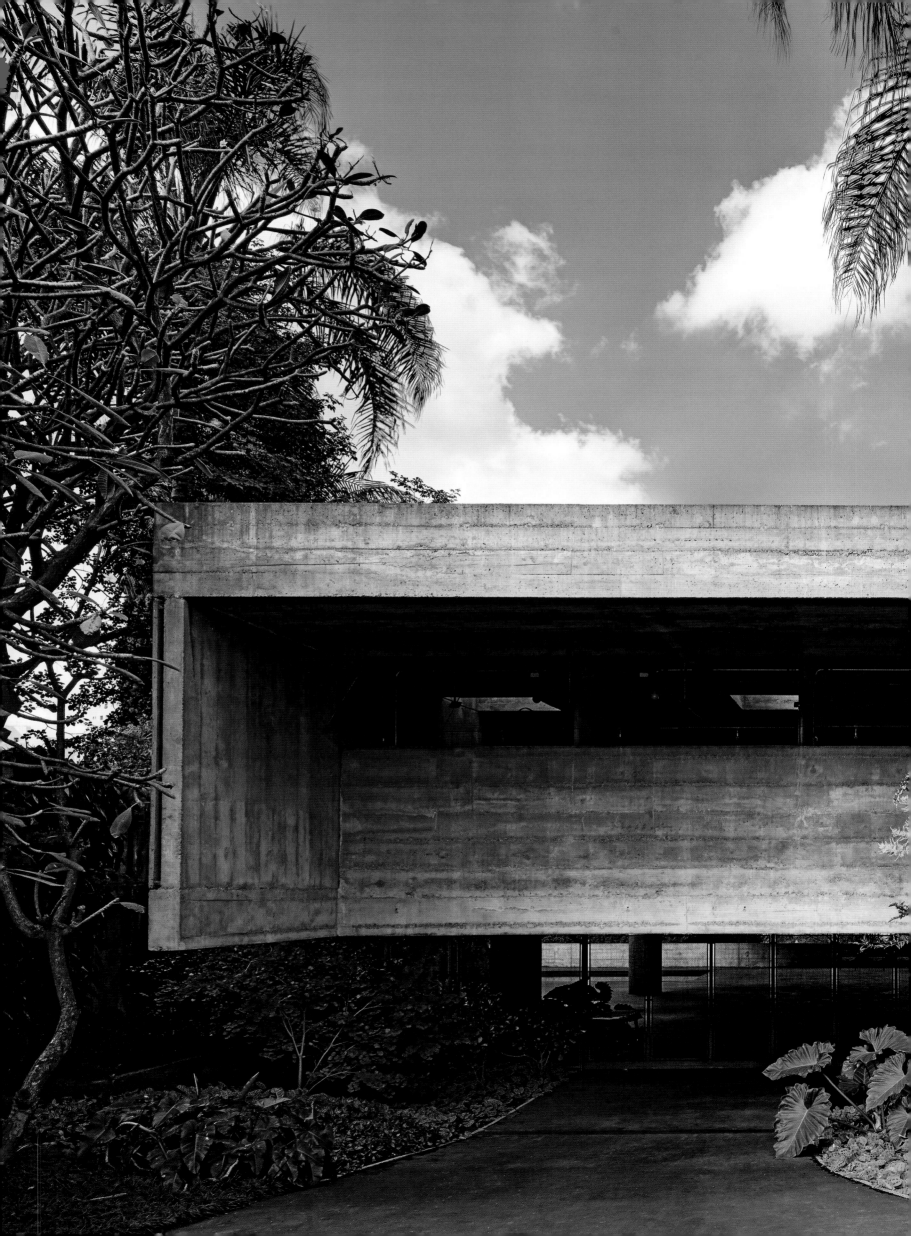

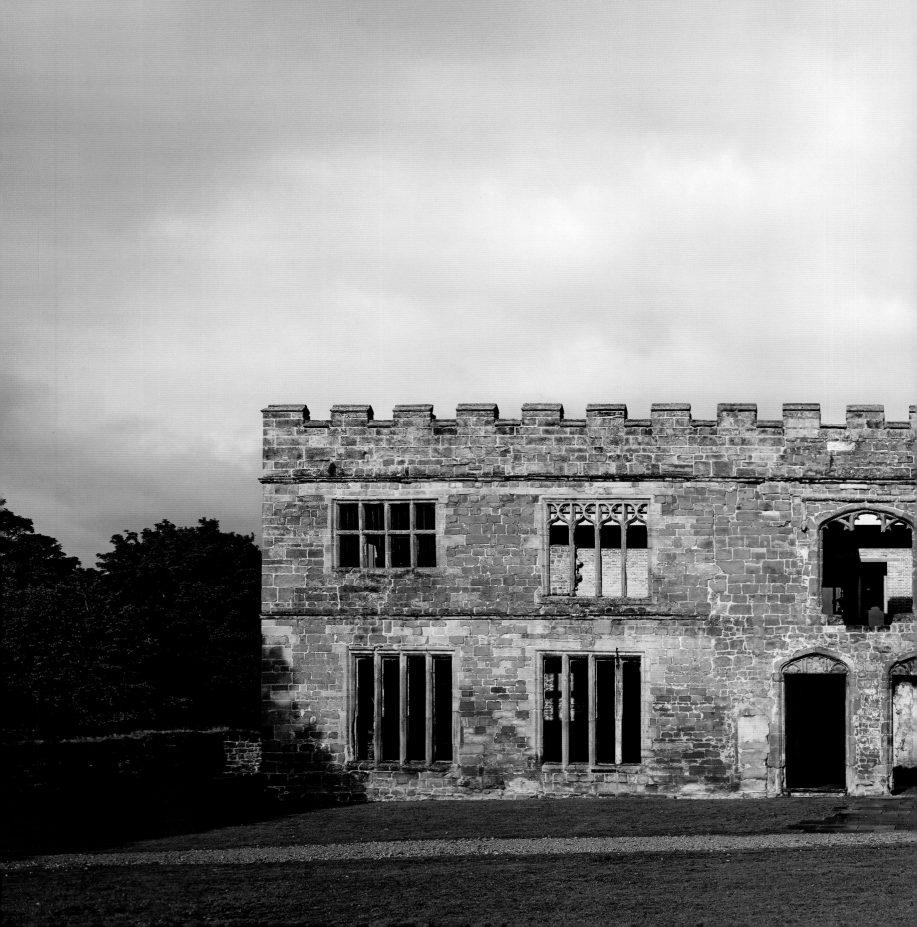

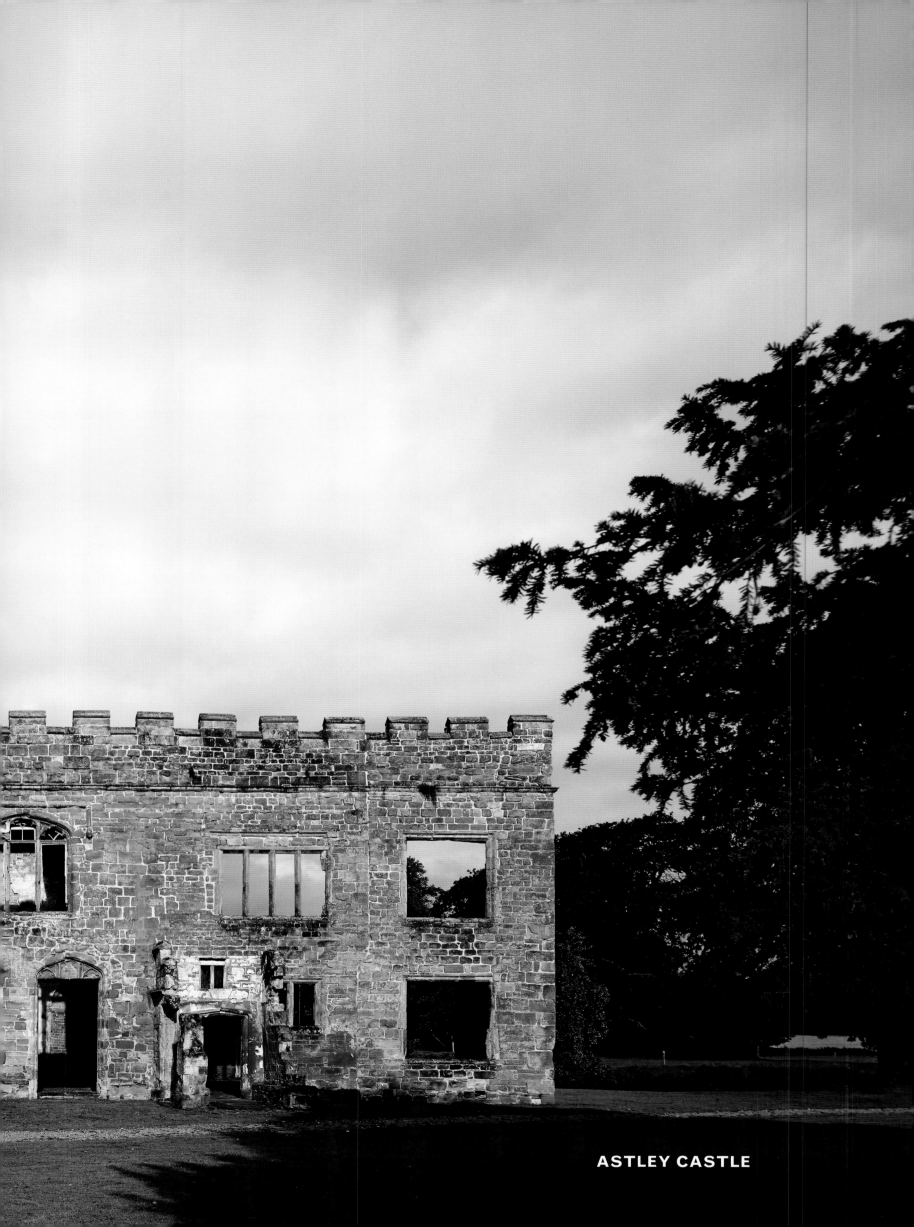

ASTLEY CASTLE

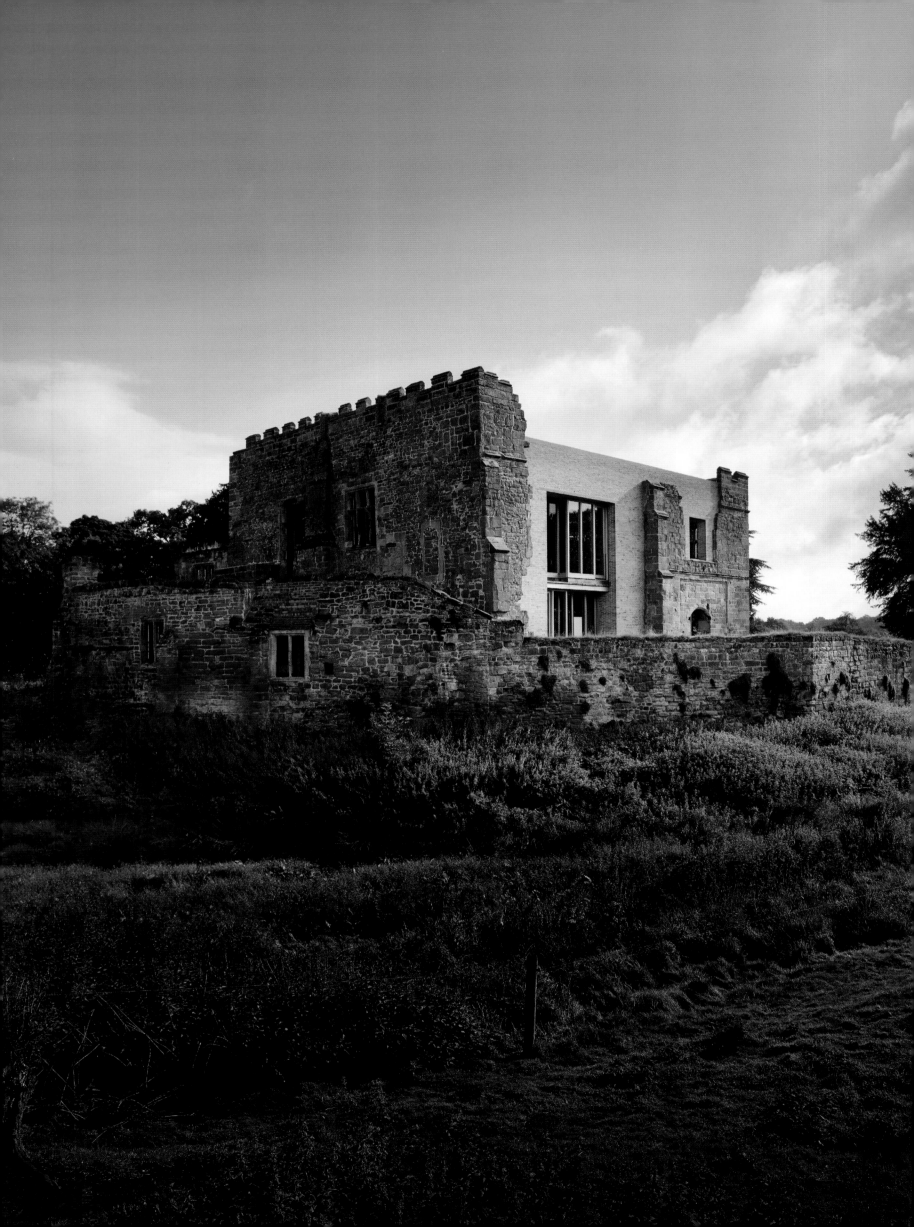

**ASTLEY CASTLE
(2012)**

◇

**WITHERFORD
WATSON MANN
ARCHITECTS**

⋈

**NUNEATON,
WARWICKSHIRE, ENGLAND**

The photographs of Astley Castle taken in 2006, at the time of the architectural competition for its renewal, show a ruin on its way to becoming a mere remnant. The Landmark Trust, a charity organisation that protects and restores significant British buildings with the aim of providing short-term holiday lets, had a longstanding interest in Astley Castle but had been unable to solve the conundrum of its restoration. In recent history, it had been a rehabilitation centre for servicemen injured in World War II and, from the 1950s, a hotel. Structurally, it suffered a major blow when an unexplained fire broke out shortly after the hotel's lease expired in 1978. It was in such bad shape that English Heritage, the British government's statutory adviser on the historic environment, listed it on its Heritage At Risk register.

There is a sense that Landmark Trust's competition was a last-ditch attempt to revitalise the ailing structure, the earliest parts of which date back to the twelfth century. Solutions were sought that may have been previously unpalatable to an organisation with a philosophy of faithful restoration rather than the leap of imagination required for a modern intervention. It is to their immense credit that they seized the challenge and invited 12 architectural firms to submit a scheme. The Landmark Trust's brief was sensible, considered and intelligent. They wanted, 'a bold response to the question of how a strong contemporary building can cohabit with one that is remarkable and very old. The purpose of which is to give exemplary integration of old and new for a fine building beyond the reach of normal restorations.'

In truth, Astley Castle is more of a moated, medieval manor than a castle but the historical pedigree of this Grade II listed building cannot be underestimated. It was home to royalty in the fifteenth and sixteenth centuries: Elizabeth Woodville who married Edward IV; her daughter Elizabeth of York who married Henry VII, and Lady Jane Grey who was queen for a mere nine days before being beheaded. She was followed by her politically ambitious father Henry Grey, the Duke of Suffolk, who was captured when hiding in a hollowed-out tree in the castle grounds.

What was interesting about the winning scheme from Witherford Watson Mann Architects (WWM) was that, while respectful, they tried to be unsentimental in their approach and didn't get too bogged down in scholarly conservation. Neither, they point out, did they strive to create 'a conscientiously differentiated structure that stands in opposition to what exists'. While some proposals played with more radical ideas of independent glass boxes and coloured structures, WWM sought to bind ancient and modern in an approach that is unapologetically structural. The poetry comes later.

Working with a ruin, the architects designed a new structure that stabilised and fused with the old.

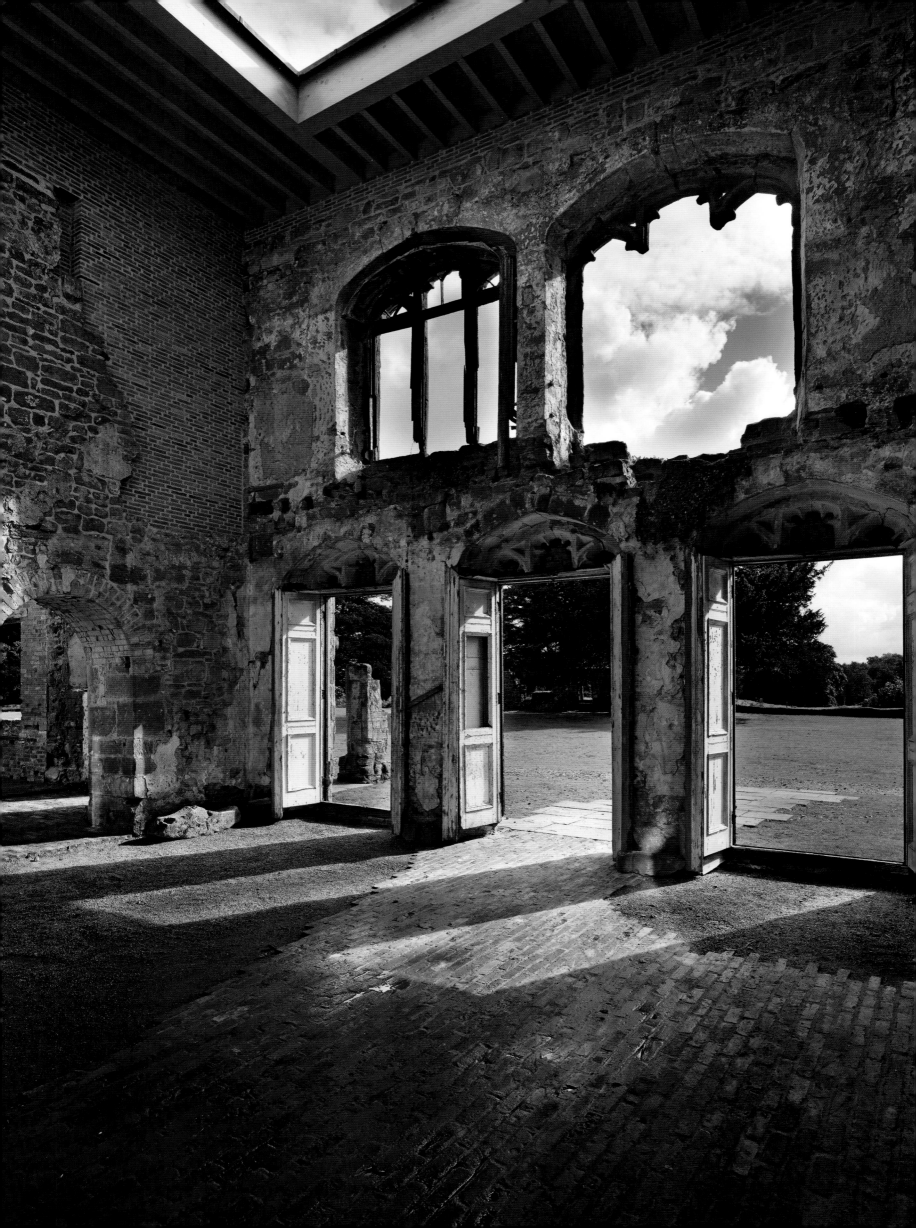

The experience of arrival at Astley Castle involves passing through the facade of the ruins.

The precision of the new clearly juxtaposes with the randomness of the ruins.

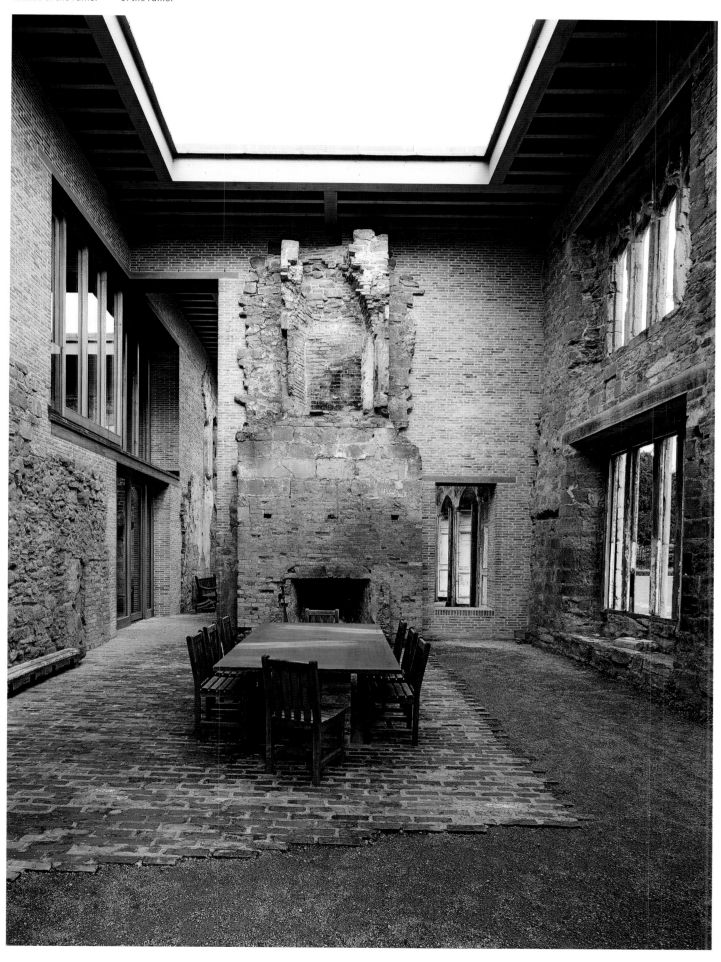

While retaining the historic experience, the refurbishment introduces modern comforts.

The architects have sourced a selection of low-key materials, including Spanish tiles.

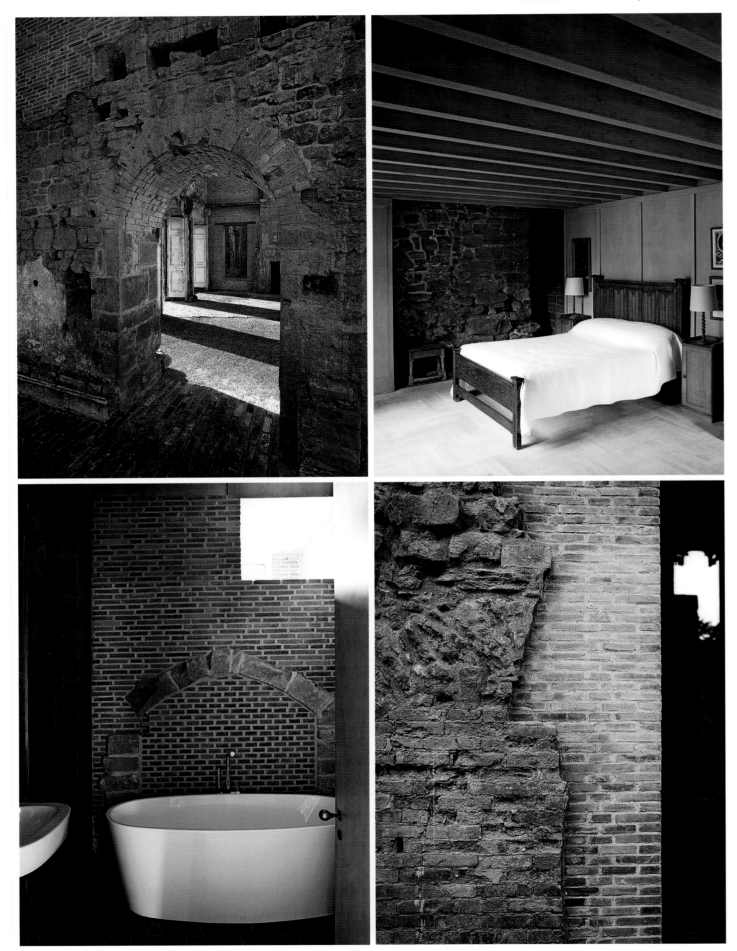

ASTLEY CASTLE —— WITHERFORD WATSON MANN ARCHITECTS

'At Astley Castle we take a different line, confident in the brutal continuity of history, believing that it is speaking now, in a conversation rather than an awkward silence,' says WWM to explain their treatment. 'We have carefully distorted the new architecture to fit the ruin, respecting what exists, finding irregular but precise meetings of spaces and materials.'

After visiting the site, architect Christopher Watson came back with two very clear opinions. The first was that the new building needed to be sited in the most ancient part of the building and the second was to make the most of its setting, on a defensive ridge, with views across the Warwickshire countryside. Informing their strategy was what the architecture could deliver in terms of experience; the internal living spaces, both old and new, and the subtle dynamism where they meet, the vistas both within the layers of the castle itself, and the immediate context of church and stables.

William Mann is frank about the process. 'When I see how close the end result is to our original idea, I sometimes wonder what we spent five years doing. But it was only after two years, and a planning consent that could only be based on partial information, that we were able to clear out the rubble, demolish the unsalvageable bits, and know close-up what we were dealing with. Eight centuries of different constructional techniques and several states of decay created a myriad of conditions, all slightly different.'

In essence, that meant the nineteenth-century section was removed, distilling the building to a more compact footprint. 'We did an analysis of how the building had developed over the centuries and gained a sense of what we could and couldn't do,' says Mann. 'We allowed the building itself to inform us as we worked within it.'

Aware that they were working with a ruin, an unnatural state for a building, they focused on the fundamentals of creating a masonry armature that tied and buttressed the existing shell. 'When you build in a ruin, you have to forget about perfection,' says Mann. 'Both the masonry and the timber are distorted, incomplete – they are also ruins of sorts.'

He also points out that they were dealing with a number of 'atmospheres'. 'In the twelfth century, when life was about hunkering down and surviving, the architecture had small round-arched windows and a defensive spirit, whereas in the seventeenth century, it was all about lace and pleasure gardens and that was reflected in the architecture too.'

'Eight centuries of different
constructional techniques and
several states of decay created
a myriad of conditions,
all slightly different.'

WILLIAM MANN

One of the most notable elements of the scheme is the expertly applied palette of materials. It boils down to timber, concrete, tiles and brick, each sourced for their specific qualities. The timber mixes oak, sycamore and birch plywood and laminated pine, according to application; the tiles are Spanish matt-glazed terracotta, and the slim, dark bricks are from Denmark. Yet all have a stylistic bond – they are unfussy and robust with a quiet presence. 'The ruin itself had so much nervous energy that we felt if we tried to be clever with materials, the result would be enervating,' says Mann.

Much thought has been applied to the transitions – where ancient meets modern – and the level of emphasis the existing walls have in maintaining the character of the space. There is a sense that the new binds and stabilises the old with large precast concrete lintels and major structural work, but that the finer brickwork subtly stitches into the shell, never dominating but simply providing support. While WWM claims not to have been hostage to history, there is respect at every turn.

Of the £2.5 million raised for the project, equal amounts were spent on the new elements and on protecting the old, with repointing and chemical stitching playing a major role in consolidating the ruined sections. But this

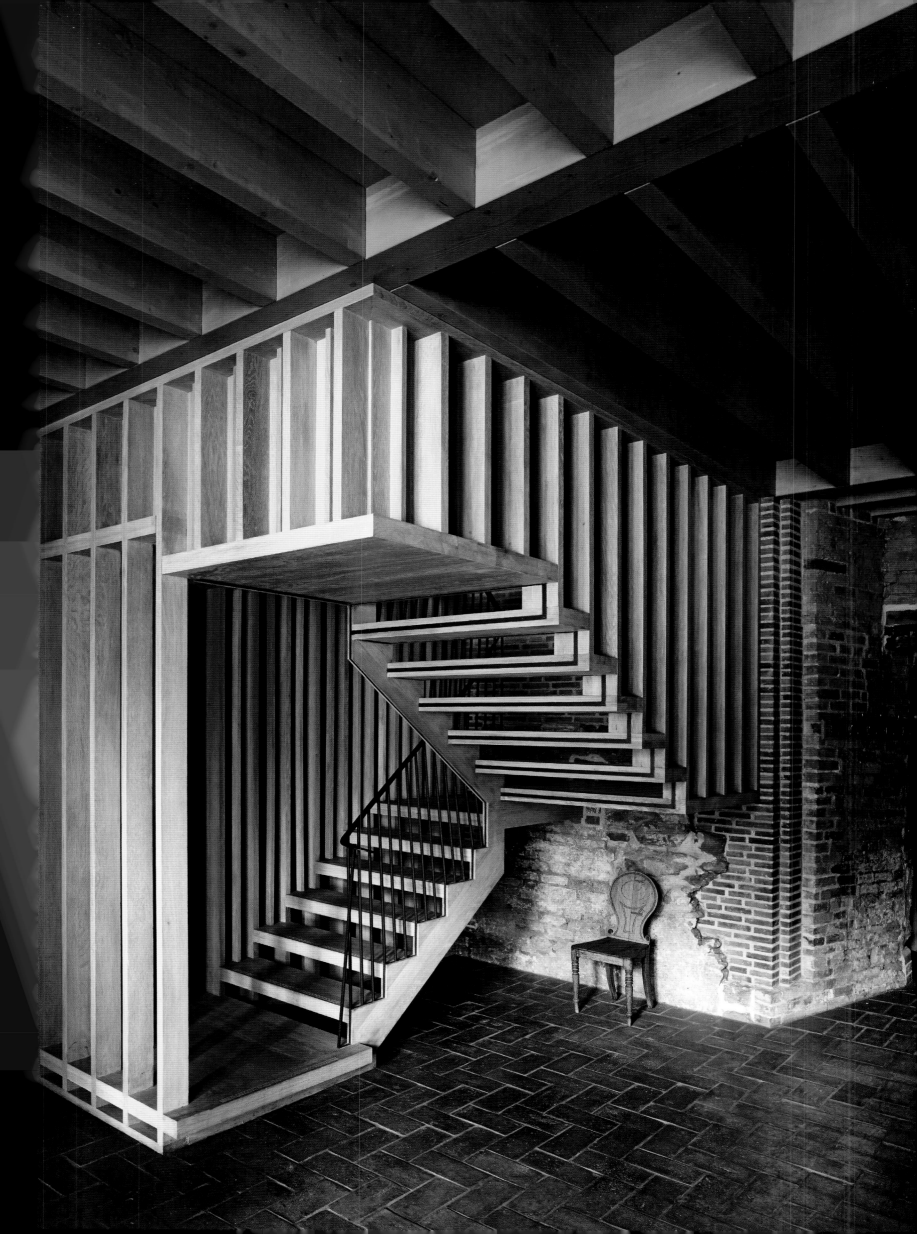

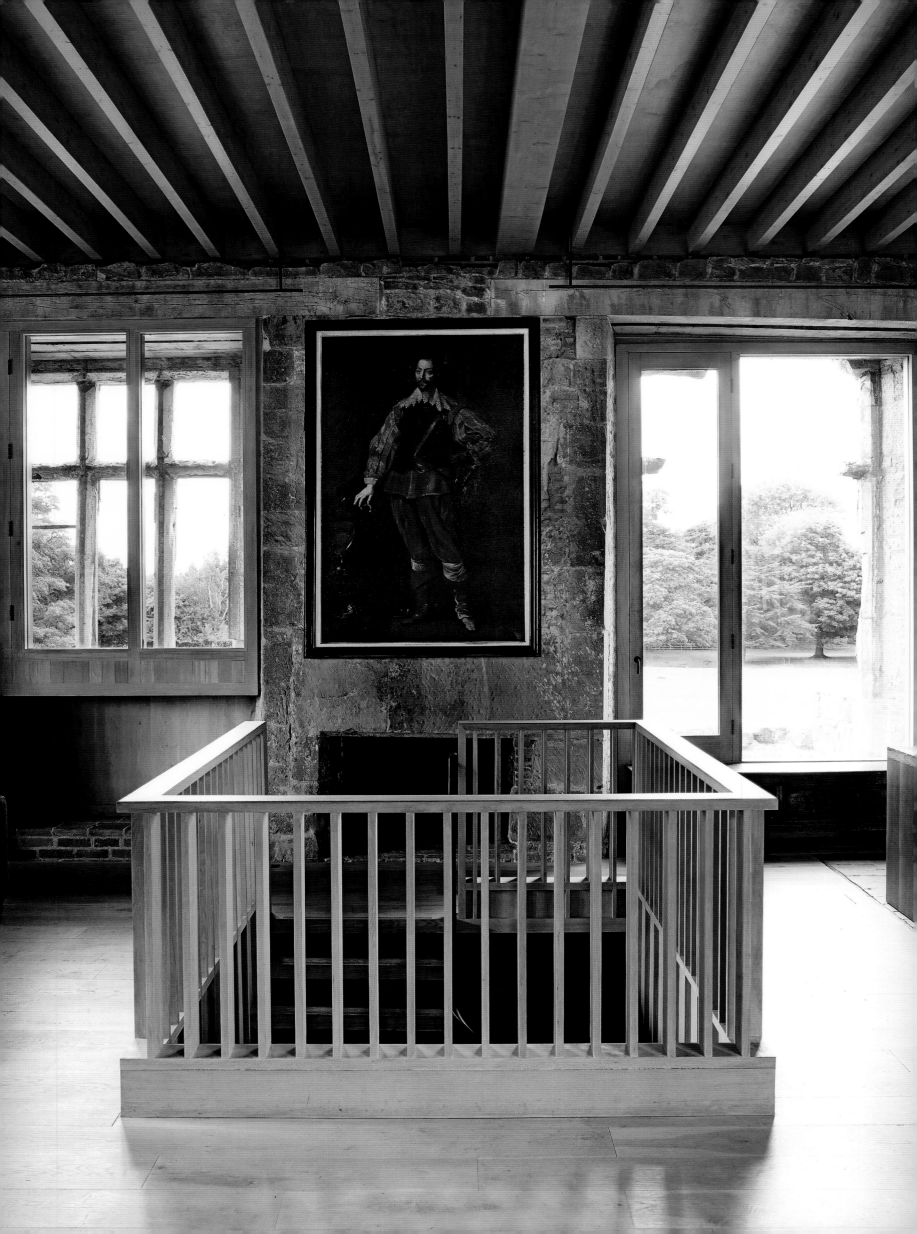

The top of the
stairway clearly
acts as a division
between kitchen
and living spaces.

Large expanses of
glass give courtyard
views through
the ruin to the
countryside beyond.

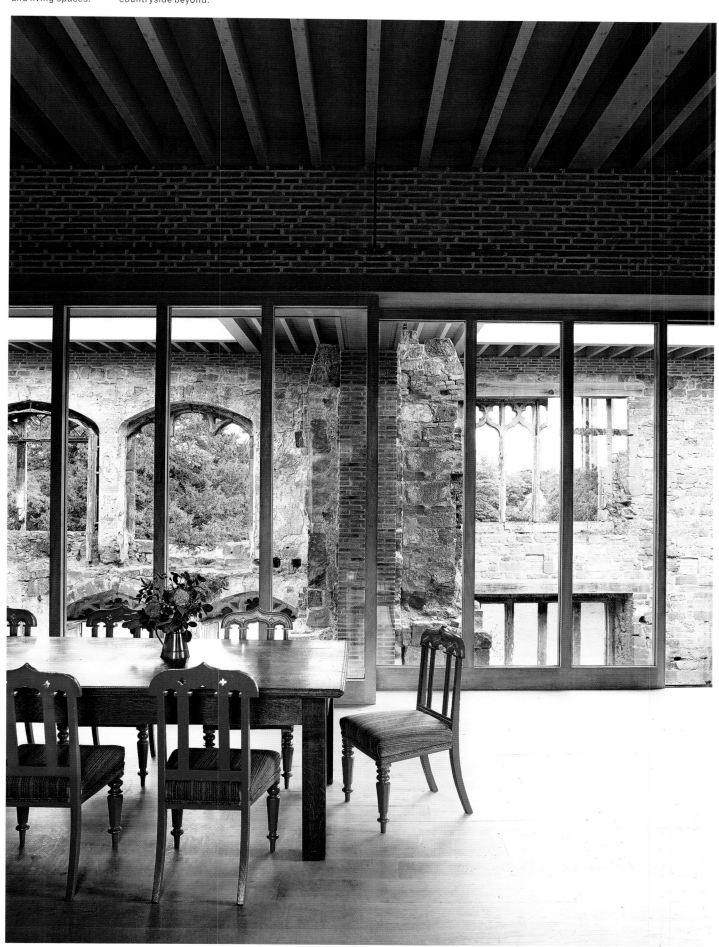

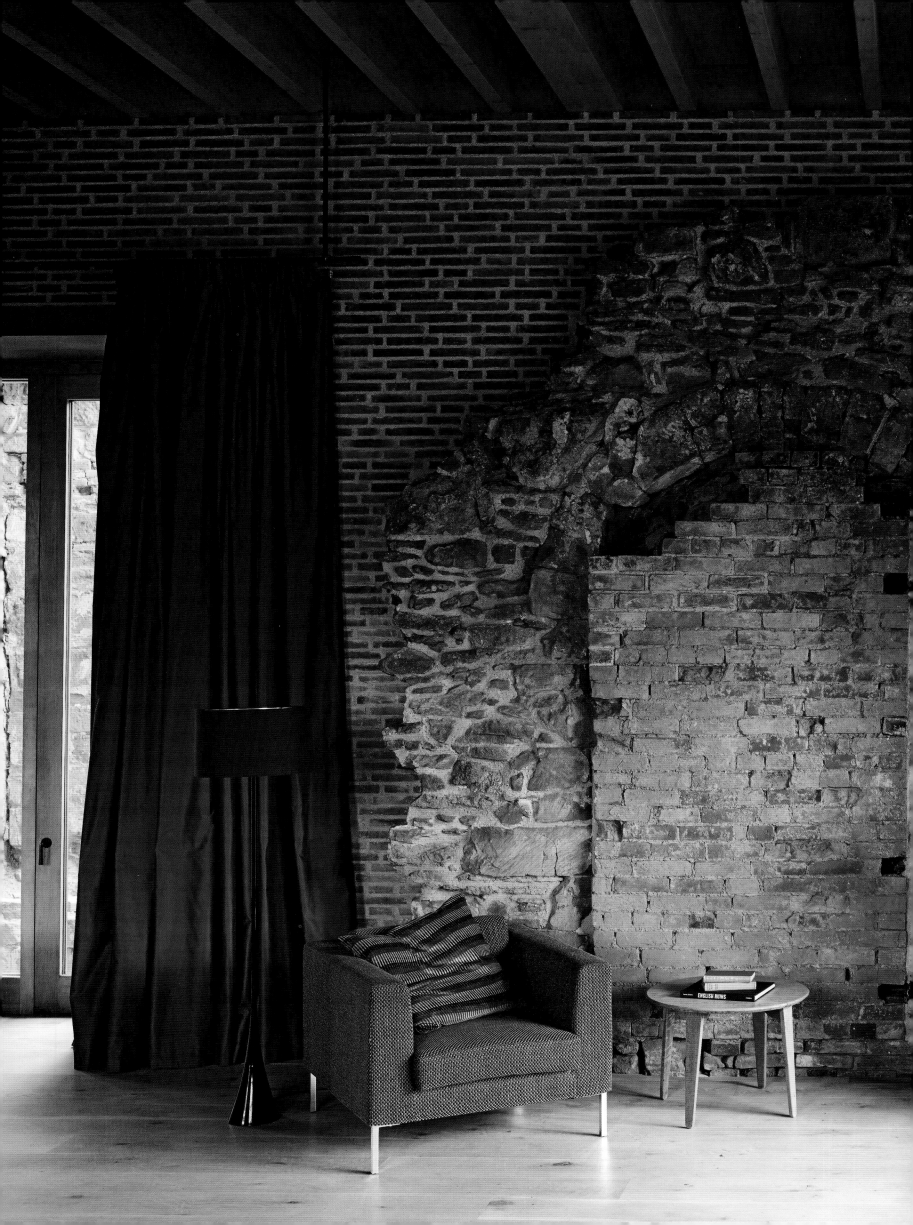

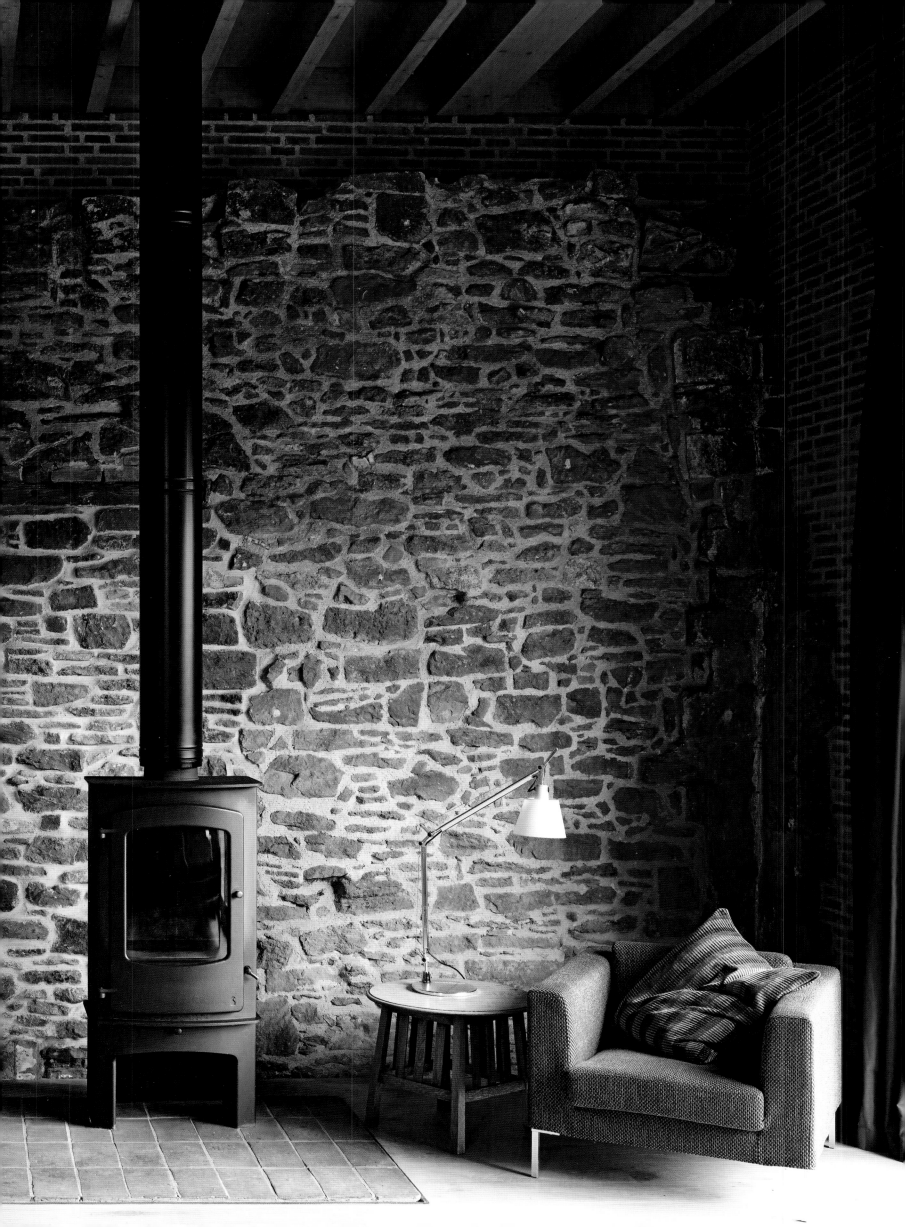

By creating a more contained kitchen area, a human scale is achieved within the four-metre-high space.

is very much where the success of the building lies. The castle is approached and perceived in layers. From a distance, it is the crenellated silhouette that dominates the landscape, as it has done for centuries but, on closer inspection, it becomes clear that some sections are only a facade while others house an entirely new building.

The entrance to the house is literally through decayed arches, left unglazed and forming a portico, and outside dining area, open to the sky. It also serves to set up anticipation for the experience of the interior. Where once was planned a large entry hall (the scheme underwent revisions as the budgets shifted) is now a beautiful piece of timber sculpture which houses the staircase to the first floor. It is the first encounter with the determinedly modern and it works well. 'We tried a more sculptural version before settling on the idea of a stud box, which we gradually cut into to create this very open structure,' says Mann.

Inside the studwork frame enclosure, a steel stringer allows the inside to be more open; plywood infill and steel straps support the upper flight where the stud frame has been cut away. The steel straps and stringer and balusters are painted in a bronze metallic paint to relate to the bronze ironmongery. There is also a lift from ground to first floor, cunningly hidden in an existing shaft, accessing the main living space from the rear of the kitchen area.

The ground floor houses four comfortable bedrooms and three bathrooms, but it is the first floor living, dining and kitchen space, reworked and refined during the design process, that is the tour de force. This cavernous space with four-metre-high ceilings required attention to bring it back to human scale. One scheme shows the room as daunting, but a few simple changes evoked a completely different feeling. WWM used the top of the timber staircase to act as a division between kitchen/dining and living areas. As well, the windows facing the courtyard and the approach were stepped into the room, and the ceiling joists aligned across rather than along the room, bearing on a central beam, to encourage courtyard views. This room is remarkably accommodating for families and friends of all generations, allowing for cooking, reading, talking, drinking and playing board games to happen simultaneously. As WWM puts it, 'Dialogue across the centuries frames conversations between friends.'

The experience wholly imparts the sense that one is living, albeit comfortably, within the heart of a ruin and the guestbook is full of praise for the experience – the architectural prowess is not lost on visitors, nor is the efficiency of the heating. Even the housekeeper acknowledged that she feels the building is happy to be occupied once again.

Few buildings manage to please both the architectural profession and the public, and yet WWM has managed to do this with Astley Castle. Not only is it booked out 16 months in advance but it also won the 2013 RIBA Stirling Prize for architecture, Britain's most prestigious award. The RIBA president, Stephen Hodder, in announcing the prize said, 'Rather than a conventional restoration project, the architects have designed an incredibly powerful contemporary house which is expertly and intrinsically interwoven with 800 years of history.'

It is rare for architects to get emails from the public, but one of William Mann's favourites is from the group of friends who said that, when staying at Astley Castle, they had 'lived life just that little bit more richly and as slightly better versions of ourselves. It made us happy. Is that not what great architecture is about?'

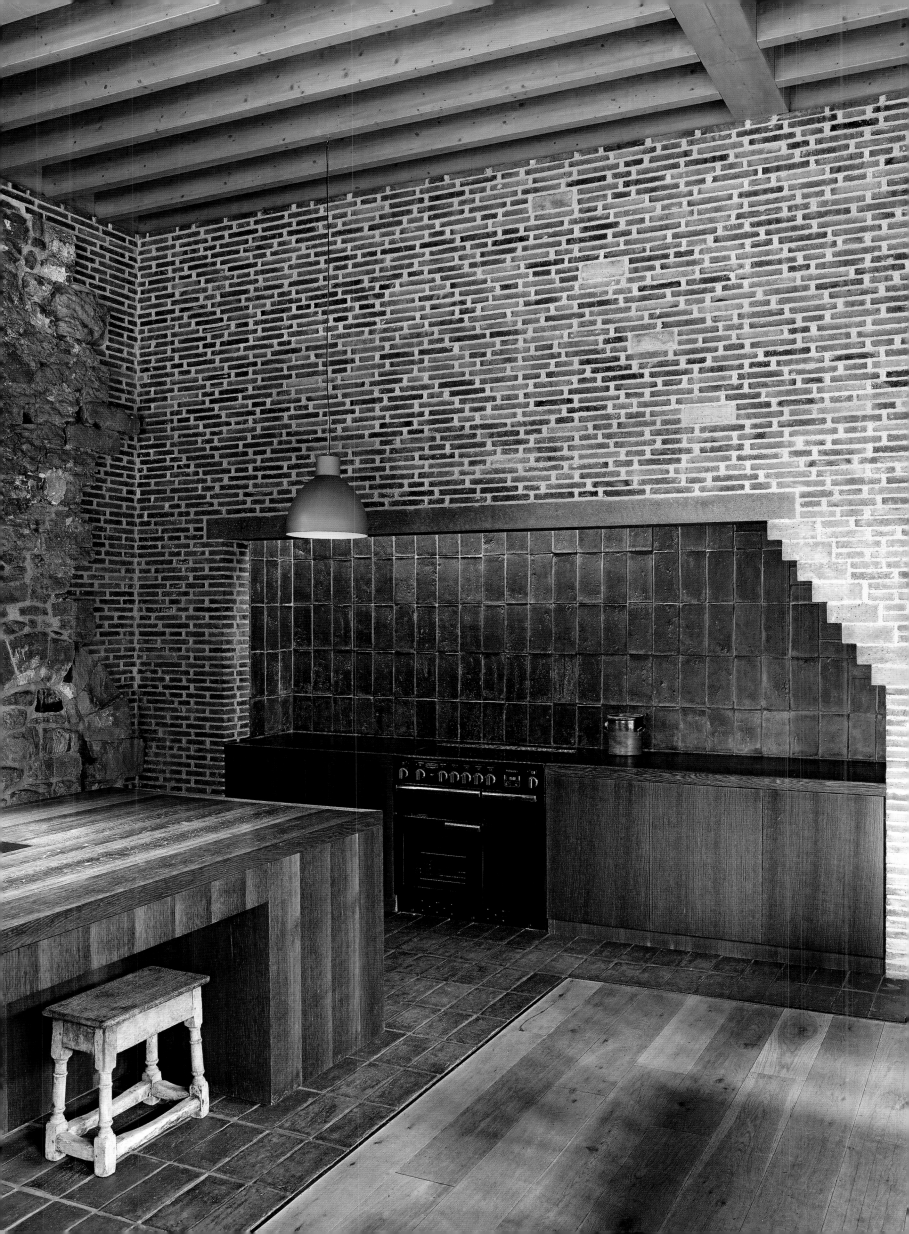

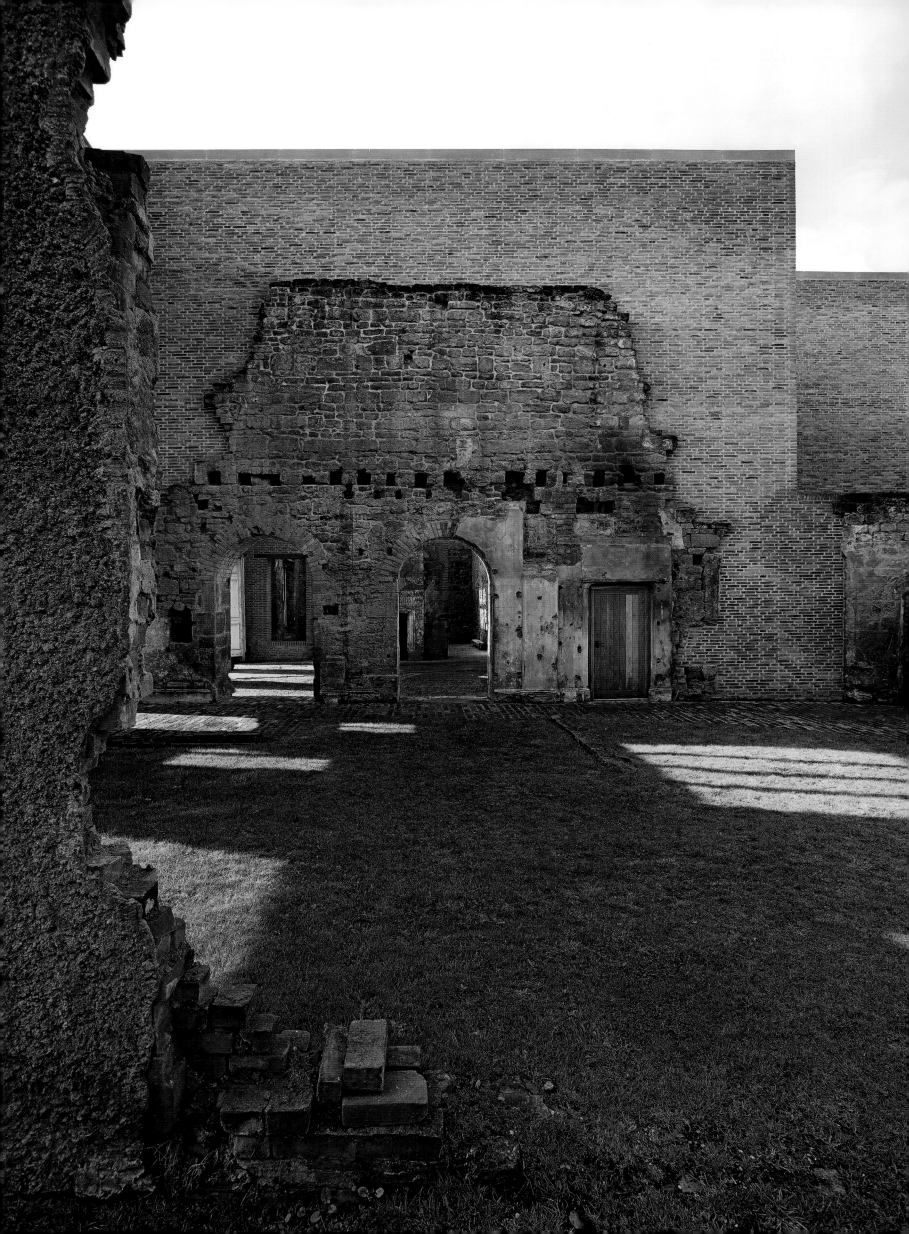

In the stitching together between old and new, there is still a pleasing fraying at the edges.

From the original entrance, there is little indication of the architectural experience to come.

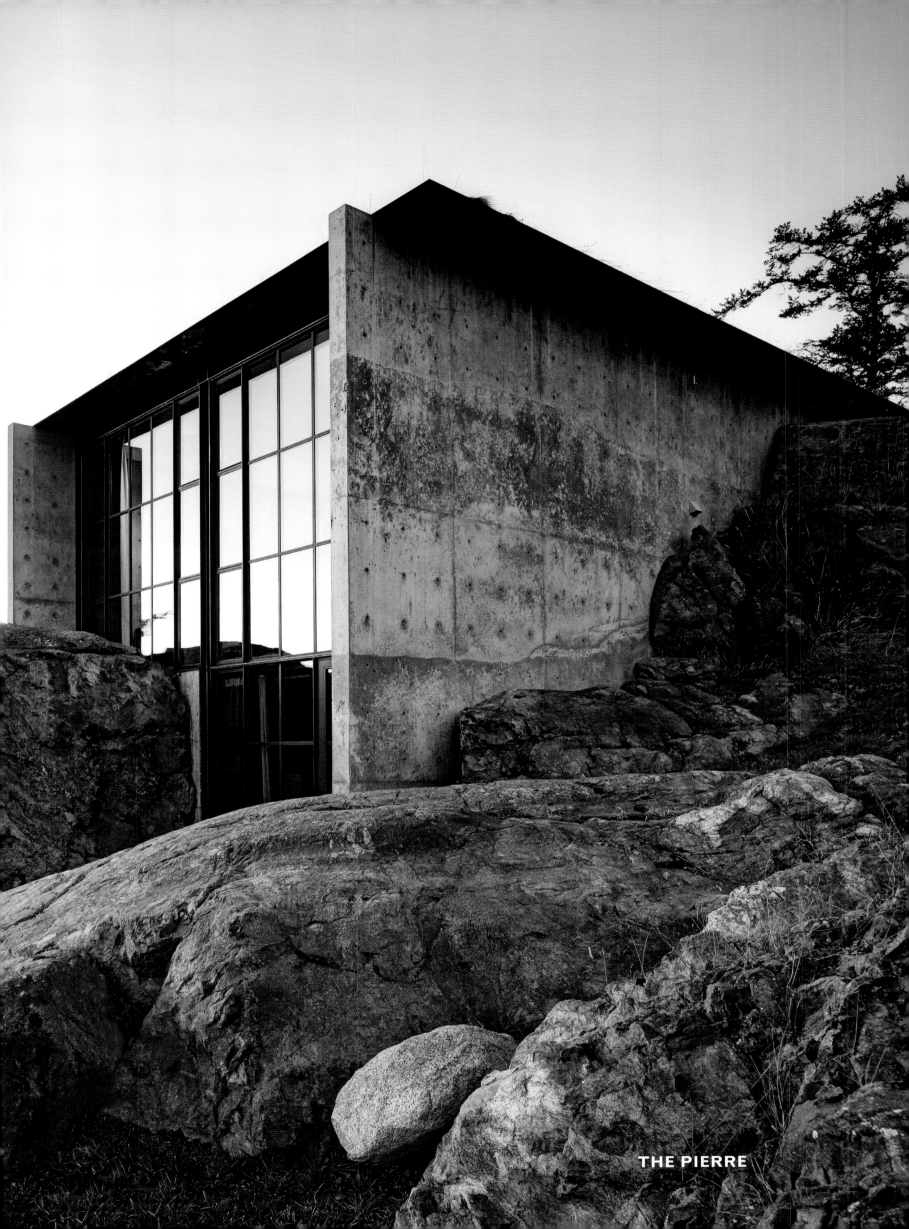

THE PIERRE

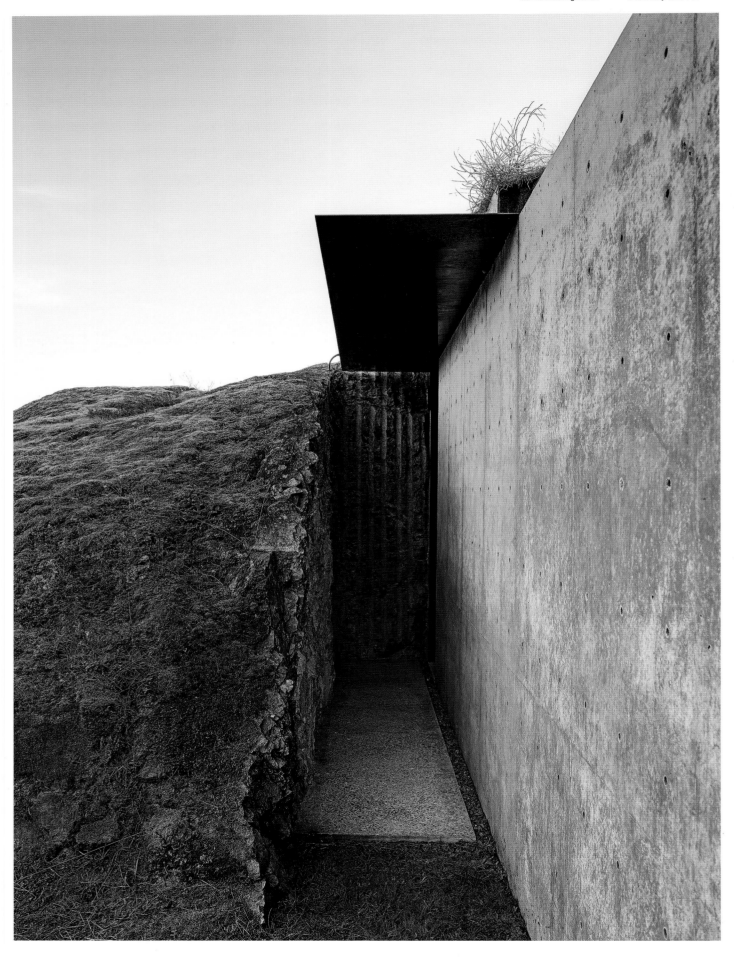

From the entrance,
the dynamic is
set up between
the house and the
surrounding rock.

A sense of history
is established by
the use of timber
reclaimed from
a nearby house.

THE PIERRE —— OLSON KUNDIG ARCHITECTS

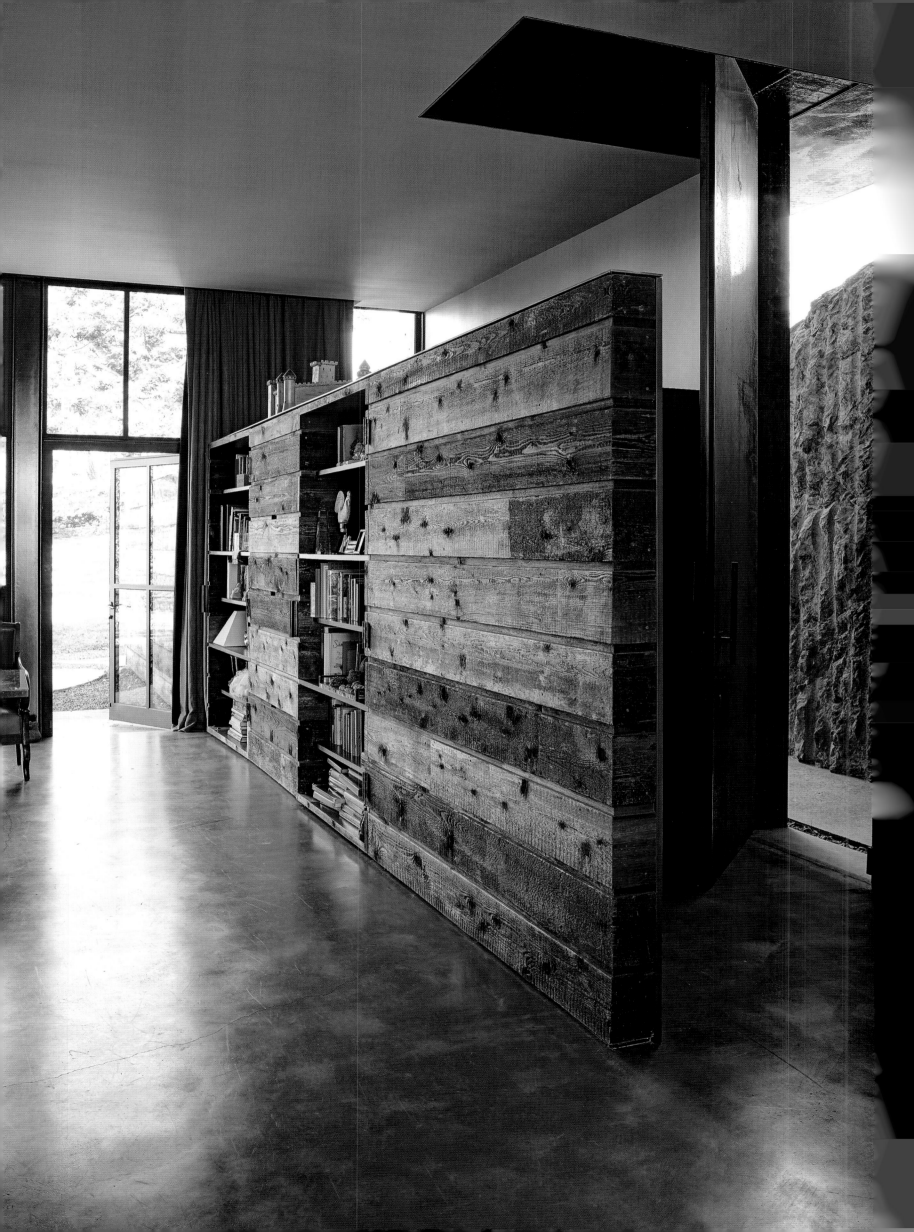

THE PIERRE
(2010)

◇

OLSON KUNDIG
ARCHITECTS

⋈

SAN JUAN ISLANDS,
WASHINGTON, USA

Tom Kundig is an architect with such a distinct back story that to understand it upfront provides a shortcut to appreciating the muscular beauty of his work. He has a very clear sense of his own personal creative influences – and encourages others to tune into theirs – and this self-awareness enables him to be both consistent and exploratory in his work. He taps into a number of longstanding, core preoccupations. These include the big, varied landscape of the Pacific Northwest, with its moody, shifting skies; his understanding of the force of nature through years spent climbing mountains; an appreciation of mechanics gleaned from growing up in Seattle, where its powerful industries of logging, mining and farming utilise large-scale machinery as a means of harnessing the earth. Kundig notes, 'I saw beauty in what others considered ugly.'

Mentor Harold Balazs, an American sculptor working in steel, assisted early explorations into three-dimensional form with which Kundig could test concepts, fabricate his own ideas and deal directly with materials. He was also drawn to the work of Swiss artist Jean Tinguely whose 'meta-mechanical' sculptures embraced movement and change, and celebrated the beauty of machinery parts while satirising the age of over-industrialisation.

It is not hard to see how these elements play out in Kundig's architecture. There is a tremendous relationship to site, a confidence with materials and the manipulation of their inherent properties, and a love of the mechanical, or 'gizmos', as Kundig refers to them. What moves the work to a higher plane is the finely tuned sensibility that takes these rather masculine attributes and hones them in a sensitive and fluid way. This balance is best expressed by architect and writer, Juhani Pallasmaa: 'The architecture is rigorously organised and aesthetically refined and elegant, but at the same time tough, rough, and matter-of-fact.'

The Pierre is a perfect example of this fusion. Located in the San Juan Islands, an archipelago off the coast of Washington state, it is a site of great natural beauty. The resulting engagement with the landscape and the climate becomes essential to the experience for the house.

The brief was simple; the house was to be a second home where family and friends could gather and enjoy each other's company within the surrounding landscape. First sketches were for a house with a big room for hanging out and for cooking, eating and socialising, and a design that allowed for both indoor and outdoor experiences. 'The client was interested in simple and elemental materials—a home that embraced the modern sensibilities of clean lines based on the craft and technology of our time, and that could serve as a backdrop for her eclectic collection of art and furnishings,' says Kundig. 'She was also very interested in a home that engaged the

The rock, showing marks of excavation, serves as a backdrop to Tom Kundig's signature metalwork.

Stone, used in
an elemental way,
is brought into
the house and
contrasts with the
sharp manmade
concrete wall.

land and emerged naturally from the landscape . . . perhaps locating it on, or around, one of the prominent rocks on site.'

Just as Frank Lloyd Wright placed Fallingwater over the waterfall, Kundig suggested putting the house in the rock. 'The idea of building on the least productive portion of the site is based on an ancient practice, which leaves the productive portions of the land for cultivation,' says Kundig.

For Kundig, visiting the site is essential. 'There is a lot of nuance that just isn't possible to discover through drawings, photographs or other source material.' His design approach is often to devise one 'big idea' around which subordinate ideas form. In his own home, the Hot Rod House, the defining idea is the origami steel staircase. At Olson Kundig Architects' office, in a historic building in Seattle, it is a hydraulically powered skylight. In The Pierre, it is all about the rock. 'The decision to truly engage the site is the most important idea of this project,' says Kundig. 'That led to building in the rock, and then using the crushed rock that was quarried in the flooring as well as using the larger boulders to build the garage.' The effect is of the house hunkering down, being part of the landscape. 'Its position responds to the very human desire to be able to survey the surroundings while being safe.'

As well as being built into the rock, the house is set into an existing landscape of mature trees. Its grassed roof, growing wilder with the years, allows the eye to travel over the house towards the water views. The manmade doesn't dominate the natural setting but, rather, the roof partially obscures the structure as though nature is gradually reclaiming it. This is something that appeals to Kundig's sensibility. The same can be said for his fondness for reclaimed materials such as timber which has served a useful purpose in another context and bears the mark of an honest working life, adding character and warmth to a newly built space. In the same way, he appreciates how steel rusts and mutates with age.

'Buildings become more beautiful with time,' he says. 'They acquire the patina of time that can't be bought. As they weather, they slowly merge with the landscape . . . I try to design with the future in mind, knowing that the ultimate success of a house or building is how it is able to adapt to future needs and for future generations.'

'The architecture is rigorously organised and aesthetically refined and elegant, but at the same time tough, rough and matter-of-fact.'

/

JUHANI PALLASMAA

The material mix and construction of the house blurs the lines between the manmade and the natural, the new and reclaimed, the outside and in. This dialogue begins with the treatment of the entrance. The narrow approach to the front door features smooth, repetitive off-form concrete on one side and a cleaved, lichen-covered rock bearing the marks of its excavation on the other. 'I think the yin-yang play that comes from balancing materials is important,' says Kundig. 'Here, they help to illustrate the different states of a material, from stone to hand-worked stone to concrete.'

Rock formations are very effectively pulled into the envelope of the house to form a majestic hearth in the living space, while the powder room, hewn entirely out of rock, transcends its cave-like appearance as light is taken in via a skylight and an elongated mirror. In the master bedroom there are three natural sink formations in the stone into which water falls. Further linking external and internal spaces is the large external storage box, which moves through the glazing to form shelving, of the same dimensions, on the inside. The whole structure is clad in recycled timbers from a demolished house on the island, designed by Lionel Pries (1897–1968), a leading architect, artist and educator working in the Pacific Northwest from the 1920s. Even this nod to local history adds to the building's narrative. 'Any time you work with live materials – rock, wood, and so on – it becomes a reciprocal relationship,'

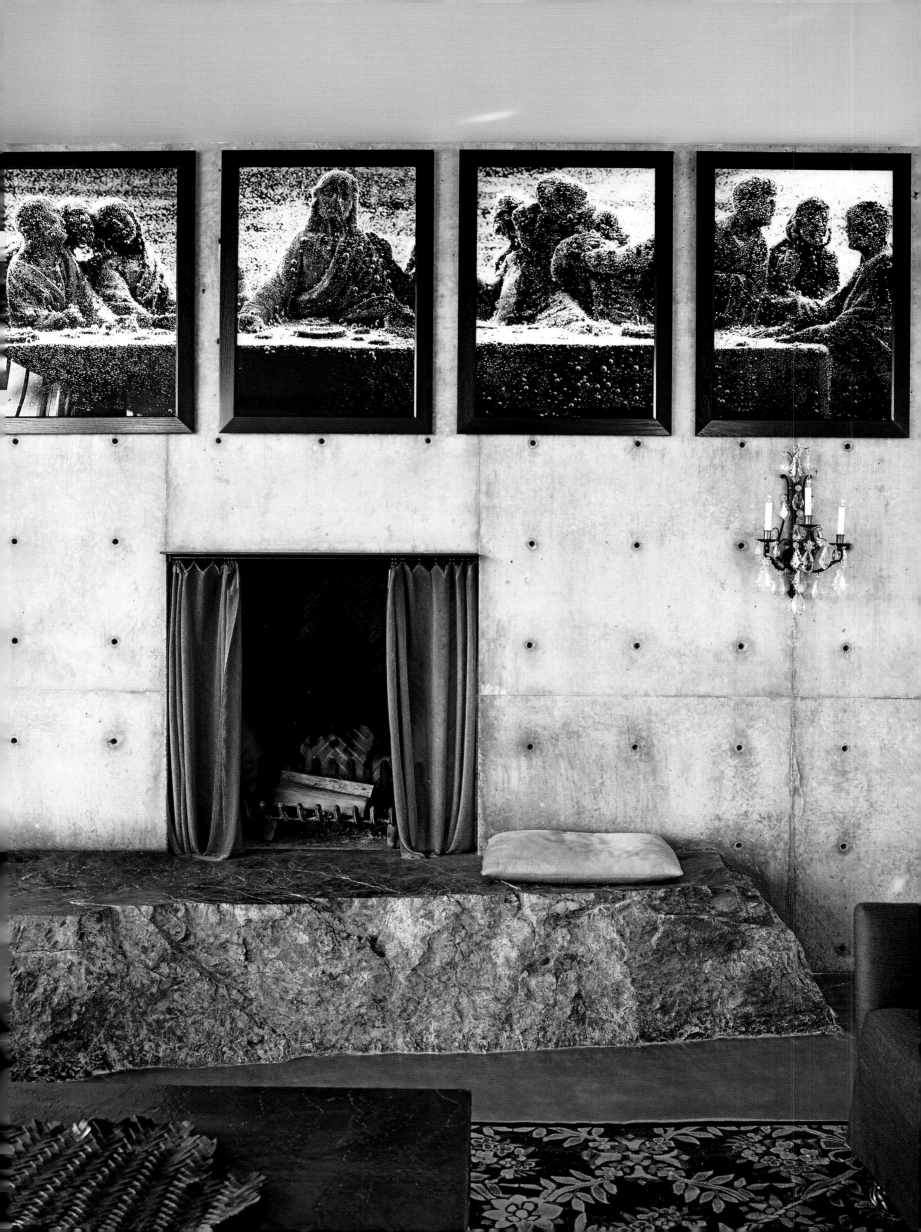

A subtle sense of geometry is seen in the windows, concrete and even the raw stone.

says Kundig. 'The results are best the more you know and understand the materials you work with.'

The main living area, which includes kitchen/dining and living, connects with the outdoor space through a large-scale pivoting glass door. This concrete pad is contained by the perimeter of the rock, creating an outdoor entertaining area furnished with a cluster of chairs and a table adjacent to the external fireplace, which mimics the internal one with its hearth of rock. By pulling the elements into the heart of the house, there is a remarkable sense of nature being involved. The house is embedded in the land, grass clad, made from materials that weather and age, set on an island where water is everywhere and the skies are in constant motion. There's something primordial, too, about the fact that the internal and external fireplaces, designed for heat and comfort, are set within rock. 'Making a place that resonates with people stems from understanding the essential qualities that make us human and our relationship with our world,' says Kundig. 'I look for ways to connect to those elements in as direct a way as possible.'

The more public areas for socialising are balanced with a private master bedroom, sitting area and en suite, set at right angles to the main living area, linking visually with the view through floor-to-ceiling glazing.

As well as wanting a house that engaged strongly with its surroundings, the client also requested it be capable of housing her art collection. Thus it required a degree of quiet and calm so as not to visually spar with the artworks. The combination of concrete, stone, timber and glass is both robust and mute, and allows the rich furnishings and artworks to become more prominent. The design is generous both in its scale and in its restraint. 'I think balance is essential for good design,' says Kundig. 'It is something I strive for in all of my work.'

One of the design elements for which Kundig is best known is his interest in, and use of, mechanical components, such as cogs, wheels and pulleys. Elegantly expressed, they become the architectural hardware in many of his buildings. These 'gizmos' crank open window walls, such as the 5.4 tonne example at Chicken Point Cabin (2002); raise roofs, and access airflow from a high Dutch entry door such as at Montecito Residence (2008). Visually, their industrial antecedents are domesticated through their precision engineering and beauty of execution, and it is not surprising that Kundig now has his own architectural hardware range. Craft and the input of craftspeople is very important to Kundig. The practice of this is very evident in the bespoke nature of The Pierre, both externally and internally, with the mark of the craftsperson evident at every turn – the layers of effort and skill are a visible part of the house's journey. 'Building anything on a small island is an exercise in logistics – machinery, materials, crafts-people – it was no different for this project,' says Kundig. 'Every project is unique, but building in a remote location is always more challenging.'

Kundig's practice is not defined by large-scale projects; some of his most interesting and highly acknowledged work comes from the challenges and limitations of site, location, climate and regulation. The Rolling Huts (2007), for instance, are an ingenious solution to restricted land use, which forbade permanent dwellings on a former camping ground. Wheels and a low-tech construction approach, with steel, wood and glass as the main protagonists, allow these huts to conform to the code and suit the client's requirements for guesthouses for his friends. There are several of them, and they are described as being grouped like 'a herd'.

'I try to find an appropriate solution for each challenge,' says Kundig. 'I come to the table with my own background and legacy, and that invariably mixes with my client's history and that of the site. The opportunity to work with great clients, great sites and talented designers and fabricators is why I do what I do.' ▬

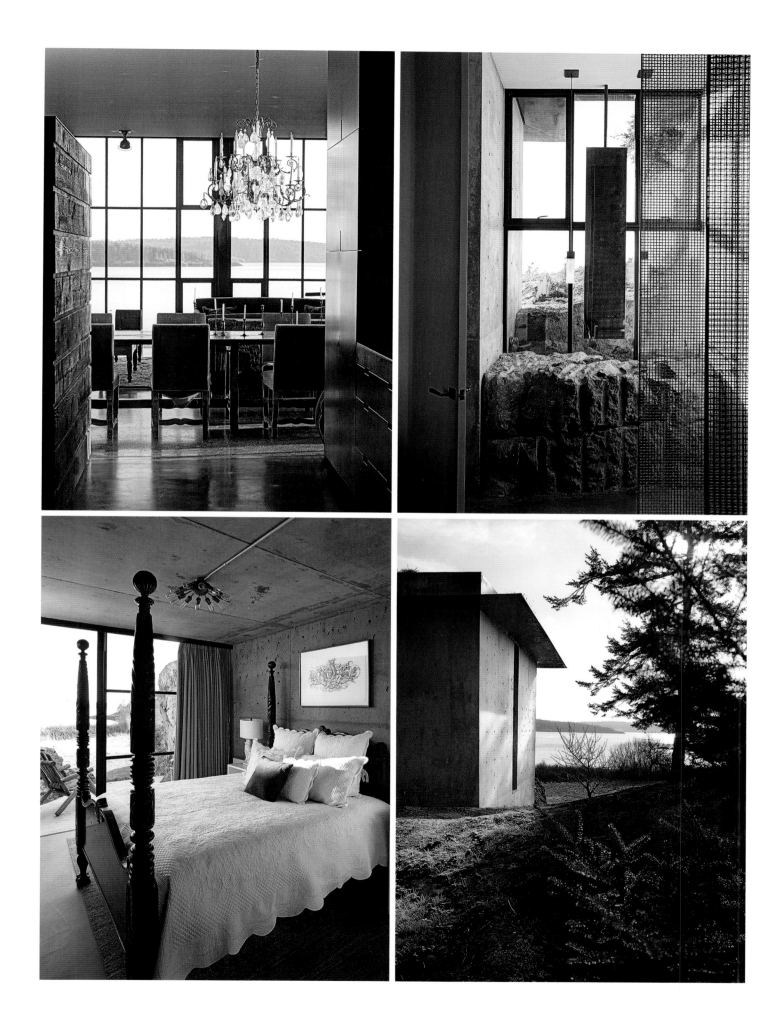

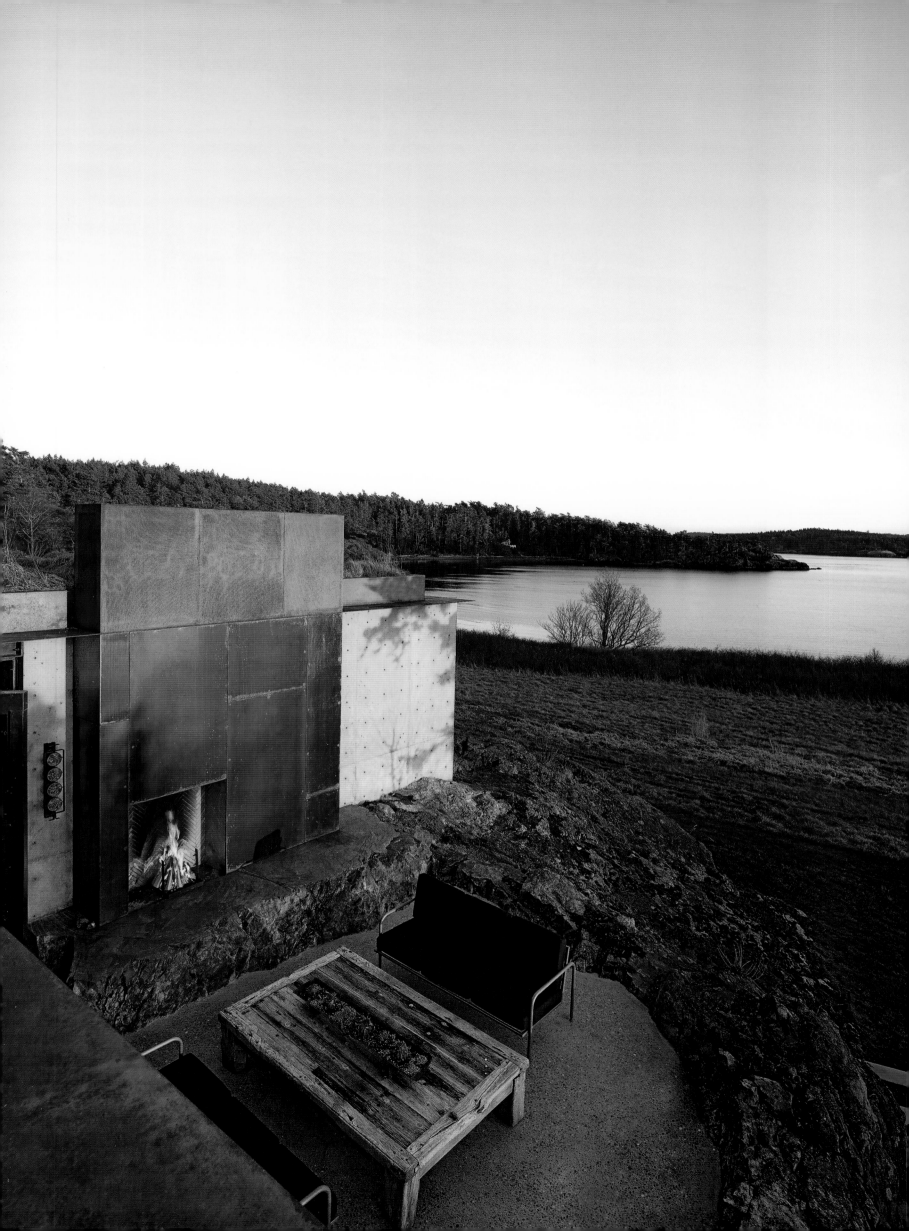

The indoor and outside fireplaces, which each have a monumental hearth, share a chimney.

As time goes by, there will be a sense of the building increasingly being reclaimed by nature.

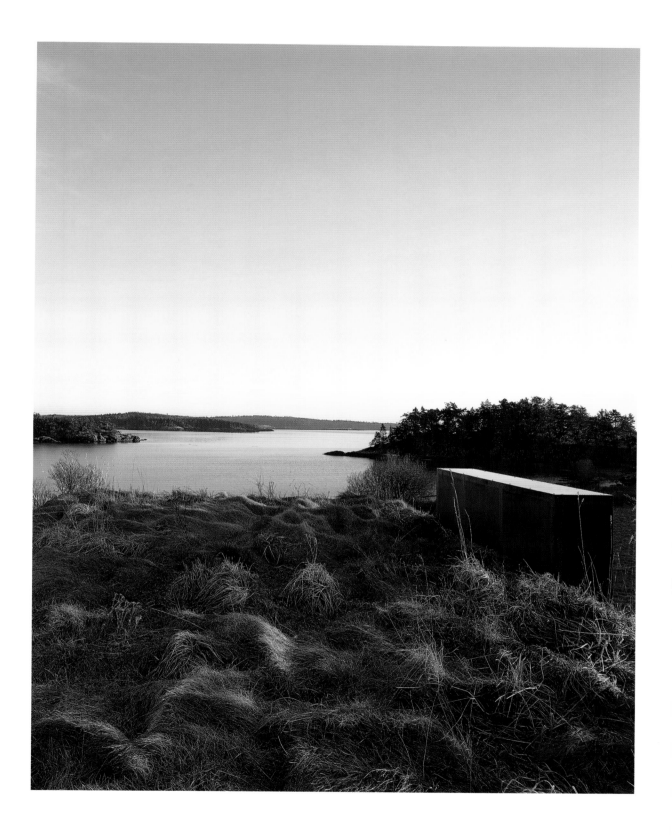

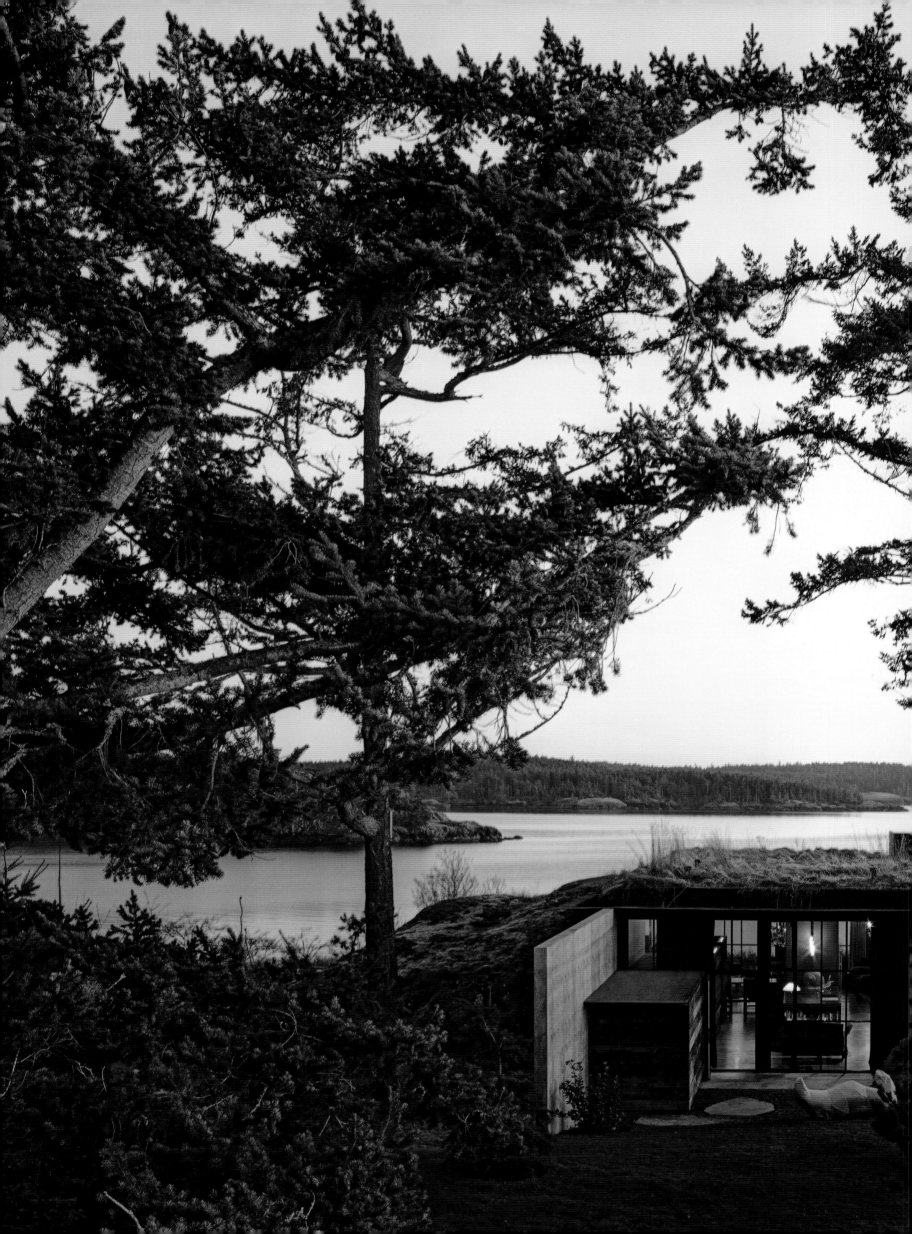

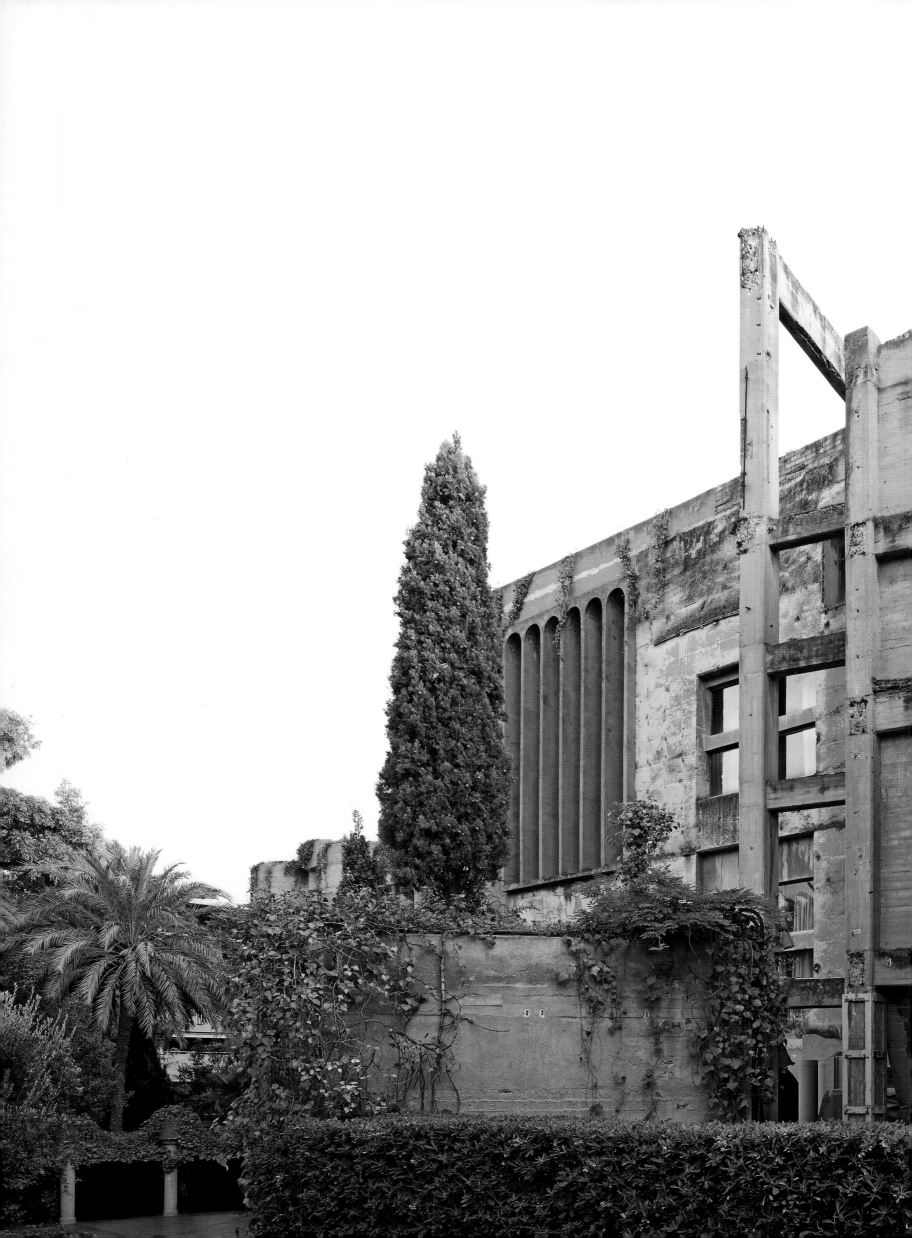

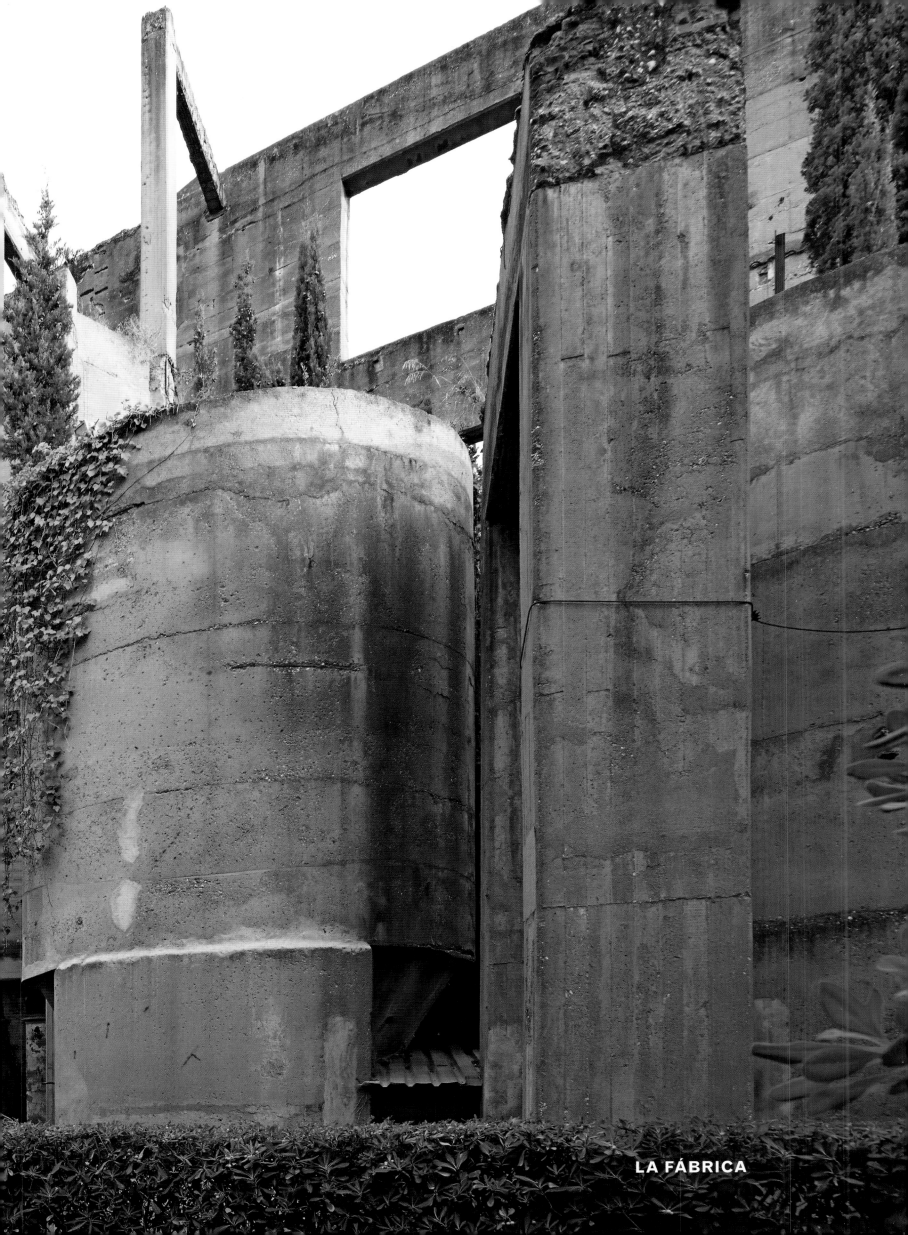

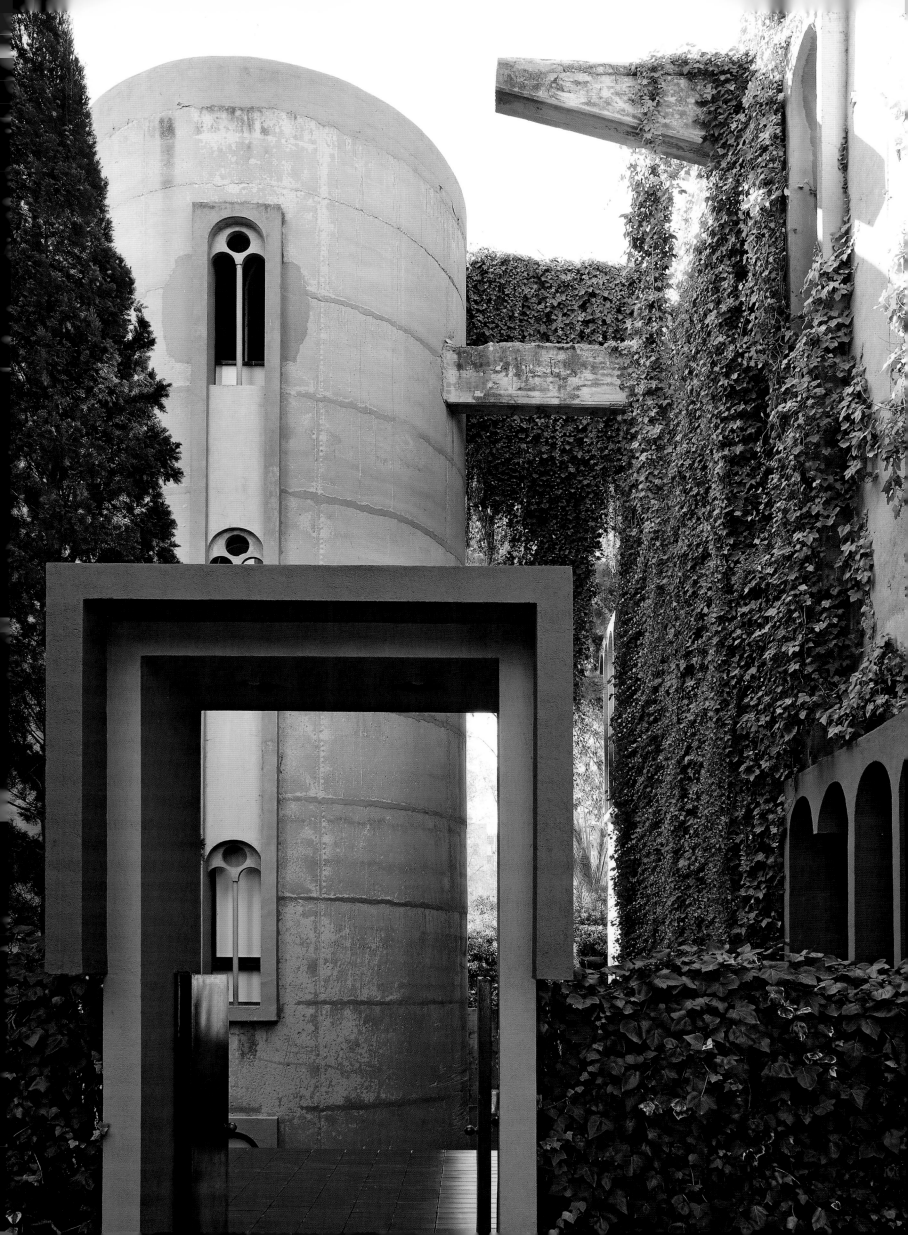

LA FÁBRICA
(1975)

◇

RICARDO BOFILL

⋈

SANT JUST DESVERN, BARCELONA, SPAIN

'It was all about destroying in order to find the hidden beauty inside the factory. It is an almost sculptural work of destruction,' said architect Ricardo Bofill of his approach to turning an enormous defunct cement factory into his Taller de Arquitectura (RB) and his home. It is credit to his vision and willpower that he could look at the post-apocalyptic mess of silos, administrative offices, bridges and polluting chimneys and see that out of it could emerge an architecture rich in narrative, referencing Brutalism, romanticism and surrealism, and with homage to the history of Catalan architectural heritage and Bofill's nomadic travels.

In lesser hands it could have been a disaster, but Bofill's vision is matched with clarity of purpose. 'I had got myself what people thought was the most horrific place on earth, full of smoke and cement dust. Transforming it was an exciting challenge,' he said. He bought the land at a good price in exchange for the promise to the municipality that he would transform the barren industrial zone into a regenerated, mixed-use area creating a new centrality for Barcelona. This was radical thinking for the period, but his plan was facilitated by the fact that the area of Sant Just Desvern was on the outskirts of Barcelona and had fewer regulations and, in the broader political landscape, Franco's dictatorship was coming to an end.

Some of Bofill's unflinching confidence came from his father, an architect, and from his training at the Barcelona School of Architecture, where Bofill learnt to think, and plan, not just in terms of individual buildings but also in terms of communities and cities. 'I wanted to make a leap in terms of scale – I wanted to plan a whole neighbourhood,' he said.

His first foray into this approach was the vertical neighbourhood Walden 7 (1974) which was revolutionary both philosophically as well as physically. Inhabitants bought shares in the property, taking up as many modules as they required for their circumstances. The modules are multi-functional rather than prescriptive in terms of use and so could adapt to the individual or family needs of the occupants. Bofill describes it as 'an object in a double scale, monumental and human'.

This philosophy of 'double scale' is also true in La Fábrica: it is at once massive and intimate and, although Bofill's strategic plan was incredibly clear, the specific use of the space was not determined too early in the thinking – that came later. The process in Bofill's words was 'to clear, to clean, destroy, plant, introduce historical aspects and include the accumulated influence of my different travels'. The cleaning and clearing took two years and the destruction was an editing process that eliminated 70 per cent of the buildings on the site with the goal of releasing

One of the key elements in the transformation of the old factory is the Babylonian use of foliage.

A staircase, treated with garage paint, links the living area to an elevated dining room.

Enough of the character of the building has been maintained not to feel sanitised.

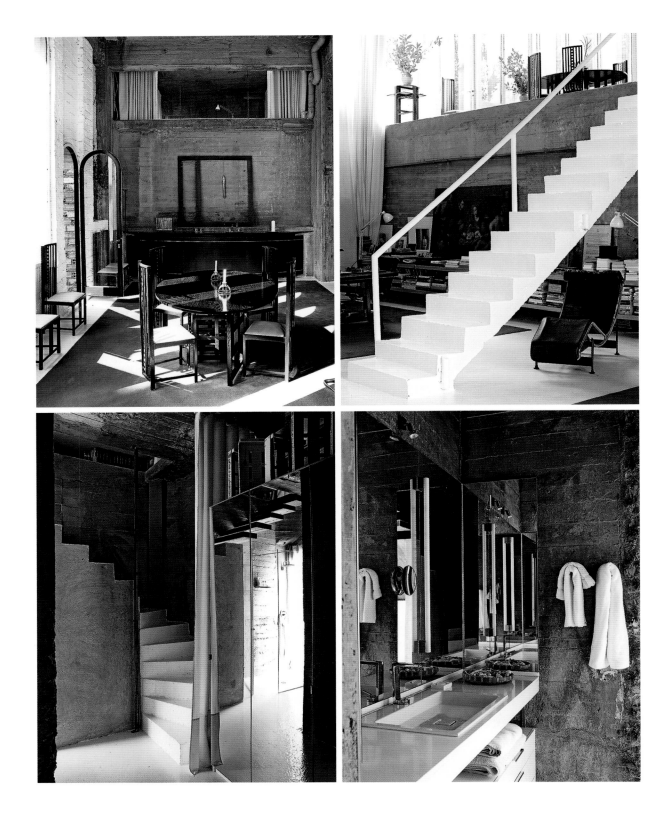

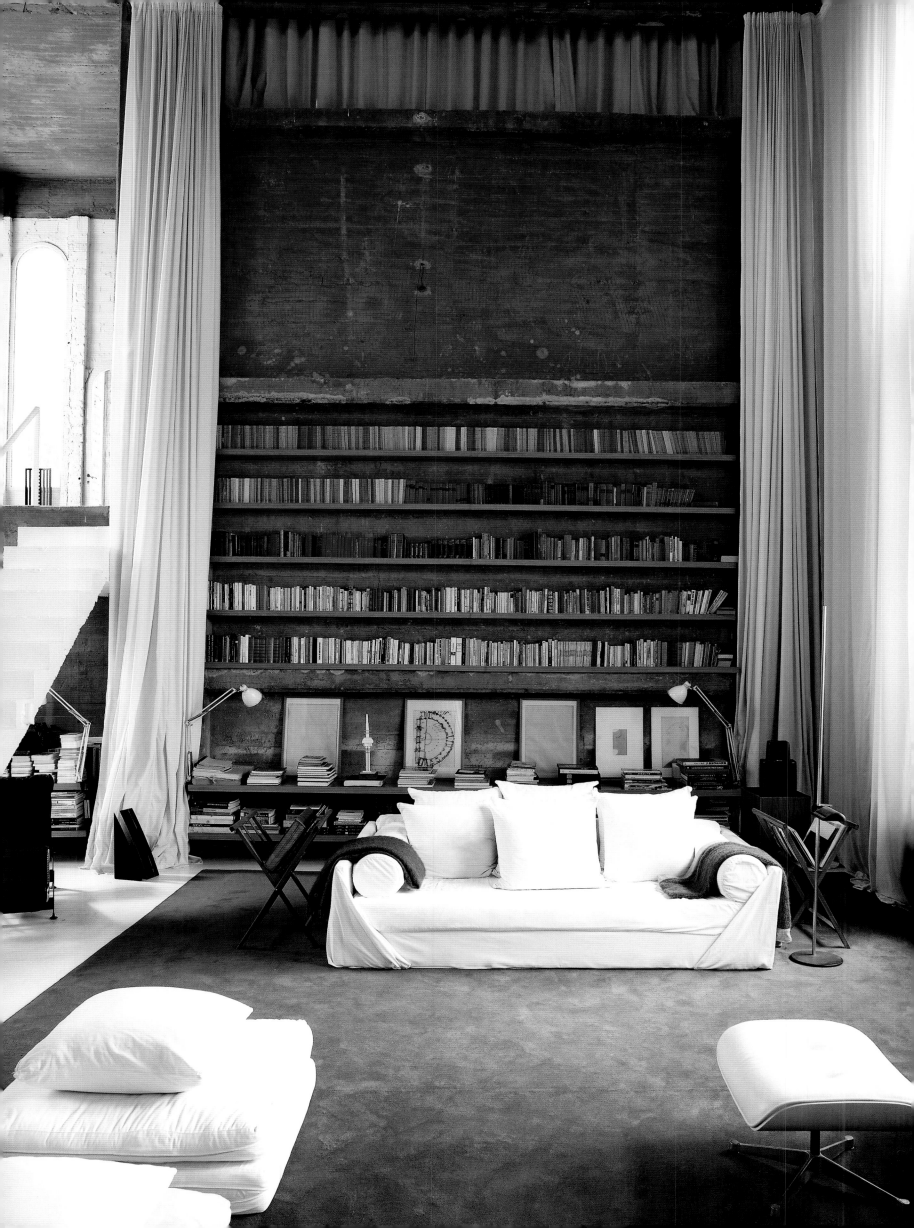

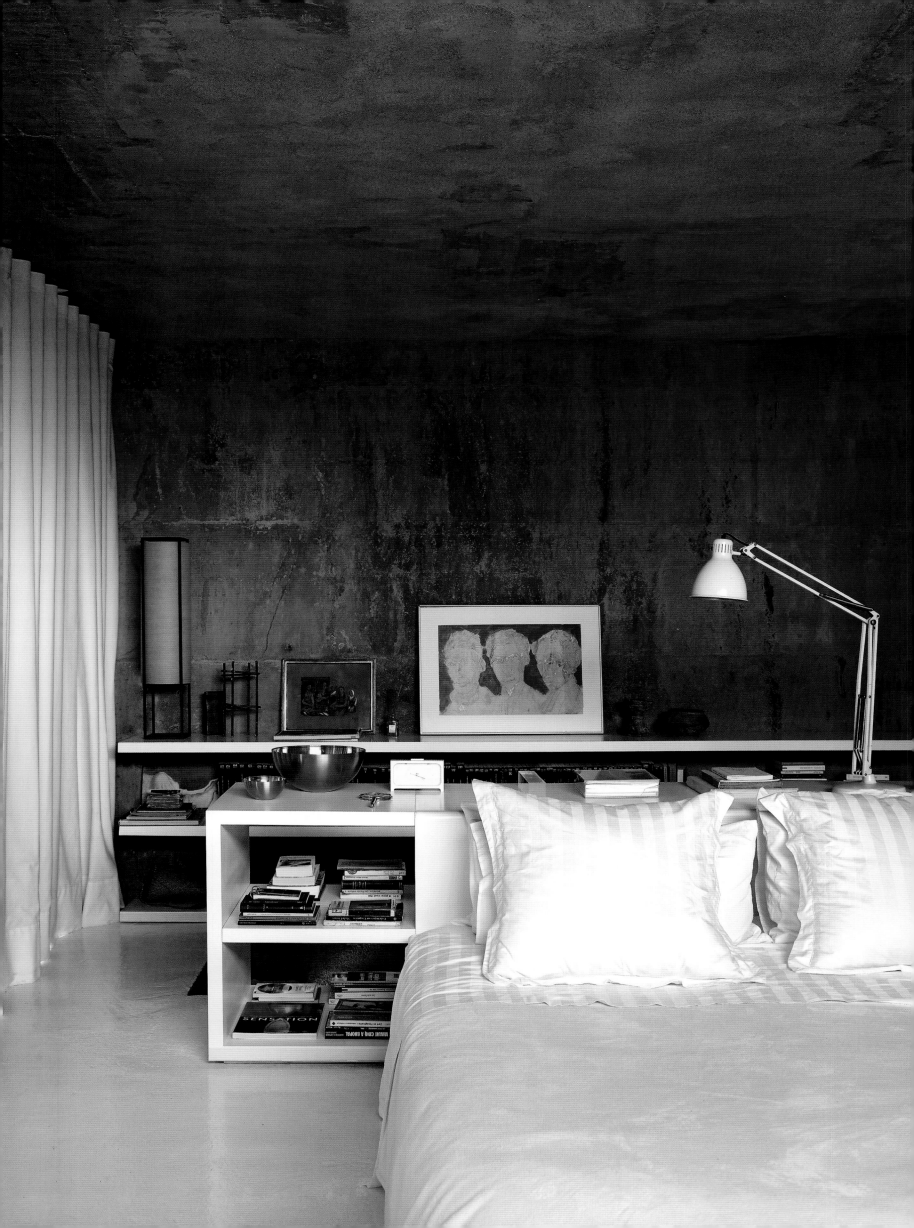

Bofill's refusal
to obscure years
of industrial
use ensures the
character of
the walls remain.

Memorabilia and
a tonally sensitive
arrangement of
books adds an
individually human
touch to the space.

Lengths of fabric
serve to diffuse the
light and emphasise
the scale of the
cavernous space.

the inherent geometry masked by the sheer volume and variety of building type. 'The factory had grown organically as functional needs dictated, and my father pulled it back to the pure shapes – the cube and the cylinder – the most aesthetically pleasing of forms,' says Ricardo Bofill Jnr, now president of the practice (his brother Pablo Bofill is CEO). The mid-Seventies was the beginning of post-modernism; there was a reaction against the reductive aspects of minimalism, and a desire to see a contemporary reinterpretation of historical architectural language. So that when the need to create windows in the silos arose, Bofill turned to traditional Catalan architecture for inspiration and, in doing so, imbued the silos with an elegance that transcends time and place.

'It was like moulding a sculpture – cutting out walls, removing to adapt for new use, cutting out holes to create new windows, with the goal that new forms would be pure geometric forms,' said Bofill. There seems to have been an incredible degree of plasticity in the process, brought about through the freedom of working within an existing form, without preconceived notions of outcomes and prescriptive use, helped by the fact that the architect was also the client.

The next stage was that of planting and turning this eccentric world, with its industrial vernacular past, into a Hanging Gardens of Babylon. The greenery pulls La Fábrica back into nature, intertwining with purposefully unfinished elements, or bits of building that go nowhere and do nothing but add to the sense of history and layered narrative. The fronts of the silos are buffered from the street with a large grassed area and a mix of traditional Mediterranean vegetation such as olive and cypress trees alongside palms. On buildings throughout the complex, plants drape and hang, softening the formal structural geometry. The roof is planted in a way that we now accept as commonplace but was quite radical in the mid-Seventies. 'It was done instinctively, before the ecology movement, to create a world, a green environment on the roof,' says Ricardo Bofill Jnr.

Our tour takes us across a narrow band of masonry linking to a rooftop garden planted with cypress trees – a sky garden with access only to those with nerves of steel and lack of vertigo. Here the determinedly unfinished nature of the building is clear, be it a rough hole in a silo, a project started but abandoned, or a partial wall covered in tangled growth. Bofill has affection for ruins. 'The incomplete, half-finished work in ruins is a subject that has always fascinated me,' he said. A great example of his travel-inspired structures also sits on this rooftop. Ricardo Bofill Jnr explains: 'After my father visited Japan, he wanted to design a glass box, a sort of pleasure house with sauna and steam baths, a fire and comfortable beds. It is a very private space up here.'

'I had got myself what people thought was the most horrific place on earth, full of smoke and cement dust. Transforming it was an exciting challenge.'

RICARDO BOFILL

In terms of silos, there are groups of six, of four and of two, which have been opened up and connected to make working spaces for the Taller de Arquitectura as well as private spaces, including Bofill's own apartment within the building. One of the hero spaces in the complex is 'The Cathedral', a cavernous area with a ceiling eight metres high, illustrating the balance between the reclaimed and the re-created. Great imposing steel hoppers hang into the space, emphasising its rawness despite the introduction of an elegant boardroom table designed by Ricardo Bofill and surrounded by Eames Aluminum Group chairs, a grand piano and a remarkable Casa Batlló Double Bench by Gaudí. Amongst these furnishings are Perspex-boxed models of projects, including Barcelona's W hotel and seating designed for airports and other commercial projects.

Moving through La Fábrica, the experience recalls *Alice in Wonderland*. One minute you are an insignificant figure in an enormous space and the

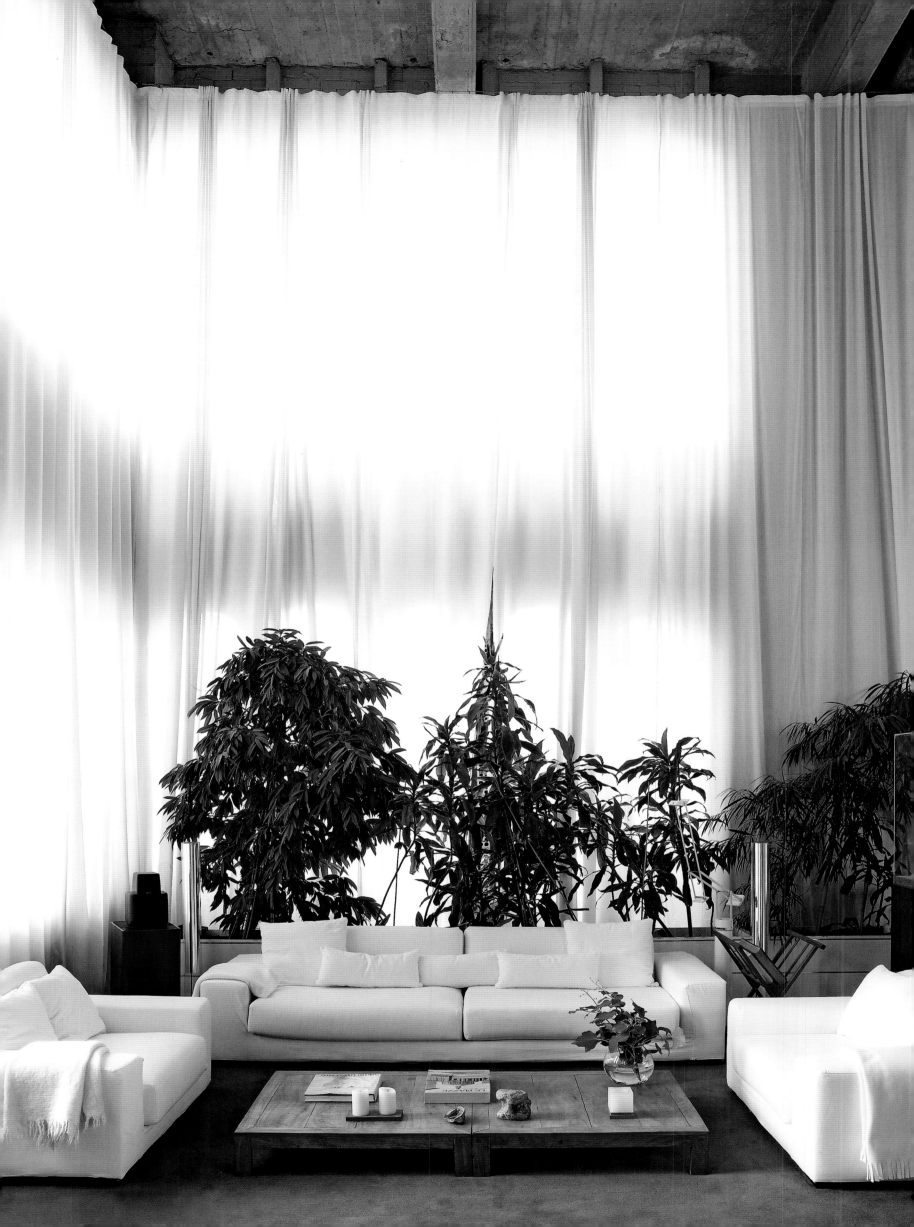

Playfulness comes
through the blend
of formal arches and
anthropomorphic
Gaudí chairs.

More refined rooms,
for meetings,
utilise the signature
window arch to
maximum effect.

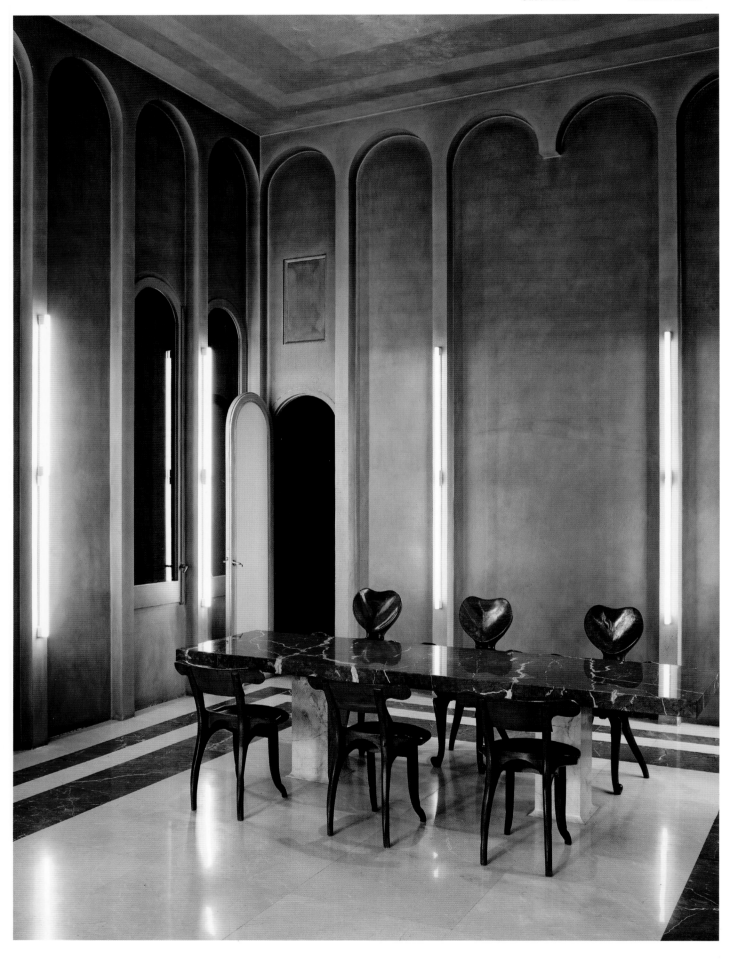

LA FÁBRICA —— RICARDO BOFILL

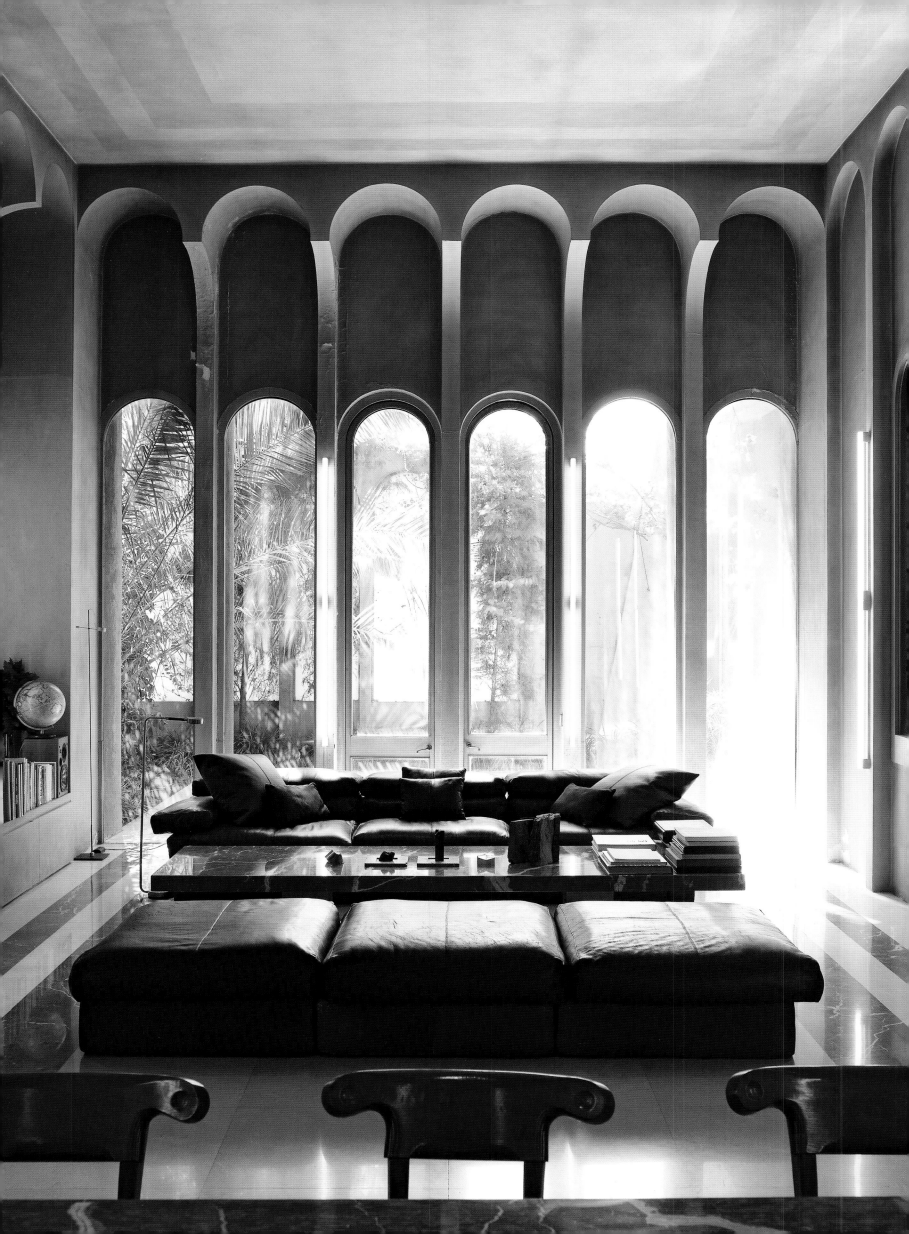

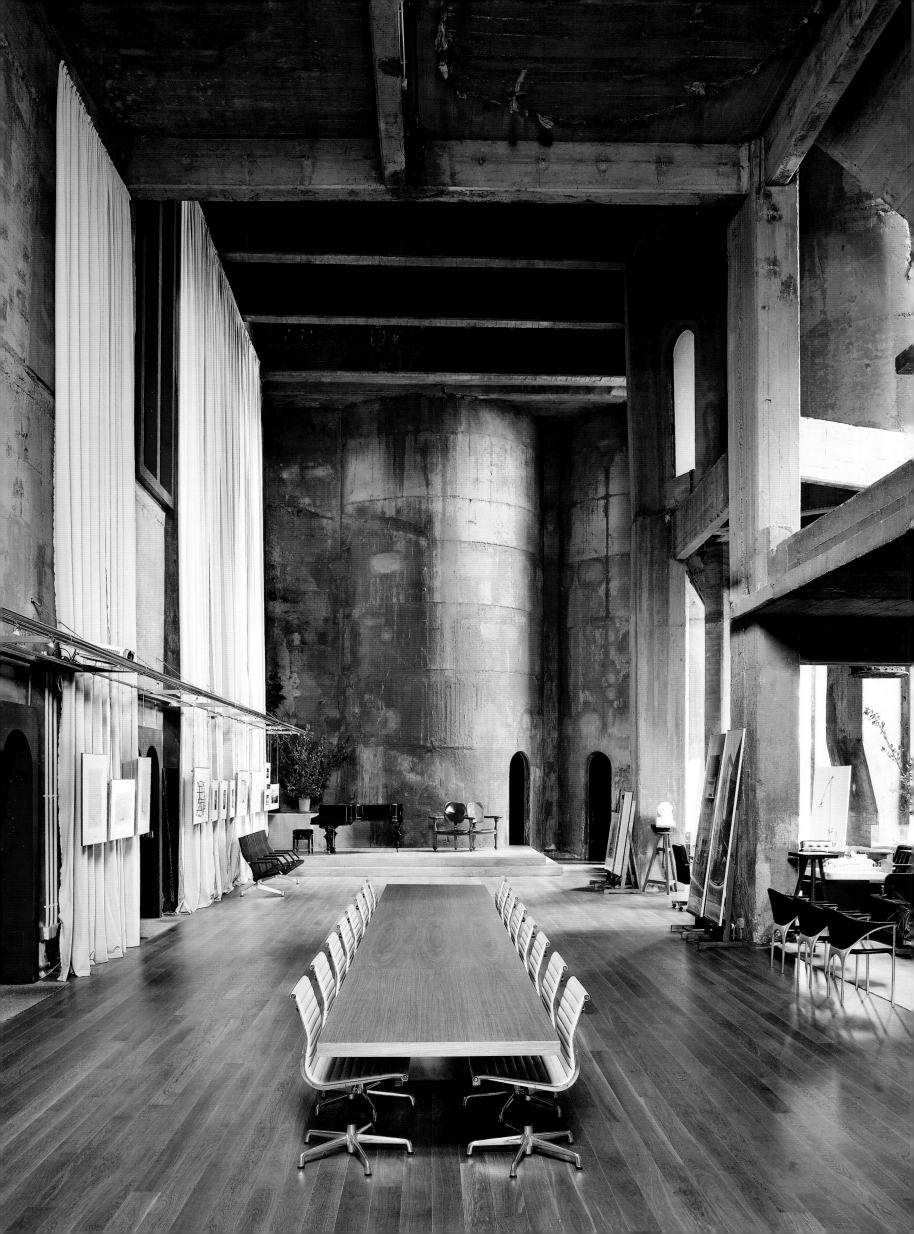

The scale of the
office, with eight-
metre-high ceilings,
manages to dwarf
even a grand piano.

Retention of the
large hopper is
where the building's
industrial past
is most evident.

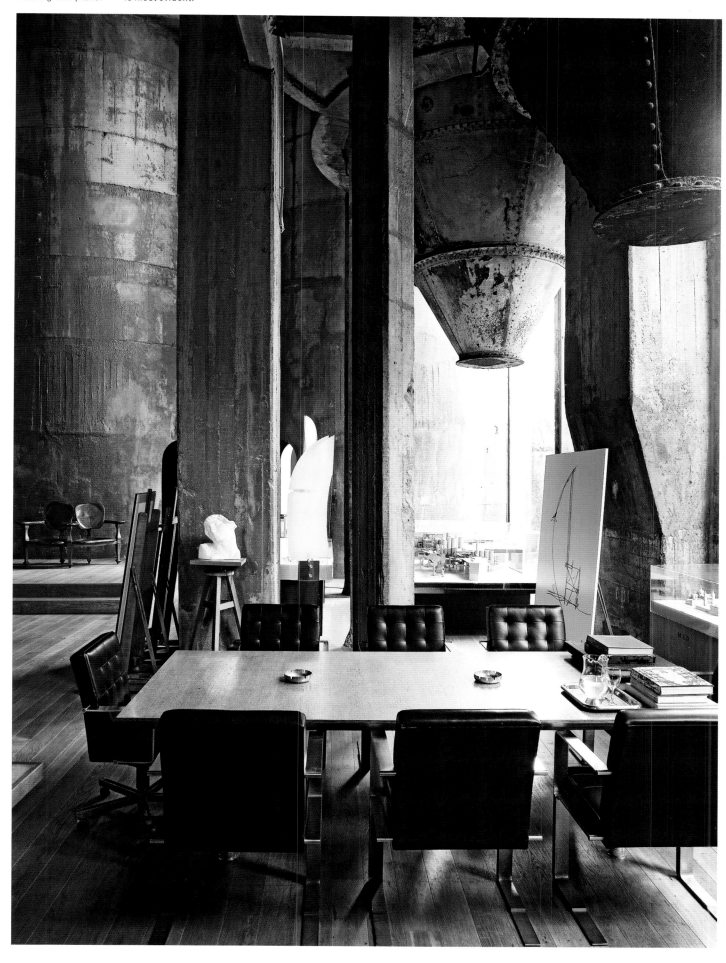

next you feel overlarge as you squeeze through a narrow arched doorway or climb a tightly curving staircase. The play of scale against the human form makes the experience more acute and also increases the sense of awe as vistas are disguised and then revealed, or you make a sudden, unexpected connection, either visual or physical, in this labyrinthine complex. To add to the intrigue, there are even catacombs used for storing 50 years of archive material, for a model-making workshop and for housing the large blinking server that fills an entire side room. The tunnels extend for a remarkable seven kilometres and, although Ricardo Bofill Jnr would play in them for hours as a child, the only thing he found were very large rats.

Ricardo Bofill Jnr is keen to point out the economy of the building's transformation. 'We used garage paint to white out the rooms, and the columns outside are made from drainage tubes. We used simple, economical materials because here the luxury is space and light. Here, function is second to narrative.'

Said Bofill: 'You can see there are as few things as possible in this house/studio. I like brick walls. I like minimal things. The tables and chairs are the same as 40 years ago, the bare necessity, the purest look possible.' And this is manifestly clear when you look at his personal apartment. The intrinsic character of the space is informed by the original building with its earth-coloured walls, the exposed brick and the characterful remnants purposefully maintained – a discoloured rope hangs from the ceiling and some wooden boards remain nailed in place. 'We have kept the guts of the building and maintained the material expression of the building – rather like the work of Spanish artist Tàpies', says Ricardo Bofill Jnr. The loft space is generous in terms of the arrangement of space, but is configured without partitions – rather, it is the furniture, the rugs, the bookcases and the staircase that create logical living zones. Dramatic floor-to-ceiling curtains diffuse the light in an all-white area of Ricardo Bofill–designed sofas alongside a pair of white leather-covered Eames lounge chairs and ottomans. A large working table defines another area and a soaring bookcase of sensitively colour-themed spines fills an entire wall, with personal memorabilia and family portraits propped up on the lower shelves. A graphic concrete staircase painted white rises from this level to an elevated dining room complete with a Charles Rennie Mackintosh dining table and chairs.

It is impossible not to be struck by the modesty of the bathroom and laundry facilities, as they illustrate Bofill's statement, 'I don't like luxury', to be absolutely true. White garage paint and simple unpretentious fittings indicate that he is happy to live as a man in his 70s as he did aged 30.

Given that RB employs 50 to 60 people, across 20 nationalities, and across a multiplicity of disciplines within the architectural profession, the success of the practice is testament to the fact that the building works for him creatively. The nature of the work is global, with projects in China, Texas, Lima, Dubrovnik and St Petersburg; the scope of some of the projects is staggering in their level of complexity, such as a proposal for the radical rethinking of Moscow, which includes a new Kremlin building. 'My father is 73 years old, we have 20 projects in development and he can remember the name of the contractor dealing with the elevator on one project and the beam stress necessary on another,' says Ricardo Bofill Jnr. 'He has a phenomenal mind.'

He tells me that for every new project his father needs the calm and serenity of a clean white page and as little distraction as possible. Even beyond the windows of La Fábrica, the greenery outside maintains the illusion of a sealed world. 'What I can say is that the place where I live, here, is where I am at my best, where I feel most comfortable and where I can think most clearly,' said Bofill. ▬▬▬

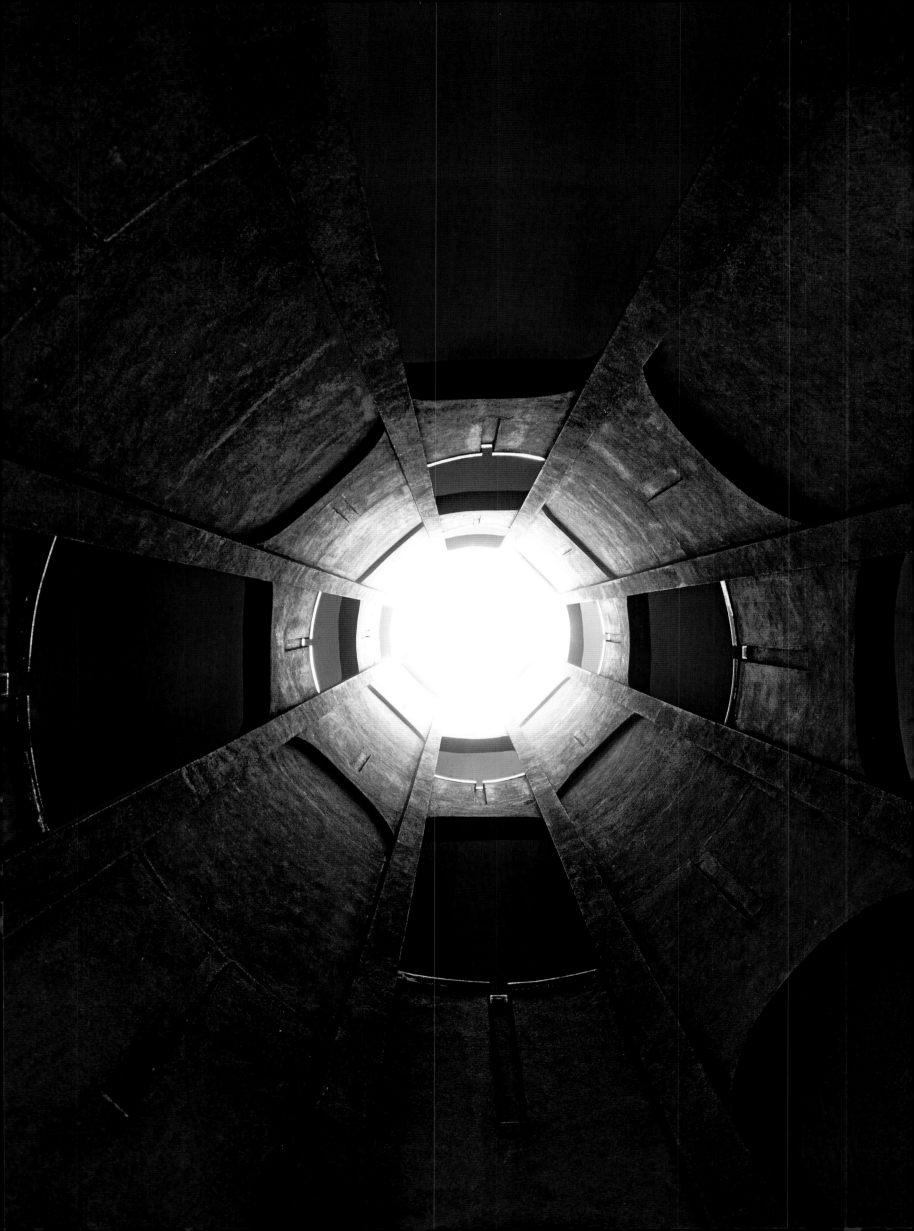

A shady courtyard area has been set up for staff lunches during the hot summer months.

Cypress, olives and palms sit within a grassed area on the street side of the complex.

LA FÁBRICA —— RICARDO BOFILL

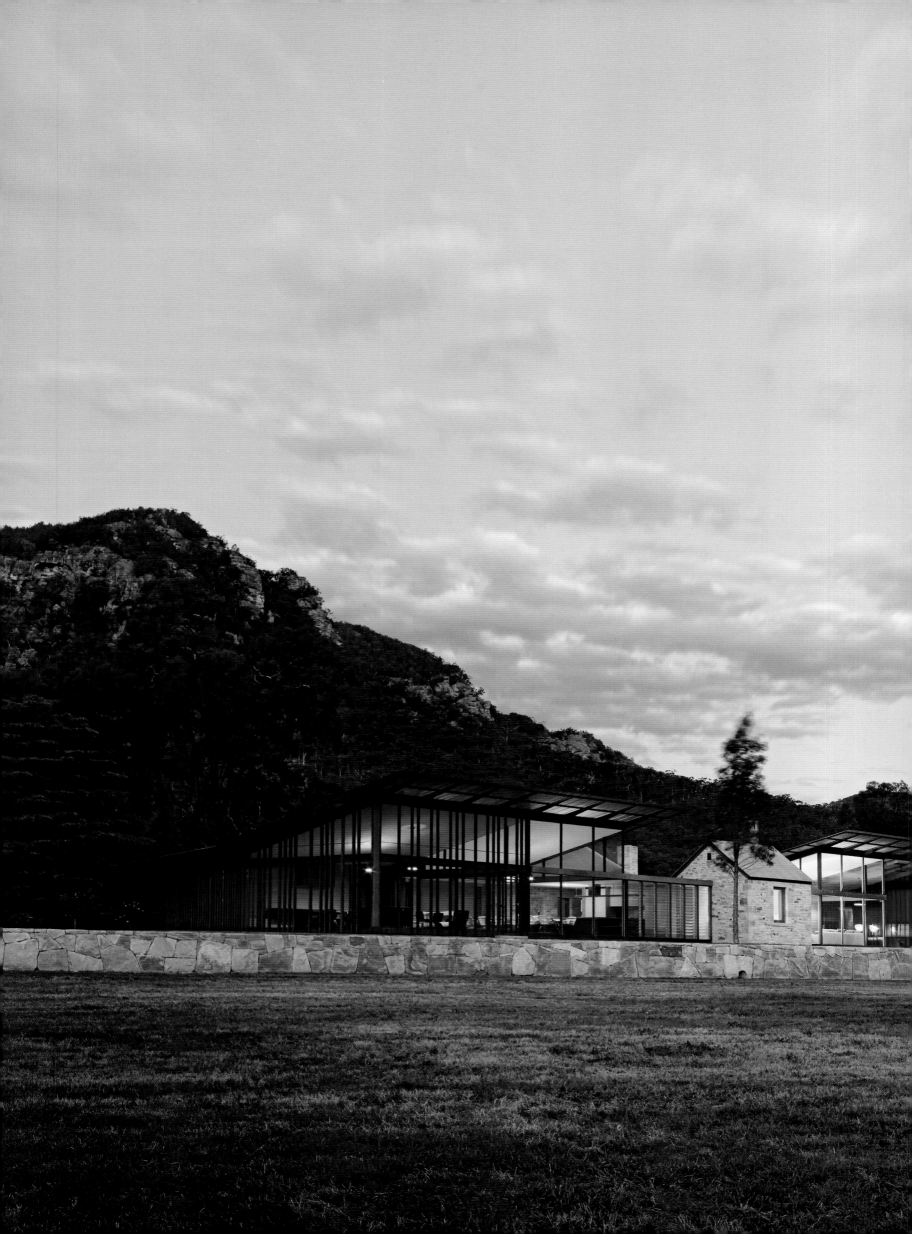

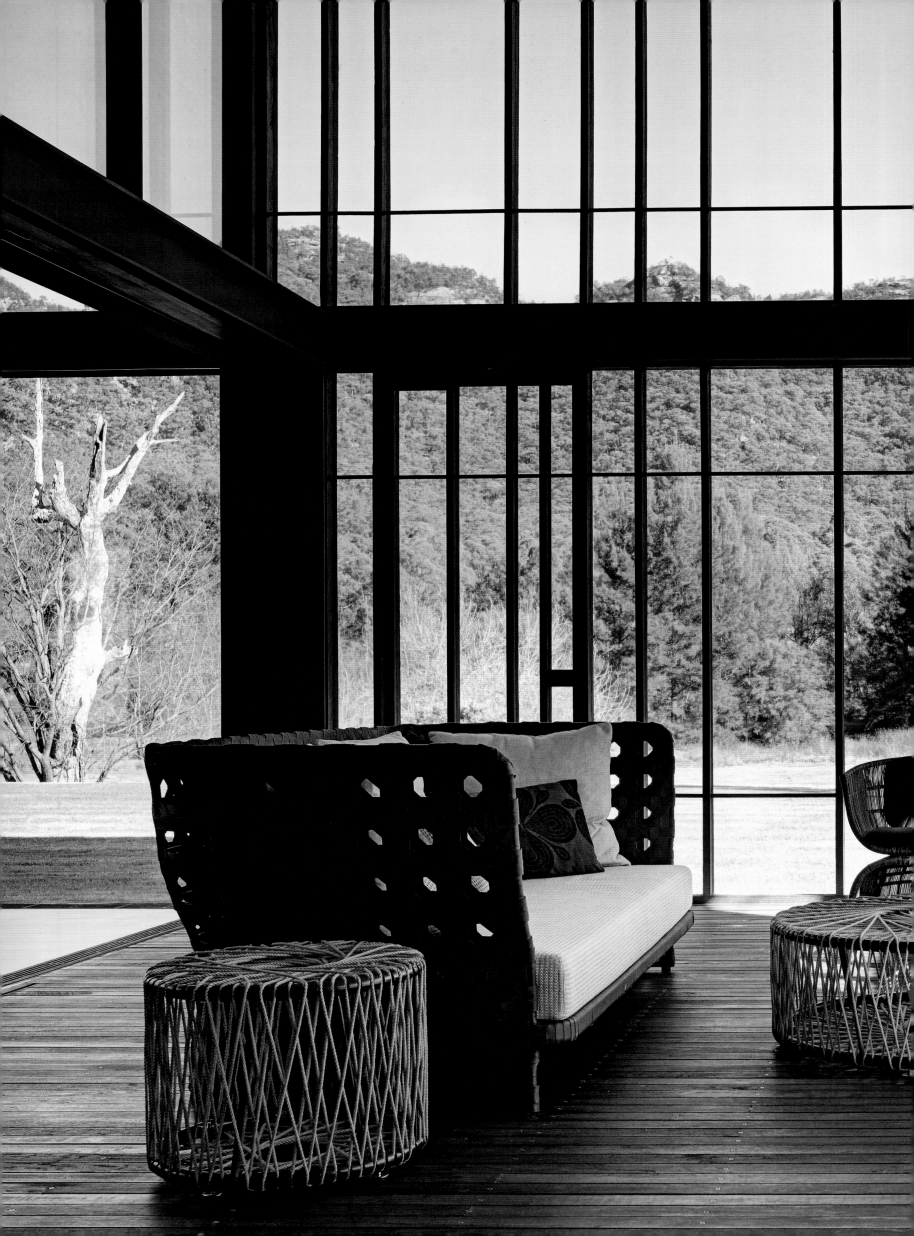

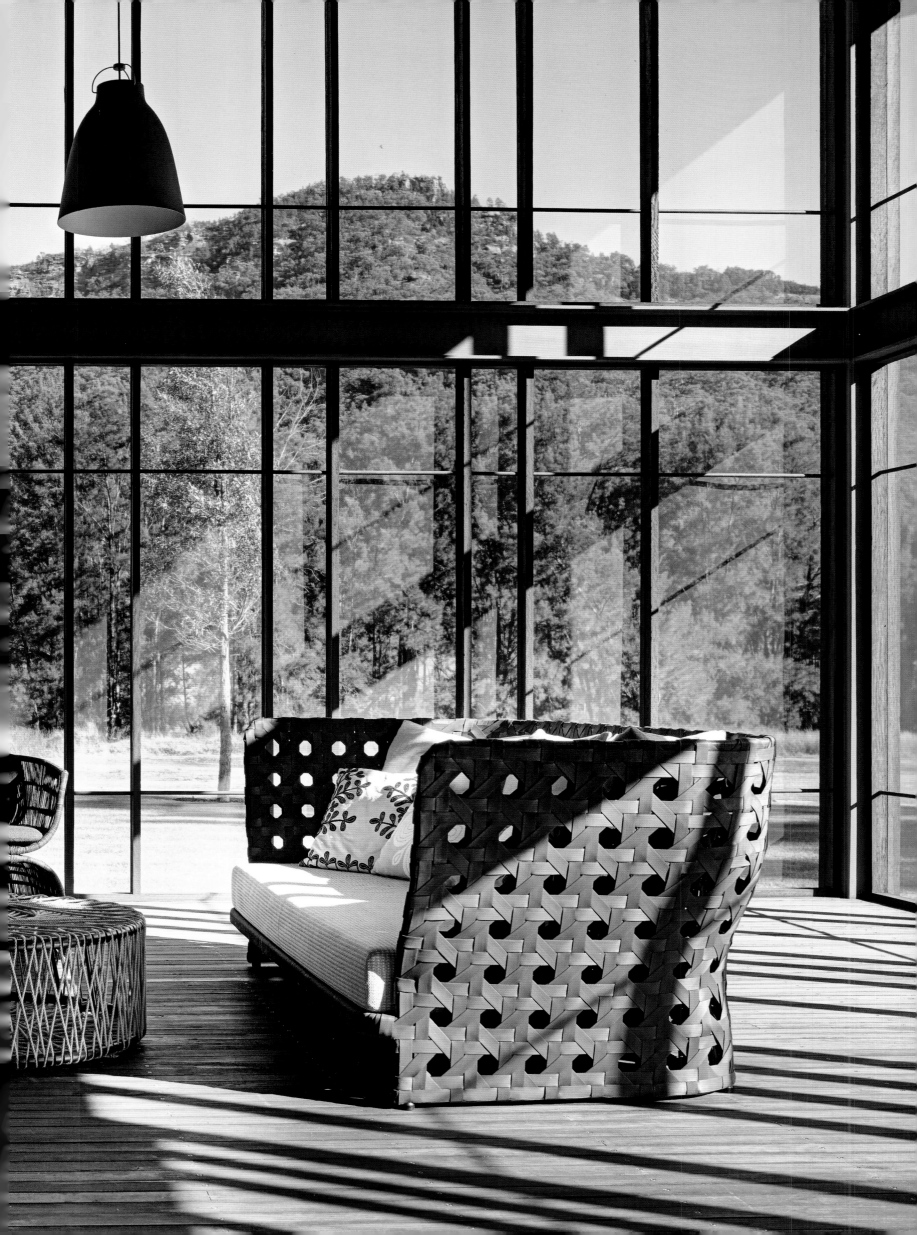

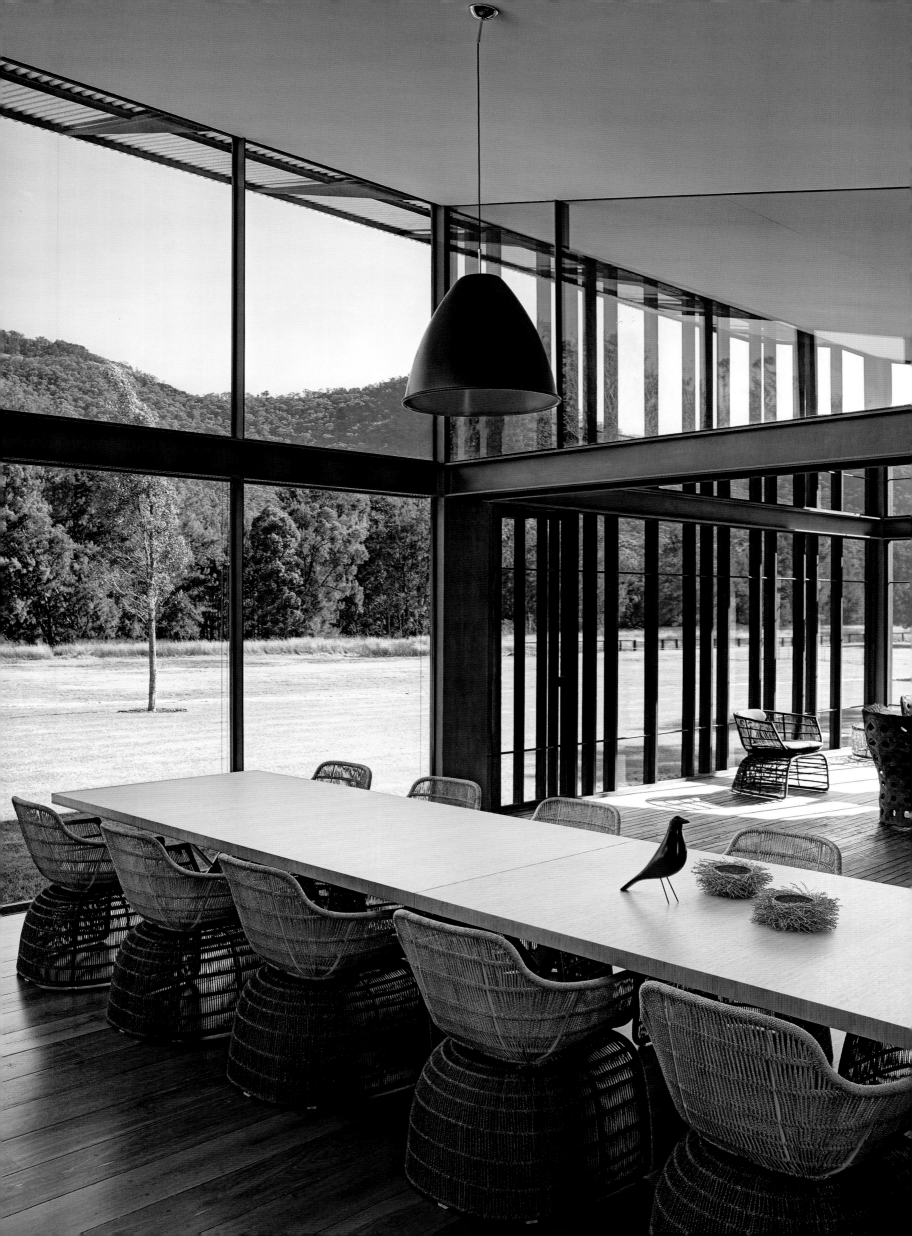

**HOUSE IN COUNTRY NSW
(2010)**

◇

**VIRGINIA KERRIDGE
ARCHITECT**

⋈

**UPPER HUNTER,
NEW SOUTH WALES,
AUSTRALIA**

The journey to the Upper Hunter, five hours north of Sydney, passes through towns that proudly declare their settlement in 1822, giving you a profound sense of an older, more agricultural Australia. Go over a tiny creek named Dingo's Gully, and gradually the landscape becomes a mixture of craggy, bush-covered mountains and low-lying green pasture for cattle and horses. It is in this setting that architect Virginia Kerridge has designed a house with a deep connection to the landscape and its built heritage.

There are a number of accomplished houses in Sydney designed by Kerridge, often on steep waterside blocks, the topology of which dictated a scheme of levels stepping down the site. Her architectural preoccupations are long held – the use of natural materials, particularly timber and sandstone, the manipulation of light through siting and screening, the integration of Japanese-style gardens and an incredibly acute concentration on detailing.

To Kerridge, one of the enjoyable aspects of each new design is that it can explore different aspects of detail, and the consideration of those evolve over time and are developed on every job. 'The detail reveals the core element of the design, as the detail reflects the whole.' As Mies van der Rohe said, 'God is in the detail.'

Kerridge had already designed two houses for the client, who she describes as decisive but not domineering, before the commissioning of this project. It was something they'd been speaking about for some years. A believer in the maxim that good clients get good houses, Kerridge was given the freedom to run with ideas. The brief was simple and direct. 'Five bedrooms, a large table for entertaining, a spot for a cup of tea in the morning and somewhere for a drink in the evening with a view of the mountains,' she recalls.

Kerridge admits it was the site itself, a valley between two sets of mountains, and the original bushranger's cottage that dictated the form of the building, moving her away from the freer planning of constructing levels on a hillside. 'We looked at different options, such as fingers working across the land, but in the end the mountains were too strong to fight and so the linear nature of the valley led to a linear construction, with the creek in front of the house and the mountains as both the view and backdrop.'

A heritage report indicated that the only building of importance was the nineteenth-century sandstone bushranger's cottage, which Kerridge used to inform the design, making it an obvious part of the plan, both externally and internally. Kerridge is no stranger to bringing new and old together – her award-winning Taylor Square warehouse (1995) did just that by using materials found on-site – and her intention when adding to old buildings is to 'preserve

The house is oriented towards the mountain views through expansive floor-to-ceiling glazing.

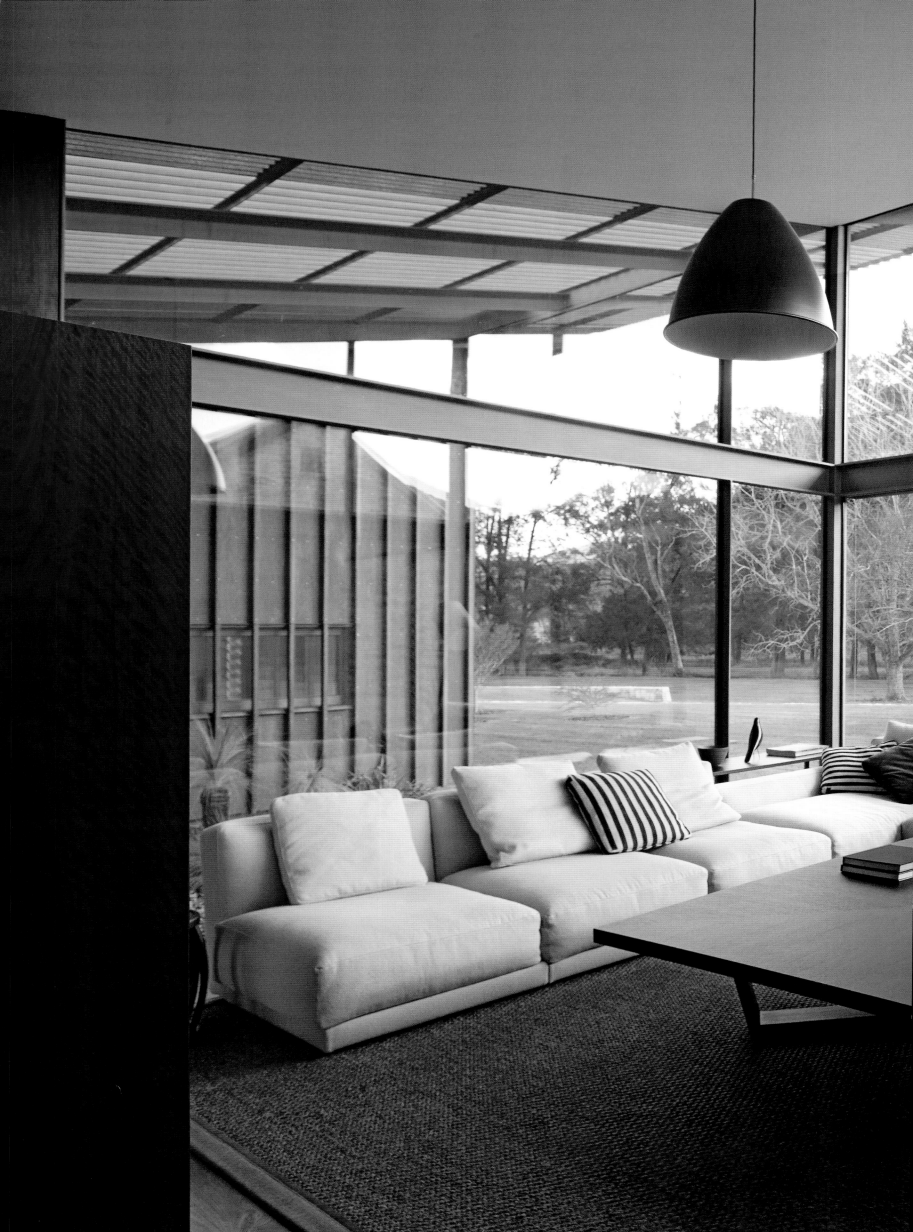

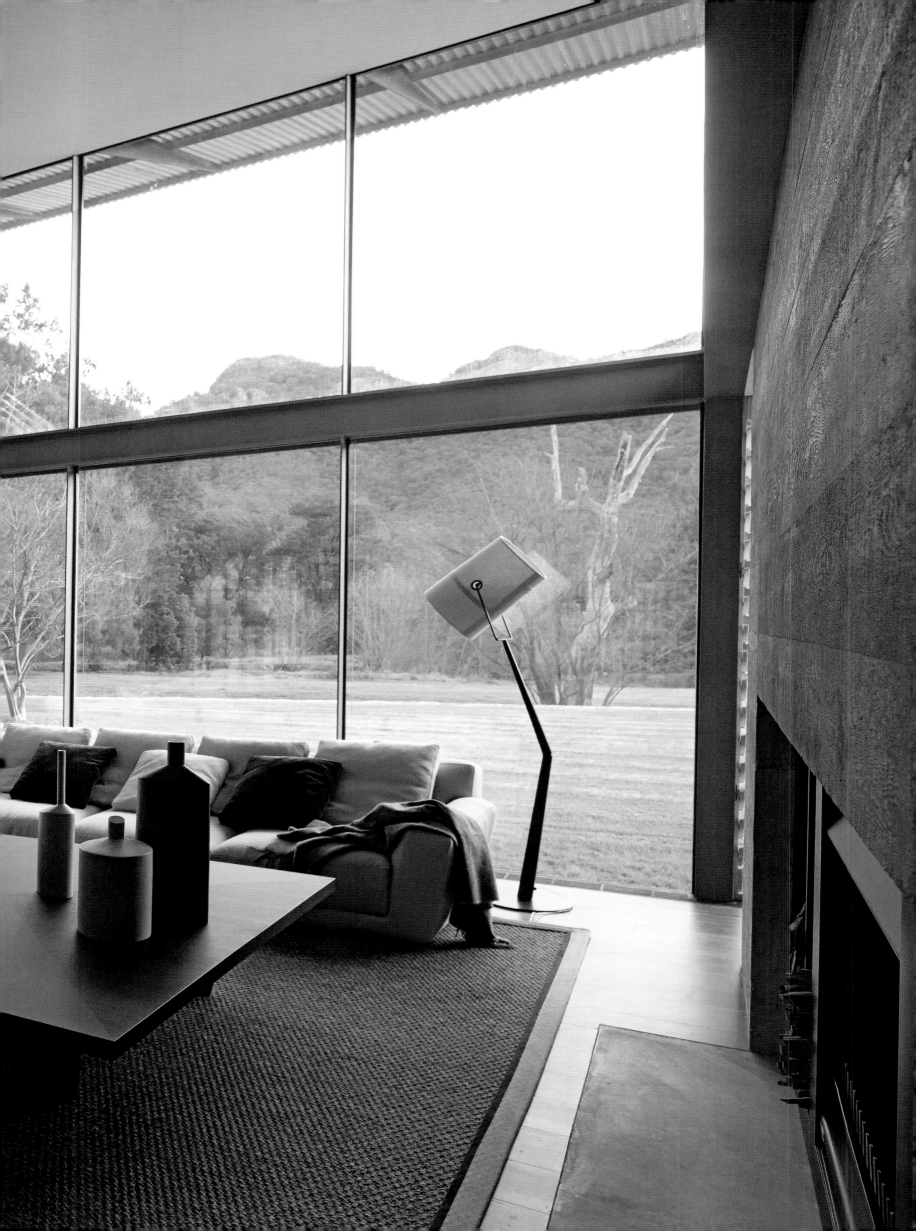

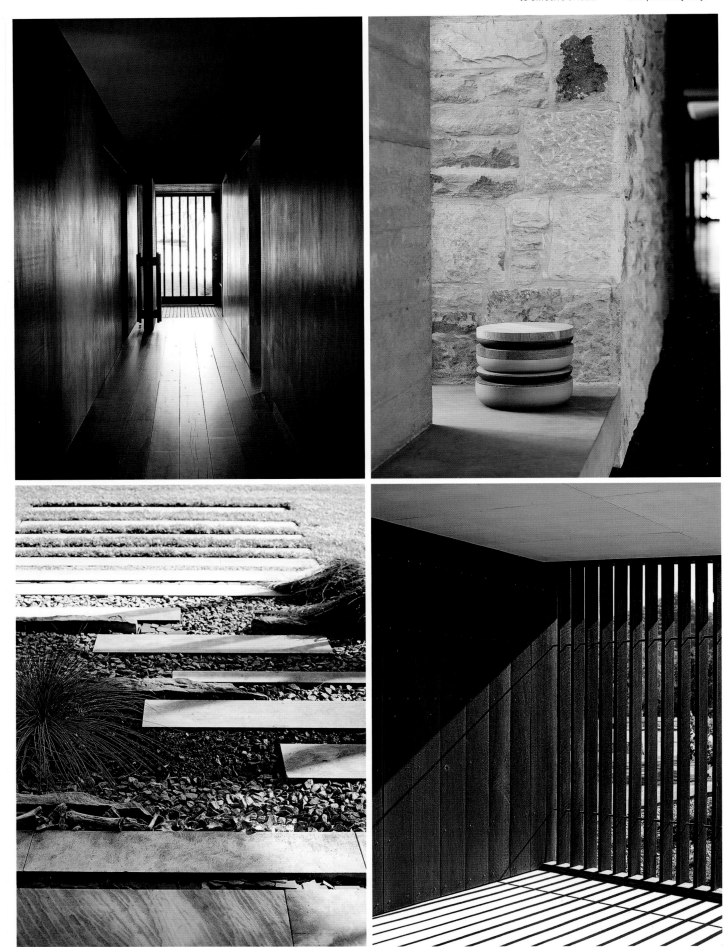

Materials including timber, old stone and even horses' bones are crafted to emotive effect.

The use of slatted timber captures morning light in a most dynamic and painterly way.

HOUSE IN COUNTRY NSW —— VIRGINIA KERRIDGE ARCHITECT

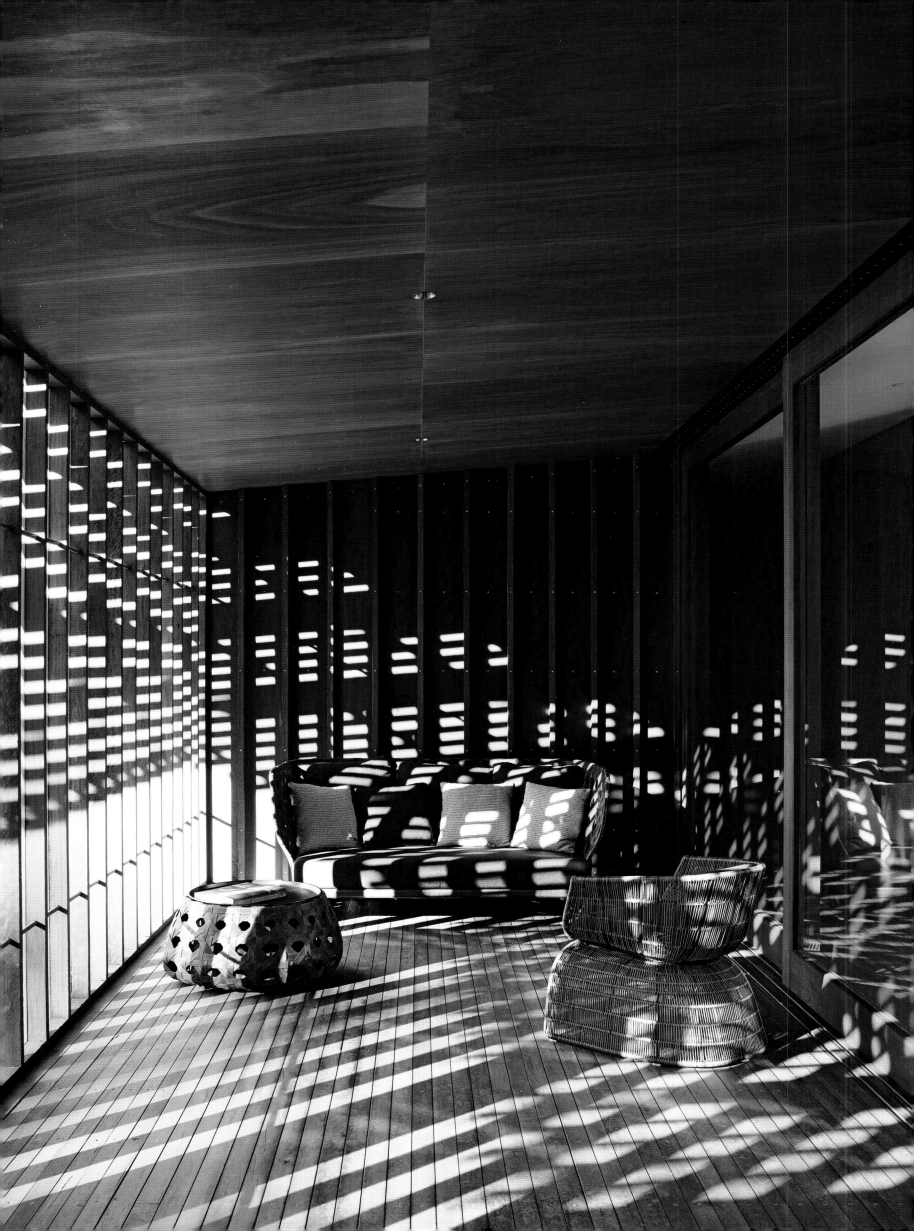

the qualities of the old buildings by sensitively adding to them in a manner where it is quite evident what is new and what is old'. She is also mindful to absorb some of the visual qualities of the old to form a 'seamless combination without discordance'.

This sense of integration is equally true of her material preferences, and becomes one of the defining elements of the House in Country NSW. 'The use of texture is a natural response to the site that the building inhabits,' says Kerridge. 'There is, of course, the texture of the old cottage, but new textures have been brought in which relate to the surroundings.' Earth for the rammed earth was sourced locally, and the recycled ironbark relates to the many ironbark trees in the area.

Rammed earth was originally considered as the material for the whole construction but was eventually ruled out as cost prohibitive, so it is used strategically to give warmth, add texture and link spaces visually. The walls were built on-site, by hand, using timber formwork, which subtly reveals itself in the patina of the walls. Traditionally hard to waterproof, these rammed earth walls were built with a cavity to reduce moisture.

Ironbark is used throughout the interior and exterior but in different applications as best suit the functional and aesthetic needs of the house. The flooring is recycled ironbark from a wharf – its wide, characterful boards evoking a sense of history and, on the exterior of the house, ironbark battens came from timber recycled from old sheds on the site.

Different timber treatments are used to change the atmosphere of a room. For example, in the flyscreened barbecue area to the north, the floor has a decking treatment and the ironbark on the window frames is left rough-sawn, whereas in the glazed interior, the door and window frames are fine-grade sanded and oiled to a soft sheen finish.

The cottage was meticulously dismantled, with each stone numbered, and it was rebuilt at the same level as the new structure. Internally, it is completely embraced by the new building but still asserts its identity externally. It forms a secondary kitchen and pantry, off the main kitchen/dining area to the west of the building and, on the east, the main part of the cottage forms two rooms – a cosy sitting room and an office, both connected via doors to the new space.

'The use of texture is a natural response to the site that the building inhabits. There is, of course, the texture of the old cottage, but new textures have been brought in which relate to the surroundings.'

VIRGINIA KERRIDGE

In the new part of the house, the skillion roof of galvanised corrugated iron is another nod to the working buildings in the area, but its uplifting trajectory speaks a different language – that of a modern Australian aesthetic. The design of the house manages to anchor it firmly on the land but also produces a sense of drama worthy of the sculptural backdrop the escarpment provides.

The floor area of the house is 633 square metres but the manipulation of space means it does not feel cavernous or devoid of human scale. Kerridge quotes Rudolph Schindler to express her thoughts on the matter. 'The architectural product must be part of human life and, unless related to us in scale and rhythm, is monstrous.'

In this house, Kerridge has responded to the site, the light and the usage. The northern side of the building is for entertaining and is the hero in terms of the double-height volume and the sheer impact of the mountain view. The journey through towards the bedrooms becomes quieter and scaled-back. 'Buildings,' says Kerridge, 'are experiential, and the architect's composition creates a harmony with the client and how they will inhabit the space.'

The second outdoor room faces east and is best in the morning (a place to take tea), with light patterns generating a texture all their own. The eaves are broken with gunmetal grey–painted blades allowing light and rainfall to nourish the garden beds below, while fine-grade brass flyscreens filter the

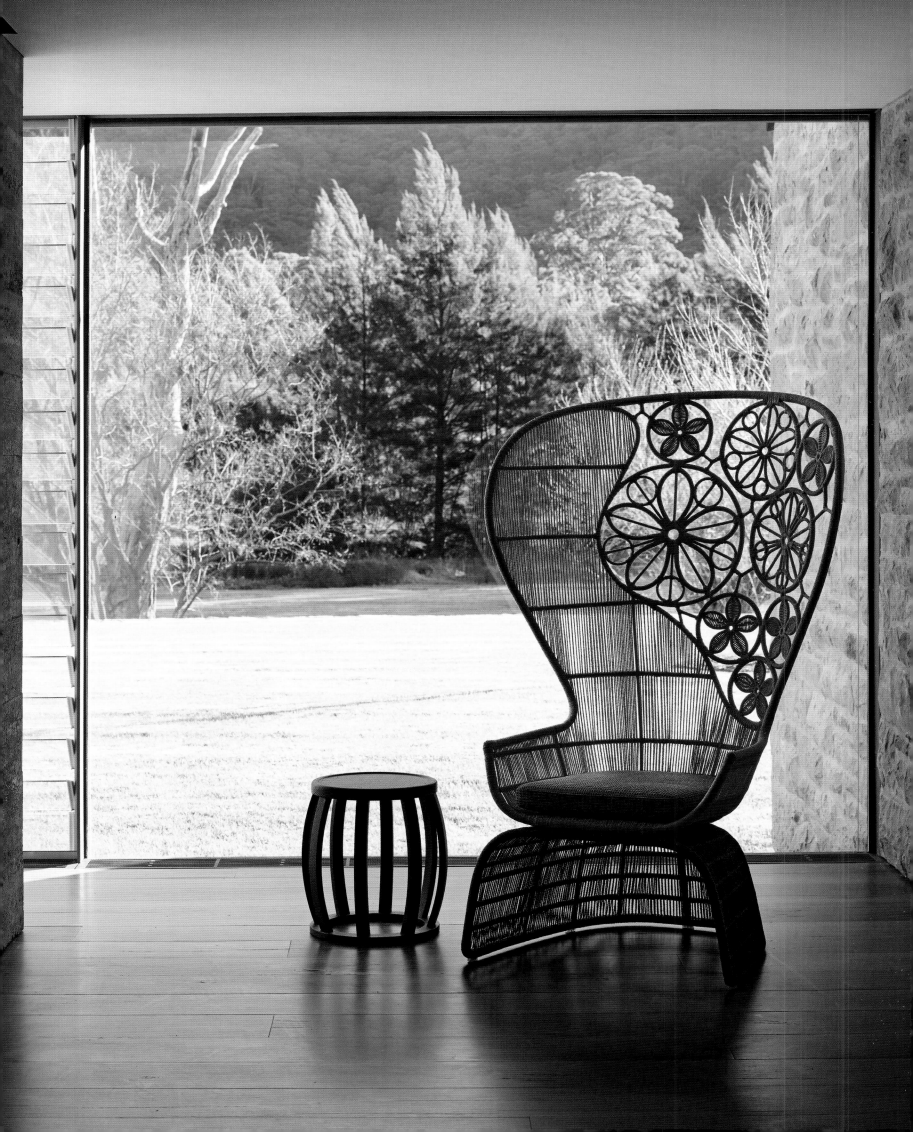

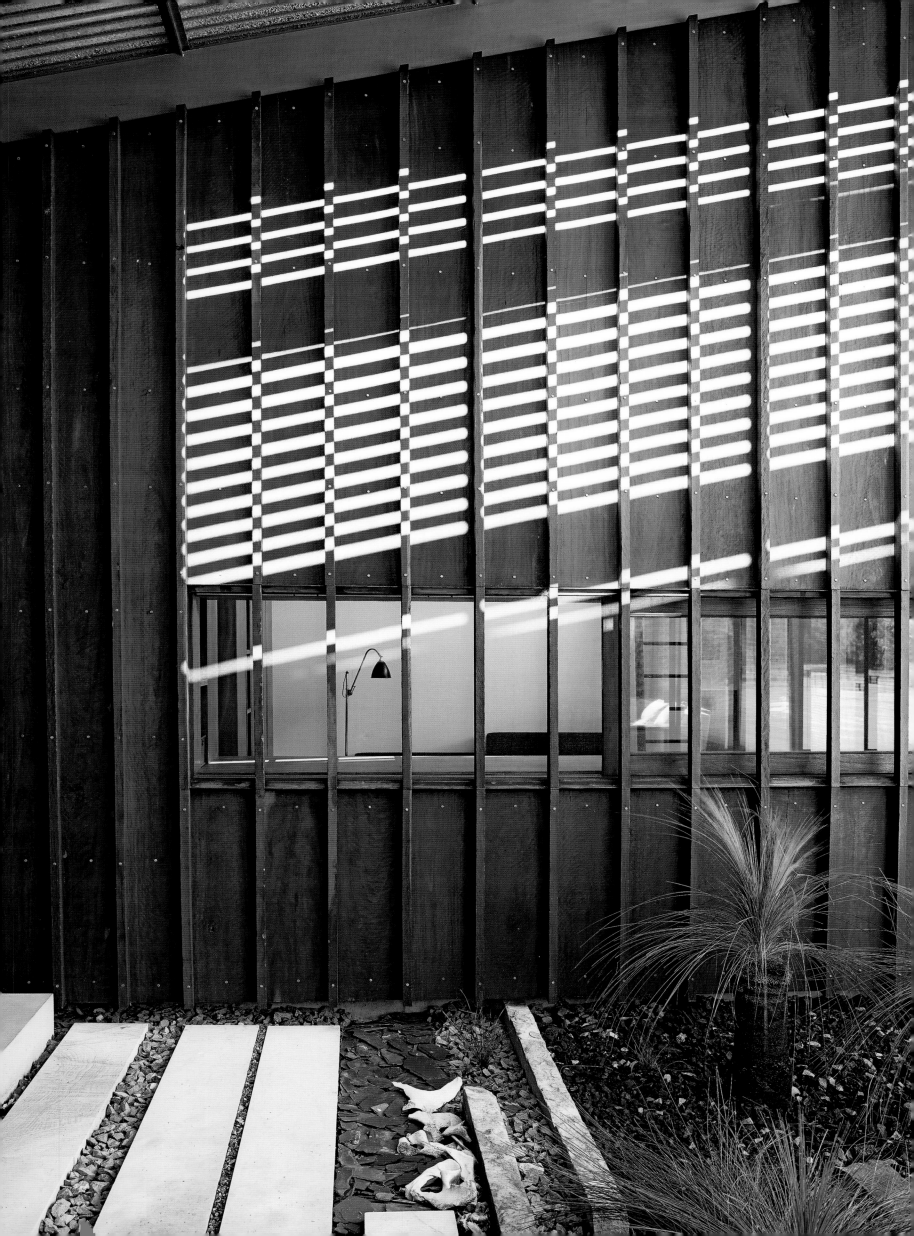

In a courtyard off the living space, strips of sandstone and concrete mix with animal bones.

The bedrooms, at the rear of the house, employ scaled-back and finely executed joinery detail.

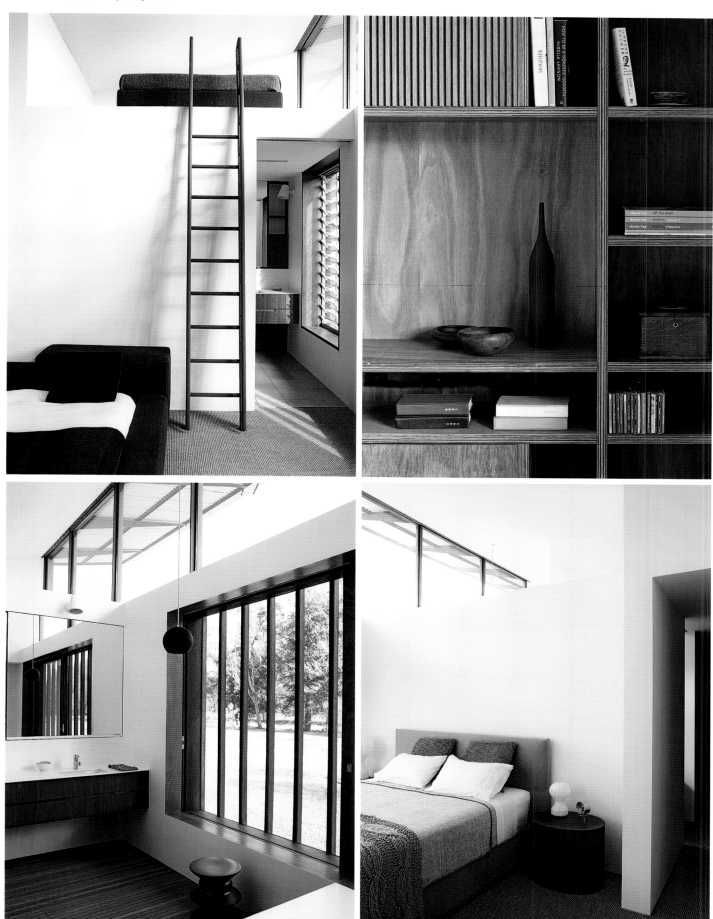

A section of
the galvanised
corrugated roof,
linking with
its vernacular
surrounds, is open
to the garden.

light and let the room breathe while protecting it from insects and any wind debris. The giant sliding glass doors onto the corridor from this room allow light to penetrate through into the hallway and the body of the house.

Rammed earth forms part of the wide corridor and a dividing wall between the vestibule and living room. The wall also serves to frame the view directly from the front door. The space flows, with many walls not full height or not fully meeting other walls, but breaking up and modulating space, establishing an ability for the journey around the house to take several different routes.

In this regard, Kerridge is heavily influenced by Japanese architecture in general, and the Katsura Imperial Villa in particular. Her interest in Katsura started when she worked for Bonnie Roche in New York (Kerridge assisted Roche in designing an apartment for Paloma Picasso) and she later visited it when staying in Kyoto. 'Katsura has an almost lyrical journey around the compound gardens, with a carefully controlled sequence of views and vistas,' she says.

In line with this philosophy, the view from the living space is of a Japanese-style garden by Jane Irwin. With artistic precision, irregular slabs of textured sandstone and smooth concrete are interspersed with coal, broken slate and horse bones found on the site, alongside grass trees and kangaroo paw. The timber-battened wall provides the perfect, measured backdrop to the simple beauty of the garden, and the open steel fins interrupting the corrugated roof add another visual dimension, as well as letting in light and rainwater.

Kerridge reflects: 'The approach to detail on this project takes cues from traditional Japanese architecture in the care and consideration of every detail. What Japanese architecture tends to excel at is invoking a great respect for nature and external spaces, and in doing so gives a sense of calm and repose.'

Part of this sense of calm comes from both a lack of visual distraction and difficulty in the house that, with its limited palette of materials, is easy on the eye. Huge doors open and enormous screens slide back effortlessly – a credit to the builders Bellevarde – so that the house can open up, or close down, responding to the weather and time of day. The house is devoid of handles, as cupboard doors are shaped to accommodate easy opening. While there are rooms for privacy, there is also a sense of being connected as one space visually relates to another. The wide corridor acts as a spine, with rooms, often deeply recessed, leading off it and creating clarity of connection as one end of the house can be seen from the other.

It is a home with a carefully considered interior journey that links with its site and its history, in ways both dramatic and subtle and, as such, retains the best of both worlds. 'The family is most at peace there,' the owner said and, for an architect who strives for calm and repose, there could be no greater compliment. ▬▬▬

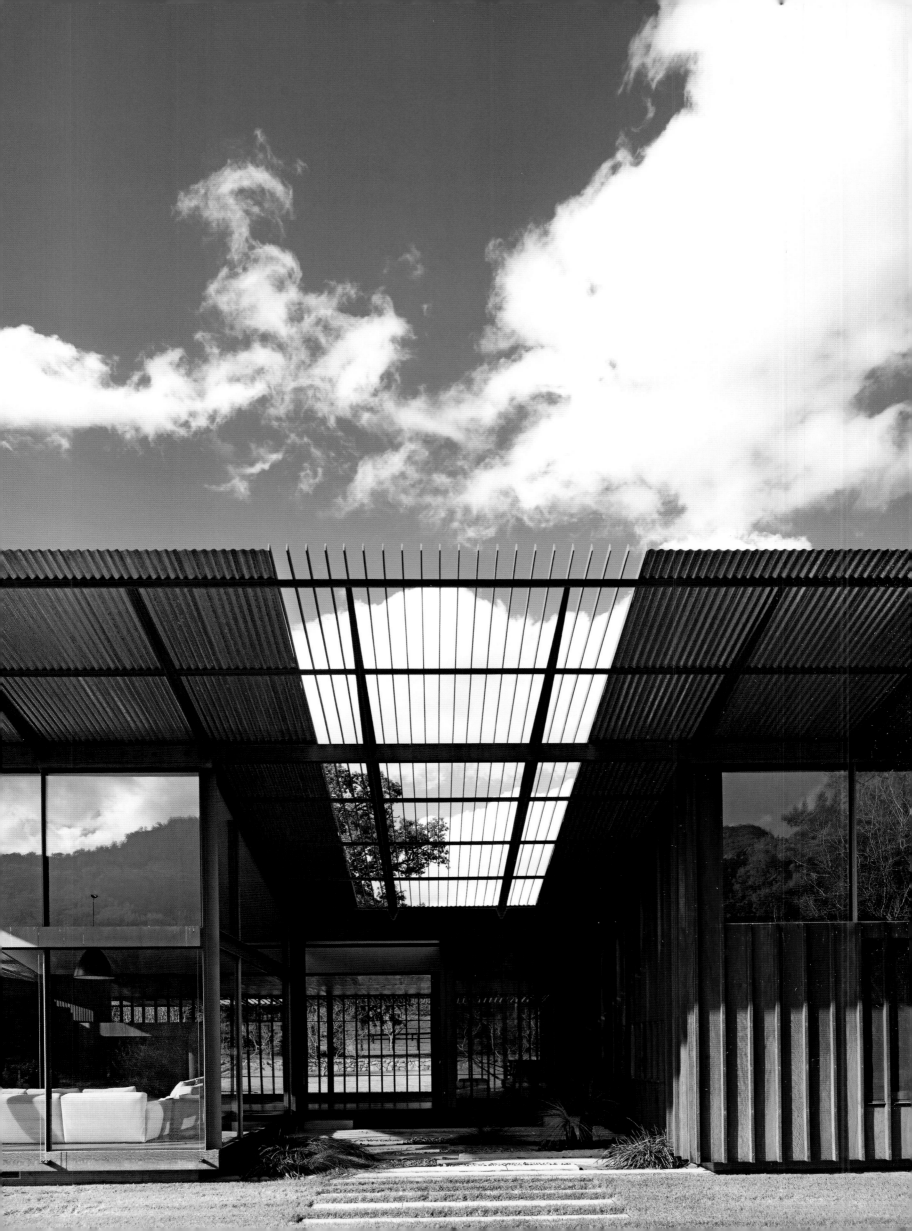

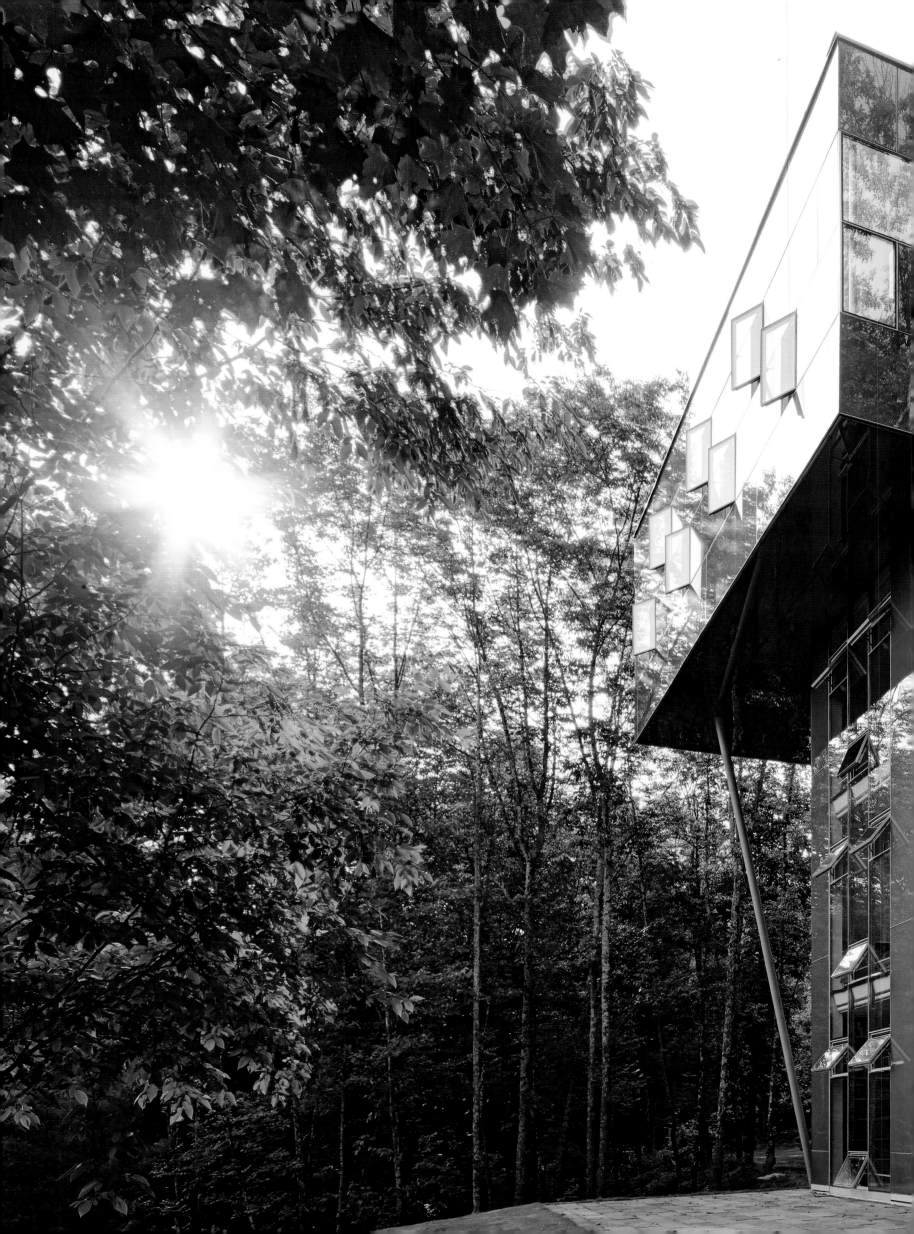

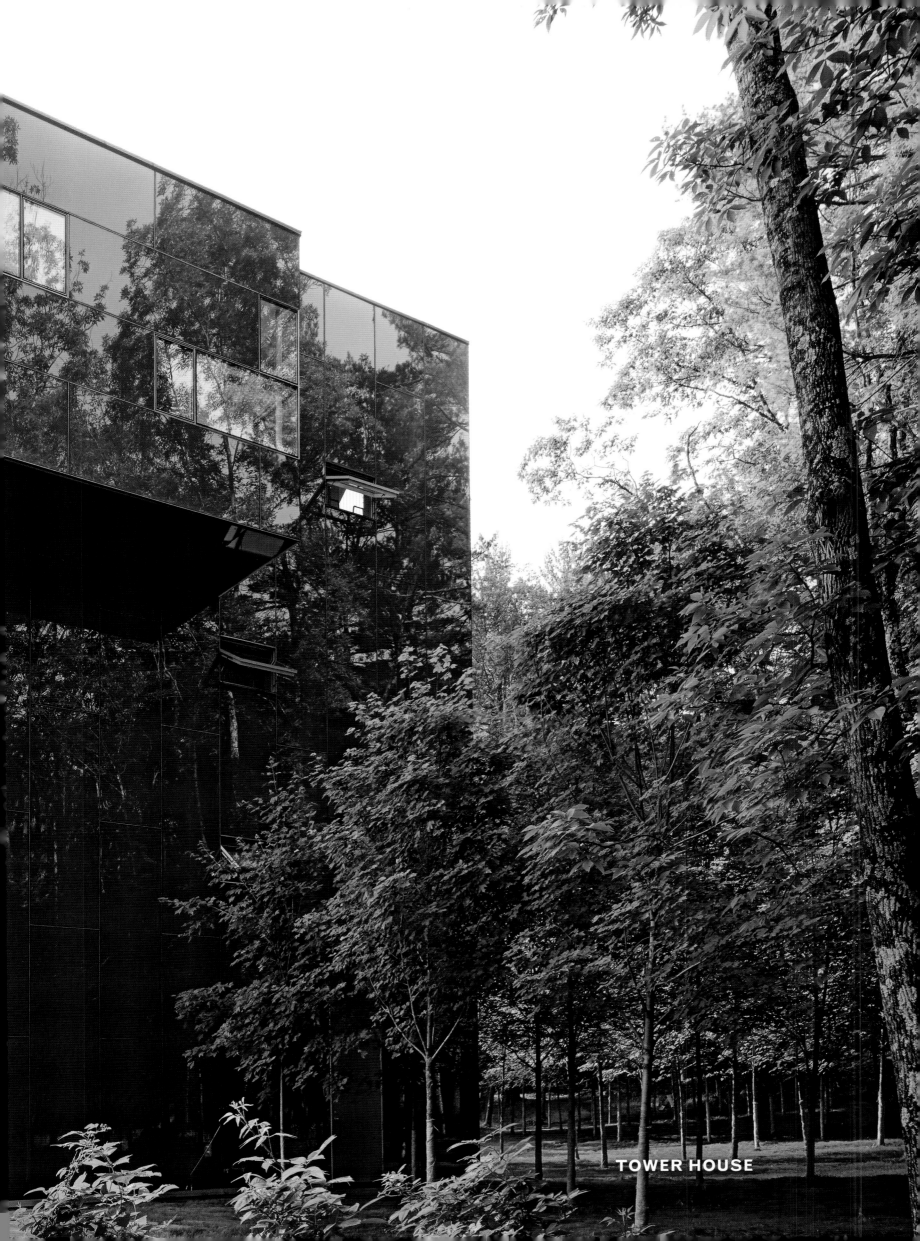

TOWER HOUSE

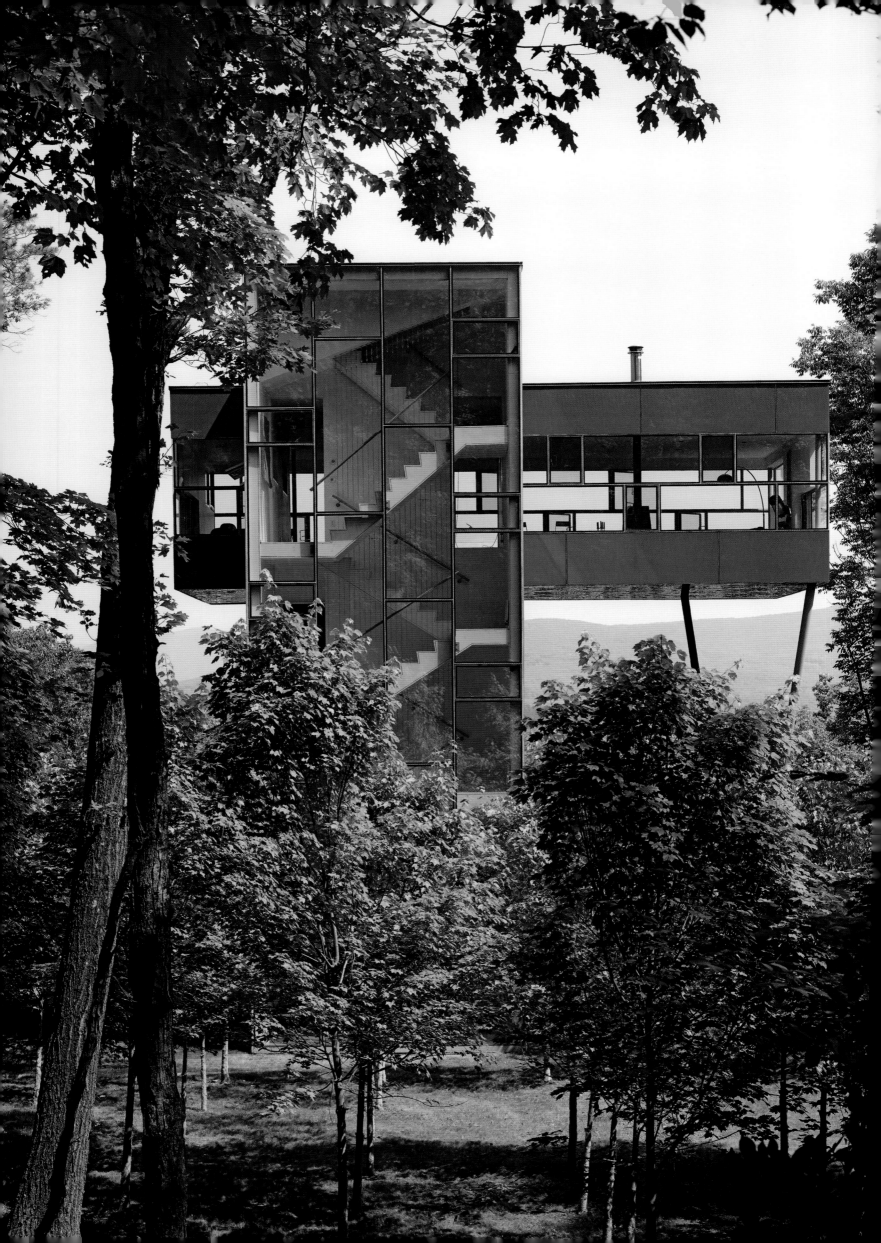

**TOWER HOUSE
(2012)**

◇

GLUCK+

⋈

**UPSTATE NEW YORK,
USA**

The wonder of the Tower House lies in the balance of seeming contradictions within the one building. Writer Joann Gonchar notes that it 'resembles the offspring of a Modernist skyscraper and a tree house'. And that is just the beginning. The vertical staircase, in the sunniest of yellows, is active and dynamic, and balances the calm of the horizontal living space floating 10 metres above ground level. High-tech windows and exterior walls, conceived and prefabricated in Europe, were assembled by local carpenters, guided every step of the way by the architects. In addition, the highly sculptural, manmade structure reflects, through use of olive-tinted fritted glass, its surrounds to the degree that it is hard to know where the building ends and its natural context begins.

The house, by New York practice GLUCK+, is a collaboration between Peter Gluck and his son Thomas. The younger Gluck was the major author of the design and, happily, the sometime occupant of this remarkable holiday house. 'We all lead such frantic urban lives that the Tower House is a retreat,' he says. 'To be up in the trees with the view, to witness the changing weather patterns and the relationship of site to nature has a tremendous impact. The reaction of guests is visceral – it doesn't need explaining.'

An aspect that was very well understood from the outset by the architects was the topography of this 19-hectare block of land in Upstate New York, two hours' drive from Manhattan. It's an area they have both known for many years – Thomas has been holidaying on the land since the age of two and, according to his father, 'while he is as urban a guy as you can get, he also loves the country, hiking and backpacking'.

There are three other buildings on the site, the first of which, a tiny white clapboard farmhouse built in 1820, is where Peter Gluck and his wife stay and, in his words, 'started this whole thing'. The second dwelling is the Bridge House, which rethinks the planning of a traditional holiday house with an emphasis on sleeping quarters for guests and large gatherings. It was hand-built by Thomas Gluck in 1996 before he set off for architecture school, giving him a much-valued understanding of building techniques. GLUCK+ is an architect-led design build office, so the emphasis on practical skills and building knowledge was essential. Thomas Gluck describes the character of the house itself as very different from that of the Tower House. 'It is a house with a strong relationship to the landscape: hunkered down, up against the cliff, feeling embedded and cool, with very little direct sunlight.'

The Bridge House is so named because it has a bridge starting from the top floor, apparently going nowhere but, in reality, ending at the base of the plateau upon which the Tower House is

To ensure the building was high enough for views, the architects built a temporary scaffold beforehand.

One of the key
elements is the
dynamic zigzag
staircase leading
to the cantilevered
living space.

built. 'The bridge is there because I knew there was a wonderful site up there,' says Peter Gluck. 'The bridge means you are already three storeys up – essentially halfway up the hill.'

The arrangement of the buildings, which includes the movingly simple Scholar's Library (2003), is a unique program for this particular site and for the evolving Gluck family and their friends. Sensitivity to the landscape is clearly of great importance to the practice; the Tower House has the tiny footprint of 4.3 metres by 10 metres, which ensured minimum disruption to vegetation. It was crucial to determine the correct height for the building and, to this end, a temporary scaffold to the proposed top was erected beforehand. 'Can you imagine building the whole thing and discovering you didn't have a view?' says Peter Gluck. The panorama over the mountains is exceptional, stretching more than 30 kilometres miles to the north.

The intention was always to find a balance between the functional and the creatively expressive within its natural context. 'We didn't think that melding meant using natural, romantic, woody materials,' says Peter Gluck. 'This very strong powerful shape dissolves because of the reflectivity of the building. In all our work, we are very interested in a building's movement and changes with time of day, or year, and in it becoming part of the environment.'

In terms of design, the planning is remarkably simple. The bedrooms, with adjacent bathrooms, are stacked one on top of each other with the kitchen positioned on top of the bathroom stack to ensure a central service core. The staircase is akin to a vertical corridor, with a glazed south-facing wall, open to the surrounding forest and the warming effects of the winter sun. GLUCK+ seeks to create buildings with 'resolution in a way that makes aesthetic and experiential sense', particularly in response to changes of weather, light and season. This stairway, animated through its graphic design and colour choice, combines the physical action of climbing with a shifting perspective as one starts at the trunks and rises to the treetops. 'It is rare to have a multi-storey stairway exposed in this way,' says Peter Gluck.

This activated, dynamic part of the building is cleverly counterbalanced by the serenity of the top storey cantilevered living space. This large horizontal room, painted almost entirely white, seems suspended in space. It is not overly detailed or decorated, rather allowing the views both near and far, managed through a continuous band of windows to the north and the south, to become the focal point. 'Because the floor is the same colour as the walls and ceiling, it does create this pure volume and adds to the feeling of floating in the trees,' says Thomas Gluck. It is also simply furnished with streamlined built-in pieces, such as the window seat with storage underneath, running the length of the ribbon window. Even the colour of the padded seat cushion is a soft green, blurring the sense of inside and out. Design classics such as Saarinen's Womb chair provides a blast of colour, and a pair of Hans Wegner's CHO7 chairs provide the curves in an otherwise rectilinear context.

'In all our work, we are very interested in a building's movement and changes with time of day, or year, and in it becoming part of the environment.'

PETER GLUCK

The upward journey does not end in the living space but extends to a viewing platform, which takes on a different character from the precise geometry of the rest of the building – it is wooden, weathered and organic. 'That was the one place where wood seemed appropriate, as it is not visible from anywhere, and creates an experience rather like an eagle's nest,' says Peter Gluck.

While the Tower House is a beautifully calibrated, artificial object in its forest setting, part of its appeal is found not in its visual presence, or the arrangement of space, but in the resolution of the practical issue of energy use. The arrangement of the kitchen and bathrooms in a stack means that they form a vertical thermal core, which can be isolated and heated when

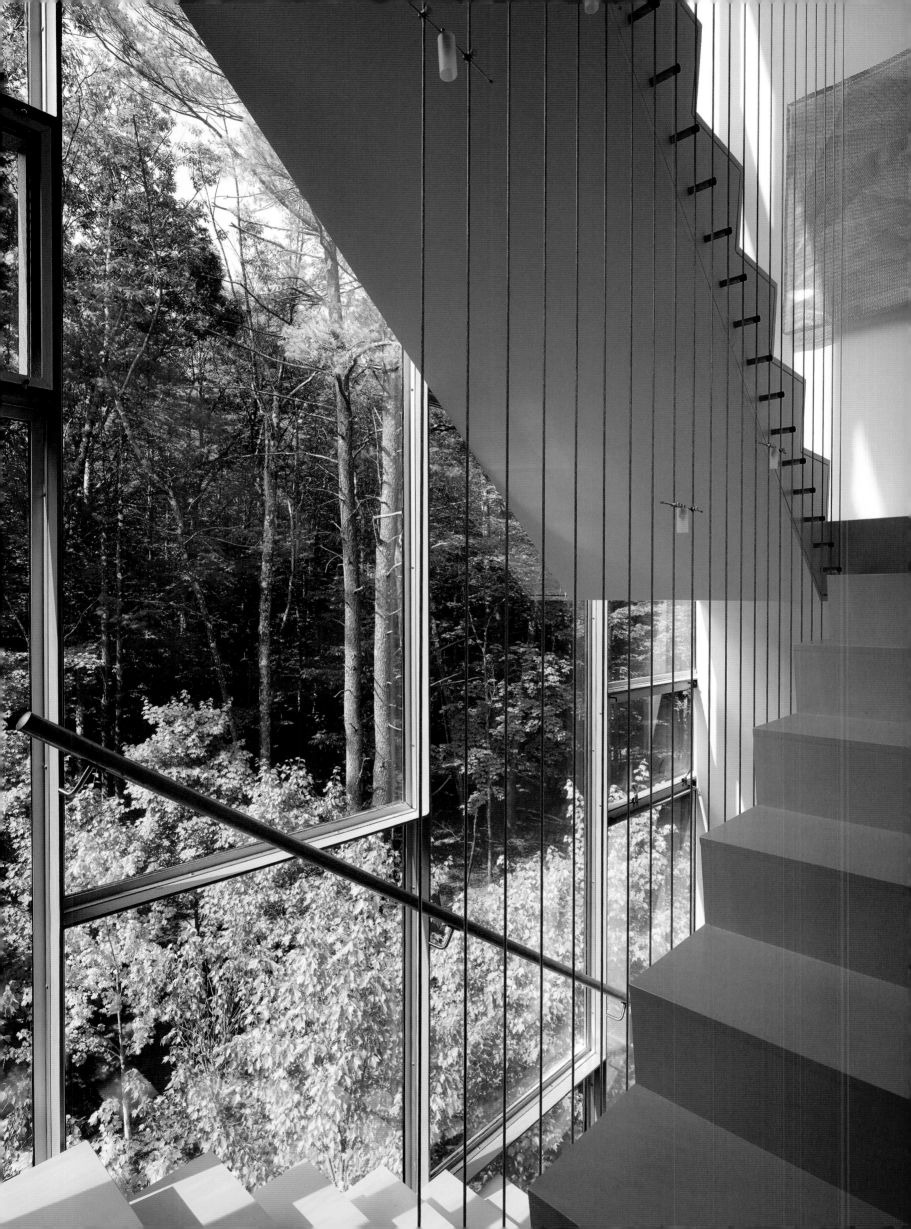

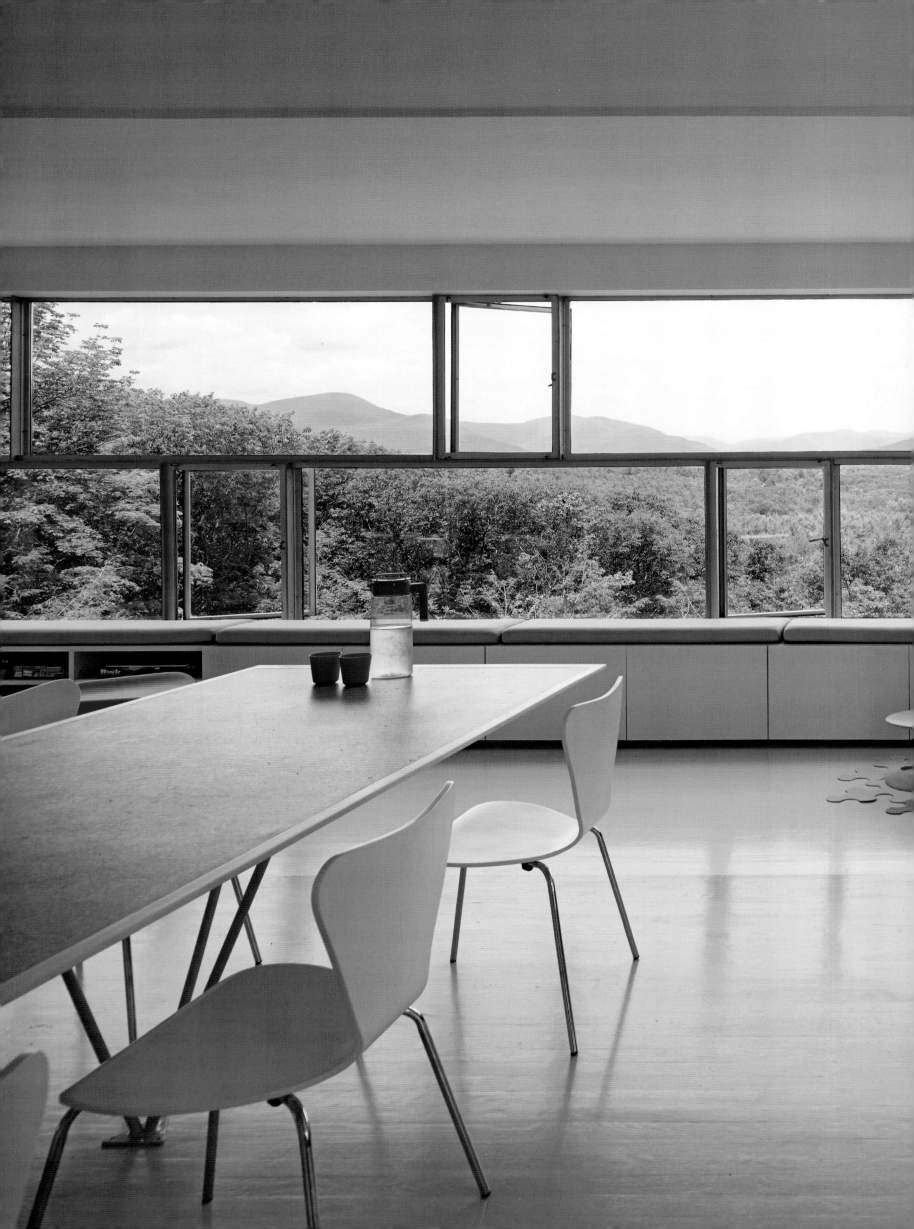

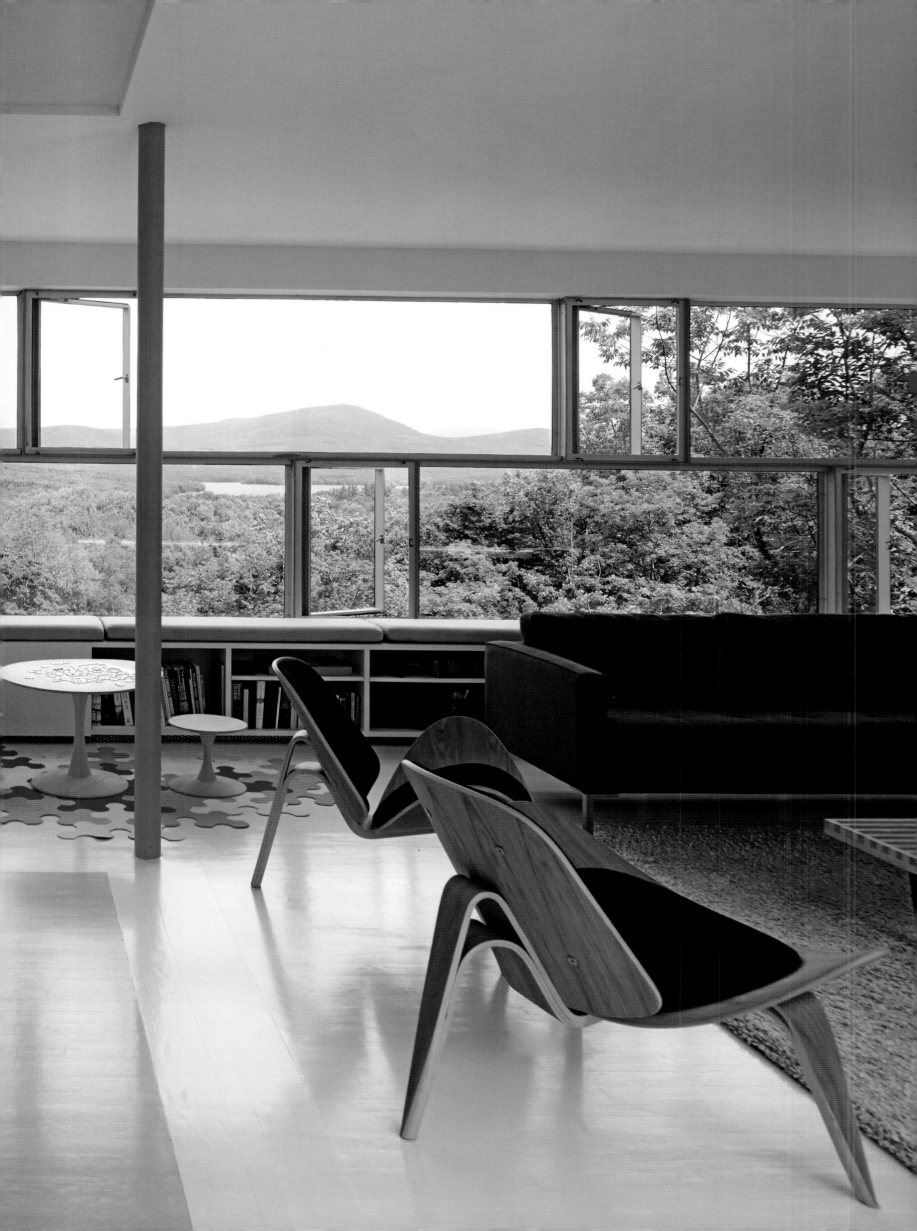

the house is closed in winter, to avoid both frozen pipes and excessive heating bills. Because of such measures, the Tower House uses a third of the energy of a house of comparable size.

With regard to cooling, Peter Gluck is quite adamant that 'we don't go to the country to be air-conditioned', and describes how the adaptation of an attic fan system used in traditional American houses was influential in their thinking. Air is heated through the glass in the stair enclosure and, by creating a difference in pressure, air from outside is drawn in through small awning windows or horizontally placed casement windows. At night, either an open hatch at the roof level or a fan positioned under the roofline draws warm air out of the building through the stack effect.

These pleasingly simple solutions at first seem at odds with the construction of the building. While a local workforce was used, it was, according to Peter Gluck, 'a very sophisticated house and not an easy house to build'. Structurally, the frame is timber and steel, with clear glass for transparency and view, and olive fritted glass, even on the underside of the elevated living room, to create a reflective surface for the play of light and movement. This allows the building to be both a sculptural object and integrated into its natural context.

What Thomas Gluck is keen to point out is the pleasure the house gives him, his family and friends. 'It is a playful house, not overly serious, with the sense that everything is turned on its head.' He describes kids charging up and down the staircase, friends who arrive in the dead of night and are stunned by the morning view that greets them, gatherings of families who stay in the Bridge House, equidistant between his parents' cottage and the Tower House. He paints a picture of oneness with nature, of calm and retreat from urban life but, even more so, of tremendous fun and conviviality. 'It is a building that works on every level. The simplicity of the program and form allows functional things to work well.'

And it seems that this combination of functionality and aesthetics is very much at the heart of the practice. In the firm's monograph, *The Modern Impulse*, Peter Gluck outlines how this notion rests on four analytical attributes: use, structure, context and social effect. When all four are observed, the result is a building that, although 'conceived from, and for, a specific situation, the architecture would do more than meet its needs: it would enhance human experience and raise the threshold of aesthetic and social imagination'. He also acknowledges that it is not always easy. 'It is an heroic attempt but also it is fun trying to get there.'

When Peter Gluck designed the Bridge House, it was defined by, and named after, a bridge that ostensibly went nowhere but somehow pointed to future opportunity. And when it did manifest in the Tower House, it was with the most marvellous set of balancing and counter-balancing attributes. The building footprint is small, the view expansive, the materials and construction are high-tech, so that the play of nature's light and movement is heightened. There are stairs keeping the occupants active, but also provision for a lift stack should it become necessary. Future planning, it seems, is something of a Gluck speciality. ▬▬▬

The building is
ventilated naturally
through hopper
windows and an
attic fan system.

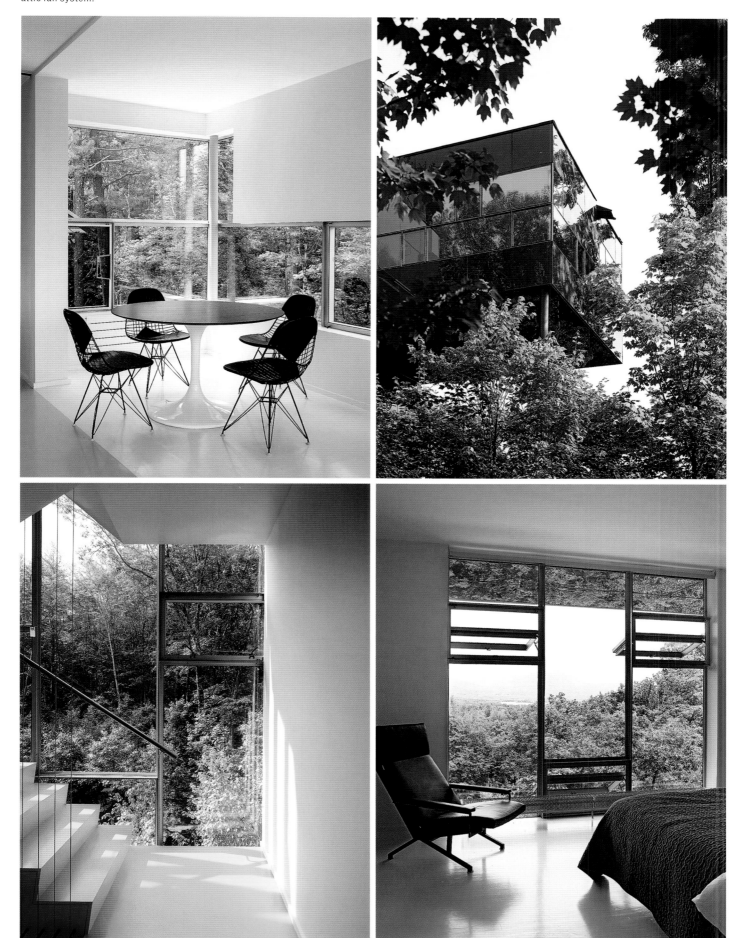

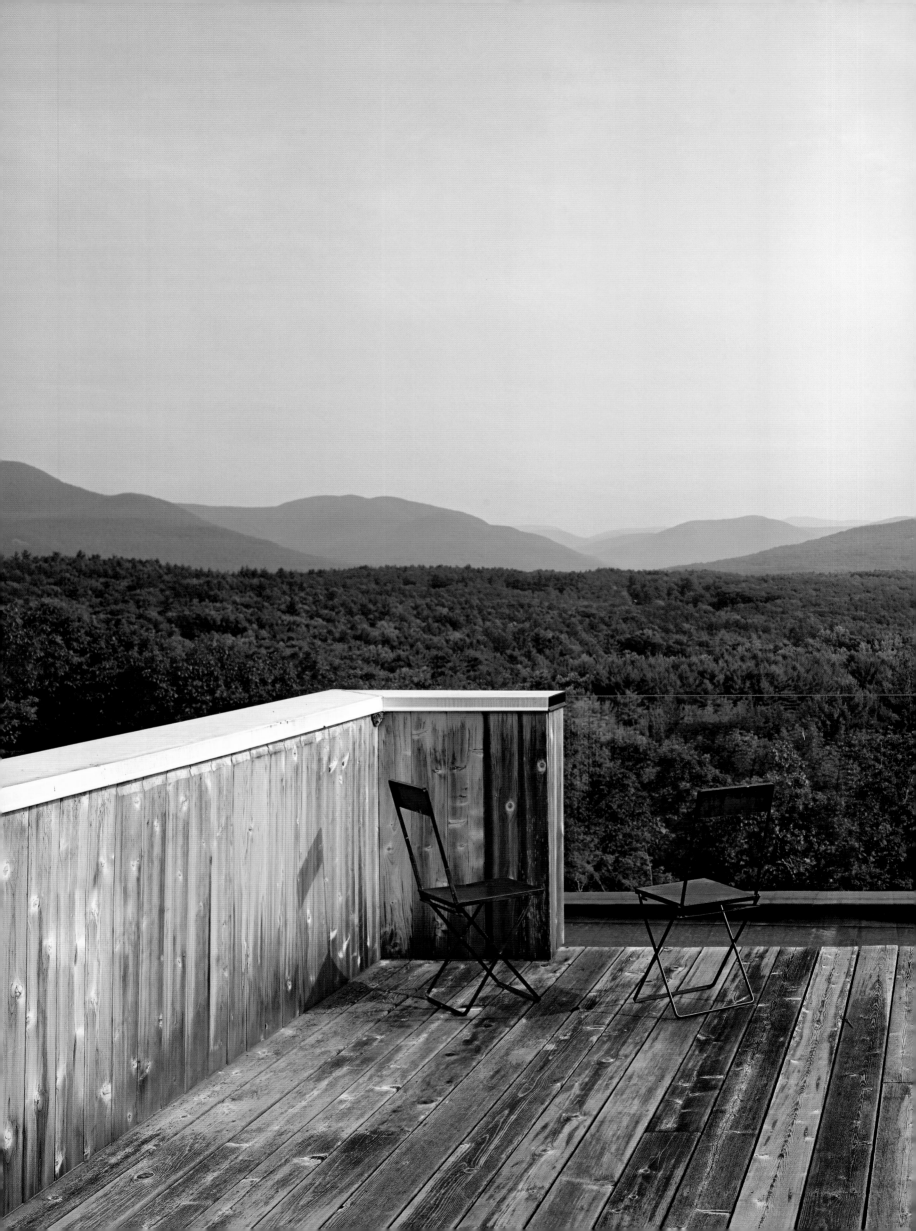

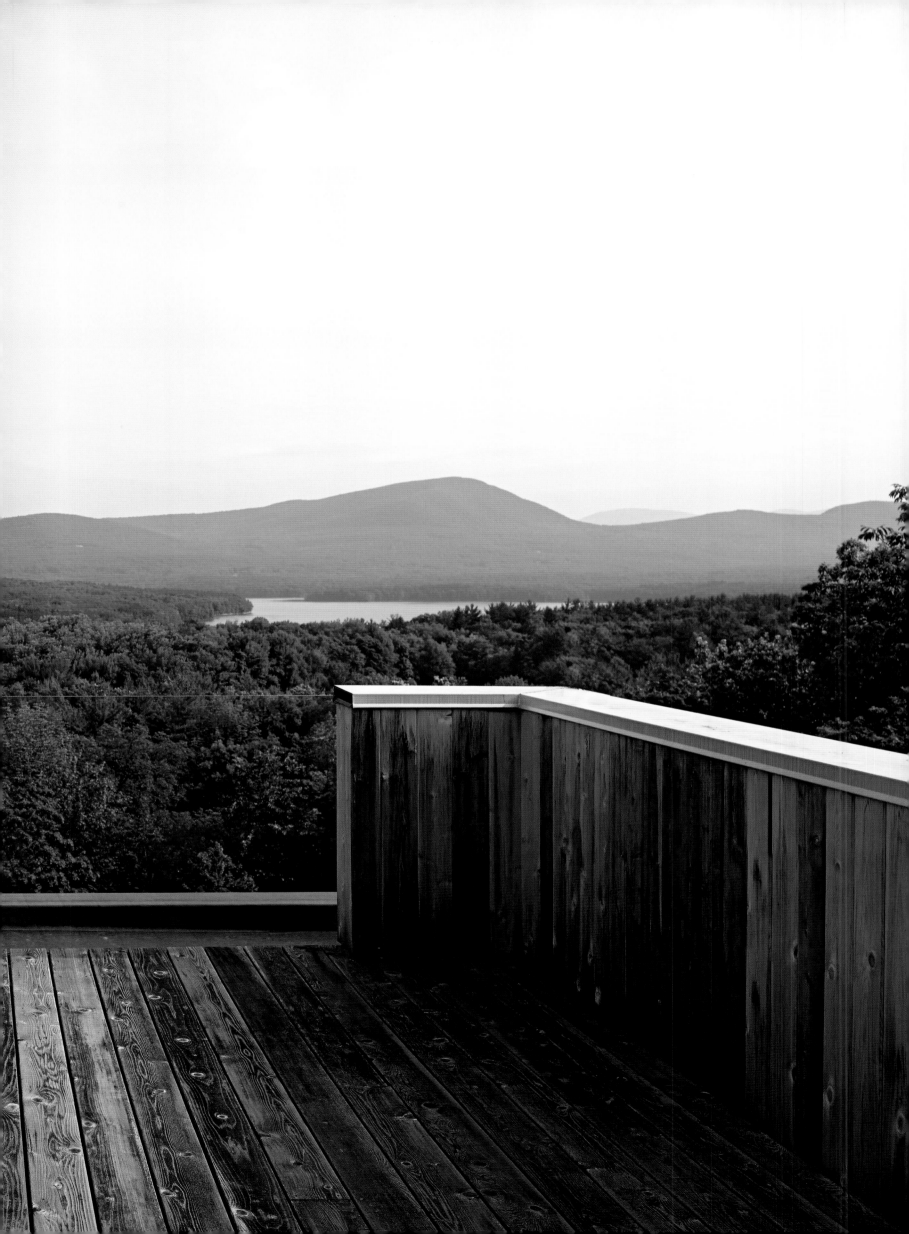

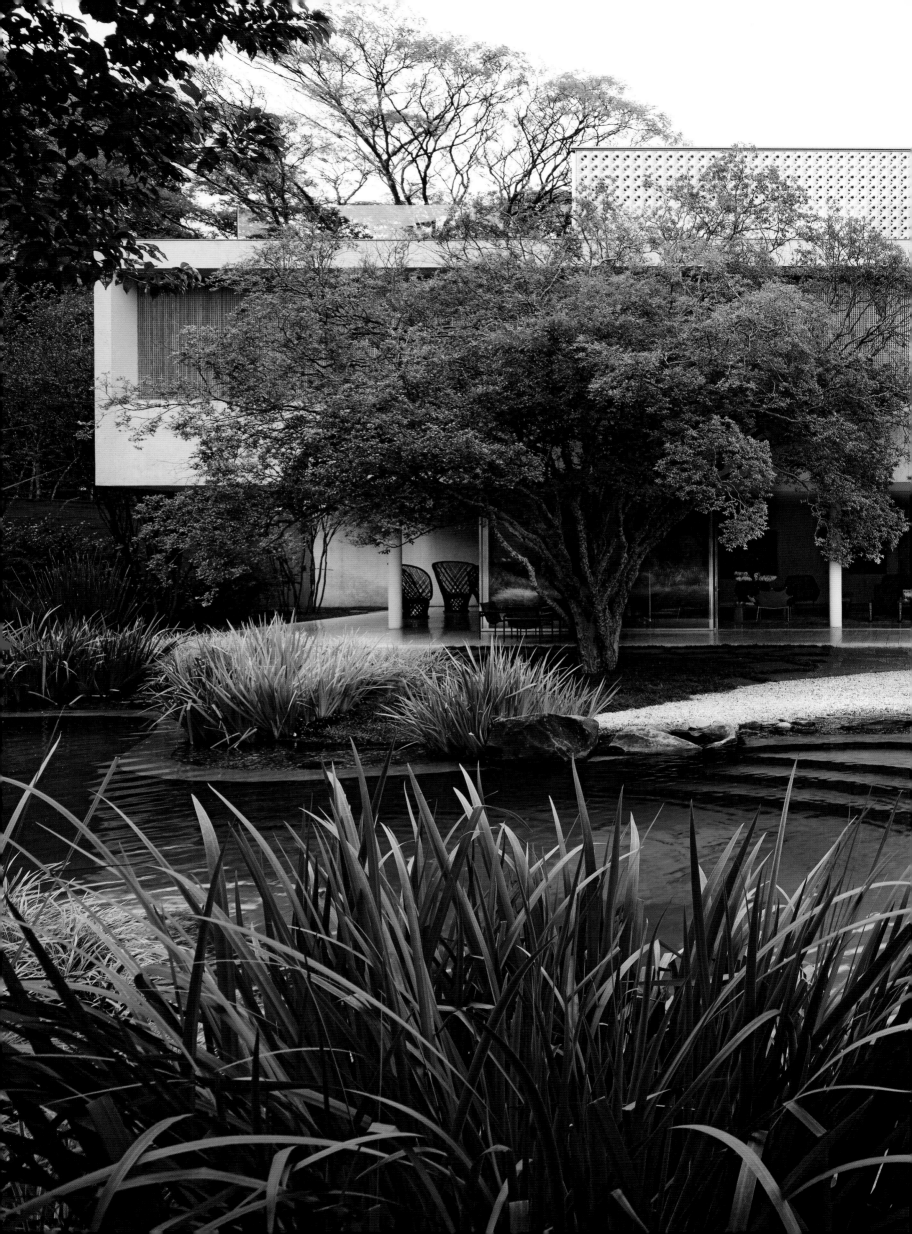

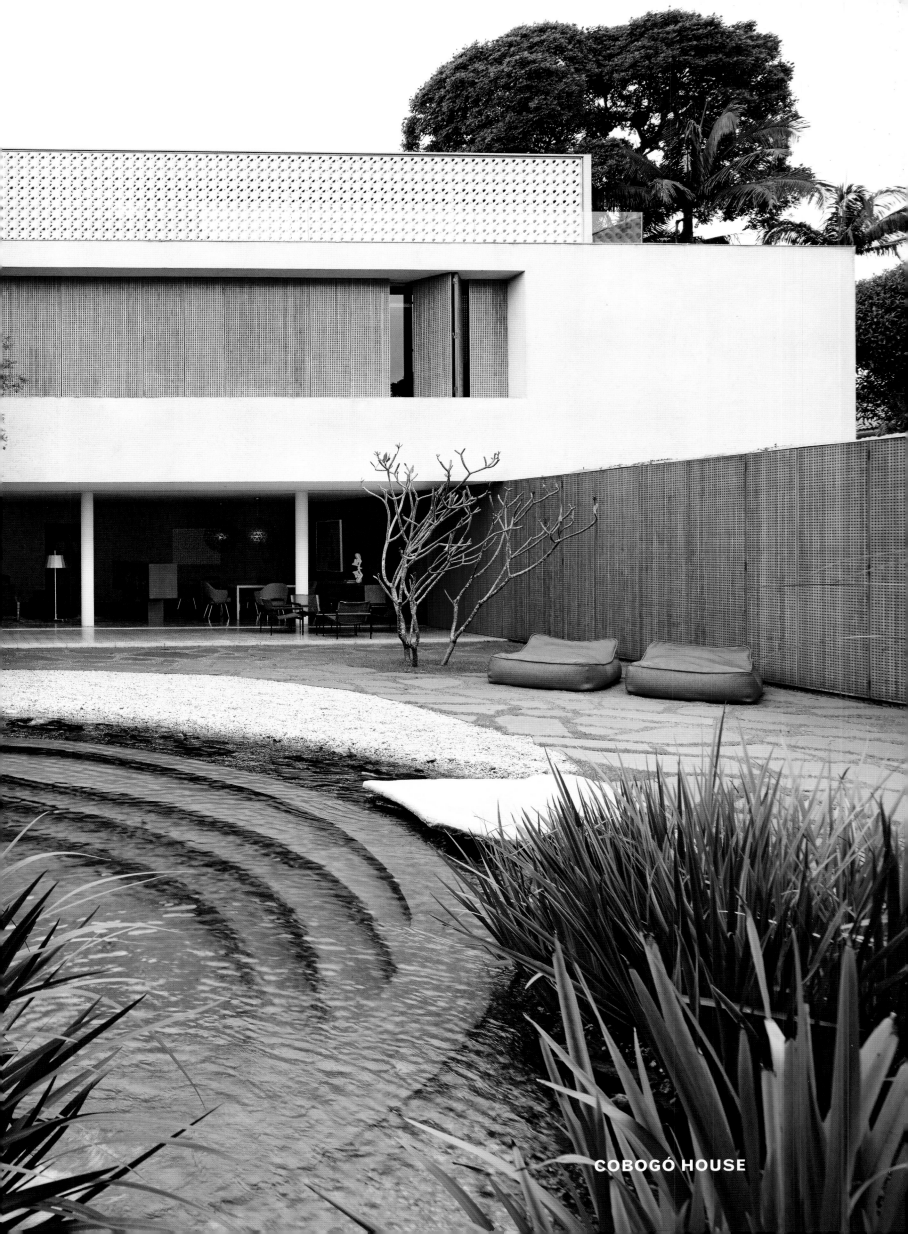

COBOGÓ HOUSE

COBOGÓ HOUSE
(2010)

◇

STUDIOMK27

⋈

**SÃO PAULO,
BRAZIL**

Marcio Kogan, of Brazilian architecture practice studiomk27, is not only renowned for his show-stopping houses but also for his playful provocation. 'I think that I am a prostitute – the client has paid for me to give pleasure. It is my mission,' he said on a recent video interview online. One of the comments below the post said that he designed 'naughty architecture'. But make no mistake, this is a peepshow of the most sophisticated kind.

The Cobogó House is characterised by its use of decorative modules by artist Erwin Hauer.

When representing Brazil at the Venice Biennale in 2012, he chose to return to his previous career of moviemaking and produced a short film, with co-director Lea Van Steen, called *Peep*, based around the interior life of his V4 House (2011). Kogan has a sense of humour; as the owners, amidst crafted designer luxury, play out intimate scenes, the maid and maintenance man run the house. There are two poetic moments that really sum up the beauty of Kogan's aesthetic. In one shot, the maid, small in the frame, smokes a cigarette leaning against a sun-dappled concrete wall, and in another, at dusk, massive glass doors glide on tracks to close up the house for the night. Kogan's use of materials, the way they interact with light and shade and the ability to dissolve the line between outdoors and in, are at the heart of his work. 'In *Peep* we wanted to show the architecture while it was in use and unimportant,' he says. 'As Niemeyer used to say "The most important is not architecture, but life."'

His father, who died when Kogan was eight years old, was a structural engineer/architect at a very exciting time for Brazilian design. 'In 1959 he built the house in which I lived,' he says. 'The house was exactly like Villa Arpel from the movie *Mon Oncle* by Jacques Tati. It was modernist and filled with non-working technology.' He is aware of the heritage of the greats in Brazilian architecture: from Oscar Niemeyer and Lúcio Costa to the numerous other architects producing spectacular work at the time. 'It is impossible not to be contaminated by that entire generation, and continue that work with a contemporary vision.'

And it is for his contemporary vision that clients come; his houses are statements in modern-day luxe with a judicious amount of restraint tempering the grand structural gestures. They are confident expressions in terms of interlocking, stacked or stretched volumes, and present a complete vision in terms of overall structure – both bold and sensitively configured. In his work, Kogan strives to balance this desire for 'minimum' with the requirements of the inhabitants and, working intuitively, constantly reduces his schemes to their most powerful and effective core. 'We love simplicity,' he says. 'We begin the design with 400 lines and then we transform it into 50.'

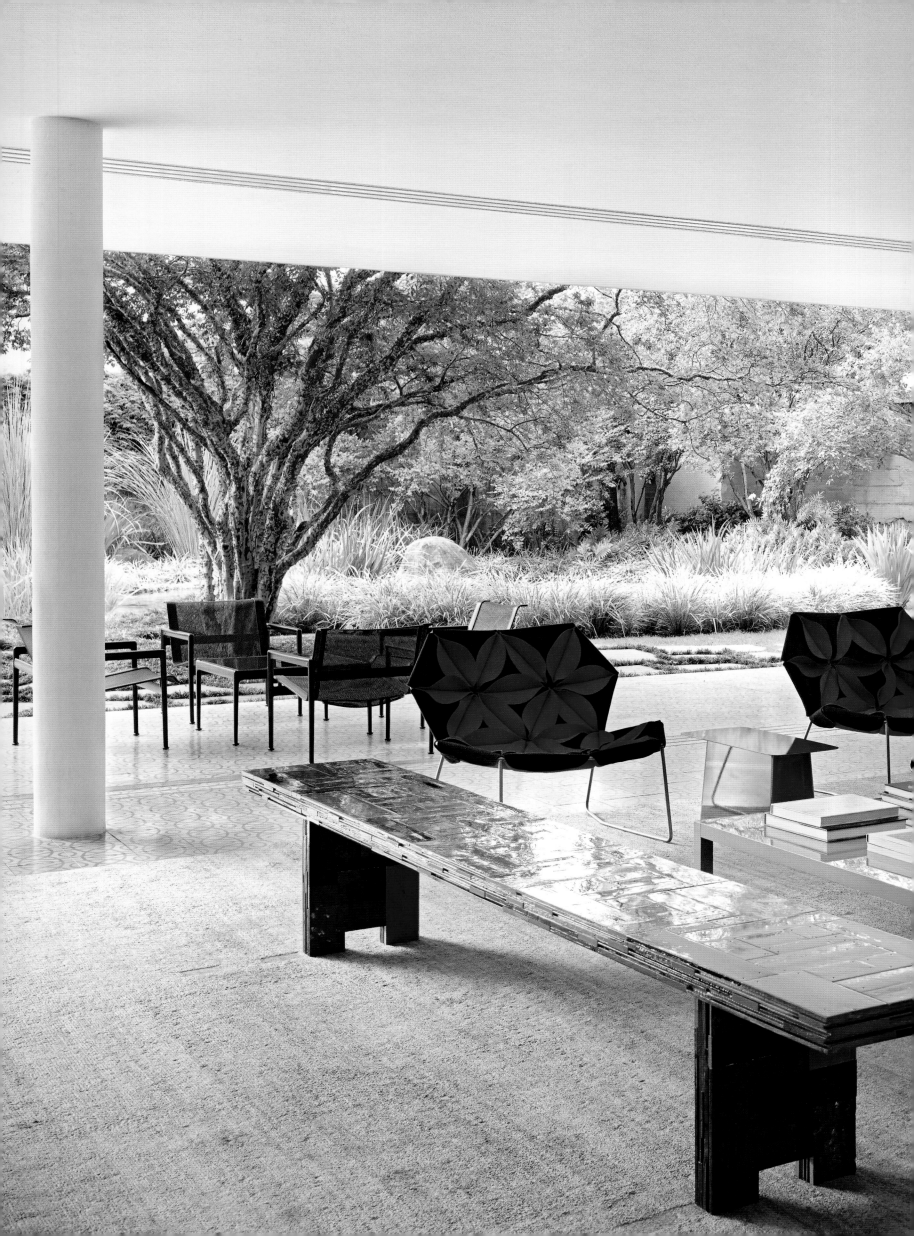

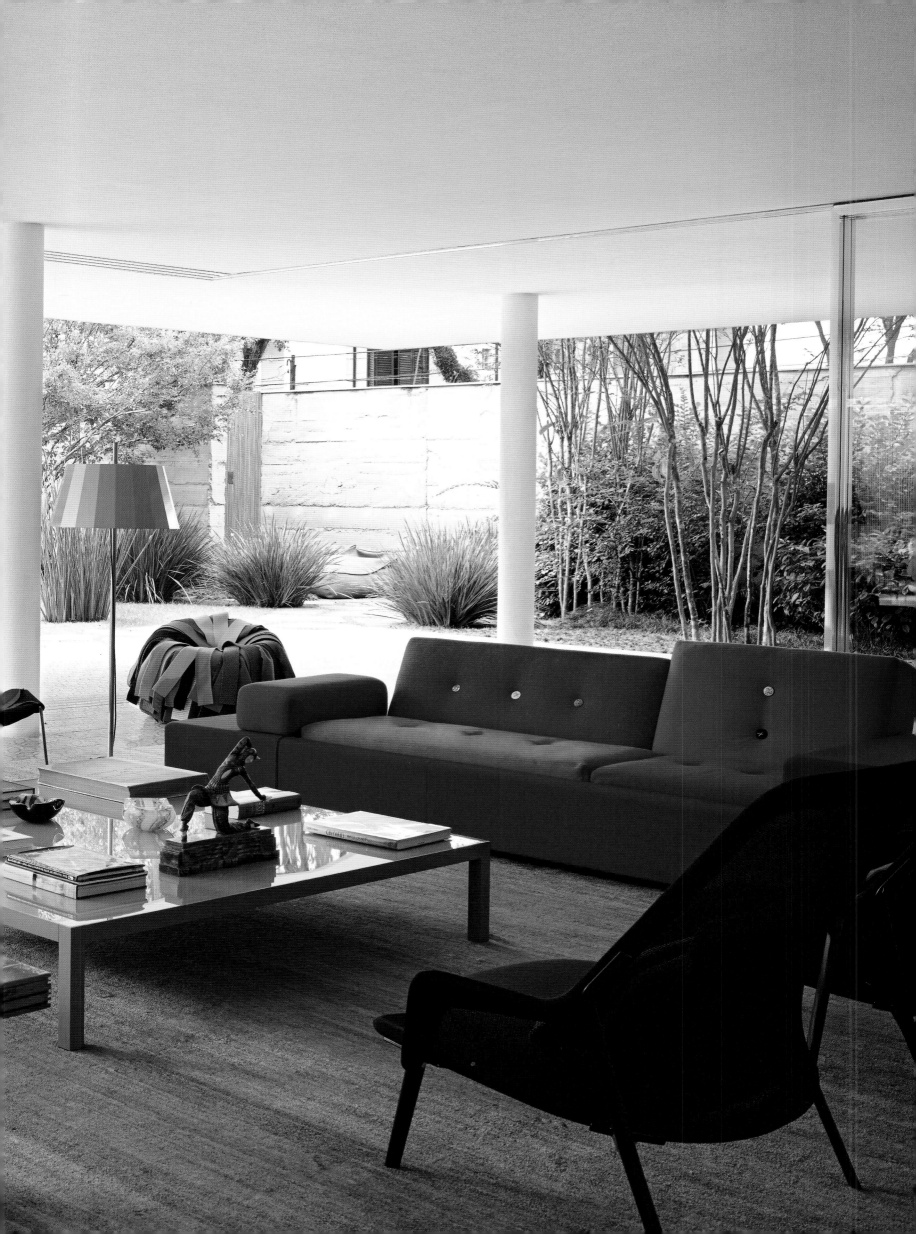

Every project has the sense of a team effort; Kogan enjoys tapping into the creativity of others, of drawing out ideas and exploring and testing concepts. In the case of the Cobogó House, his main architectural collaborator was Carolina Castroviejo.

A hallmark of the work of studiomk27 is that the house and site amplify one another – the structure makes the site more beautiful and vice versa. 'We always seek to get the maximum feeling from the space, and integrate fully into the landscape,' says Kogan. 'The external architecture merges with the internal so separation does not exist.'

A large jabuticaba tree was growing at the centre of the site of the Cobogó House and, because it is Kogan's favourite tree (the fruit is delicious, he says), the house was constructed in an L-shape to skirt it. It is a house without a foyer and without a predetermined front door, hence the journey to the facade is a walk through the garden and you can choose to enter through any door or window. 'The relaxing sound of the filtered water circulating the pool, the song of the birds that fly by to peck on "my" jabuticaba, the scent of the flowers and intense lavenders of the garden provoke the feeling of being in the country on a pleasant weekend, but quickly we note that we are in the centre of the chaotic and polluted city of São Paulo,' says Kogan.

While site is obviously vital, Kogan is aware that the relationship with the client is the pivot upon which the success of any project turns. 'The client will make the project be better or worse. In the Cobogó House, the client was deeply committed to the quality of the execution and, as a result, the house is impeccably built.' Taking it one step further, the client also supported the sustainable aspects of the house design – the grassed roof, the solar panels and energy efficiency; the natural water lake/pool with its small fish and the way the vegetation creates an oasis into which the house is integrated. Kogan's philosophy extends to thinking of the building envelope as porous, as a breathing skin wrapped around the structure, as opposed to walls that divide the internal and external spaces.

If there is one signature of a studiomk27 house, it is the massive indoor/outdoor room, with retractable glass walls that open the entire room to the light, scent and breezes of the natural world. Kogan admits that his early houses were 'completely white and antiseptic' but that, with time, he has come to explore a sensual mixture of materials – stone, concrete, timber and glass – in terms of contrasts, and primarily, in relation to light. 'I believe that through this palette of materials we were able to access the feeling of shelter and cosiness that we so seek in architecture,' he says.

There are certain prevailing themes in the work of studiomk27, yet there is also the sense that each building is utterly bespoke and the arrangement of internal space is one of Kogan's favourite exercises. 'In the candy-crush of architecture, a Lego for an adult, we enjoy thinking of different arrangements, of full and empty, of circulation and being, of light and darkness,' he says. There is certainly a great visual cohesion in all his buildings, deriving from his combined mastery of the controlled palette, the confident arrangement of volumes and a surety of placement within the site.

What differentiates this house, and gives it its name, are the decorative modules created from cement and crushed marble bought by the client from modern artist Erwin Hauer, and recalling the open brise-soleils of northeastern Brazil. Hauer is an Austrian-born sculptor who taught, initially at the request of Josef Albers, at Yale University, for 33 years. He developed a series of biomorphic forms in the 1950s that combine a mesmeric repetition with structural rigour, making them suitable as architectural screens and building facades. While they faded in popularity in the 1960s (like the hula hoop, noted Hauer), there has been a resurgence of interest in them, and

The highly sophisticated treatment of materials is balanced by a playful approach to furnishings.

'We always seek to get the maximum feeling from the space, and integrate fully into the landscape. The external architecture merges with the internal so separation does not exist.'

MARCIO KOGAN

Instead of solid walls separating indoors and out, Kogan uses a more porous material.

The architect uses a variety of devices to let in, and also omit, light, both day and night.

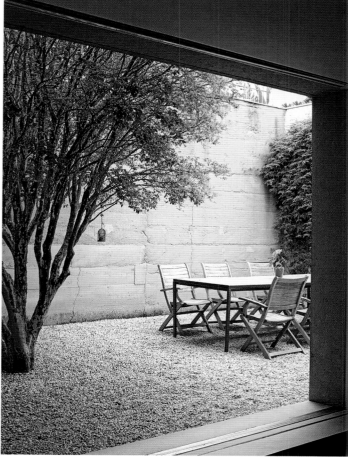

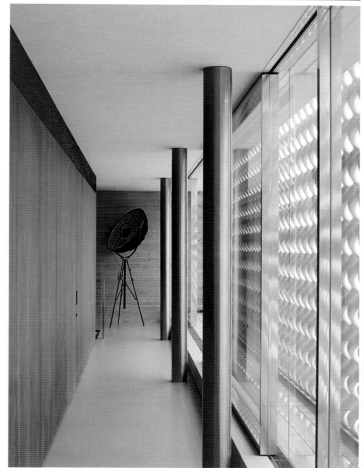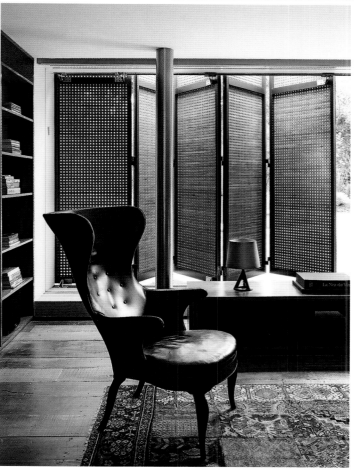

The modules,
created by Erwin
Hauer, act as a
built-in sculpture,
filtering light.

the company has been revived as Hauer has gone into partnership with an ex-student, Enrique Rosado. Kogan worked with Hauer to create a product suitable for outdoor use, as the modules were originally manufactured in gypsum, a soft mineral used in the manufacture of plaster of Paris. Their perforations allow, in Kogan's words, 'crazy beautiful light effects in the whole pavilion', which houses a gym. At night, the reverse occurs and this rectangular structure at the top of the house glows like a decorative beacon. The nature of the concave and convex curves allows the light to both penetrate inwards and be expelled outwards.

The play of scale comes through strongly in the work, as expansive volumes are matched by perfectionism in the smallest of details. For example, the crafting of the cabinetry, the stonework in the bathrooms and the fine, folding timber shutters that modulate the light are all testament to the focus on the minutiae of the building. Kogan admits both to a high level of self-criticism and a deep respect for the trades that work on his projects. 'I love to go to the site and talk about the forms of construction with the workers, who for me are the true anonymous heroes of each project.'

A snapshot of studiomk27's houses reveals a remarkable consistency in the quality of the interior design; Kogan notes that 'a poorly executed interior design project can destroy the architecture'. As a practice, they aim for an entire solution, 'incorporating what the clients like to bring from their previous lives and their personality to make the choices'. He likes to tell the story of Niemeyer visiting a completed project that he particularly loved. When the owner said that she liked the house so much she would do the decoration herself, Niemeyer 'went crazy'. Kogan's admiration for Brazilian mid-century modernism extends to his furniture choices, with the timber and leather pieces of Sergio Rodrigues featuring in many of his interiors. The Cobogó House, on which he collaborated with Diana Radomysler, however, has a more textural feel, with contemporary Polder sofas by Hella Jongerius and Tropicalia chairs by Patricia Urquiola for Moroso indicative of a more craft-orientated design, and Prouvé Cité chairs and the Executive chair by Saarinen providing a modernist pedigree. Add into the mix pieces by the Bouroullec and the Campana brothers and it is a roll call of the best of modernist and contemporary designers. Patterned rugs with chairs skilfully arranged in pairs are grouped to create areas of comfort and intimacy within the large space.

Kogan has also turned his hand to the design of smaller objects – a beautifully crafted bowl for When Objects Work and a project involving debris left over from construction sites which has been turned into furniture pieces. 'We collected the furniture the workers made for themselves while they were living at the site for four years. They built this furniture with wooden remains simply and quickly.' The idea was to design pieces without overthinking them, to produce pieces, as Kogan says, with 'a certain absence of concern', while recognising the design language and 'making little insertions that point out their sophistication'. Hence the collection is called Prostheses and Grafts.

And this sums up much of what is appealing about Kogan's approach to life as much as to architecture. He understands the need for play. While his houses are seriously conceived and impeccably executed, they create a context for contemporary life that is as much about ease and pleasure as it is about functionality. He understands that if integrity is at the core of design intent and built expression, then there is nothing wrong with the 'adornments of life, sources of little pleasures and comforts that are delicious'.

Says Kogan: 'Recently a client confided to us that the house we had made for him to live in had changed and influenced his life for the better and he thanked me for this. I was moved; architecture fulfilled its mission.'

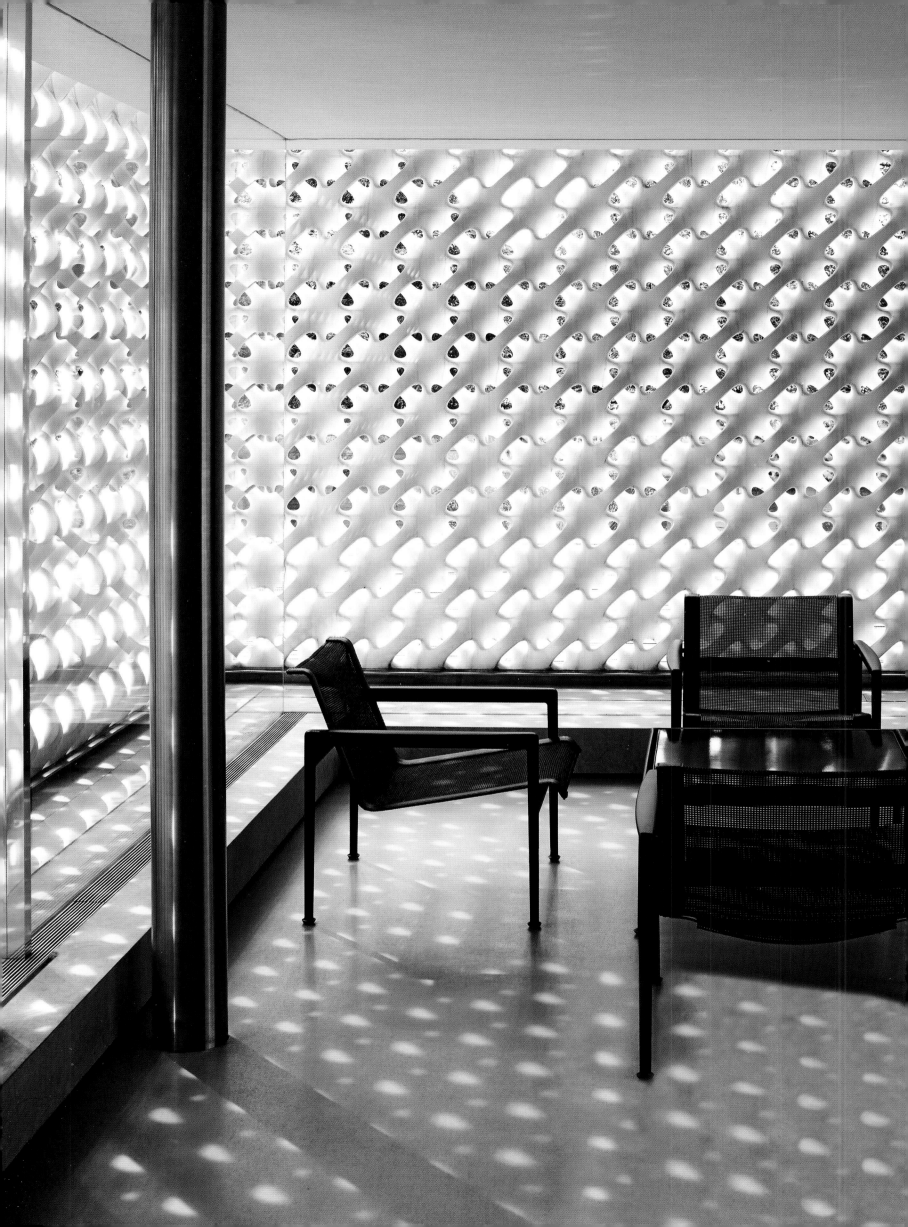

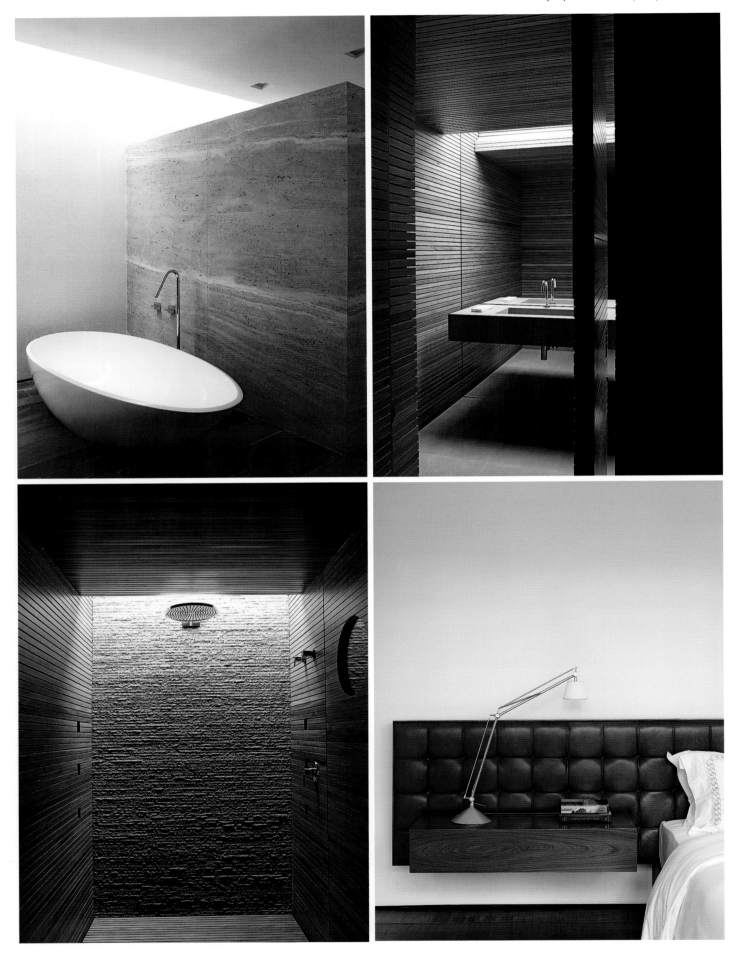

In intimate areas of the house, the exploration of textural surfaces is fully explored.

Even the staircase manages to take on a sculptural, light-filtering quality.

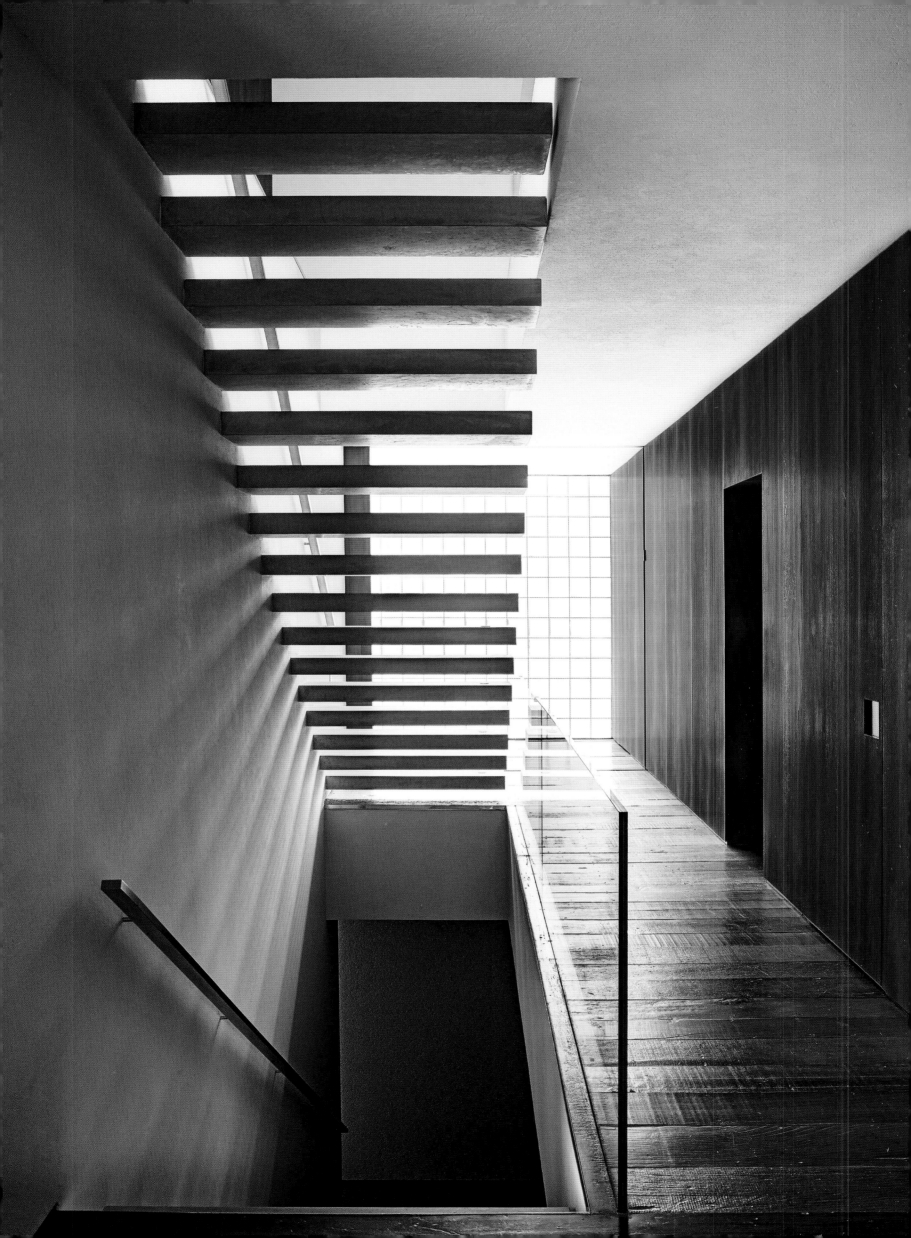

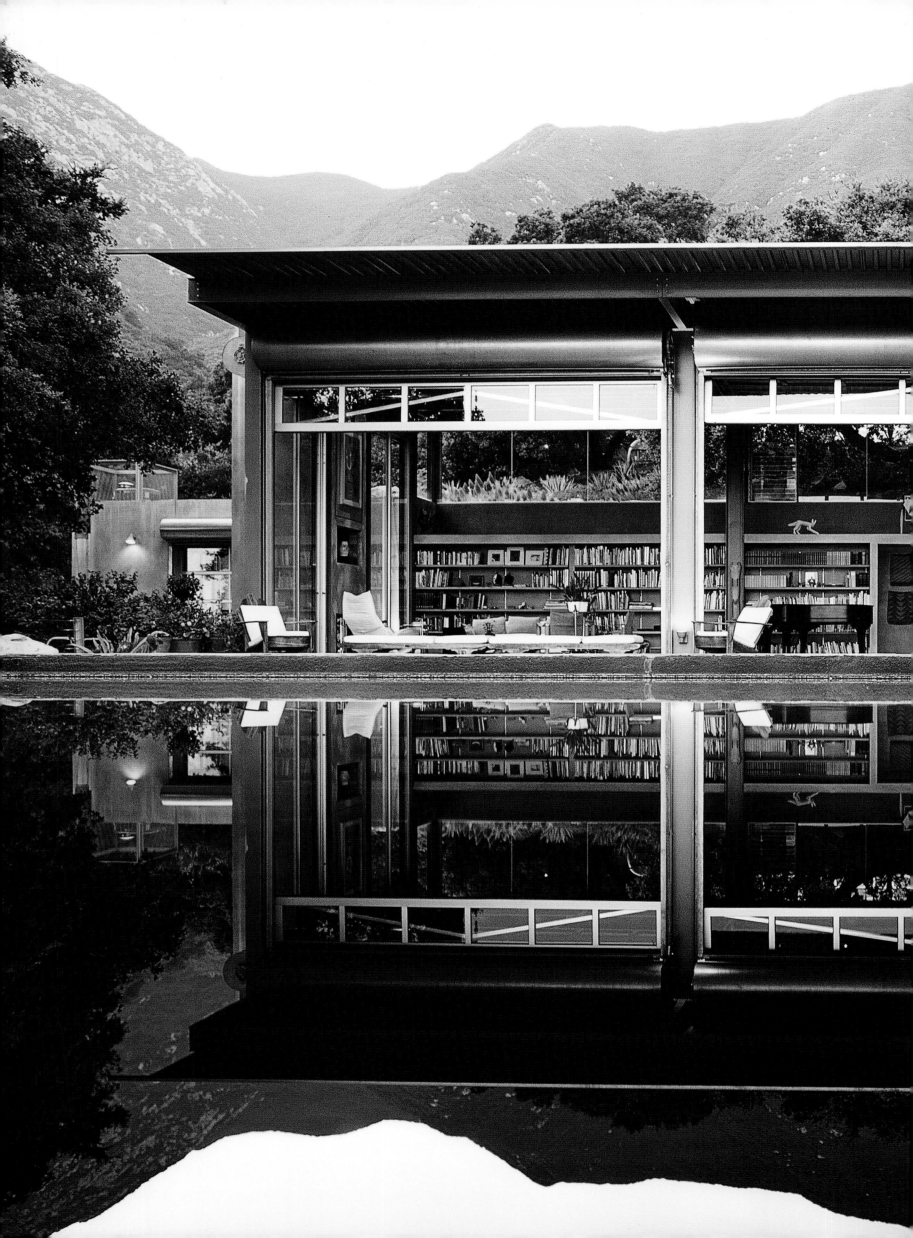

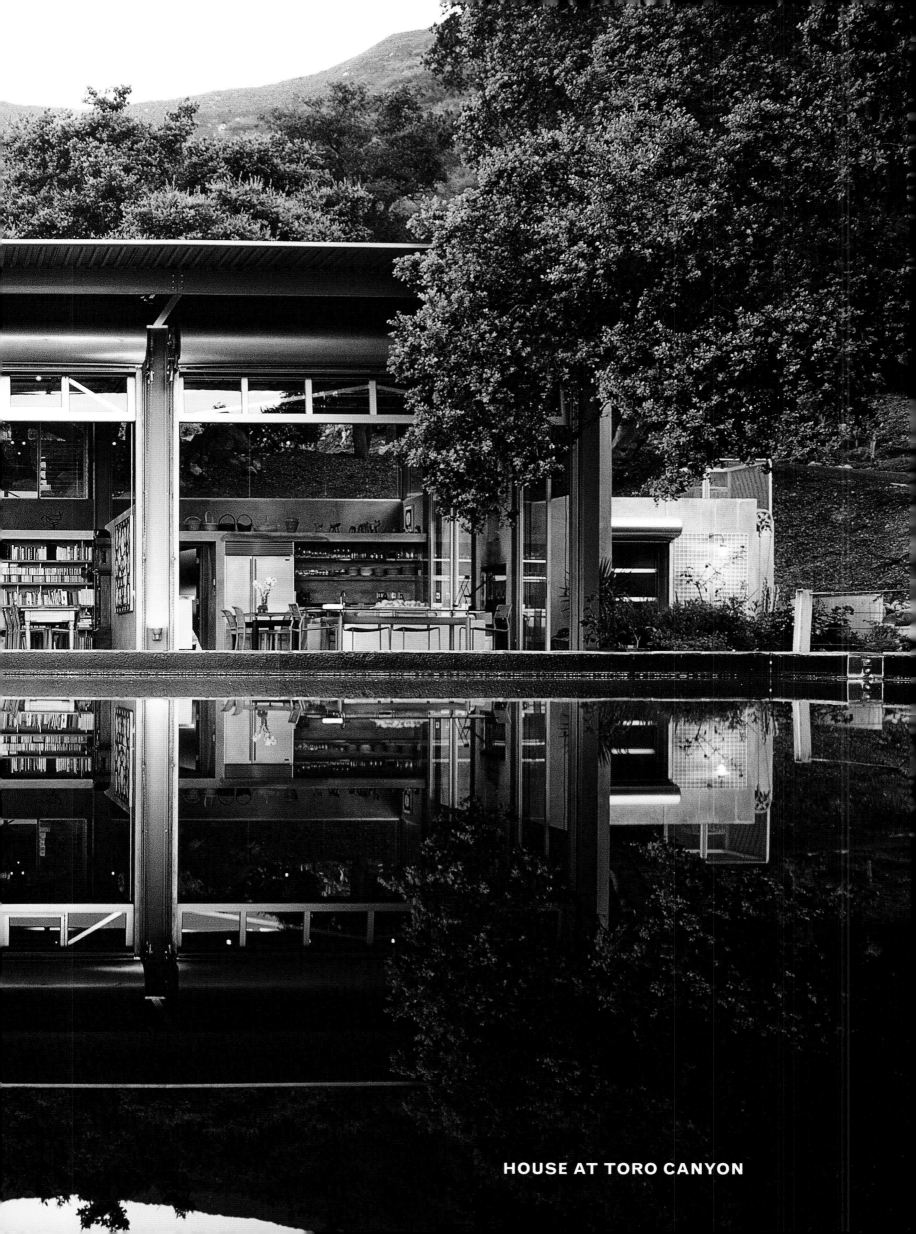

HOUSE AT TORO CANYON

HOUSE AT TORO CANYON —— BARTON MYERS ASSOCIATES

**HOUSE AT
TORO CANYON
(1998)**

◇

**BARTON MYERS
ASSOCIATES**

⋈

**MONTECITO,
CALIFORNIA, USA**

'Its conception, scale, detail, siting and precautionary attention to the potential of brush fire resulted in a synthesis of highly practical and beautiful elements,' wrote professor of architecture Robert M. Craig, from the Georgia Institute of Technology, after a visit to the House at Toro Canyon in 2003.

Settled within
its mountainous
context, the planting
of succulents is
strategic in bushfire
protection.

From Ahmedabad to Toronto, architects from all over the world have paid homage to the house in California, and their letters of appreciation fill three ring binders. They reference Mies van der Rohe's Barcelona Pavilion, Charles and Ray Eames' house at Pacific Palisades and Rudolph Schindler's West Hollywood studio, and they are not wrong. These are some of the influences that Barton Myers acknowledges in the genesis of the building, but there is much that is his alone.

When I first see Myers, he is sweeping up after a 100-kilometre-an-hour wind has scattered leaves from the ancient oak trees that are so intrinsic to the beauty of the site. He is an inveterate sweeper, claims his wife, Vicki, a habit ingrained since his days in the US Air Force. A switch to the study of architecture, as a graduate student, at the University of Pennsylvania (1961–64) was followed by an apprenticeship in the office of the late, great Louis Kahn, where he learnt the power of geometry and the absolute need for an ordered plan.

It is no surprise, therefore, that steel is Myers' material of choice. Not only is he well-versed in its history, from the Crystal Palace to the Maison de Verre, via the Eiffel Tower, but has spent two decades working with his UCLA students to document more than 250 twentieth-century steel houses. Within Myers' own career, his appreciation can be traced, very clearly, through three houses – two designed for his family and the other for a client. The material holds in common between the three, and many of the principles and aesthetic judgements behind them follow a clear line of development over 25 years, divided only by site, climate and experience.

The Myers moved to Toronto where work was plentiful, and he set up an architectural firm, Diamond and Myers (1967–75), and subsequently Barton Myers Associates in 1975. Intending to relocate for a couple of years, they stayed for 20. Their home, the Myers Residence (1970–71), in Berryman Street, was a narrow infill house in the predominantly Victorian neighbourhood of Yorkville. Vicki recalls being concerned that it was so radical no-one would want to buy it when they were ready to leave. They need not have worried.

It was a house that declared its modernity instantly, with its bold steel frame, oversize house number and primary colours on the exterior, not to mention its exposed ducting, framing and mechanical services internally. Its design predates the Pompidou Centre where the defining

The marriage of
domesticity and
the industrial
creates an elegant
warehouse
aesthetic.

hallmark is the exposure on the exterior of the building of mechanical systems and colour-coded ducts. However, what Myers also worked hard to achieve here (as he also did many years later on a much greater scale with his steel and glass extension to the Sacramento Hall of Justice) was a visual commonality in terms of proportion, alignment and scale between this small avant-garde house and its neighbours from another era. The arrangement of space, the height of the rooms (for Myers, reminiscent of Georgian Dublin) and the light created by a central atrium made a slim block, 7.6 metres by 36 metres, seem generous and open.

Myers' second celebrated residence, the Wolf House (1974), won the Prix du XXe Siècle in 2007 for the house which most pointed to the 21st century. 'Berryman could be described as a composite house, a partially steel frame house; this is all steel, so it's a much purer structure,' says Myers.

Larry and Mary Wolf had wanted to buy Myers' house but settled for one designed and built by Myers on an exceptionally beautiful block of land in the upmarket Toronto suburb of Rosedale. The request was to replicate Berryman Street, only slightly larger, but Myers stretched the brief, as the site demanded, opening the house to the western views of the park and hence creating an open, rather than closed, courtyard. The Wolf House is an exercise in spatial and light management. Glass, structural steel beams and corrugated steel – all painted white – are the components with which this remarkable house is constructed. It is organised into clearly defined zones with both dividing and linking devices: The courtyard separates entry, carport and service area from the kitchen, dining and living at the rear, while a bridge links bedrooms and playrooms with the master suite. In terms of light control, a great deal is adjustable, with canvas awnings under skylights and roller blinds on glass walls. This elegant steel and glass box sits on slim columns in its woodland surrounds, and foliage has further been integrated into the house with a tree spanning two floors positioned in the double-height dining area. It is no wonder the Wolfs remained there until 2013 when they put the house up for sale.

In the 24 years between the Wolf House and the House at Toro Canyon, Myers undertook large-scale regeneration projects of mind-boggling complexity. His shift to California was initiated by participation in the Bunker Hill Competition (1980), as master planner and lead architect on a development team. He gradually relocated to LA, and a Spanish Mission house sited high above the Hollywood Bowl became home in 1987.

'The pavilion idea allowed me to get the houses within the oak trees and not take any out. When the studio has all its doors open and you are standing below, the only thing you see is the floating roof.'

BARTON MYERS

The urge to build is never far away if you are an architect and, after a decade, thoughts of a new, more rural location began to take hold. Hawaii was given serious consideration before he and Vicki started to explore sites outside Santa Barbara – 90 minutes drive north of Los Angeles. 'We wanted to do something that seemed more Californian, more agrarian, preserving as much of the site as possible,' said Myers.

And what a site. Even Myers couldn't believe his luck when he found it. Protected by a dramatic mountain range to the north and enjoying a magnificent view of the ocean to the south, here was 16 hectares of land, including a virgin Californian creek, with two building platforms already rough cut into the land. He has since named one of the mountains Bart's Peak.

Yet he was mindful that the area was prone to severe fires and erosion, and that he would have to solve not only the aesthetic issues but also the broader considerations of safety and stability. His consummate skill as an architect was the act of holding both in equal balance.

The first major design decision was to break down the living requirements into four components – a garage, guesthouse, main residence and

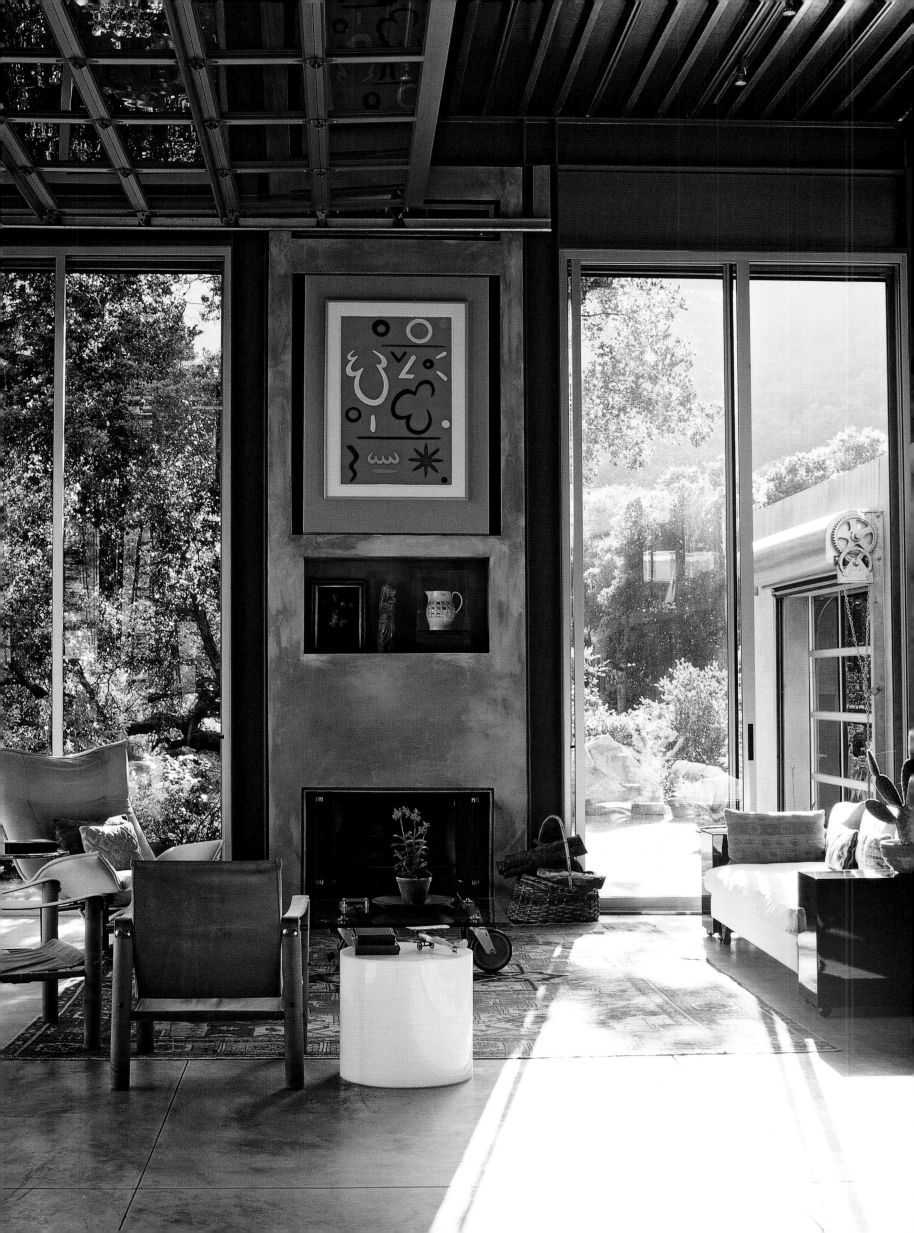

A broad concrete platform, situated between the house and reflecting pool, is an integral part of the living space.

studio – to avoid the mass and height of a large structure. As Myers points out, 'The pavilion idea allowed me to get the houses within the oak trees and not take any out.' It also meant that the pavilions, with their massive opening doors and simple structure, could disappear into the landscape rather than dominate it. 'When the studio has all its doors open and you are standing below, the only thing you see is the floating roof,' he said. He sited the studio at the top of the slope and the garage and guest pavilion at the bottom, leaving the main residence to sit comfortably, and logically, in the middle.

The main house is a single-storey building with an internal ceiling height of 4.5 metres, which imparts an impressive sense of scale, rendered unpretentious by the choice of materials. Using off-the-shelf steel components for the structure ('It's basically a catalogue house – modified,' says Myers), a plaster skim over blueboard, left uncoloured, for the walls, and natural concrete for the floors. The shell of the house is muted and natural.

It has been described as an 'elegant warehouse' and, indeed, the visibility of the mechanics and construction detailing add to the sense of utility and honesty of the space. It is without pretence, both in its structure and in its furnishings, with artworks, thousands of books (6000 to be precise), oriental rugs and family heirlooms warming up the interior with character and layers of meaning.

Sited to face the sun and the view over the Pacific Ocean and Channel Islands, the entire face of the house opens up as the enormous garage-style doors are rolled up by hand with a pulley system. Electrics are avoided in case of a power cut. This allows the broad concrete platform to become a seamless extension of the living space. The line between inside and out becomes completely irrelevant, and this blurring of demarcation is, to Myers, one of the defining aspects of modernism in southern California.

As well as the more standard devices such as sprinklers and smoke detectors, what really gives the house a serious chance of survival is the fact that it is made of steel. 'Two years ago we had a fire in a neighbouring canyon and Vicki was here on her own,' says Myers. 'Within 30 minutes, she was able to pull down the roll-down steel shutters and protect all the buildings on the site.' He has become something of a global expert on the subject: In 2009, when bushfires swept Victoria, Myers was interviewed on Australian radio to discuss his architectural approach to fire prevention.

The black-lined reflecting pools of water on the roof of the guesthouse and the main residence are key features of the house and solve the aesthetic problem of one pavilion looking down upon the roof of the other. Practically, they provide insulation, and there is also a lap pool sunken into the roof of the guesthouse, for cooling down on hot days.

Water is recirculated from uphill storage tanks and is permanently at hand so a pump can be hooked up in case of emergency. Other fireproofing strategies include reducing the combustible nature of the site and changing the vegetation through the introduction of walls of cacti which hold water and act as a barrier against local deer (and possibly coyote but, unfortunately, not the rattlesnakes). To help stabilise the land and minimise erosion, hedges of vetiver, a type of grass, have been planted on the advice of a landscape consultant, D.G. Richardson. Terraces of olive trees, blood oranges and grapes have also been introduced. All the gardening is done, or supervised, by Vicki. Paradise takes work.

'I have always wanted a house that was integrated with the landscape,' said Myers. 'This is it.' As glass walls disappear, the intrinsic qualities of the site become part of the experience of the house. The oaks, the Noguchi-style rock formations, the dappled light, the sea breezes and the murmur of water combine to give a sense of oneness with nature. It feels as if the house has always been there. And, hopefully, with Myers' fire strategies, it always will be. ■

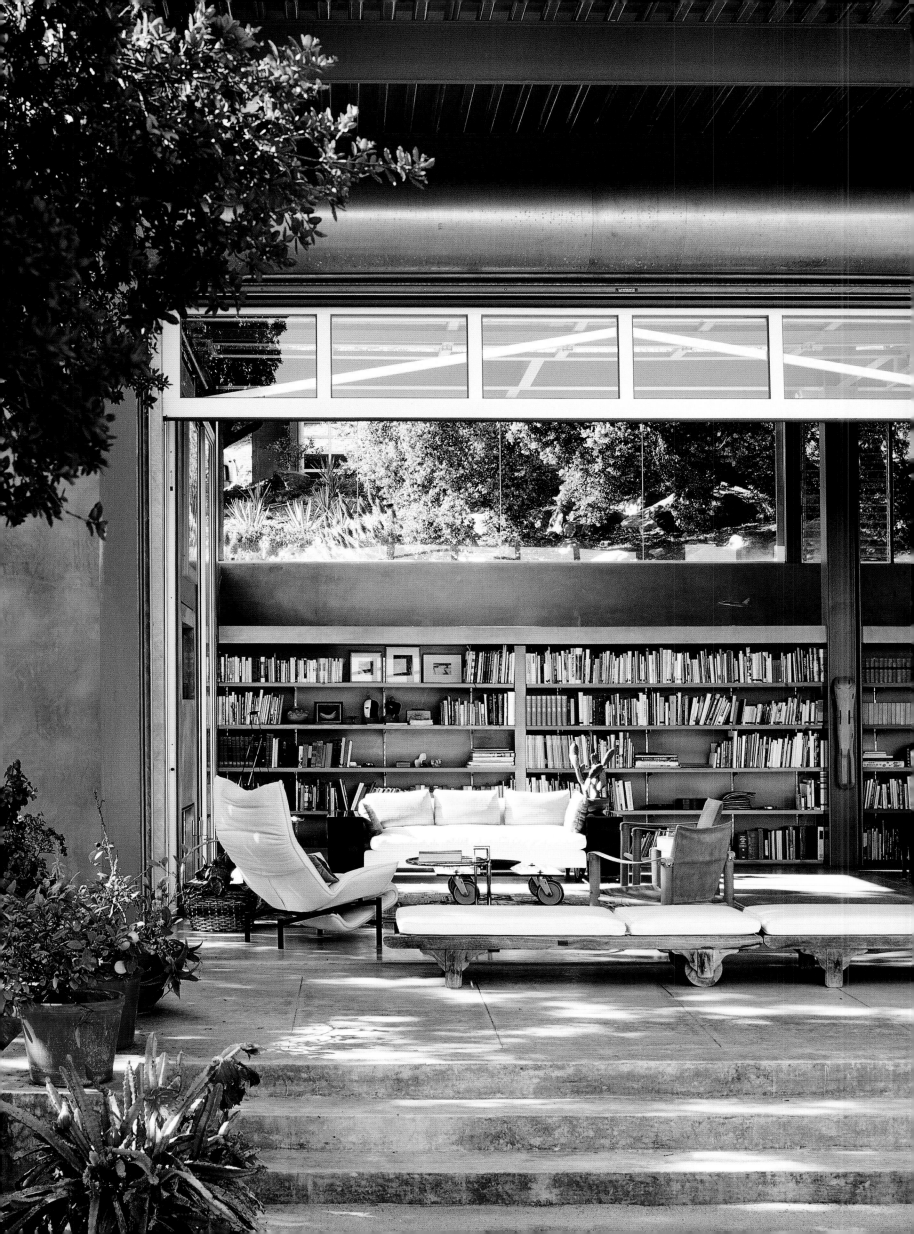

The exposed honesty of the mechanics of the House at Toro Canyon is very much part of its appeal.

In this house, connections to the outdoors are often found in quite unexpected places.

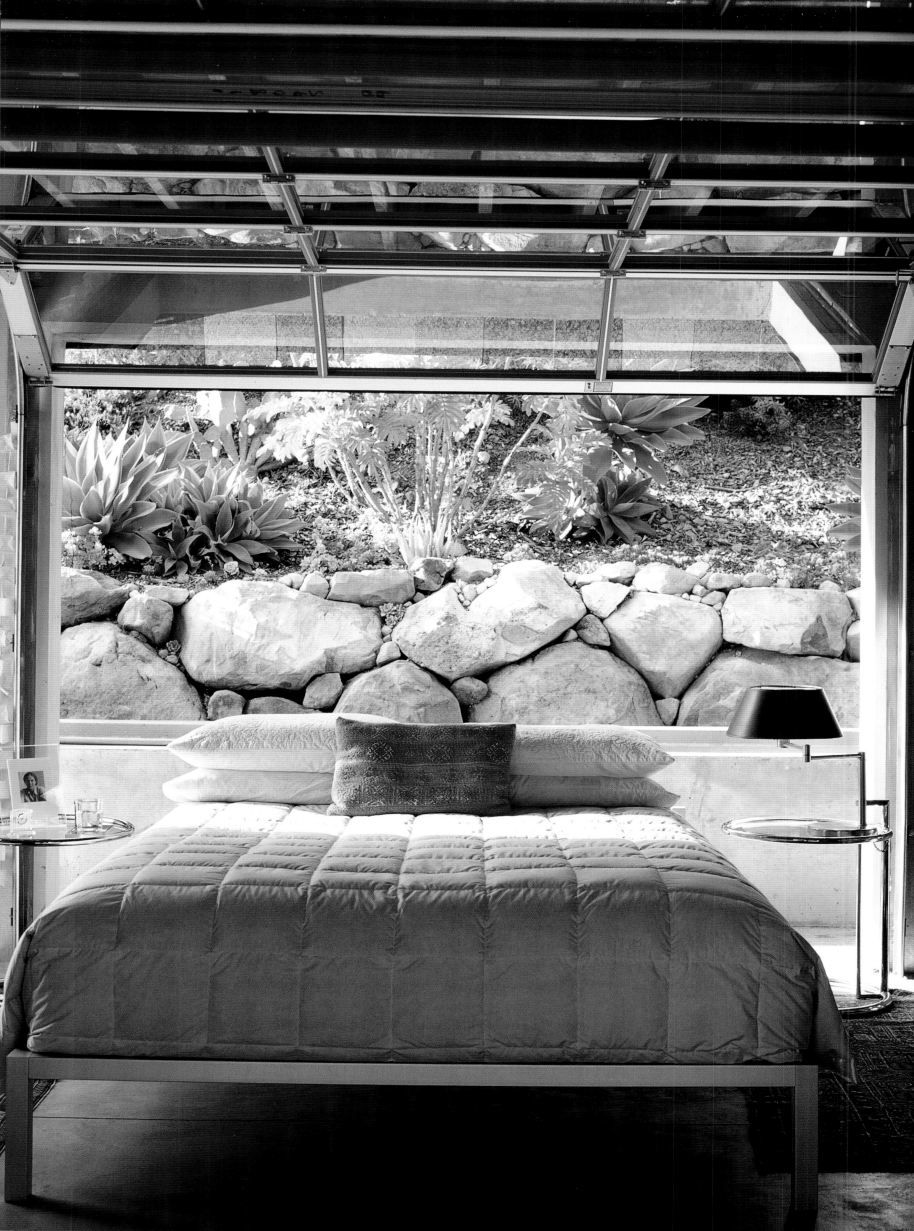

The black-lined reflecting pool is a readily available source of water in case of fire.

The character of the interior can accommodate a grand piano as well as an Adirondack chair.

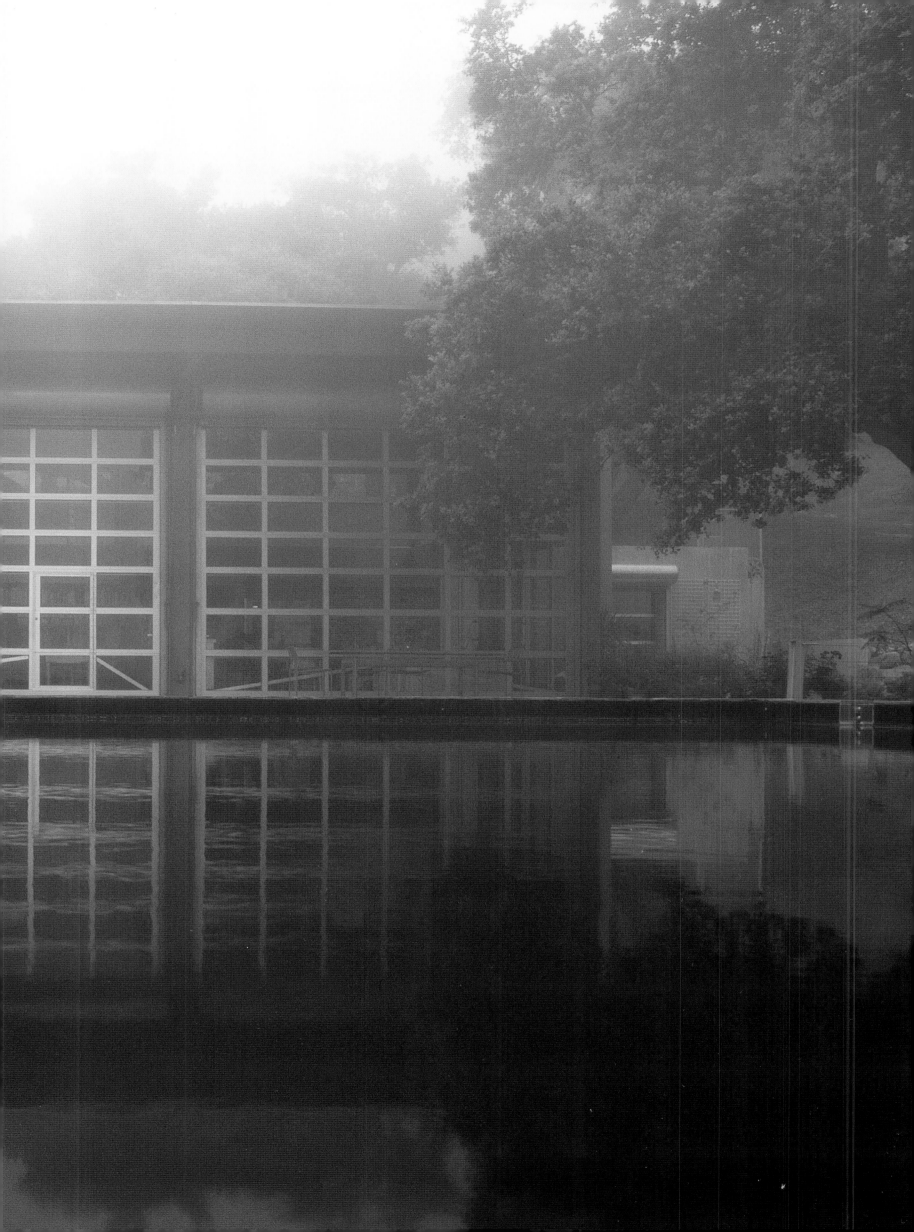

ACKNOWLEDGEMENTS

Julie Gibbs for providing the opportunity to create such a beautiful book.

Richard Powers, globetrotting photographer extraordinaire,
for shared trips on trains, planes, and automobiles.

Evi Oetomo for letting me be part of the wonderful experience of the design process,
and for being such a remarkable talent.

Leta Keens for her editing skills and for being the most trustworthy sounding board.

Katrina O'Brien for allowing me to work right up to the deadline.

Fran Moore for her support.

A thank you to all those people who helped along the way – Eduardo and Marina Colonelli,
Houssein and Omar Jarouche, Sharon Tredinnick, Carine Goossens, Donatella Brun,
Andrew Ghadimi, David Flannery, Christian Bourdais, Vicki Myers and Scott Robertson.

Dominic Bradbury for his collegiate spirit.

Danielle Powers for producing Barton Myers, and Maximilian Powers for his tireless
assistance shooting in Italy and Australia.

All the owners and architects for the access to their homes and information
so readily and generously given.

David Harrison, as always – stylist, chauffeur, proofreader, uncompromising critic.

KAREN McCARTNEY

SOURCES

Pezo von Ellrichshausen —— Solo House
2G No. 61 Pezo von Ellrichshausen
pezo.cl
Interview with Christian Bourdais and PVE

**Benthem Crouwel Architekten ——
 Almere House**
Pre-fab, Allison Arieff and Bryan Burkhart,
 Gibbs Smith, 2002
*Integrated Buildings: The Systems Basis of
 Architecture*, Leonard R Bachman, Wiley, 2002
benthemcrouwel.nl
Interview with Jan Benthem

Wood Marsh Architecture —— Flinders House
'Flinders House', Fleur Watson and Martyn Hook,
 Architecture Australia, March/April 2013
Wood Marsh Architects: Residential Work,
 published by Beta Plus 15/1/13
woodmarsh.com.au
Tour and interview with Randal Marsh

**Scott Tallon Walker ——
 Goulding Summerhouse**
'The Summerhouse', Shane O'Toole,
 The Sunday Times, October 2000
'Party on in the Summerhouse', Bernice Harrison,
 The Irish Times Property Supplement,
 September 5, 2002
Comments by Shane O'Toole at the presentation
 of the inaugural RIAI James Gandon Medal
 for Lifetime Achievement in Architecture
 to Dr Ronald Tallon at 8 Merrion Square
 on November 23, 2010.
*The Cambridge Companion to Modern Irish
 Culture*, edited by Joe Cleary and Claire
 Connolly, Cambridge University Press, 2005
'Early, Modern and Late: Scott Tallon Walker',
 Sean O'Reilly, *Irish Arts Review*, Volume 23, 2006
*Scott Tallon Walker – 100 Buildings and Projects
 1960–2005*, edited by John O'Regan,
 Gandon Editions, 2006
'Object in a Landscape: Robin Walker's Weekend
 Houses, Kinsale', Alexander Kearney,
 Irish Arts Review, Volume 16, 2000
The Iconic House, Dominic Bradbury and
 Richard Powers, Thames & Hudson, 2009
stwarchitects.com
With thanks to architect Frank Fahy for his
 information and for the assistance in sourcing
 material, and to Lingard Goulding for sharing
 his experiences of the Goulding Summerhouse.

**Vincent Van Duysen Architects ——
 VDCA House**
Vincent Van Duysen Complete Works,
 Thames & Hudson, 2010
vincentvanduysen.com
Interview with Vincent Van Duysen

**Wespi de Meuron Romeo Architetti ——
 Concrete House**
wespidemeuron.ch
Interview with Jérôme de Meuron

Lissoni Associati —— Monza Loft
Piero Lissoni, daab, 2007
Piero Lissoni: Recent Architecture, Deyan Sudjic,
 Giovanni Gastel, Stefano Casciani and
 Birte Kreft, Hatje Cantz, 2010
'20 Odd Questions', Wall Street Journal,
 edited text from interview by David Kaufman,
 Wall Street Journal, June 15, 2012
'10 minutes with Piero Lissoni', Erika Heet,
 Dwell, May 2011
'Piero Lissoni in Conversation', Janice Seow,
 InDesign Live, October 12, 2011
lissoniarchitetti.com

**John Wardle Architects ——
 Fairhaven Beach House**
Volume: John Wardle Architects, Leon Van Schaik,
 Thames & Hudson, 2008
'Home on the Range', David Meagher,
 Wish Magazine, November 2012
AIA Jury (Victorian chapter)
johnwardlearchitects.com
Interview with John Wardle

Studio KO —— Villa D
The Iconic Interior, Dominic Bradbury and
 Richard Powers, Thames & Hudson, 2012
'Minimalist Exotica from Studio KO Architects',
 Julie Carlson, Remodelista, June 11, 2012
www.studioko.fr/
http://en.vogue.fr/fashion-culture/address-book/
 diaporama/studio-ko-s-secret-marrakech/8716
www.archilovers.com/studio-ko
studioko.fr
Interview with Studio KO

Fearon Hay —— Dune House
fearonhay.com
Interview with Tim and Penny Hay and
 Jeff Fearon and homeowner

Paul Morgan Architects —— The Trunk House
'Trunk House', Philip Goad, *Australian Design
 Review*, March 8, 2012
'Freshwater Creature', Helen Kaiser, Mark #8
 Amsterdam 2007
'Paul Morgan enters indigenous territory',
 Fabrizia Vecchione, *Mark #37*, Amsterdam 2012
'Trunk House' www.peterbennetts.com,
 November 11, 2011
Robin Boyd Award for Residential Architecture
 – Houses, Cape Schanck House, Paul Morgan
 Architects, Jury Citation, *Architecture Australia*,
 Volume 96, Number 6 Melbourne 2007

paulmorganarchitects.com
Interview with Paul Morgan

**Paulo Mendes da Rocha ——
 Masetti House**
*Paulo Mendes da Rocha Fifty Years (Projects
 1957–2007)*, Paulo Mendes da Rocha,
 edited by Rosa Artigas with contributor
 Guilherme Wisnik, Rizzoli, 2007
2G No. 45: Paulo Mendes da Rocha
'The Second Coming' Raul Barreneche,
 Interior Design, January 11, 2011
Brazil's Modern Architecture, edited by Elisabetta
 Andreoli and Adrian Forty, Phaidon, 2004
www.pritzkerprize.com/2006/announcement
With thanks to owner of the Masetti House,
 Houssein Jarouche, and architect Eduardo
 Colonelli of São Paulo Studio of Architecture
 for his advice and detailed information about
 the restoration.

**Witherford Watson Mann Architects ——
 Astley Castle**
'Astley Castle – New Life for an Ancient Ruin:
 the History and Revival of Astley Castle',
 The Landmark Trust 2012
www.telegraph.co.uk/culture/art/
 architecture/10337860/RIBA-Stirling-
 Prize-2013-Astley-Castle-wins.html
www.wwmarchitects.co.uk
Interview with William Mann

Olson Kundig Architects —— The Pierre
Tom Kundig: Houses 2, Tom Kundig,
 Princeton Architectural Press, 2011
Tom Kundig interview and lecture,
 National Building Museum, March 7, 2012
olsonkundigarchitects.com
Interview with Tom Kundig

Ricardo Bofill —— La Fábrica
Ricardo Bofill interview, *Apartamento*, issue 11
 Spring/Summer 2013
ricardobofill.com
Tour of La Fábrica and interview with
 Ricardo Bofill Junior

**Virginia Kerridge Architect ——
 House in Country NSW**
'Past Occupation', Virginia Kerridge,
 Architecture Australia, Sept/Oct 2012
Houses, Awards issue, No. 81, August 2011
vk.com.au
Interview with Virginia Kerridge

GLUCK+ —— Tower House
The Modern Impulse, Peter L. Gluck and partners,
 Joseph Giovaninni and Peter L. Gluck,
 ORO Editions, 2008

'The Tower House', Matteo Vercelloni, *Interni*,
 May 2013
'A Stairway to the Treetops', Joann Gonchar,
 Architectural Record, April 2013
'Up in the air', Dominic Bradbury, *Vogue Living*,
 Sept/Oct 2013
gluckplus.com
Interview with Peter and Thomas Gluck

studiomk27 —— Cobogó House
www.archdaily.com/264564/venice-biennale-
 2012-studiomk27-represents-brazil-with-peep
www.archdaily.com/tag/studio-mk27/
www.designboom.com/tag/studio-mk27/
www.designboom.com/architecture/studio-mk27-
 cobogo-house/
www.marciokogan.com.br/
www.world-architects.com/en/mk27
erwinhauer.com/eh/installations/cobogo-
 house-private-residence-rooftop-pavilion-
 sao-paulo-brazil
www.archilovers.com/marcio-kogan/
marciokogan.com.br
Interview with Marcio Kogan

**Barton Myers Associates ——
 House at Toro Canyon**
3 Steel Houses, Barton Myers,
 Images Publishing, 2005
Barton Myers 'A Machine in the Wilderness',
 by Michael Webb, Graphis352
Barton Myers – Selected and Current Works,
 Barton Myers, Images Publishing, 1994
Letter from Robert M. Craig to Barton Myers
bartonmyers.com
Interview with Barton Myers

General
Twentieth Century Houses (Architecture 3s),
 Robert McCarter, Phaidon, 1999
Frank Lloyd Wright, Robert McCarter,
 Phaidon, 1999
Key Buildings of the 20th Century, Richard Weston,
 Laurence King, 2004
The World as Flux, Japanese Spatiality, C3 No. 326,
 JaeHong Lee, C3 Publishing Company, 2012
www.archlovers.com
www.wallpaper.com
www.dezeen.com
www.designboom.com
www.europaconcorsi.com
www.archdaily.com

CREDITS

Pages 44–45: Artwork by Clement
 Meadmore and Dale Frank
Page 48–49: Artwork by Nicholas Morley
 and Ozzie Wright
Page 52: Artwork by Lisa Roet
Page 74: Artwork by Juan Muñoz
Page 75: Artwork by Gilbert & George
Page 78: Artwork by Mathieu Nab
Page 79: Artwork by Anish Kapoor
Page 83: Artwork by Lucio Fontana
Page 87: Artwork by Heinz Mack

ARCHITECTURAL PLANS,
ELEVATIONS AND DRAWINGS

◇

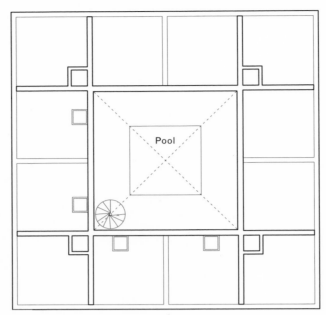

Roof

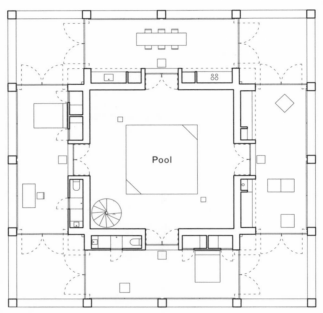

Main Floor

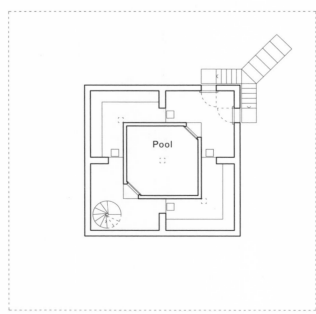

Entrance

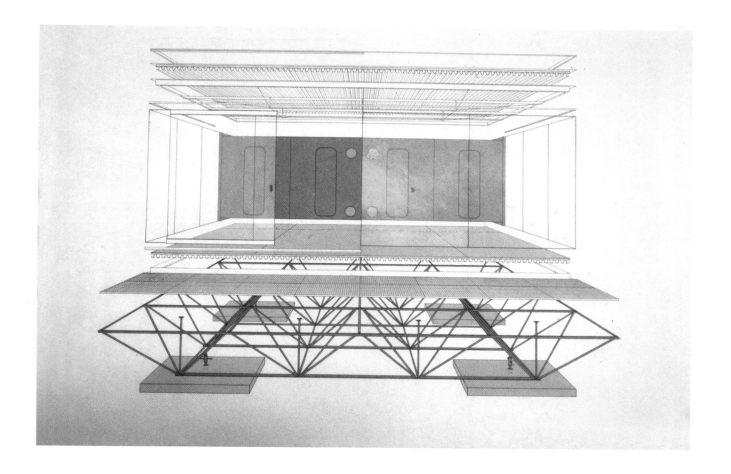

WOOD MARSH ARCHITECTURE ——— FLINDERS HOUSE

Ground Floor

First Floor

1 Entry
2 Bridge
3 Living & Dining
4 Bar
5 Den
6 Powder Room/Bathroom
7 Kitchen
8 Hall
9 Bedroom
10 Living
11 Store/Services
12 Cloak
13 Cellar
14 Mud Room
15 Laundry
16 Steam Room
17 Gym
18 Study/Guest Living
19 Garage
20 External Store/Services
21 Pond
22 Pool
23 Terrace

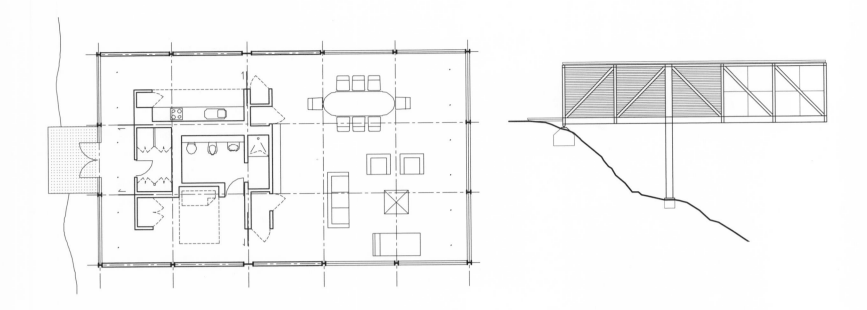

WESPI DE MEURON ROMEO ARCHITETTI ⸺ **CONCRETE HOUSE**

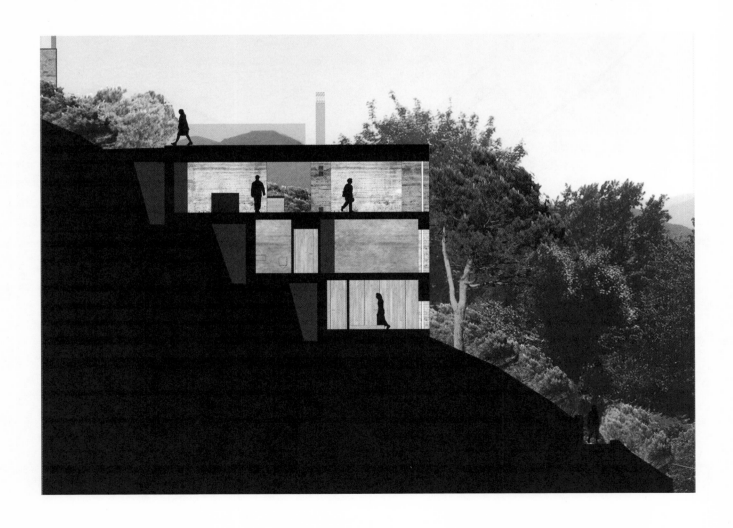

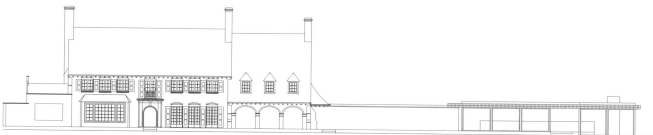

1 Entry
2 Cloakroom
3 Mudroom
4 Kitchen
5 Living Room Summer
6 Living Room Winter
7 Office
8 Hall
9 Garage
10 Dining Room
11 Wellness Area
12 Master Bedroom
13 Master Bathroom
14 Dressing
15 Guest Room
16 Guest Bathroom
17 Bedroom
18 Bathroom
19 Bedroom

Ground Floor

First Floor

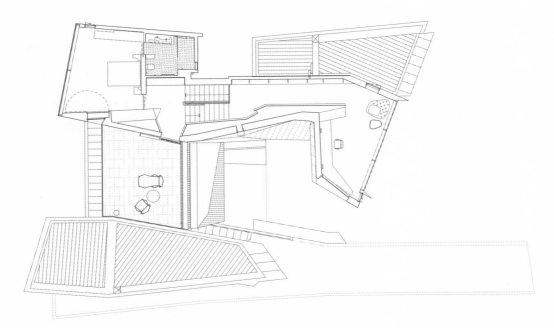

Upper Floor

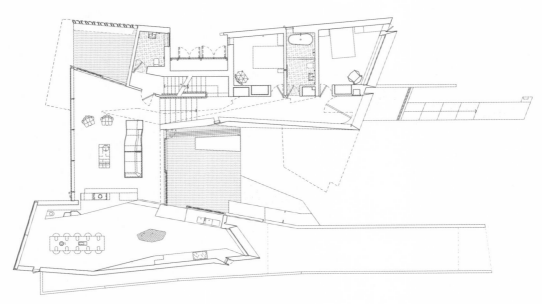

Main Floor

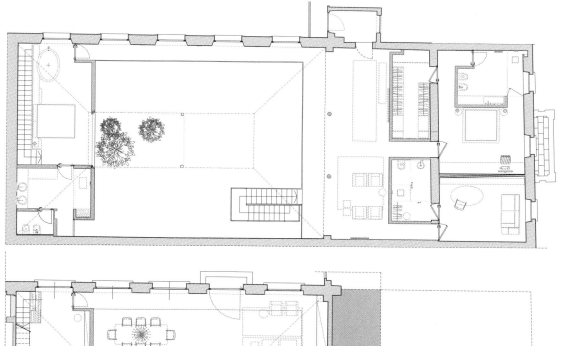

Main Floor

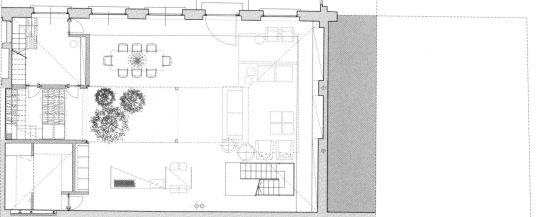

Upper Floor

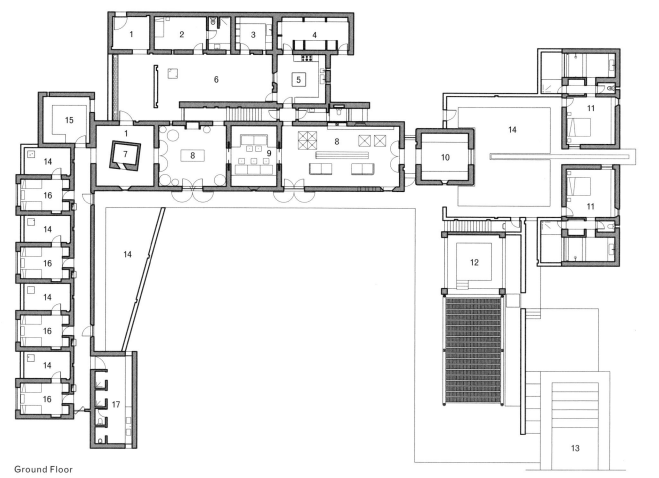

1 Entrance
2 Staff Bedroom
3 Laundry
4 Storage
5 Kitchen
6 Staff Courtyard
7 Chapel
8 Living Room
9 Dining Room
10 Library
11 Guest Room
12 Loggia
13 Swimming Pool
14 Patio
15 Media Room
16 Children's Bedrooms
17 Bathroom

Master suite level
not shown

Ground Floor

FEARON HAY —— DUNE HOUSE

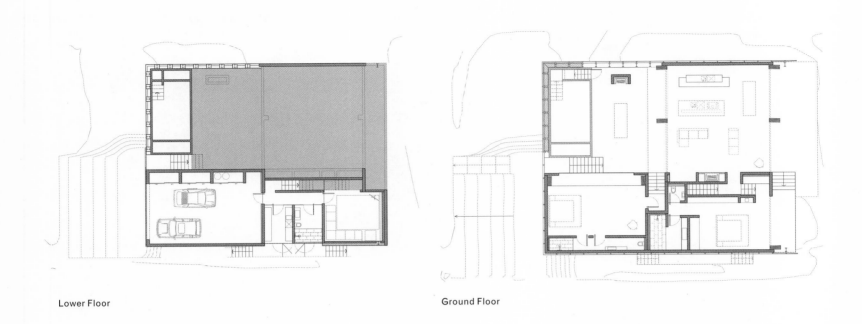

Lower Floor

Ground Floor

PAUL MORGAN ARCHITECTS —— THE TRUNK HOUSE

1 Deck
2 Living Room
3 Kitchen
4 Bedroom
5 Bathroom
6 Laundry
7 Carport
8 Store
9 Terrace

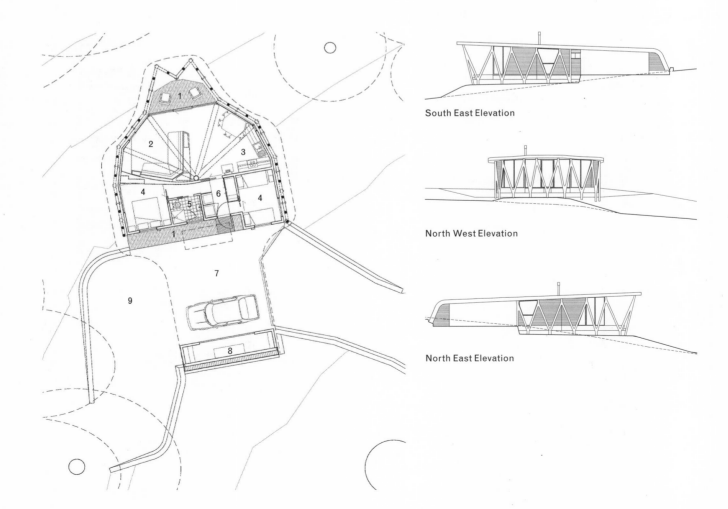

South East Elevation

North West Elevation

North East Elevation

Basement

Main Floor

1 Bedroom
2 Bathroom
3 Service Area
4 Cupboard
5 Courtyard
6 Pool
7 Main Room
8 Kitchen

Ground

Roof

WITHERFORD WATSON MANN ARCHITECTS —— ASTLEY CASTLE ███████████

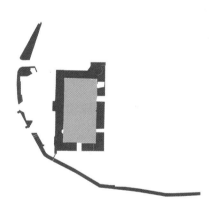

11–13th Century

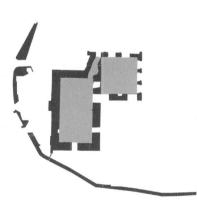

15th Century

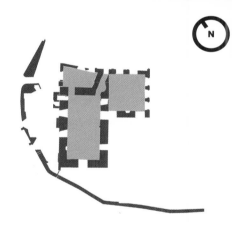

Early 16th Century

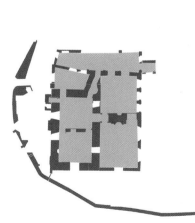

Early 17th Century

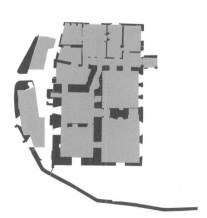

Early 19th Century

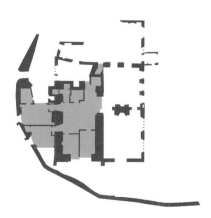

Present

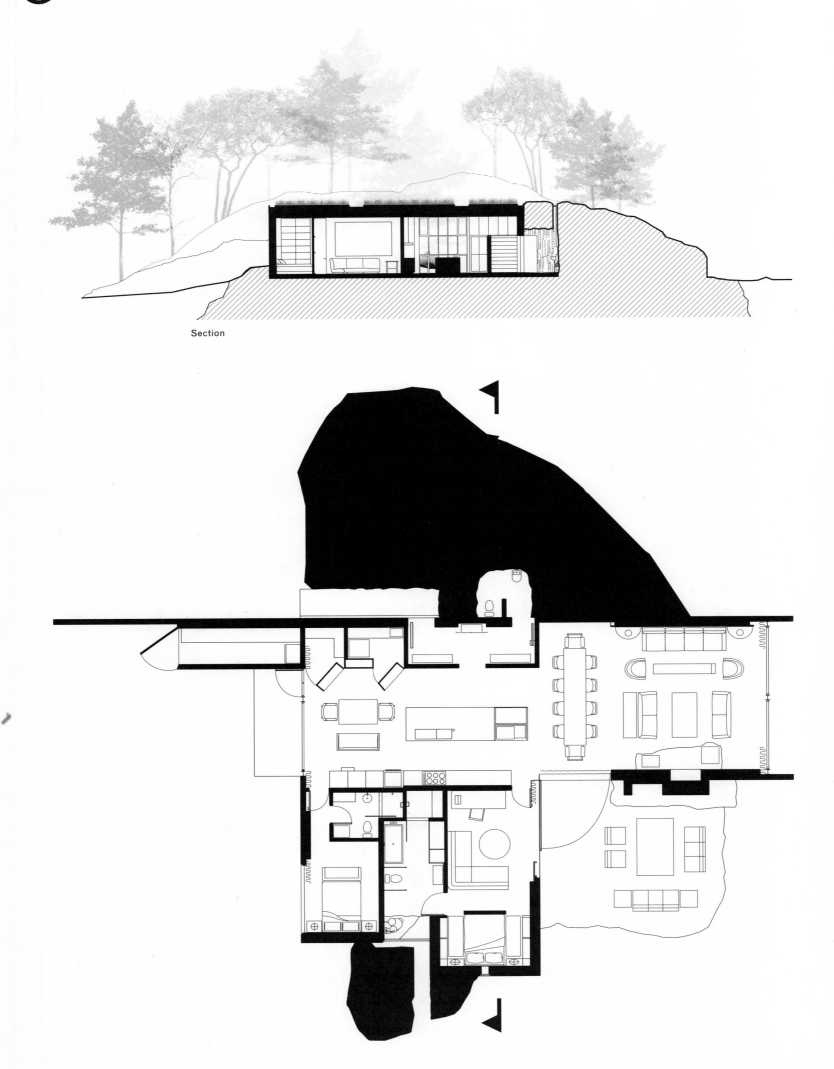

Section

Roof Terrace

Ground Floor

1 Office
2 Archive
3 Library

Second Floor

Upper Basement

First Floor

Lower Basement

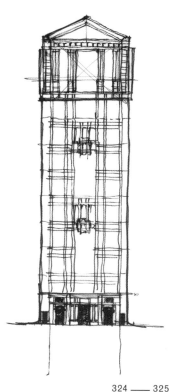

1 Entry
2 Living
3 Verandah (Mesh enclosed)
4 Lounge
5 Study
6 WC
7 Pantry
8 Cool Room
9 Kitchen
10 Dining
11 Laundry
12 Garage
13 Master bedroom
14 Master bathroom
15 Dressing room
16 Bedroom
17 Hall
18 Sitting
19 Bathroom
20 Garden

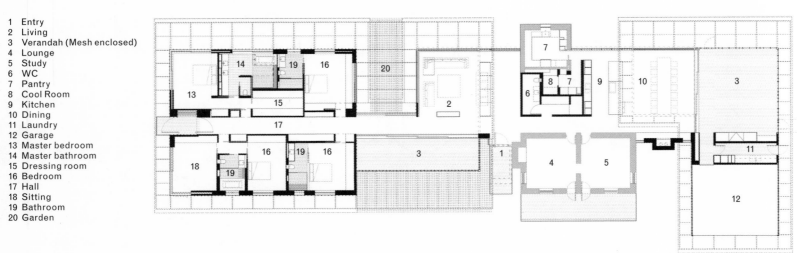

GLUCK+ —— TOWER HOUSE

1 Start with a 3BR/3Bath house on grade.

Bedrooms
Bath

Kitchen
Dining and Living
Outdoor Deck

2 Stack the bedrooms.

3 Stack the kicthen and baths to create a heated core.

4 Raise the living space to access the view.

5 Tilt up the hallway to become stairs.

6 Result: Tower House

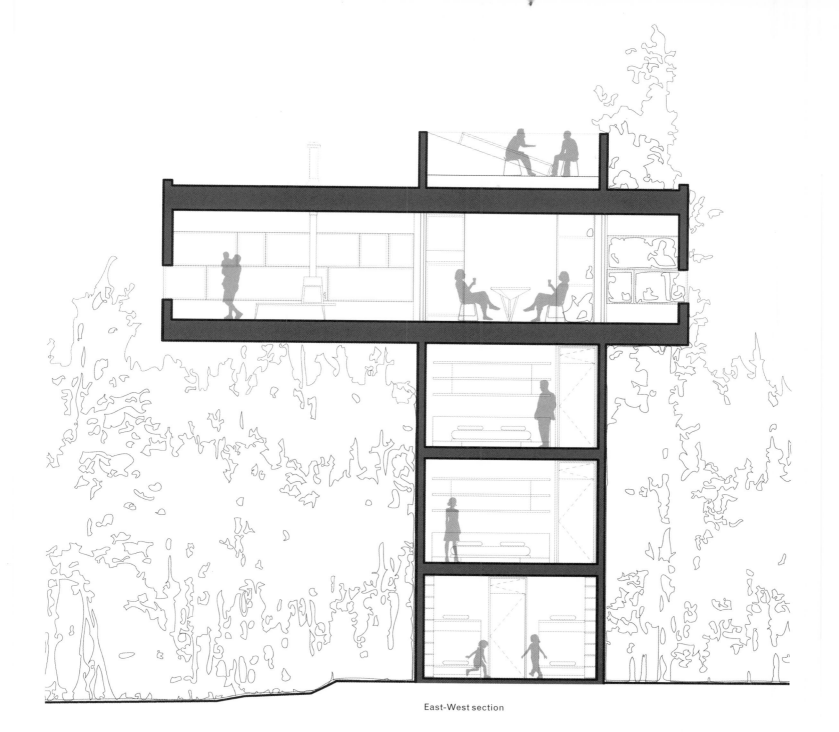

East-West section

Ground Floor

Top Floor

1 Living Room
2 Dining Room
3 Kitchen
4 TV Room
5 Barbecue
6 Terrace
7 Guest Room
8 Bedroom
9 Office/TV Room
10 Master Bedroom
11 Closet
12 Wine Cellar
13 Pantry
14 Laundry
15 Gym
16 Sauna
17 Deck

Ground Floor

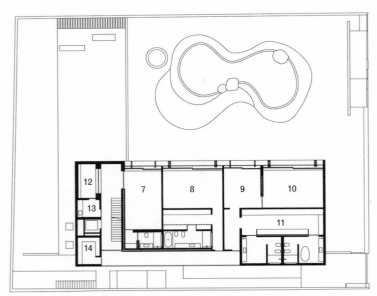

First Floor

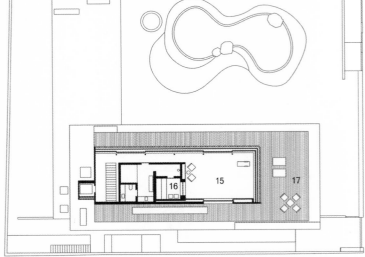

Second Floor

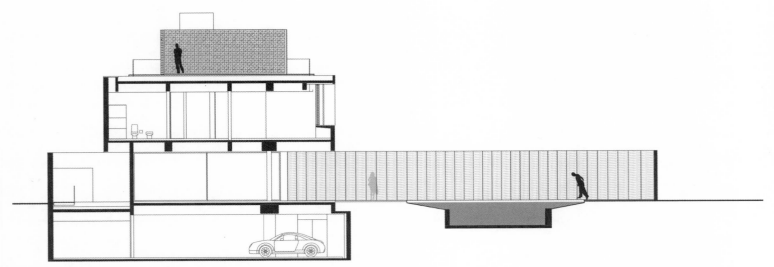

North South Section

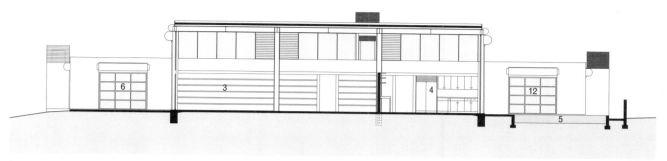

1 Terrace
2 Master Bedroom Terrace
3 Living/Dining
4 Kitchen
5 Garden
6 Master Bedroom
7 Master Bath
8 Dressing Room
9 Guest Room
10 Utility Room
11 Guest Bath
12 Guest Room
13 Recirculating Tank

Longitudinal Section

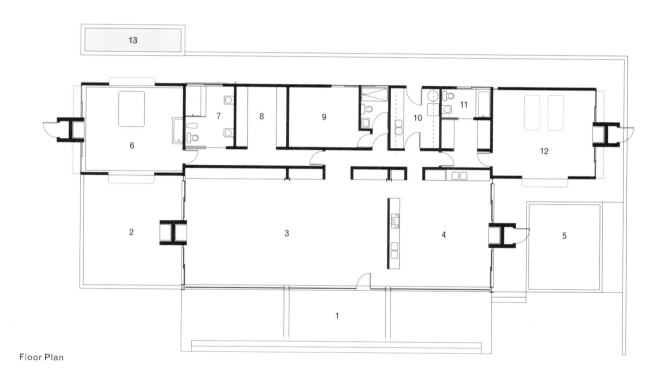

Floor Plan

LANTERN

Published by the Penguin Group
Penguin Group (Australia)
707 Collins Street Melbourne, Victoria, 3008, Australia
(a division of Pearson Australia Group Pty Ltd)
Penguin Group (USA) inc.
375 Hudson Street, New York, New York 10014, USA
Penguin Group (Canada)
90 Eglinton Avenue East, Suite 700, Toronto, Canada ON M4P 2Y3
(a division of Pearson Penguin Canada Inc.)
Penguin Books Ltd
80 Strand, London WC2R 0RL England
Penguin Ireland
25 St Stephen's Green, Dublin 2, Ireland
(a division of Penguin Books Ltd)
Penguin Books India Pvt Ltd
11 Community Centre, Panchsheel Park, New Delhi – 110 017, India
Penguin Group (NZ)
67 Apollo Drive, Rosedale, Auckland 0632, New Zealand
(a division of Pearson New Zealand Ltd)
Penguin Books (South Africa) Pty Ltd, Rosebank Office Park, Block D, 181 Jan Smuts Avenue, Parktown North,
Johannesburg, 2196, South Africa
Penguin (Beijing) Ltd
7F, Tower B, Jiaming Center, 27 East Third Ring Road North, Chaoyang District, Beijing 100020, China

Penguin Books Ltd, Registered Offices: 80 Strand, London, WC2R 0RL, England

First published by Penguin Group (Australia), 2014

10 9 8 7 6 5 4 3 2 1

Design by Evi O. © Penguin Group (Australia)
Photography by Richard Powers
Author photography by Hugh Stewart
Typeset in Chronicle by Evi O.
Colour separation by Splitting Image Colour Studio, Clayton, Victoria
Printed and bound in China by 1010 Printing International Ltd

National Library of Australia
Cataloguing-in-Publication data:

McCartney, Karen.
Superhouse/Karen McCartney; photography by Richard Powers.
ISBN: 9781921383571 (hardback)
Includes bibliographical references and index.
Architecture, Domestic. Architect-designed houses. Interior decoration.
Powers, Richard.

728

penguin.com.au/lantern

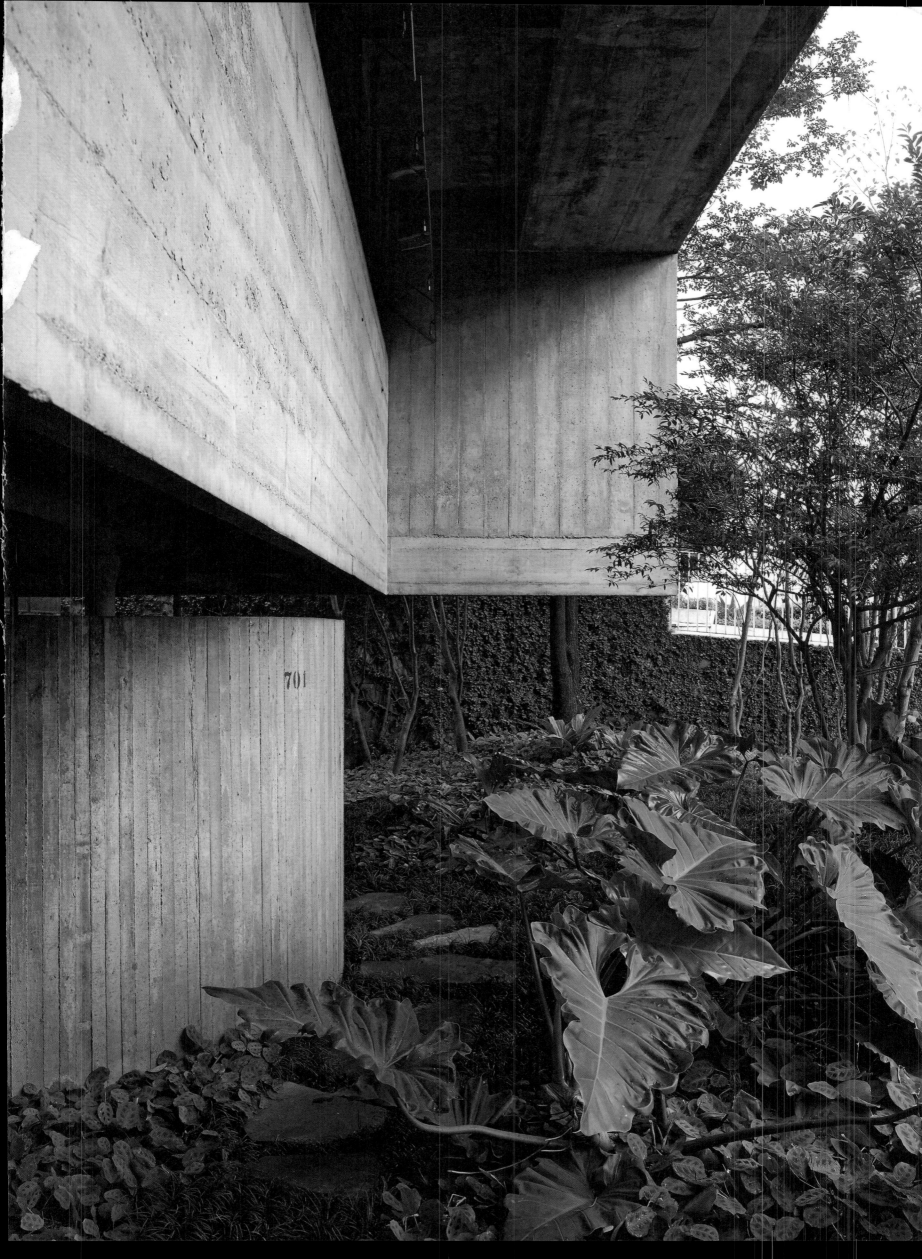

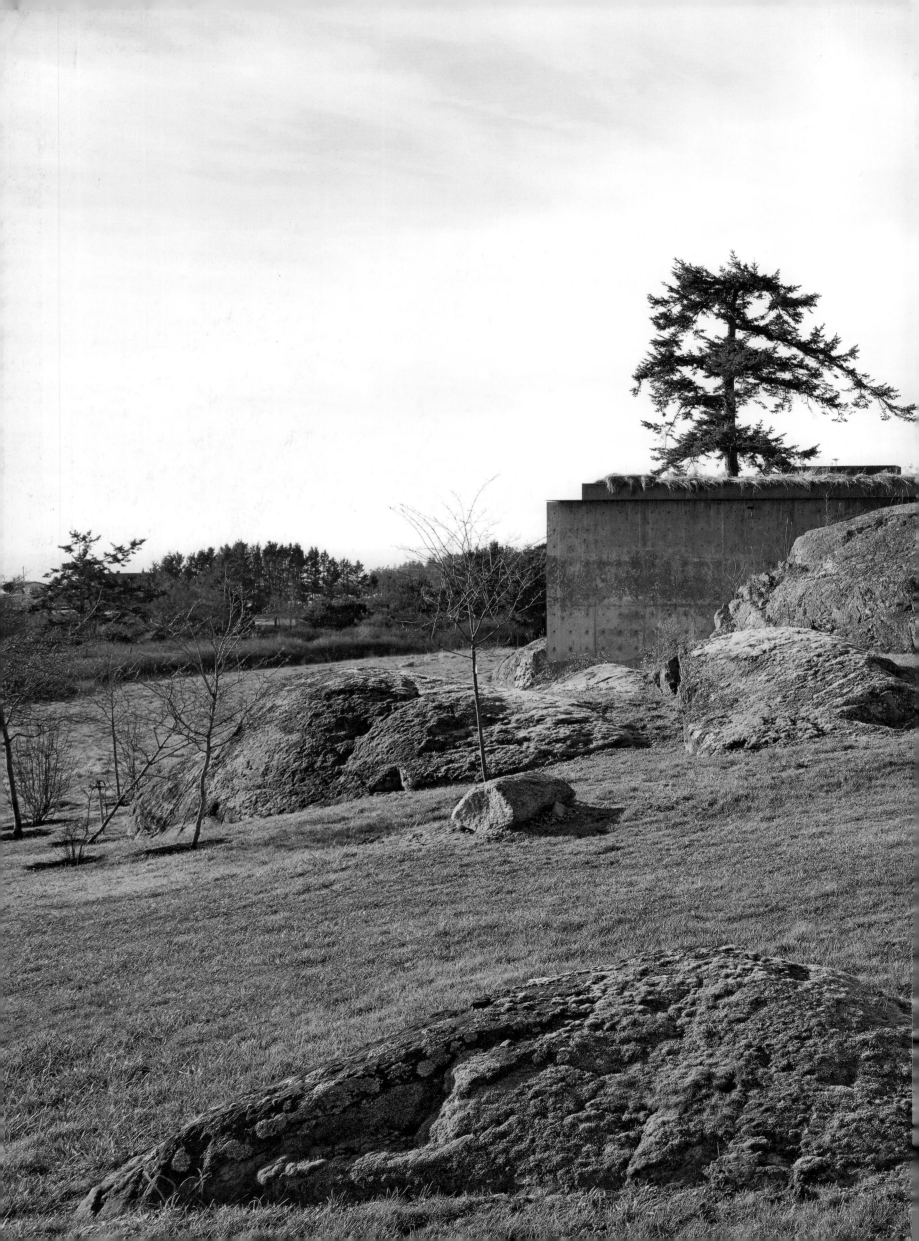